———

THE

NATIVE AMERICAN

CURIO TRADE IN

NEW MEXICO

———

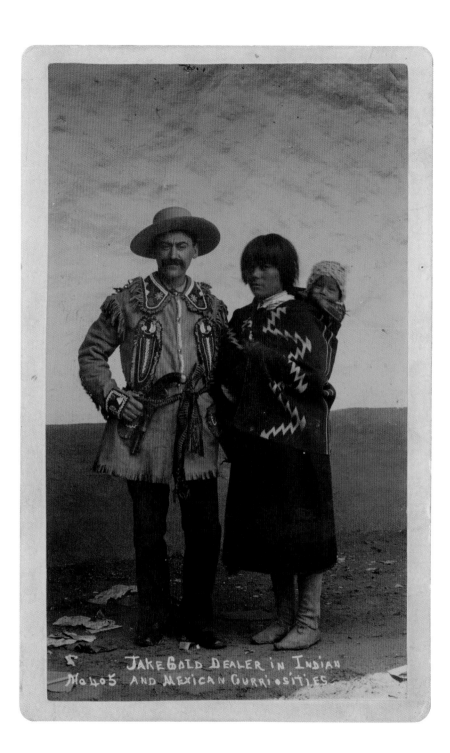

JAKE GOLD DEALER IN INDIAN
No. 605 AND MEXICAN CURRIOSITIES

# THE

# NATIVE AMERICAN

# CURIO TRADE IN

# NEW MEXICO

*Jonathan Batkin*

WHEELWRIGHT MUSEUM OF THE AMERICAN INDIAN

# Contents

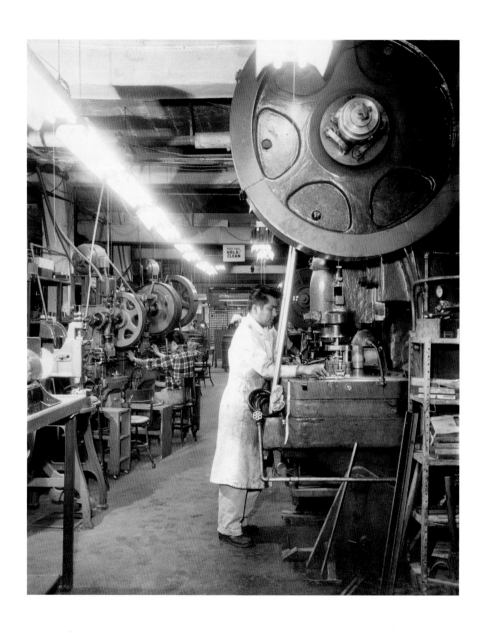

*Unidentified workman at 110-ton press, Maisel's Indian Trading Post, ca. 1950. Photograph by S. L. Maisel. Collection of Mr. and Mrs. S. L. Maisel.*

PREFACE

AND

ACKNOWLEDGEMENTS

*H. A. Montfort is remodeling his store room on First street, putting in a partition to separate his Indian curio department from the undertaking rooms and fitting up things to first class style.*

When this notice was printed in the *Albuquerque Daily Citizen* on January 31, 1888, Albuquerque's undertaker was hardly alone. Starting in the 1880s, hundreds of people became curio dealers, selling Indian goods from curio stores, groceries, pharmacies, and other establishments—even from their living rooms. By 1910 the urban curio store was commonplace in towns throughout the Rocky Mountains and Southwest, and by the 1920s the trade had expanded into machine-assisted mass production of silver jewelry.

This subject first attracted my attention more than twenty years ago, when I was studying historic Pueblo Indian pottery in preparation for writing a catalog of the Taylor Museum's collection. Prior authors had acknowledged that Pueblo pottery had changed with the arrival of the railroads, and change was assumed to have been due to the influence of tourism. It was clear that tourism alone did not explain changes in pottery, but I failed to understand that curio dealers and Native American craftspeople had collaborated to invent and market objects that had no purpose but to satiate a nearly irrational desire to own Indian

artifacts. The astounding volume of production for the curio trade and the mail-order marketing of artifacts had been forgotten.

In those instances where the curio trade's influence had been acknowledged, for example with respect to the Tesuque rain god, it was invariably seen in a negative light. Curio dealers were maligned as early as the 1880s, and many of the objects they handled were dismissed as inauthentic and tainted. On the other hand, the first person visited by many scholars who traveled to the Southwest was a curio dealer, and many scholars purchased from curio stores for their institutions or for themselves. Adolph F. Bandelier befriended both Aaron Gold, who loaned him rare Spanish colonial manuscripts for his study, and Aaron's youngest brother, Jake, who made introductions for him in the pueblos and sold him artifacts for museums in the United States and Germany. The anthropologist George H. Pepper of the American Museum of Natural History purchased from J. S. Candelario, as did the great naturalist Louis Agassiz Fuertes.

Still little that is reliable has been published on the curio trade in the Southwest, despite the fact that in the Southwest the trade had a greater presence than elsewhere in the United States. Misconceptions abound. For example the expression, "Fred Harvey jewelry," is a misnomer, and the notion that the Fred Harvey Company was involved in the mass production of silver jewelry is incorrect. In fact the common preoccupation with the Harvey Company as a paradigm for the curio trade is misguided. The company had an enormous influence on tourism and dealt heavily in curios, but it entered the trade in New Mexico more than twenty years after the first curio dealers opened shops there, and it acquired almost all of its inventory from other curio dealers and from traders on the Navajo reservation.

My purpose in this book and the accompanying exhibition is to lay out some of the facts of the Native American curio trade in New Mexico. I have divided the study into two parts. In the first part I have outlined the origins of the curio trade in the Rocky Mountain West from southern Wyoming to El Paso, Texas, and have followed the trade in New Mexico up to about 1915. I have emphasized major dealers of Santa Fe whose business practices can be reconstructed, but I have also included Francis E. Lester of Mesilla Park, who exerted a profound influence on the trade in his time.

In the second part I have focused on the manufacture and marketing of mass-produced silver jewelry, which swept the Southwest starting in the 1920s.

Silversmithing in the curio shops influenced the teaching of silversmithing in the Indian schools, incited traders on the Navajo reservation, triggered a federal prosecution, and inspired many Native workers in curio shops to go on to successful careers as independent artists. I have followed silversmithing in the curio shops up to World War II, when metals were rationed and many smiths went to war.

Curio stores were often performance spaces, and each had its own persona. In the early years some dealers entertained visitors with outlandish fabrications and salesmanship, while others, who probably never met an Indian, projected themselves as experts on Native American culture in their mail-order catalogs. In the 1920s and 1930s curio dealers hired young Pueblos and Navajos — primarily men — to learn and demonstrate silversmithing for the public. While those artisans provided inexpensive labor, their presence lent the shops an air of authority and authenticity.

Throughout, my emphasis is on production and sale, rather than consumption. I have focused on the individuals who ran curio businesses and the artists who supplied them, on the objects that were sold and the sources of materials used to make them, and on the manipulation and control of production and the marketing of goods, both in the shops and through mail-order catalogs.

The story of the curio trade is one of people as much as it is of artifacts, and I dedicate this account to those who shared their stories with me.

I could not have undertaken this project without the constant support of my wife, Linda, and daughter, Elizabeth. Their patience and encouragement, even during my many absences, sustained my interest and endurance.

The trustees of the Wheelwright Museum encouraged me to work on this project when time allowed and in the past five years granted me several months to complete it. Several of the museum's donors provided generous financial support to cover the expenses of travel and publishing. For helping to make this book a reality, I especially want to thank Lucia Woods Lindley, Martha Ann Healy, Leo and Donna Krulitz, Seymour Merrin, Leonie F. Batkin, and the Thaw Charitable Trust.

Harold Gans shared his memories of Southwest Arts & Crafts, which his father, Julius Gans, founded in Santa Fe in 1916, and which Harold later ran. Harold worked in the shop starting in the early 1930s, and his recollections of it prior to World War II are richly detailed and precise. I am grateful to him for answering my questions on many occasions.

The late Manuel Naranjo of Santa Clara Pueblo learned silversmithing at Maisel's Indian Trading Post in Albuquerque in 1929. In the early 1930s he moved to Denver, where he worked as a silversmith for nearly sixty years. Manuel became not only a trusted source, but an important part of my story. His daughter, Evelyn Arnold, has been supportive of this project since we first met, and I thank her for her encouragement and assistance. I also thank Nancy Snively for making the connection between Manuel and his workbench, which is now in the Wheelwright Museum; and I thank her parents, Frank and Jean Moore, for facilitating my first meeting with Manuel and Evelyn in 2001.

S. L. "Bud" Maisel shared his memories of Maisel's Indian Trading Post, which his father, Maurice M. Maisel, founded in Albuquerque in 1923, and which Bud eventually ran. Like Harold Gans, Bud shared detailed memories that helped me reconstruct the history and practices of his family's company.

At Isleta Pueblo several individuals contributed to my knowledge of Maisel's Indian Trading Post and the independent silversmiths at the pueblo. I am grateful to Agnes Dill for sharing her precise recollections and for introducing me to several other people at the pueblo. Joe Anzara, Josephine Lente, and Agnes's sister, Isadora Sarracino, all helped fill gaps in my knowledge.

Several members of the Seligman family shared memories of its shops in Bernalillo and Albuquerque. I thank Randy and Jack Seligman, Julia Seligman and her late husband, Milton, and Susan Seligman Kennedy for generously giving their time and knowledge. I also thank Armen Chakerian, whose father acquired the Seligman's shop in Albuquerque in 1959, for his constant encouragement, and for answering questions on many occasions. His firsthand experience with a shop that has run until the present in exactly the same manner as did shops in the 1930s proved to be one of my most valuable sources of knowledge.

Several members of the staff of the Wheelwright Museum assisted me. Cheri Falkenstien-Doyle, curator, provided suggestions, shared references, and read and critiqued every draft of the manuscript and every layout of the book. Leatrice Armstrong, my assistant, provided numerous valuable references and filled in for me while I wrote. Mary Katherine Ellis, collections manager, worked with curators, registrars, conservators, and photographers in several institutions; secured all permissions and loans; and arranged for shipping.

For sharing memories, ideas, and references; locating ephemera, photographs, and archival sources; and making loans available I want to thank Tad

Anderman, Bob Bauver, Jerry and Deanna Becker, Bruce Bernstein, Mike and Allison Bird-Romero, Lew Bobrick, Erika Bsumek, Chad and Erika Burkhardt, Vidal Chavez, David Cook, Lane Coulter, Cippy Crazyhorse, Ray Dewey, Bob Doyle, Kate Duncan, Jay Evetts, the late John C. Ewers, Alan Ferg, Beth Finkel, Julia Herrera, Bill Holm, Ken Horner, Kathy Howard, Yazzie Johnson and Gail Bird, Bob Kapoun, J. C. H. King, Cindra Kline, Barbara Landis, Patricia Fogelman Lange, Edwin Naranjo, Phil Nathanson, Diana Pardue, the late Richard A. Pohrt, Bill Seis, Robert Shorty, William M. Smith, Russ Todd, Bob Vandenberg, the late C. G. Wallace, Liz Wallace, David and Joan Wenger, the late Joe Ben Wheat, the late Tom Woodard, and Will Wroth.

I also want to thank the institutions and individuals who made collections and archives available for study, for organizing the loans of objects for the exhibition, and for providing images and other material. Our good neighbors at the Museum of New Mexico deserve special recognition for their consistent support of our exhibitions and publications. They include Fray Angélico Chávez History Library, Palace of the Governors, Santa Fe: Blair Clark, Tomas Jaehn, Hazel Romero; Museum of Indian Arts and Culture/Laboratory of Anthropology, Santa Fe: Diane Bird, Tony Chavarria, Anita McNeece, David McNeece, Shelby Tisdale, Valerie Verzuh; Museum of International Folk Art, Santa Fe: Deborah Garcia, Barbara Mauldin; Photo Archives, Palace of the Governors, Santa Fe: Daniel Kosharek, Lane Willard.

Also providing essential support were Albuquerque Public Library, Special Collections; Center for Southwest Research, Zimmerman Library, University of New Mexico, Albuquerque; Colorado Historical Society, Stephen H. Hart Library, Denver; Denver Art Museum: Nancy Blomberg, Becky Ceravolo, Sarah Cucinella-McDaniel, Lori S. Iliff, Jennifer Pray; Denver Public Library, Western History and Genealogy Department; El Paso Public Library; Field Museum of Natural History, Chicago: Jerice Barrios, John Dodge, Angela Steinmetz; Heard Museum, Phoenix: LaRee Bates, Mario Klimiades, Diana Pardue; Missouri Historical Society, St. Louis: Steven Call, Linda Landry, Duane Sneddeker; Museum of Spanish Colonial Art, Santa Fe: Robin Farwell Gavin, Alessa Greenway Palacio; National Archives and Records Administration, Rocky Mountain Region, Denver: Eileen Bolger, Rick Martinez, Marene E. Sweeney; National Archives and Records Administration, Washington, DC: Mary Frances Morrow; New Mexico State Records Center and Archives, Santa Fe: Sandra Jaramillo, Estévan

Rael-Gálvez, Al Regensberg; New Mexico State University Library, Archives and Special Collections Department, Las Cruces: Charles B. Stanford, Cheryl Wilson; Penrose Public Library, Special Collections, Colorado Springs; Princeton University Art Museum, Princeton, New Jersey: Alexia Hughes, Maureen McCormick, Karen E. Richter; Rutherford B. Hayes Presidential Center, Fremont, Ohio: Mary Lou Rendon; Taylor Museum for Southwestern Studies, Colorado Springs Fine Arts Center: Saskia Kesners, Tariana Navas-Nieves; Smithsonian National Museum of the American Indian, Washington, DC: Anya Montiel, Patricia Nietfield, Erik Satrum, Lou Stancari; Arizona State Museum and Arizona State Museum Archive, University of Arizona, Tucson: Diane Dittemore, Alan Ferg; University of Arizona Library, Special Collections, Tucson; C. L. Sonnichsen Special Collections Department, University Library, the University of Texas at El Paso: Roberta Sago.

THE

NATIVE AMERICAN

CURIO TRADE IN

NEW MEXICO

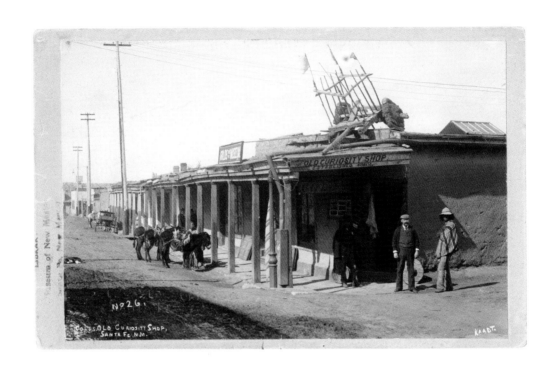

Figure 1. Gold's Free Museum, ca. 1895–1898.
Photograph by C. G. Kaadt. Jake Gold poses in the
street with an unidentified man. Photo Archives,
Palace of the Governors, Museum of New Mexico/
Department of Cultural Affairs, Santa Fe, 10728.

# A Cast of Characters

The dilapidated appearance of Jake Gold's curio shop at the corner of West San Francisco Street and Burro Alley in Santa Fe was one of its greatest charms. Gold's Free Museum, with a rickety *carreta* mounted on its roof, and the braying burros on the adjoining street and alley, often laden with firewood, were two of Santa Fe's most photographed subjects in the late nineteenth century (figure 1).

If Gold's adobe building appeared ancient and unstable, it was not out of neglect. When he renovated it in 1893 he deliberately preserved its antiquated look. A notice in the *Santa Fe Daily New Mexican* stated that Gold was about to "make extensive improvements" to his store: "The establishment will be nearly doubled in capacity, but the ancient style of interior finish will be preserved, as the curio dealer thinks it would be vandalism to modernize the house considering that he will continue to dub it the 'old curiosity shop.'"[1]

In 1901 Gold formed a new curio business with his friend, J. S. Candelario. In their store, a few doors east of Gold's original location, they created a similarly crowded interior and put a *carreta* on the roof. The chaotic interiors were as deliberate as the carts on the roofs (figures 2, 33). One Santa Fe dealer described the shop as it appeared in the 1930s: "Candelario's was the biggest junk shop you ever saw in your life — very cleverly done."[2]

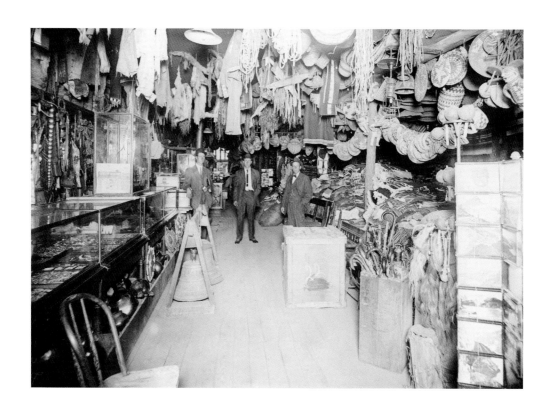

Figure 2. The Original Old Curio Store, May
1914. Photographer unidentified. J. S. Candelario,
at right, poses with two unidentified men. Museum
of Spanish Colonial Art, Spanish Colonial Arts
Society, Inc., Santa Fe, 2005.17b.

Gold and Candelario were legendary. For a photograph taken in the mid- to late 1880s, Gold presented himself as an adventurer, dressed in a jacket decorated with Iroquoian beadwork and with a single-shot, muzzle-loading pistol in his belt; the Pueblo woman and child who posed with him implied familiarity with Indian people (frontispiece). For his portrait, Candelario sat comfortably in a wicker chair, wearing a suit and proclaiming his authority on Indian arts by holding a pair of moccasins (figure 36). In 1894 Gold's brilliant salesmanship was the subject of an article published in Philadelphia, and as Candelario once said, "The tourists want to hear tales, and I am here to administer the same." He may have meant that visitors wanted to be entertained, but every retailer knows that buyers are eager for reinforcement, even in the form of half-truths.[3]

Gold and Candelario were not unusual. Many early curio dealers fashioned themselves as adventurers, risk-takers, intermediaries between Anglos and Indians, experts in Indian arts, or trustworthy sophisticates. They stretched the truth in order to draw attention to themselves, to generate a sense of confidence, and to instill desire. Amos H. Gottschall of Harrisburg, Pennsylvania, published repeatedly on his adventures, reminding his readers just how hard-won his authority was. His travels were the subject of much that he wrote, and in his book, *Travels from Ocean to Ocean, from the Lakes to the Gulf*, he explained his yearning:

> To be able . . . to live with the Indians in their native wilds, and to travel over the vast extent of country between the Atlantic and the Pacific, and the Great Lakes and the Gulf of Mexico, was my aim and object even from the time I could read a book or understand a map. . . .
>
> Finally, I concluded to run away; and in the month of July, 1864, when in my tenth year, I left my kind, loving mother, father, sisters and brothers, to face the storms and rebuffs of this cold, unfriendly world.[4]

Gottschall's first journey was short, but at sixteen he embarked on the first of many trips that took him throughout the United States, working as a typesetter for newspapers and as a canvasser when he needed cash. By the late nineteenth century Gottschall had become a curio dealer, and in his mail-order curio catalogs of the ensuing twenty-five years he played on the "vanishing red man" theme, which was employed by many mail-order dealers.[5]

Of the millions of red men, women and children once inhabiting what is now the United States and Canada, but a poor, weak, scattered remnant are left. Their sun has set to rise no more; their bows are unstrung; their council-fires have died out; their war-whoop has ceased forever. They present a sad, pathetic contrast to the Indian among whom I lived and traveled forty, fifty and more years ago. . . .

Soon the red man will live only in history, in illustration, in the Indian names given to streams and places, and in the remaining Indian handicraft, the latter once so diligently gathered by interested white men and now so faithfully and carefully preserved by those who realize and appreciate the historical and educational value of these mementoes. . . .

Then should the memory of this people not only command the sympathy of Americans, but cause us to faithfully preserve the remaining handicraft of the red man as one of the last tributes we can pay him?[6]

Gottschall described hardship in his effort to deepen the reader's desire:

. . . I secured a varied and valuable collection of their handicraft, traveling thousands of miles over prairies, tablelands and desert wastes, through vast forests, deep canyons and delightful valleys, across rugged bluffs and lofty mountains and along the shores of lakes and rivers. Leaving the borders of civilization with a team or on horseback, with camping outfit, weapons, photographic material, etc., and at times with an Indian or two as guides and helpers, but generally going alone, and sometimes, especially in the earlier days, I made these wilderness journeys on foot for hundreds of miles. . . . I have traveled for months and months, summer after summer, among the Indians in their native wilds, meanwhile camping right in their villages, and buying what the warriors and squaws brought to me.[7]

Gottschall claimed to have collected Pueblo Indian pottery between 1897 and 1900, while he "camped and traded" in the pueblos. Although that may be true, he

purchased artifacts from Jake Gold and J. S. Candelario. His assertion that Hopi pottery was "scarcer and more difficult to procure, than that of any other pottery-making tribe" is telling. A more credible Joseph Schmedding, who in about 1916 acquired Juan Lorenzo (J. L.) Hubbell's inventory of Hopi pottery at Keams Canyon, estimated its number in the "tens of thousands." Hubbell, the famous trader of Ganado, Arizona, had in turn acquired his inventory from Thomas V. Keam in 1902, when he purchased Keam's establishment, the Tusayan Trading Post. For years Hubbell supplied the curio trade with Hopi pottery.[8]

Chauncey Wales (Captain C. W.) Riggs was a like-minded, self-styled adventurer who sold artifacts and collections of artifacts to several museums. *Camp Life in the Wilderness*, written by Riggs, his wife, Althea, and Frank Markwood of the *Kansas City Times*, and published about 1897, was a promotion for Riggs's exhibition-sales of Indian artifacts in department stores in Boston, Philadelphia, Brooklyn, New York, Newport, Providence, Baltimore, and Washington from 1897 to 1899. Riggs described his exhibition as a "Navajo Indian Art Collection, Wigwam and Barbaric Den. Nothing Approaching it in Extent or Variety Has Ever Been Seen Before."[9]

In her chapter, "Among the Indians. A Unique Life in the Saddle and About the Camp Fire. Three Hundred Miles with a Burro Train through the Mountains and Canons and over the Mesas of New Mexico," Althea Riggs spoke of the "vanishing" Navajo and claimed that "The winter of '93 and '94 we spent in gathering pottery from the Pueblo Indians along the Rio Grande river.... There were eight of us, eighteen horses, and a string of burros." After collecting in the pueblos, they went to Santa Fe, where an injured C. W. Riggs spent a month recuperating and seeing the sights.

Again, by 1893 Pueblo pottery was available by the barrel from Jake Gold and other curio dealers, so Althea Riggs's account may also represent exaggeration. Markwood's contribution was a poem, "A Navajo Indian Weaver," which he dedicated to "Captain C. W. Riggs, who allowed me to examine his magnificent collection of Navajo rugs, and his kindly efforts in explaining the manner of producing the wonderful examples of Indian Art he has collected."

> The threads were as the days of life,
>    The dark and the brightly fair;
> The shuttle blent the peace and strife
>    As it slowly swung in the air.

No guide but an untutored mind
   And the wealth of Nature's bloom,
As the weaving skeins twine and wind
   In the rude barbaric loom.

Before it sat the sibyl brown,
   And guided each shining strand,
The mystic shuttle up and down
   Invoked the spell of her hand.
And with each touch the story grew,
   Tho' it spoke in an unknown tongue
A tale the white man never knew,
   A song that his heart ne'er sung.

The lines were gray as storm pent clouds,
   And red as a battle plain,
Yet white withal as dead man's shroud
   Glowed each swaying shining skein.
Green as the grass of prairie's sod,
   And black as the soul of night,
Bright as the thunderbolt of God
   That leaps from the heaven's height.

These were the thoughts that mazed and strove
   Into an unknown tongue;
These were the songs the sibyl wove
   That never a white man sung.
For her soul is bound to a sphere
   Where the lost years ebb and flow,
Nor logic nor reason can clear
   The art of the Navajo.[10]

In 1899, to promote his sale at A. A. Vantine & Co. in New York, Riggs published a small booklet about Navajo rugs titled *"Rough Rider" Robes of the Wild West*, with an engraved portrait of himself on the title page (figure 3). The implication

is that Riggs was a Rough Rider, but more likely he was exploiting the current popularity of those heroes. Riggs depicted himself as a robust warrior, though in a photo of him published in 1897 he appeared gaunt and unhealthy.[11]

Frank Markwood's cloying verse is but one of many poems printed in early curio catalogs and related publications. In the September 1893 issue of *The Great Divide*, a magazine published by Denver's leading curio dealer, H. H. Tammen, is "My Zuñi Water Jar," a lament by J. C. Davis:[12]

> In fragments at my feet lies — my Zuñi jar! Tears dim my eyes.
> What cruel fate decreed the fall of this most precious bit of all
> My bric-a-brac?
> Ah, now the pungent, strange perfume of desert Sage pervades
> my room
> And glimmering through the mist of tears, fair scenes of other
> happier years
> Come stealing back.
> Against the sapphire southern skies creamy adobe walls arise
> And everywhere blue shadows fall, beneath white sun-rays
> vertical,
> While silently
> Lithe dusky forms with sinuous grace clamber to some high
> vantage place
> Whence furtive eyes, alert and bright through tangled elf-locks
> black as night,
> Peer down at me!

The curio trade in the Rocky Mountains and Southwest attracted all variety of offbeat personalities, as well as respected scientists and businesspeople. The trade evolved simultaneously with completion of the transcontinental railroads and their branch routes. From its inception the curio trade was a mail-order industry, and though most curio dealers catered to tourists, many also relied on the railroads to distribute mail and carry freight.

The pattern repeated itself throughout the Rockies as the east-west lines were built. At Laramie, Wyoming, on the Union Pacific Railway, which was completed in 1869, the first known mail-order curio dealer published a catalog in

1874. George B. Boswell, a self-described assayer and mineralogist, offered mineral specimens and mineral cabinets, as well as Plains Indian artifacts (figure 4). Boswell claimed that his "collection of minerals and natural curiosities is increasing rapidly and being personally known to all the Trappers Hunters and Frontiers-men of this vast unknown region." In his crudely printed offering, Boswell stated that his Indian goods were acquired through interaction with "war like tribes." As we will see, his mineral specimens were cast-offs of mining operations. His Indian artifacts were probably acquired from individuals at Fort Laramie.[13]

In Colorado several dealers became active between 1873 and 1880, most of whom were taxidermists or mineralogists. Martha A. Maxwell, a celebrated hunter and taxidermist, became famous for her lifelike presentations of animals. She founded the Rocky Mountain Museum at Boulder in 1874 and moved it to Denver in 1875, shortly before she represented the state of Colorado with a display of her work at the Philadelphia Exposition of 1876. Maxwell was admired as an amateur scientist, and when her first biography was published in 1879 it included contributions by the esteemed naturalists Elliott Coues and Robert Ridgway. Based on her own specimens and the scientific knowledge of the time, Ridgway named a subspecies of the Eastern Screech-Owl after her.[14]

Maxwell's biographers discussed her sales of mounted animals, even before she founded her museum, but neither mentioned her activity as a dealer in mineral specimens. The first account of collecting mineral specimens was in a letter to Maxwell from her husband, James, in September 1873: "We got in South Park about 100 lbs. of petrified cedar & various birds. . . . We expect to cross the Range from north fork of the Poudre on to Big Laramie in the North Park where we are to get fine Agates."[15]

The following February a collector named J. W. Glass shipped 920 pounds of mineral specimens to Maxwell. He had collected at Black Hawk and Nevada, Colorado, and planned to collect at the towns of Idaho and Russell. He had dug in the "Dump pile of the Delaware mine" and acquired specimens from miners:

> I ought to have money to buy fine crystalizations so as to have at least one fine case of crystals. The miners here select for themselves all the fine crystalizations that are taken from the mines, and the only way to obtain them is by purches [sic],

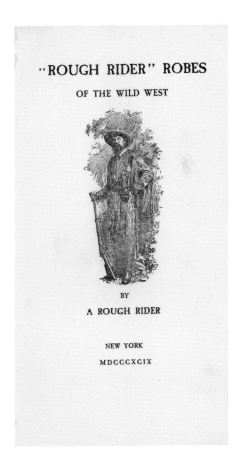

"ROUGH RIDER" ROBES

OF THE WILD WEST

BY

A ROUGH RIDER

NEW YORK

MDCCCXCIX

*Figure 3. C. W. Riggs presented himself as a robust adventurer on the title page of the 1899 catalog promoting his exhibition-sale at A. A. Vantine & Co., New York. Private collection.*

*Figure 4. George B. Boswell's catalog from his Rocky Mountain Mineral Agency, 1874. This crudely printed broadsheet is the earliest known curio catalog from the Rocky Mountain states. Yale Collection of Western Americana, Beinecke Rare Book and Manuscript Library, New Haven, Connecticut.*

OFFICE OF THE ROCKY,
MOUNTAIN MINERAL AGENCY.

LARAMIE, CITY, W. T.
MARCH, 20th 1874.

My Dear Sir,

I would respectfully ask of
you a careful perusal of the enclosed list
Of Mineral specimens Indian goods and
Natural curiosities in addition to the with
-in named specimens, I have a choice ass-
-ortment of ores from the renowned mines
of Utah and Nevada, some of them Assay
-ing as high as $20,000, per ton,
Price from 25 cts to $5.00.
My Indian curiosities of which I have a g
-reat variety consists of Bows Arrows Pip
-es Moccasins Flint's War-clubs &c. Rel-
-ics of the Sioux, Cheyenes, Arapahoes,
Utes and other war like tribes, My colle-
ction of minerals and curiosities
is increasing rapidly and being personaly
known to all the Trapers Hunters and F-
rontiers-men of this vast unknown regio-
n, I flatter myself that my facilities for
furnishing minerals and curiosities is un-
surpassed. If you do not find what you
want in this list, I will e willing wite pl-
ain, be brief, tell me what it is and if pos-
sible I will get it for you.

INDIAN CURIOSITIES.

Bow six arrows and quiver, $5.00.
Moccasins plain,              " 2 "
Moccasins beaded,             " 4 "
Pipes from 25 cts to          " 1 "
Bells from 1.00, to           " 3 "
War-clubs, 1.00, to           " 3 "
Flints from 10 to             25 cts
Scalping knives.              $.5. each
Sent by mail or express,

LIST OF MINERALS, &C.

Those Marked With One Star, 10 To 50 Cents.
Those Marked With Two Stars, 50 cts To $1.00.

Agate Moss.                  * Agate water,       *
Auriferous Pyrites,          : Antimony,
Argentiferous "              : Arsenical Iron,
Arseno                       : Antimonial Sulf
Brown Iron Ore,              : Black Jack,
Bismuth (mettalic)           : Beyrl,
Cynnite                      : Cale Spar,
Cinabar (quick-silver)       : Chromic Iron
Chrysocolla                  : Chrysolite,
Copper Pyrites,              : Copper Grey,
Copper Glance.               : Copper Black,
Copper Vitreous,             : Copper Native.
Graphite,                    ; Gypsum crystalice ;
Galena Sulphuret,            : Garnet,
Galena Argetferous,          : Galena Auriferous, :
Gold Ore,                    " Gold Native 1. to —
Iron Specular.               " Iron Pyrites,
Iron Arsenical               " Iron Magnetic.
Iron Red Hæmmatit.           " Iron Brown Hem"  "
Muscles petrif ed,           " Isspickel.         "
Manganese Black,             " Manganese Oxyd,  "
Sulphur Native,              " Topaz,           "
Quartz common,               " Quartz Smoky,
Quartz Crystals.             " Quartz Rose,
Encrustations com'on " Stalactites Small,
Encrustations from the Yellow stone Park.  "
Stalactites Extra Large.
Petrified Wood Snakes Fishes & Clams.

All Orders promptly Attended to, No Goods s-
ent C O D. Send Money By Registered
Letter or Post Office Money Order.
All Letters desiring answers must enclos-
e stamp for reply.    Address all letters to

GEO. B. BOSWELL, ASSAYER,
Box 178 Laramie City, Wyoming Ter.
Rawlings: SEE OVER.

which I can effect at small prices. Those I have bought already for the sum of four dollars and fifty cts. can be disposed of at the museum for over *thirty dollars*, and I will state that if you do not want them, when you see them, I would like very much to have them myself.[16]

In October 1874 Maxwell wrote to Marianne Parker Dascomb at Oberlin College, where her daughter was enrolled. She explained that she had decided to add to the collections of her museum "a good assortment of ores from our gold & silver mines and minerals and fossils (many of them rare) found in the [Rocky Mountain] region. For this purpose we kept a collector in the field over a year." Maxwell then proposed to sell the college some of the collection for credit for her daughter's education.[17] In another letter to Dascomb, she described her planned curio business more fully:

> [In] connection with this museum I hope to carry on a sale and exchange business, and have on hand a good stock of bird skins and minerals &c aside from my museum; from which I can make up cabinets worth from five to one hundred dol. or more. The birds and mammals I can furnish in skin or mounted. . . . I have just commenced this business and our house [is] quite too small to warrant success. . . . [18]

Maxwell's museum was described in contemporaneous newspaper articles: "Passing through the assorting rooms for minerals . . . we enter a sort of ante-chamber, in the middle of which stands a buffalo with eyes distended and horns in a threatening attitude." And, "Where we expected to find one small room, sparsely filled, we found three rooms, two being quite large and high; with the ends and sides, floor and ceiling literally crowded with rare, curious and valuable specimens. The walls are lined with cabinets with sliding doors, and the deep shelves within are covered with handsome mineral specimens and gems."[19]

Maxwell collected Indian artifacts and featured them in her museum: "The walls are hung with trophies of the chase and battle-field — deer and elk antlers, Indian shields, leggins, war clubs, bows and arrows, boat paddles from Vancouver's island. . . ." Considering the fact that Maxwell dealt in mounted animals

and mineral specimens, it may be safe to assume that she also dealt in Indian artifacts. Certainly artifacts from Vancouver Island were acquired in trade, but so also was a Navajo blanket, which appears in a photograph of the interior of the museum taken in October 1875.[20]

Maxwell was so accomplished and admired that it seems unlikely she would embellish stories or play to the press. Nevertheless, an account published in the *Philadelphia Press* in 1876 included a description of her encounters with Indians, which is unlike anything recounted in her letters or biographies:

> At her home in Mountain City, and afterwards in Boulder, Colorado, she frequently met Indians of the Sioux, Arapaho, and Cheyenne tribes, but, fully understanding their treachery as well as their cowardice and their vanity, was able to protect herself from harm under all circumstances. When they found a house with no one but women and children in it they would, if not on the war-path, do not actual harm, but delighted in frightening the inmates, and invariably carried off anything, whether valuable or useless, which they took a fancy to. These pilferings generally included everything eatable in the house, and usually they would compel the women to stand over a stove and cook pan-cakes for them until the victims almost sank from exhaustion. In such cases Mrs. Maxwell, though actually frightened, would assume all necessary courage, speak in a tone which led them to fear that she might possess resources of which they knew not, and influence them to good behavior by admiring their trinkets. Many times she saw them at a distance on the plains, or in the "parks," but never happened to meet a band face to face.[21]

Dom Pedro II, Emperor of Brazil, visited Maxwell at the Philadelphia Exposition. "He took quite a fancy to her little dog which used to be her companion when it was alive, and she keeps it sitting by her desk where it stays as natural as life with its bright eyes." Maxwell had stuffed the dog, named Pills, for a druggist who was distraught over its death. She never had dogs of her own, but when the druggist failed to return she kept Pills as a silent companion (figure 5).[22]

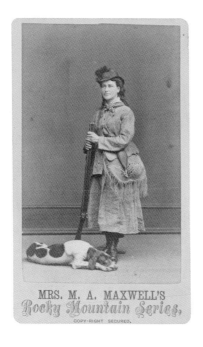

MRS. M. A. MAXWELL'S
*Rocky Mountain Series,*
COPY-RIGHT SECURED.

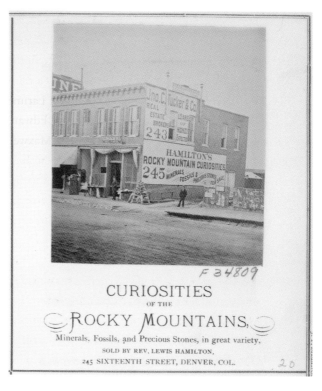

*F 34809*

CURIOSITIES
OF THE
ROCKY MOUNTAINS,
Minerals, Fossils, and Precious Stones, in great variety,
SOLD BY REV. LEWIS HAMILTON,
245 SIXTEENTH STREET, DENVER, COL.

*Figure 5. Martha Maxwell in her hunting outfit, ca. 1875, posing with Pills, the stuffed dog that she took to the Philadelphia Exposition. Photographer unidentified. Private collection.*

*Figure 6. The Reverend Lewis Hamilton's store, Rocky Mountain Curiosities, Denver, ca. 1875. Photograph by the Duhem Brothers. Note the sign, "Denver Museum," over the door. Denver Public Library, Western History Collection, X 18492.*

An earlier "museum" was founded in Denver no later than 1873 by the Reverend Lewis Hamilton. At Rocky Mountain Curiosities Hamilton sold minerals, fossils, and "precious stones." In a photograph of the shop taken around 1875, a sign over the door reads, "Denver Museum" (figure 6). Hamilton was Colorado's pioneer Presbyterian minister, preaching at Denver and Central City in June 1859, following the discovery of gold on Cherry Creek and his own twenty-nine-day trip by wagon. He had a distinguished career with the church before being killed by a train at Pueblo, Colorado, in 1881.[23]

In 1874 George L. Taylor went to work as a photographer, entering into a partnership with W. H. Masters in a studio on Larimer Street in Denver. The following year Taylor became a partner with Edward E. Achert, dealing in "Rocky Mountain curiosities."[24] While Martha Maxwell collected specimens of poorly known indigenous birds for the Smithsonian Institution, Achert and Taylor were instrumental in helping to spread the exotic English Sparrow (now House Sparrow), which is aggressive and destructive toward indigenous species and now ubiquitous in North America. An article in the *Rocky Mountain News* in February 1875 explained that the dealers

> have already taken several orders for English sparrows, and, as their introduction in the city and territory is of great importance to farmers, gardeners, and land-owners, the orders will not be forwarded for a few days yet, so that others wishing birds may also have the benefit of sparrows of the first importation. Coloradoans who have visited parks and gardens in New York and other eastern cities, before and after the introduction of English sparrows, are aware of the good service they have done in destroying insects, grubs, grasshoppers, etc.... [25]

By 1877 Taylor had founded Taylor's Free Museum on 16th Street, specializing in taxidermy, mineral specimens, and rugs and robes made from pelts.[26] He made the news in February 1881, when he announced the formation of Colorado's first airline in an article in the *Denver Daily Times*, "Ærial Navigation. Denver Forms the First Company... Interview With the Inventor and Description of the Ship." After the author engaged in some boosterism and discussed the drawbacks of railroads, he described the new venture:

The Colorado Aerial Transit company is the title of the new organization, and it incorporates with a capital of $5,000,000, nearly all of which has been subscribed for. The company owns exclusively the Taylor air-ship, a new invention from the prolific brain of Mr. George L. Taylor, of Denver....

In appearance [the air ship] resembles a long trough or sluice box, studded with brass nails and braced here and there with strips of metal. On either side, extending the entire length, is a flat, projecting shelf or plane, pivoted in the centre, so that it can be operated much on the principle of a see-saw—one end being elevated, the other is depressed. Attached to the rear end of the trough is a fan-shaped wheel of great diameter, and this is the driving part of the new invention. Inside of the ship is the engine—an electric one—placed amidships, with the battery forward beneath the pilot house. Wires and levers fill this little place up almost entirely, and the pilot, sitting in his place, has complete and constant control over all the moveable parts of the ship.

The rear, or stern, behind the engine, is intended for passengers, and embraces a cabin and a deck with a high railing all around it. Beneath the engine and cabin is the hold where baggage and freight are to be carried, while beneath the forward part, are the quarters for the officers and crew.[27]

Taylor expected the craft to carry twelve passengers and two tons of freight. He proposed that there would be "stations in the principal cities of the state," and explained that the only drawback was the inability to store sufficient electric power for the ship to travel more than three hundred miles. Each station would have a fifty-foot tower for docking and three balloons that could fill instantly with hydrogen for emergencies. The reporter stated that the model was "guided entirely around the spacious store room, and was finally brought to a rest" in a successful demonstration.[28]

Taylor was described as a leading Denverite in 1880, but he may have gotten into financial difficulties with purported investors in his airline, or he may have been simply a bad businessman. In July 1879 George Eastwood, who had

been Taylor's clerk for a year or so, bought a half interest in the business. Eastwood first managed the museum, and by 1886 he owned it. In 1886 Taylor vanished from Denver, only to appear in the news in Cheyenne, Wyoming, where he started another curio business and continued to pursue his passion as an inventor. An article in the *Cheyenne Daily Leader* in September 1887 explained that he was "working on a model for a patent gas engine."[29]

In 1888 or 1889 Taylor returned to Denver from Cheyenne. Jobless, his desire to make it big with an invention had prevented him from focusing on his own businesses. Over the next ten years he worked as a clerk for George Eastwood in the establishment bearing his own name, as a clerk for the H. H. Tammen Company, as a clerk in other shops, and even selling cigars from his own rented room. On April 29, 1901, he passed away at the county hospital and "his few personal belongings were turned over to relatives."[30]

The most successful curio dealer of Denver, and in fact in the entire American West, was H. H. Tammen, who was born Heye Heinrich Tammen but "who later anglicized and rearranged his name to Harry (and sometimes Henry) Heye Tammen." Tammen was born in Baltimore and worked as a printer's devil in Philadelphia before moving to Denver in 1880 to become head barkeeper at the newly built Windsor Hotel. He was an amateur mineralogist, and in an October 1881 article about a topical remedy called St. Jacob's Oil, he was identified as "a well known and reliable collector of Colorado natural curiosities."[31]

Tammen launched his curio venture in 1881 in partnership with Charles A. Stuart. The firm of H. H. Tammen and Company initially manufactured "mineral ink stands" but quickly expanded into mineral specimen cabinets (figure 7). In 1882 Tammen and Stuart published the first substantial curiosity catalog in the western United States, and though their partnership was dissolved in 1885, Tammen and his company published ever-larger curio catalogs well into the twentieth century (figures 8, 9).[32]

Martha Maxwell's experience demonstrates the ease with which Tammen acquired the mineral specimens needed to create his inkstands, cabinets, and other novelty goods. The specimens were little more than unusable low-grade byproducts of the mining industry in Colorado. Tammen also offered mounted game animals, some of which, for example the pronghorn, were hunted in such numbers that they were driven nearly to extinction by 1900. He and other curio dealers reaped a deadly harvest. His business was described in 1885 as "birds and

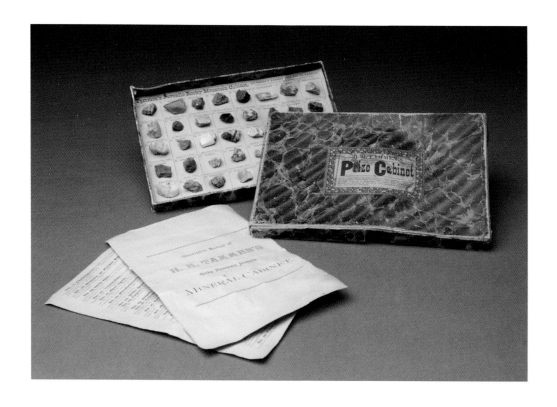

*Figure 7. H. H. Tammen and Company's Rocky Mountain Juvenile Mineral Cabinet with printed key, ca. 1886. Private collection.*

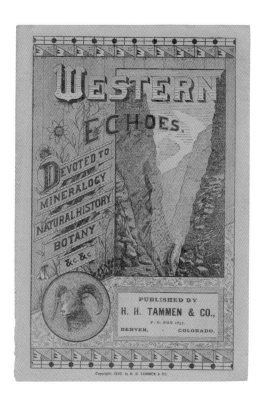

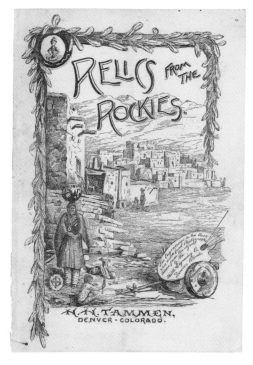

*Figure 8. H. H. Tammen and Company's first catalog,* Western Echoes, *1882. Private collection.*

*Figure 9. H. H. Tammen and Company's catalog,* Relics from the Rockies, *ca. 1887. By this date Tammen had adopted the Tesuque rain god as a logotype, seen here at upper left. Private collection.*

mineral curiosities" and in 1889 as "mineral cabinets and flowers." The Rockies — from their geological structure to their plant life, and from their avian wonders to their big game — were mined, harvested, hunted, and packaged for sale by curio dealers.[33]

When Tammen opened his business in 1881, among the items on display were Native American artifacts:

> There is one establishment in Denver that no tourist, traveler or visitor should miss seeing, and that is the free museum of Mr. H. H. Tammen. . . . It is a complete, varied and extensive exhibition of the natural history of the Great West, as shown in the precious mineral products of the earth. One can learn more of the wonders of the earth, air, streams and mountains of Colorado in this museum in a short visit than could be gleaned by a month's reading of the best compiled and most brilliantly written volume on the state. It is, in fact, a standing exposition, open during all the business hours of the day and evening, and free to all. The idea struck the public eye at once as being so novel, and at the same time so praiseworthy. . . that the proprietor jumped right into business fame, and enjoyed a large and lucrative patronage from the very first opening day. Collectors are out all the time, and have so perfected arrangements at various points that any curiosity of mine or mountain, forest or stream, canon or corral, found by Indian tribe or prospect camp, is forwarded to him at once.
>
> The whole museum is lighted by electric light and it requires but little imagination on the part of a visitor here, by changing his line of examination, to find himself down in the bowels of the earth at one moment when they are digging out the gold and silver deposits of rock and ledge, in an other change he can transform himself into a traveler, suddenly arriving in the center of an Indian country, where articles of peace and war are awaiting examination, the Indian himself being there. . . . [34]

Within a year Tammen was marketing artifacts that were made in quantity, and by the early twentieth century his company was dealing in vast numbers of

Indian artifacts and mass-producing novelties that implied Indianness, such as burned and painted hides (figure 41). Tammen was actively involved in the company in the 1890s, but management eventually passed to Carl Litzenberger, who began working for Tammen as a clerk in 1891. Tammen then began to devote more attention to his publishing ventures, which started with *The Great Divide*; he later became co-publisher of the *Denver Post*.[35]

Under the leadership of Carl Litzenberger, the H. H. Tammen Company anticipated and created trends in the curio trade, and possibly even stole ideas from other businesspeople. The company interacted with curio dealers of New Mexico from the time it was founded until well after World War II.

Just as the trade in Wyoming and Colorado reflected the natural wonders of the Rockies, the trade on the Mexican border was based on Mexican crafts. The Southern Pacific Railroad reached El Paso, Texas, in May 1881, and the Atchison, Topeka & Santa Fe followed within weeks. Several other rails reached El Paso in rapid succession, including the Mexican Central in April 1884, connecting El Paso with Mexico City and "all the large cities of Northern and Central Mexico."[36]

The first dealer in Mexican curios in El Paso was P. E. Kern, who in 1885 advertised a "full line of Mexican Filigree Jewelry and Curiosities." Kern's business was short-lived, but in 1886 William G. (W. G.) Walz, who had been in the music business in El Paso for three years, advertised a new specialization in "Mexican Art and Curiosities." Walz remained in the business of music and musical instruments and eventually sold sewing machines and sporting equipment. He also became one of the greatest dealers in Mexican crafts, publishing at least two catalogs of them, of which an elaborately illustrated catalog of 1888 was a landmark publication in its field (figure 10).[37]

Walz and his siblings came west from Mankato, Minnesota. His sister, Julia, married the noted (and by some accounts notorious) Santa Fe attorney and politician Thomas B. Catron. A brother, Edgar, was a participant in the Lincoln County War, which brought fame to outlaw Billy the Kid; Edgar's role was to look out for Catron's interests in the county. The family was not particularly close-knit. In his memoirs the only sibling Edgar mentioned was Julia; in her obituary the only sibling mentioned was William.[38]

Walz was a major figure in the first generation of curio dealers, supplying Mexican crafts to many other dealers until his death in 1913. Success led to incorporation of the W. G. Walz Company in 1890, with Thomas Catron as

*Figure 10. W. G. Walz offered few Indian artifacts in this catalog of 1888 but emphasized Mexican arts, which were the mainstay of his business. Private collection.*

*Figure 11. The Beach-Akin Curio Company of El Paso published* Illustrated Catalogue. Mexican Hand Carved Leather *in 1902. Their line included burned leather hides and pillow covers. J. S. Candelario Collection, Fray Angélico Chávez History Library, Palace of the Governors, Department of Cultural Affairs, Santa Fe.*

vice-president and William E. Sharp as secretary. The company eventually had branch operations in Ciudad Juarez, Mexico City, and San Diego. With a major interest in the Walz Company, the Catrons helped expand its scope. On a trip to the Orient in 1907, Julia acquired a substantial lot of Japanese crafts, including ceramics, furniture, drawnwork, embroidery, and other items; and she shipped ten cases to William at El Paso. Some of the purchases were apparently planned, but Julia wrote to William from aboard ship, en route to Hong Kong, to explain some last-minute additions, which were irresistible bargains for her.[39]

In about 1900 Henry S. Beach became manager of Walz's store in Juarez. Beach's background is unclear, but he was paid a significant wage of seventy dollars per month, plus 15 percent of the net profits. Beach promptly decided that he could do better on his own and in 1901 left the Walz Company to enter into partnership with John S. Akin, a former bank bookkeeper and insurance agent. Beach managed the Beach-Akin Curio Company, which immediately had stores in both El Paso and Juarez (figure 11). The partnership was dissolved by 1903, but Beach went on to become a respected dealer, not only for his business acumen, but for his intelligence and ethics.[40]

Like H. H. Tammen and his company, dealers of El Paso interacted in the curio trade's complex network and will be encountered again.

## The Early Trade in New Mexico: Aaron and Jake Gold

The curio trade in New Mexico was shaped in Santa Fe by sons of Louis Gold, a Polish immigrant who first visited Santa Fe no later than 1855. His oldest son, Moses Aaron (M. A. or Aaron), then ten years of age, either accompanied or joined him there. After going back to his family in New York, Louis returned to Santa Fe and secured his first business license in 1858. By 1860 Aaron was working for him as a clerk, and in 1859 and 1862 respectively, Louis's younger sons Abraham (Abe) and Isaac Jacob (Jake) also made the trip to Santa Fe.[41]

Louis became a successful and popular retail merchant and was known locally by the Spanish equivalent, Luis. In 1867 he entered into a partnership with Aaron and Abe and committed to it all of his known real estate. In 1865 he had purchased two houses on the south side of West San Francisco Street, where a new commercial district was quickly supplanting the 250-year-old religious and social center surrounding the town's plaza. Their property on San Francisco

Street became the location of their new business. At the time of its formation, Luis Gold & Sons also owned a third house, land, a blacksmith shop, wagons, mules, farming implements, grain, and other property. They promoted themselves as "Wholesale and Retail Dealers in General Merchandise" and offered "a full assortment of Dry Goods, Groceries, Queensware, Hardware, Clothing, Hats, Boots & Shoes, Liquors, &c, &c."[42]

One of their most valuable properties was a water-powered grist mill on the Santa Fe River, which Luis had purchased for $6,500 from Aaron and Luis Zeckendorf in 1863. Wheat flour was an important component of the business. Their first advertisement stated that they "manufacture and keep in store the best quality of superfine family flour, which is furnished at lowest [market] prices." The advertisement continued, "Wheat will be ground for customers at 75-cts. per fanega delivered at the mill and $1 per fanega when delivered at the store." The *fanega*, a Spanish-colonial measure of volume, was the equivalent of approximately 2.6 bushels.[43]

Aaron branched out on his own almost immediately. He secured his first retail license in Santa Fe County in 1867, but by 1868 he had a store at Peñasco, in Taos County. There he acquired the first Native American artifact known to have been purchased by a member of the family. In 1868 he traded two pints of whiskey to an Apache (presumably Jicarilla), or by some accounts a Ute, who was temporarily residing on a mesa near Peñasco for "a buckskin." Under federal law, the Indian was under the charge of the U. S. Indian Agent at Cimarron, New Mexico, and Aaron was indicted and eventually convicted of the offense of selling liquor to an Indian. In 1871 he paid $208 in fines and court costs. The fines may have precipitated his bankruptcy in 1872, but he went on to became the first postmaster at Peñasco in 1874.[44]

Aaron maintained businesses in both Santa Fe and Taos Counties until 1875, but after that time he resided permanently in Santa Fe, where he operated retail establishments and a saloon, and had a license for a billiard table. Santa Fe was already infamous for its drinking and gambling. One traveler wrote in 1849 that the city was "a miserable hole; gambling and drinking in all directions." The 1883 insurance map of Santa Fe identifies, in just a one-block stretch of what is now West San Francisco Street, nine saloons and a gambling house. Aaron not only contributed to Santa Fe's reputation, he caused a commotion in March 1876 when he kept his saloon open on a Sunday night for a dance. He was fined $100, and at least twenty of his customers were found guilty of breaking the law with him.[45]

A nascent curio trade existed in Santa Fe in the 1870s. For example James Stevenson, in his report of collections made in 1879 for the Smithsonian Institution's Bureau of Ethnology, described ceramic figurines "obtained in Santa Fé from traders." The identity of those earliest curio dealers has not come to light, though one or more of the Golds could have been among them. In August 1876 Aaron's youngest brother, Jake, registered as an itinerant merchant and paid taxes for two pack animals. Abe and Aaron followed his lead, registering as itinerant merchants in February and March 1877, respectively. One is tempted to suggest that one or all of the brothers were trading in the pueblos near Santa Fe for curios, but no evidence supports that, and ample evidence proves that Pueblo Indians took an abundant supply of goods to town. Throughout that period and into 1879, Aaron was also registered as a sutler, selling goods to soldiers at Fort Marcy in Santa Fe.[46]

By early 1880 Santa Fe had become sleepy. The daily newspaper had suspended printing for two years, and only a weekly paper was being published. But the Atchison, Topeka & Santa Fe Railway was making its way through New Mexico, and in early February the branch line from Lamy to Santa Fe was completed. The first train steamed into town on February 9, 1880, and a new boom started. On February 27 the *Santa Fe Daily New Mexican* resumed printing, and in that issue was the first advertisement for a store with retail space devoted to Indian curios: Aaron's newest venture, Gold's Provision House, offered "groceries and provisions" and was "the only place in town where Rare Specimens of Indian Pottery, ancient and modern," could be had.[47]

Gold's shop was at the corner of San Francisco Street and Burro Alley, in space that he leased from Jose Leandro Perea, but his advertised location was San Francisco Street and Picayune Alley. The latter name does not occur in any known document or in any other context, so Aaron probably renamed the alley to imply something about his business. In the United States at the time, picayune was a reference to a coin of little value, specifically the American five-cent piece.[48]

Gold proclaimed the importance of Pueblo pottery to his business by having "Gold's. Indian Pottery" painted on the edge of the portal along San Francisco Street. In one of the few photographs of him, he poses under the portal with Pueblo Indian pots and baskets, Navajo blankets, a Saltillo serape, and other artifacts; and in another he poses indoors with some of his inventory. Pottery from his shop is featured in other photographs, sometimes with a broadside identifying his business (figures 12–14). Traditional and nontraditional vessels

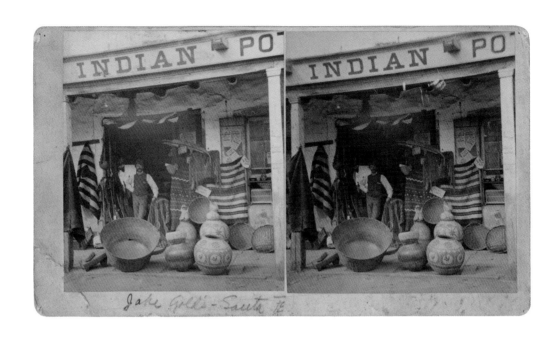

Jake Gold's - Santa Fe

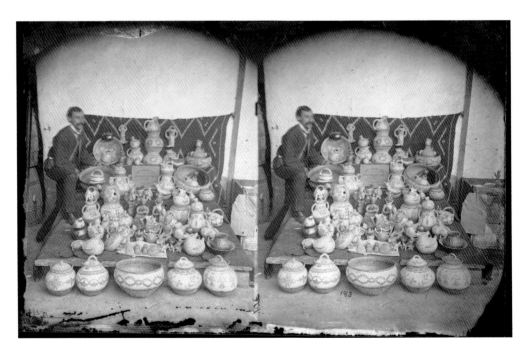

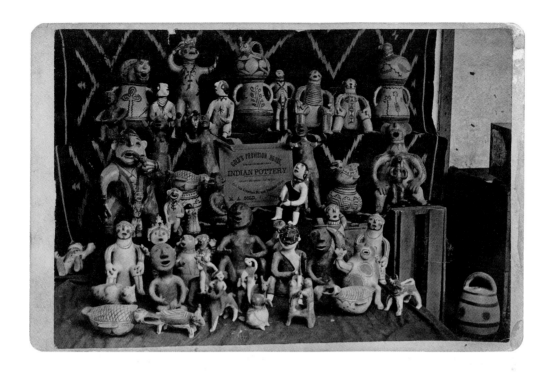

*Figure 12. Aaron Gold poses in front of his shop, Gold's Provision House, 1880 or 1881. Photograph by Ben Wittick. A marginal note identifies this as the shop of Jake Gold, which was not the case until 1883. Photo Archives, Palace of the Governors, Museum of New Mexico/Department of Cultural Affairs, Santa Fe, 86877.*

*Figure 13. Aaron Gold posing with some of his inventory, 1880 or 1881. Photograph by Ben Wittick. Except for the Navajo blanket used as a backdrop, almost every object was made at Tesuque or Cochiti. Photo Archives, Palace of the Governors, Museum of New Mexico/Department of Cultural Affairs, Santa Fe, 86857.*

*Figure 14. The same Navajo blanket and some of the same objects as in the preceding photograph are in this image of ceramics, mostly small figurines, from Aaron Gold's inventory, 1880 or 1881. Photograph by Ben Wittick. Photo Archives, Palace of the Governors, Museum of New Mexico/Department of Cultural Affairs, Santa Fe, 102092.*

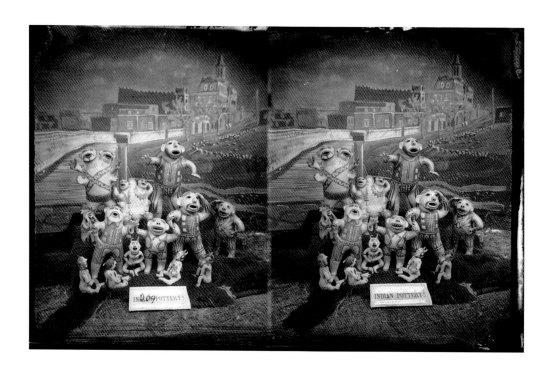

Figure 15. Figurative ceramics made at Cochiti and Tesuque from the inventory of Aaron Gold, 1880 or 1881. Photograph by Ben Wittick. The two largest figurines have survived, but none of the others have been located. Photo Archives, Palace of the Governors, Museum of New Mexico/Department of Cultural Affairs, Santa Fe, 16293.

are evident, and figurative ceramics are prominent; notably almost all of the pottery in the photos is from Tesuque and Cochiti, the pueblos nearest Santa Fe.

Potters of Tesuque and Cochiti began making figurative ceramics shortly before 1880. From 1880 on their numbers increased to an almost unimaginable level, and they became mainstays of the early curio trade. Two of those, by an anonymous potter of Cochiti, were photographed in 1880 or 1881 together with other figurines from Gold's inventory (figure 15). The larger figurine, depicting a circus acrobat or tumbler, is a masterpiece of nineteenth-century Pueblo pottery. To maintain balance, the potter made it from the ground up, starting with two legs that were built separately by coiling. Most Pueblo pottery up to that date was intended for utilitarian purposes, but this figurine had no such function. It expressed movement and emotion, and was clearly the work of an ingenious potter (figure 16).

Some figurines were parodies of Anglo-Americans, others were fanciful renderings of unfamiliar animals, and others still were simply playful. The humor in figurines was not lost on visitors to Gold's store. Lucy Hayes, wife of President Rutherford B. Hayes, accompanied her husband on his trip to the West in 1880. In October she and her entourage visited Aaron's store, and figurines caught their attention:

> The party…stopped at the store of Mr. M. A. Gold, on San Francisco street, and spent an agreeable half hour among the curious designs of Indian pottery. The many ludicrous attitudes of the little baked Indians, the shapes and proportions of the various animals, known and unknown, and fantastic designs in the decoration of earthenware, conceived only in the imagination of a facetious Indian, proved too much for their presidential decorum, and were greeted with a hearty laughter.[49]

Disrespectful though that may sound to the makers of the pottery, Mrs. Hayes also was "highly pleased by what she saw, purchasing some of the finest specimens and sending them to Ohio."[50]

Prominent in Gold's photographs are at least three different broadsides with his name and "Indian Pottery." Two of those, which appear in the image of him posing in front of his store, have lengthy text, which is unreadable in the

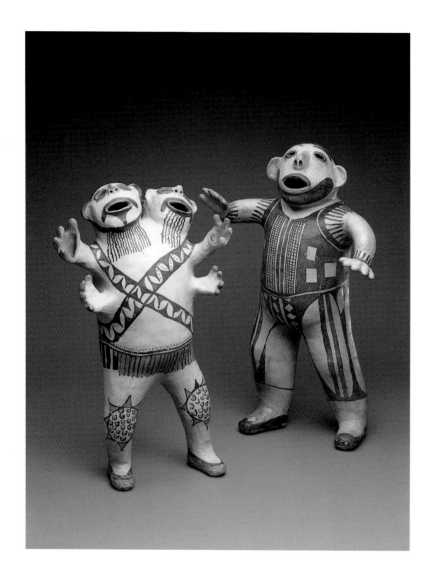

*Figure 16. An anonymous potter of Cochiti made these figurines in 1880 or 1881. The one at left, collected by the Reverend Sheldon Jackson for the Princeton Theological Seminary, may depict the Italian conjoined twins, Giovanni and Giacomo Tocci. The one at right depicts a circus tumbler or acrobat; height 27.75 inches. Left: Princeton University, 7413. Right: Spencer Museum of Art, The University of Kansas; Gift of James K. Allen.*

photographs. He did not post them on the front of his shop just for the occasion of the photographs. On April 5, 1880, he ran an ad in the *Weekly New Mexican* offering a ten dollar reward for "the detection of any person found tearing down or mutilating the posters describing the Indian pottery offered for sale by me." None of Gold's broadsides describing pottery have been located, so their content is unknown. However it is difficult to believe that he did not mail them to individuals, museums, and other curio dealers to generate sales, which was the purpose of other curio dealers' broadsides and catalogs.[51]

On August 1, 1880, Aaron sponsored a dance by Indians from San Ildefonso Pueblo, which got the attention of the local paper. Two dancers and a chorus of seven drummers and singers "proceeded to Palace avenue, in all the glory of their war paint and feathers, and halting in front of the Palace awaited the gathering of spectators." The article continued,

> The most ludicrous feature of the costume was a huge card
> hung about the necks of the dancers, having an extensive adver-
> tisement of M. A. Gold, Indian pottery seller.[52]

Following their performance, the dancers went to Gold's store for refreshments. The event was advertised by a small broadside, which also promoted *Historical Sketch of Santa Fe*, available at Hayt's bookstore (figure 17). That publication, written by H. T. Wilson, included the first known business directory for the city, as well as a chronology of events in Santa Fe, ending in June 1880. It was panned in the same issue of the *Weekly New Mexican* in which the dance was reported.

Aaron claimed that in May 1880 alone he shipped $800 worth of Indian pottery to the East. Despite his immediate success he did not stay in the business for long, and shortly after he opened his store, his younger brother Jake also entered the curio business. On May 30, 1881, Jake leased six commercial rooms on the south side of San Francisco Street near its intersection with Sandoval, across the street and a few doors west of Aaron's store. Assuming Jake took occupancy of the rooms, they were the location of his "Indian Pottery and curiosity shop," as identified in an 1882 business directory. That would have been where Adolph Bandelier visited him immediately after arriving in town in March 1882, noting in his journal, "Jac. Gold has a magnificent collection of Indian goods."[53]

By early 1883 Jake had assumed management of Aaron's store, and by early June he owned the business, which he renamed Gold's Free Museum, and later

## FREE
## INDIAN DANCE
### To EXCURSIONISTS
### SUNDAY MORNING,
—AT—
### Gold's Indian Pottery
#### And Curiosity Shop,
SAN FRANCISCO STREET.

GO TO

## Hayt's Book Store,
#### Opp. Gold's Indian Store.
Views of Santa Fe & New Mexico at $1.50 per Doz.

**HISTORICAL SKETCH OF SANTA FE.**

*Figure 17. Aaron Gold and Walter V. Hayt pub-*
*lished this broadside to advertise dances by a group*
*from San Ildefonso Pueblo on Sunday, August 1,*
*1880, and to promote H. T. Wilson's Historical*
Sketch of Santa Fe, *which included the city's*
*first business directory. Private collection.*

Gold's Free Museum and Old Curiosity Shop. Gold ran the Free Museum for fifteen years, turning it into one of Santa Fe's most famous tourist destinations and making an indelible mark on the curio trade. Gold was a consummate salesman and storyteller; he and his store were described in 1894 by nineteenth-century art critic Henry Russell Wray in an article in the *Philadelphia Ledger*:[54]

The Mecca of these curiosity shops in Santa Fe is the "Old Q'Rosity," and the patron saint is "Jake Gold," as curious an individual as the wares he makes you buy.

If the contents of your pocket-book are low and you hesitate before entering this little shop at the corner of Burro alley, your doom is sealed, for before you know it the fifty and one things hung outside, ranging from the skins of wild animals to Mexican and Navajoe blankets, will have your attention, and directly your eye will catch something through the consumptive glass doors, and you'll enter. You are in the lair of the only Jake and you'll buy until your all is gone and then you borrow to possess more of the treasures. As you enter the door a voice in Spanish greets you, "good morning, my dog;" but you don't understand, perhaps, and don't dwell on it, for Jake has already thrown out his web by handing you just the curios to suit and his parrot's indelicacy you overlook.

In this shop of Jake's you can purchase the last pair of trousers worn by Columbus, the sword De Soto wore, the hat of Cabeza de Vaca or the breastplate of silver worn by Cortez; that is, if Jake thinks you want any of these things after hearing you talk, and "sizing you up," he will call into play an eloquence so convincing and an indifference about selling that you fain would believe.

At any hour of the day you will find his shop crowded with Indians and Mexicans huddled about the stove, rolling and smoking cigarettes and with their curios displayed at their feet or hidden in the folds of their blankets. They wait for only Jake to barter with them. They have the utmost respect for him, for he treats them squarely in a bargain.

Aside from a handful of letters and invoices, few direct records of Gold's business survive. A guest register for Gold's Free Museum for the period June 1892 to January 1895 was later used by another merchant as a scrapbook, and the pasted-in business letters obscure most of the content. Mail-order catalogs of 1887, 1889, and 1892 document Gold's specialization in some artifacts and the network he developed. Letters that Gold wrote to J. S. Candelario in 1901, when they were forming a partnership, shed light on Gold's earlier business practices.[55]

Pueblo Indian pottery, both traditional and figurative, was the mainstay of Gold's business. Pueblo water jars, bowls, and other shapes had been conspicuous local commodities and objects of trade for centuries. The Pueblos provided the Spanish with ceramics for household and ecclesiastical use as early as the seventeenth century, and in the second half of the nineteenth century, several Anglo-American visitors described Pueblos selling pottery in markets on town plazas, peddling them door-to-door, selling them on roadsides, and eventually offering them on railroad platforms.[56]

In describing New Mexico in the 1850s, W. W. H. Davis said that the Pueblos "make earthenware for domestic use, and carry considerable quantities of it to the towns to be sold. It consists principally of jars . . . which are light and porous." James F. Meline, writing of his experience in the 1860s, noted that "nearly all of the pottery used by the Mexicans is of Pueblo manufacture." He also described the trade on the plaza in Santa Fe, stating that the Pueblos took "fruit, trout, and game from the mountains, and, also, nearly the sole industrial productions of the country, — jars, dishes, and cups of pottery, some of it painted so as to impart an almost Etruscan or Egyptian air."[57]

The movement of goods was the subject of many a writer's pen. Travelers encountered packs of noisy burros loaded with firewood or other goods, as well as oxen pulling *carretas*, whose crude wheels wailed as they turned on wooden axles. The people, sights, and sounds of New Mexico often led writers to draw parallels to classical antiquity, and as downtown Santa Fe was transformed into another railroad town, Gold's Free Museum became a holdover from an earlier time.

The pattern of exchange in Pueblo pottery that typified Santa Fe's curio trade, and which continues to the present in several shops, was established by Aaron Gold. Once a potter could take her wares to Gold or any other curio dealer in Santa Fe, she no longer had to spend a day selling on the plaza or peddling her work around town. Early dealers may have paid cash or extended credit

to potters and other artisans. Aaron was also a grocer, so he probably traded food and other goods for pottery. Whether Jake continued the practice is unclear, though he did have a room used for "feed" in the 1880s.[58]

In his early days in the business, Jake occasionally collected in the pueblos. He accompanied Bandelier to feast day at Cochiti on July 14, 1882, and Bandelier observed him buying, though he was not impressed with all of his purchases: "Gold bought pottery, old things, Victoriano's shield, and rubbish in general." Jake may have acquired lesser items to fulfill obligations to established sources, and Bandelier knew that Jake had a keen eye. Only weeks prior to their trip Bandelier selected two extraordinary Cochiti storage jars from Jake's inventory for the Missouri Historical Society. They were among the earliest large pots acquired by any museum (figures 18, 19).[59]

Henry Russell Wray stated that Gold had 200 "agents" collecting in the field for him. He explained that they traded "Germantown wools and cheap, but highly-colored church prints of saints. These mediums they trade for blankets, old paintings, Indian work, old Mexican basrelief and pottery." In a broadside that Gold mailed with his 1889 catalog, he made the more realistic claim of having "eight Mexican collectors and eight Indian collectors continually on the road and amongst the Indian Pueblos and Cliff Dwellings, looking for and purchasing curiosities for his store."[60]

Masterpieces of traditional Pueblo pottery and fine Navajo wearing blankets passed through Aaron's and Jake's hands, but they were not available in adequate quantity and were too high-priced to satisfy the stream of tourists who came through their doors, to say nothing of the many curio dealers who relied on the Golds for a supply. The only way for the Golds to have a constant supply of local goods for their shops was to invent some types of artifact, or to support the invention and production of them by their Pueblo suppliers. No indisputable contemporaneous evidence documents Aaron's or Jake's role in the commodification of traditional artifacts or the invention of entirely non-traditional ones, but they participated in the process.

The most famous object in which the Golds had a developmental role is the Tesuque rain god. The rain god's roots lie in the types of figurative ceramics sold by Aaron in the early 1880s. It became a standardized object no later than 1887, when the H. H. Tammen Company adopted it as a logotype. Almost all rain gods made after that date were small, seated figures, often with pots on

*Figures 18, 19. Adolph Bandelier helped to select these beautifully painted, large Cochiti storage jars from Jake Gold's inventory in 1882 for the Missouri Historical Society. Height of each 21 inches. Missouri Historical Society, St. Louis, 80—0001, 80—0002.*

their laps and their hands on the pots (figures 20, 9, 37). The rain god was maligned by many writers in the late nineteenth and early twentieth centuries as symptomatic of the bad influences of non-Indians on Pueblo culture, as well as the poor judgment exercised by curio dealers in their dealings with Indians, but it became an important element in the economy of Tesuque Pueblo.[61]

Another well-documented object is a hand drum made from a cheese ring or cheese box — the container in which cheese was shipped, but not formed — covered with either goatskin or sheepskin. In 1883 Bandelier borrowed one of these drums from Jake Gold, noting that it had been "made to order by the Indians of Tesuque," and depicted it in a painting that became part of one of his biggest projects, a huge manuscript titled *History of the Colonization and of the Missions of Sonora, Chihuahua, New Mexico, and Arizona, to the Year 1700*. Bishop John B. Salpointe of Santa Fe commissioned Bandelier to create the masterpiece as a gift to Pope Leo XIII on the occasion of the fiftieth anniversary of his ordination in 1887. It was considered the most original and scholarly gift received from any part of the world.[62]

Bandelier illustrated few artifacts in his *History*, so it was a grand setting for a humble object. This type of drum was probably not used by Pueblo Indians in their traditional dances at that time, and if it represented an abundant type in 1883, Bandelier would have been unlikely to lend it such importance. He must have depicted one of the earliest examples. This became a common object in the trade and remained so for a half century. Two early examples, collected at Santa Fe in 1885 and at Tesuque in 1886, represent its earliest incarnation, with designs derived from Spanish Colonial arts (figure 21).

Artisans at Tesuque also made clubs and rattles from discarded cowtails and horsetails. The rattles were made of hide that was shaped and sewn to form a hollow bulb and to cover a wooden handle; rocks were inserted in the bulb, and the tail hung from the other end (figure 22). The club had a stick handle wrapped in hide, a rock tightly encased in hide at one end, and a tail hanging from the opposite end (figure 23).

Jake Gold ordered beads from S. A. Frost of New York and supplied them to people at Tesuque, who made beaded objects for him. Beadworkers at Santa Clara also supplied the curio trade, which is less surprising because an old beadwork tradition existed there. By the early twentieth century those craftspeople made beaded purses and watch fobs by the hundreds (figure 24).[63]

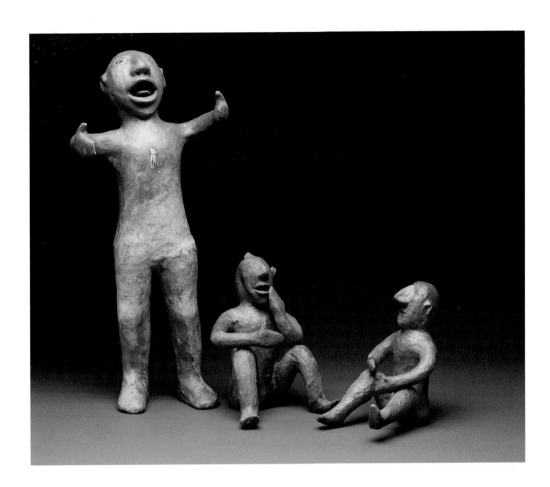

*Figure 20. The Reverend Sheldon Jackson purchased these figurines, made at Tesuque, for the Princeton Theological Seminary in 1880 or 1881. He probably acquired them from Aaron Gold. Height of standing figurine 21.25 inches. Princeton University, 7801, 7799, 7798.*

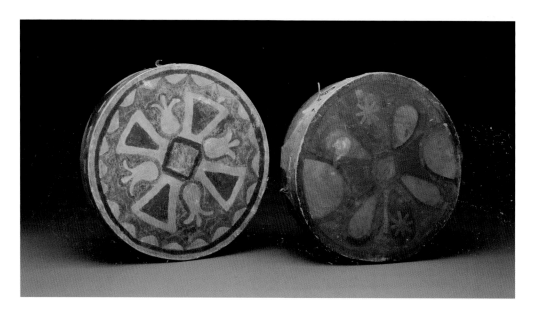

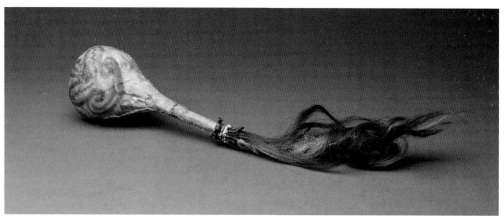

Figure 21. Hand drums made at Tesuque from cheese rings and either goatskin or sheepskin. Left: collected at Tesuque, August 1886; diameter 13.5 inches. Right: collected at Santa Fe, January 1885. Museum of Indian Arts & Culture/Laboratory of Anthropology, Department of Cultural Affairs, Santa Fe, 23968/12, 23165/12.

Figure 22. Rattle made at Tesuque from cowhide or horsehide with a tail attached to the handle, ca. 1890. The floral design was typically painted on Tesuque pottery of the late nineteenth century. Length including tail 16 inches. Museum of Indian Arts & Culture/Laboratory of Anthropology, Department of Cultural Affairs, Santa Fe, 23140/12.

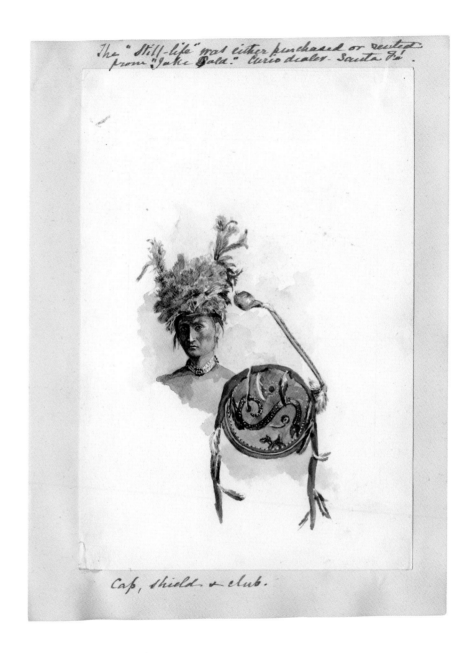

The "Still-life" was either purchased or rented from "Jake Gold." Curio dealer. Santa Fe.

Cap, shield & club.

Figure 23. Adolph Bandelier's friend, Eva S. Muse of Santa Fe, painted this watercolor of objects from Jake Gold's inventory in 1891 for a proposed illustrated edition of Bandelier's book, The Delight Makers. *A Tesuque club is among the objects depicted. Bandelier Collection, Fray Angélico Chávez History Library, Palace of the Governors, Department of Cultural Affairs, Santa Fe.*

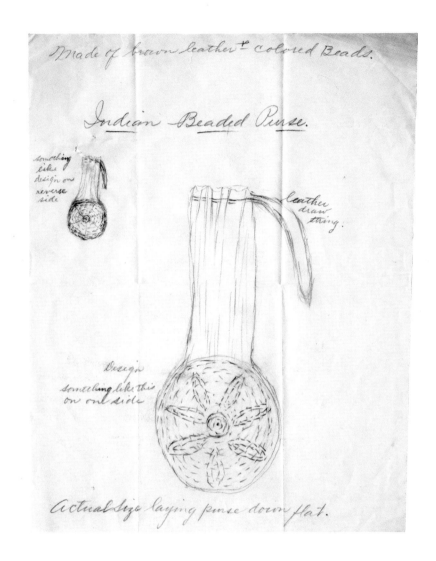

*made of brown leather + colored Beads.*

*Indian Beaded Purse.*

*something like design on reverse side*

*leather draw string.*

*Design something like this on one side*

*Actual size laying purse down flat.*

Figure 24. Gladys Eldodt of San Francisco, California, attached
this drawing of a purse from Tesuque or Santa Clara to an order
she sent to J. S. Candelario in 1911. Her old beaded purse "came
from Gold's Old Curiosity Shop" and had worn out. She enclosed
payment of fifty cents and added, "Try to pick out a pretty one."
J. S. Candelario Collection, Fray Angélico Chávez History
Library, Palace of the Governors, Department of Cultural
Affairs, Santa Fe.

Jake Gold not only enjoyed more walk-in business than most nineteenth-century curio dealers, he was actively involved in the mail-order trade. We will never know how many mail-order catalogs he published, but at least three have survived. Of those the earliest, printed about 1887, is an eight-page folding pamphlet. The four pages on one side of the sheet comprise an engraved illustration of a Navajo weaver, a description of Navajo weaving, and a history of Santa Fe. The pages on the opposite side feature Navajo textiles, Mexican rugs, tarantulas or trapdoor spiders, and spider nests (figure 25).[64]

Gold's "Mexican" rugs were woven locally. Spanish New Mexican weavers in many towns of northern New Mexico have woven wearing blankets, bed blankets, floor rugs, and other textiles for generations. Starting in the late nineteenth or early twentieth century, those textiles came to be identified with the largest weaving center, the town of Chimayo. "Chimayo" became an expression in the trade to describe all Spanish New Mexican textiles, and some curio dealers unfamiliar with the cultures of New Mexico attributed the textiles to "Chimayo Indians."

The types of Navajo textiles that Gold sold are illuminating, but his comments raise difficult questions. His may be the earliest published description of Navajo floor rugs. Beneath his illustration is the heading, "Prices of Rugs," and first on the list is "Rugs, 5 feet 10 inches long by 22 inches wide, the same colors and designs as above." In addition to rugs, he described textiles as both blankets and "portierres," or curtains, which was a decorative function of some Navajo and other southwestern textiles until 1910 or later. He described the traditional Navajo wearing blanket as a "Navajo Indian Camping Blanket, such as they use commonly for every day use."

At the time he completed his renovation and expansion of 1893, Gold explained that he had "at least thirty men and women constantly employed at Chimayo, in the Navajo country and elsewhere manufacturing his supply of Indian and Mexican blankets." That Spanish New Mexican weavers supplied him regularly is not surprising, but his source of Navajo textiles is mysterious.[65]

In his 1887 catalog is stated, "Navajo Blanket Made at Santa Fe, N. M." Gold repeated the illustration and statement in his catalogs of 1889 and 1892. Neither the author nor any scholar of Navajo weaving has seen evidence that a Navajo weaver was present in Santa Fe in the 1880s, and the purpose of making such a claim is unknown. On the other hand, Gold was able to supply rugs in consistent dimensions and patterns, so he had some control over the weaving process. If he had a source on the Navajo reservation it has yet to be learned.

One small clue to Gold's source may have been based on hearsay. This is in a letter from W. G. Walz to the trader C. N. Cotton at Ganado, Arizona, dated June 11, 1888:

> My competitors on the sale of Navajo blankets are in Santa Fe Jake Gold and Mr. Norfleet. They both buy them of the Indians trading beads for them and get them very cheap, almost getting them for nothing.... I have been buying them [from Gold and Norfleet] trading Mexican goods which make the blankets cheaper to me than paying cash for them.[66]

The Navajos had been trading their superlative blankets since 1700, and by 1887 traders on the Navajo reservation had only begun to act as middlemen, supplying Navajo blankets — and later rugs — to curio dealers and other retailers. The trade in Navajo textiles in the early railroad era is poorly documented and has been studied little. Some of the few descriptions of selling and freighting Navajo blankets in the 1880s are in C. N. Cotton's letters. Charles E. Aiken of Colorado Springs was one of Cotton's clients from 1889 to at least 1902.[67] In his letter accompanying an invoice for fifty-nine Navajo blankets and three pounds of garnets sent to Aiken in March 1889, Cotton wrote,

> Herewith bill for blankets shipped by team today. Will reach [railway] in 5 days. I trust this lot will suit you and that you will favor me with another order soon. I have sent a nice lot and cheap. I have got two very large blankets here suitable for rugs size about 6 x 9 price $50.00 each. Very thick. I would have sent them to you but thought perhaps t'would be [too] expensive for you to handle.

By the early twentieth century most curio dealers purchased their rugs from traders such as Cotton, though as we will see, some entrepreneurial Navajos also supplied the trade, delivering rugs to Santa Fe, far from the reservation. Gold's source for blankets may well have been an enterprising group of Navajo weavers and traders.

From a business standpoint the most puzzling aspect of Gold's catalog is the lack of Pueblo goods. Instead Gold devoted two pages to trapdoor spiders and their nests, which the H. H. Tammen Company also featured prominently in catalogs of 1886 and 1887. Perhaps the spiders and nests were popular and sold well, but Gold did not acquire them locally. The trapdoor spider does not occur in New Mexico but in California, and curio dealer W. D. Campbell of Los Angeles was Gold's source for specimens.[68]

Gold's catalogs of 1889 and 1892 are twenty pages each and nearly identical (figure 26). The illustrations of textiles, spider, and nest were repeated, and texts on New Mexico and Santa Fe were expanded to five pages. Gold added an illustration of Pueblo pottery, a list of the Pueblo towns of New Mexico, and an engraved illustration of his shop. He also added six pages of itemized goods with ranges of price, including Pueblo Indian objects and items that he acquired from other specialist dealers. For example the H. H. Tammen Company would have supplied Gold's mineral specimens, mineral cabinets, and mineral inkstands; and W. G. Walz or other wholesalers in El Paso supplied his Mexican goods.

In both catalogs Gold offered "collections" of objects at fixed prices, ranging from the "$1.00 Collection" that included three pieces of Pueblo pottery, one yucca ("soap weed") basket, and two arrows; to collections costing three, five, ten, fifteen, twenty-five, and fifty dollars. The fifty-dollar collection included

> Twelve pieces Pueblo Indian Pottery, assorted, one Pueblo Indian Water Cooler [ceramic water jar], four pieces Mexican Pottery from Old Mexico, one Apache Soap Weed Water Basket, one Pueblo Idol, one Pueblo Bow, twelve pointed Arrows, one pair Beaded Moccasins, one Indian Drum, two pieces Ancient Pottery, one Raw Hide Canteen, one Indian Necklace, one Horse Hair Lariat, one Raw Hide Whip, one Buckskin Shirt, one pair Buckskin Leggings, one [Apache] War Club, one Indian Bead Purse, one fancy Mexican Rug, one mounted Bird on Card (cabinet size), one old Spanish Painting on wood, one pair old Spanish Spurs, one Cactus Cane, one carved Mexican Quince Wood Cane.[69]

*Figure 25. Jake Gold's eight-page catalog of ca. 1887. Because it lacks a cover or title page, it was probably mailed with a broadside or some other ephemeron. Private collection.*

*Figure 26. Jake Gold's catalog of 1892, which is one sheet folded to make twenty pages. Gold mailed it in its folded state, and a recipient had to open up the entire sheet to read it. The note on the cover is in Gold's hand. Private collection.*

By 1890 Gold had created the quintessential southwestern curio store, wholesaling and retailing items from northern New Mexico and from throughout the Rockies, the Southwest, and Mexico. His renovation of 1893, in which he restated the antiquated and dilapidated look of his building, set his apart from all other establishments. Yet we cannot forget that his success relied on many other entrepreneurs, among them Pueblo Indian artisans.

Gold was a creative businessman, but he had many weaknesses that eventually led to prosecutions, a conviction, and imprisonment. Gold was an inveterate gambler, and in January 1893 he signed an agreement with Charles M. Conklin, sheriff of Santa Fe County, that required him to "stay away from all gambling tables of every description and name and not to let or gamble any amount of money" for a year. If he broke the agreement, he would have to pay Conklin's real estate taxes for the year and buy three uniforms for the Santa Fe police force. In 1894 a federal grand jury indicted him for selling pornographic photographs, but the charge was later dropped. In 1896 he was charged with adultery, and in 1899 he left his wife, Lizzie, and was charged with abandonment. He fled to El Paso to escape prosecution, losing his store and business. After he was taken back to Santa Fe, the abandonment charge was dropped, but he was convicted of adultery and in January 1901 began serving a sentence of one year and one day in the state penitentiary at Santa Fe.[70]

A local named Hyman Lowitzki briefly ran a curio store in Gold's space, and in November 1900 Mary Gold, wife of Aaron's and Jake's brother Abe, purchased the building. Abe established his own curio business there and changed the name slightly, to Gold's Old Curiosity Shop. Abe had formerly been a businessman in Santa Fe and had lived for several years in El Paso. The curio trade was a new venture for him, but it was short-lived, as he passed away in August 1903. Aside from photographs of his store and a small number of invoices and letters, no records of his business survive.[71]

Figure 27. Louis Fisher's shop on Sandoval Street in Santa Fe, on
the site of the present-day Hilton Hotel, March 1881. Photograph
by Ben Wittick. Fisher began advertising his business only days
after Aaron Gold's first ad ran in the daily paper. Photo Archives,
Palace of the Governors, Museum of New Mexico/Department of
Cultural Affairs, Santa Fe, 15824.

*Figure 28. Louis Fisher sold this Navajo serape to Charles H. Shephard on December 27, 1882. According to his travel journal, Shephard spent a "large portion of the morning looking at Indian curiosities & Navajo blankets at Fisher's on Sandoval St. . . . Mother chose one from the Navajo blankets I had sent to her room." Shephard paid Fisher thirty dollars for it. Length 75.5 inches. Private collection.*

Figure 29. Storage jar from Cochiti, ca. 1890. Jake
Gold sent this and the pots in the following three
figures to Chicago for the Columbian Exposition of
1892–1893. Height 19.25 inches. Field Museum of
Natural History, Chicago, 22483.

Figure 30. Water jar from Acoma or Laguna,
ca. 1890. Diameter 12.5 inches. Field Museum of
Natural History, Chicago, 22489B.

*Figures 31, 32. Four water jars from Acoma,*
*ca. 1890, sent by Jake Gold to the Columbian*
*Exposition. Greatest diameter 11.25 inches. Field*
*Museum of Natural History, Chicago, 22468,*
*22486; 22469, 22489A.*

*Jake Gold Becomes a Partner with J. S. Candelario*

Jesus Sito (J. S.) Candelario, a Santa Fe pawnbroker, was a good friend of Jake Gold and was one of the local citizens who unsuccessfully sought clemency for him. J. S. Candelario was known to everybody simply as Candelario. He was born in Albuquerque in 1864 and secured his first business license in Santa Fe in 1893. A Presbyterian, he briefly attended Park College in Parkville, Missouri, and later did missionary work in Mora County, New Mexico, at which time he met his wife, Estefanita Laumbach. He was successful and became a significant landowner in Santa Fe, though his business records show that his frugality was a constant source of friction for his business colleagues.[72]

While Gold was in prison, he and Candelario started a partnership as curio dealers, and in September 1901 Candelario obtained his first retail license. At that time Candelario had access to goods, but it is unclear whether some of Gold's inventory had been preserved, or whether Candelario had begun acquiring inventory. On October 22, 1901, Gold wrote from prison:

> Thanks for groceries &c Look out and have enough Idols Pottery &c when Mr. Mehesy come I allso enclose this list this man is a Customer of Mine he wants prices on Soap Weed Baskets (Chicaguites) Drums Apache Bows and Buckskin leggins &c either Beaded or not, make him out a List he is a very close buyer but he pays cash he also likes stone Idols, Arrow heads Metates &c Give him as low Cash prices as you can regards Jake (44 more days in here)[73]

Four days later Gold forwarded a letter that had been sent to him by Stephens Bros. of Kansas City, Missouri, whose letterhead identifies them as dealers in hides, wool, pelts, furs, and tallow. Here Gold divulged much about trading:

> This firm has a good stock of Furs & Rugs. They want to get some Blankets, they dont say what Kind. I expect they want some Navajo & Chimallo Blankets small & large. My opinion is that you *can sell* [their] Rugs & Robes if [their] prices are right. I use to sell lots of them especialy this time of the year. The

*Figure 33.* Carretas *are on the roofs of two curio stores on San Francisco Street, 1903. Photograph by George H. Pepper. On the right is J. S. Candelario's shop, The Old Curio Store; and on the left is Abe Gold's establishment, Gold's Old Curiosity Shop, in the location of Aaron's and Jake's earlier businesses. Wheelwright Museum of the American Indian, George H. Pepper Collection.*

only way to do is to write to them, and tell them you will send them some Blankets on approval and they can send you some Rugs on the same condition. I am satisfied you can sell them. If you send any goods by Express send over the D & R. G. [Denver & Rio Grande Railway] Express. The reason for this is that Louis Gold [son of Aaron] is working for the [Wells Fargo] Exp. Co and he will tell his *Uncle Abe*—Sabe! And give our addresses away. If you order Furs & Robes order the following (in exchange for your goods). [He lists rugs of red fox, gray fox, coyote, and wild cat, all with stuffed heads.] You can order about two (2) of each and one or two cheap Robes of the Japanese Goat, they know what I mean. You must charge him a little more on Price for your goods as you take it in exchange.[74]

Gold was released from prison on December 5, 1901, about a month short of his full sentence, and Gold and Candelario opened a curio business a few doors east of Gold's original location, which they named The Original "Jake Gold" Curio Store. While working together, Gold and Candelario created four documents, comprising several thousand line items in ledgers, which illuminate their partnership. First among these is an inventory of groceries and dry goods in Gold's hand, totaling more than $5,000 — the inventory of the grocery that adjoined Candelario's curio business in its earliest years. Second is an inventory of curios taken by Gold on December 29, 1901. This includes nearly 300 line items, of which some are entries for differently priced items of similar nature, for example two books at one dollar each. More than 1,500 individual items are identified. Including furnishings such as a display case and a lamp, the total value at cost was more than $880.00.[75]

Gold's handwriting is often difficult to decipher, and his spelling was atrocious. For example he spelled buffalo "bofolo," shell "schail," and rawhide stirrups "rohid sturps." In most cases his phonetic spellings can be interpreted. His entries are in either English or Spanish, and some of his usages are interesting. He refers to some Navajo blankets as *tílma* or *tílmita*. In the nineteenth century *tílma* was vernacular for some wearing blankets, but by 1900 the word had all but vanished from usage. One wonders whether Gold was describing a particular

type of blanket, or whether *tilma* was simply another descriptive term that he used interchangeably with others throughout the inventory.[76]

The cost for most textiles, from small rugs that were "apoliada" (*apolillado*, moth-eaten) to old Navajo and Chimayo blankets, ranged from $0.50 to $7.50. Only one large Navajo blanket, at $15.00, cost more. As expected half of the items in the inventory were made at Tesuque and elsewhere locally. Most Pueblo pottery was lumped into a single listing of 310 pieces valued at $.05 each, while 185 "monos Rain Gods" were $.05 each, 57 clay pipes were $0.10 each, and 8 *tinajas* (water jars) were $0.25 each. Of goods made from hide and wood, 55 war clubs, 54 dance rattles, 32 drums, and 26 sets of bows and arrows were valued at $0.25 each; 11 drums were listed at $0.35 each. Of beadwork, 43 "purces" ranged in price from $0.15 to $1.50.[77]

The remaining inventory includes goods similar to those in Gold's 1889 and 1892 catalogs. Photographs account for the largest number of non-Indian items; 82 cost $0.03 each and 22 cost $0.05 each. Mexican crafts include Guadalajara pottery, drawnwork, and rag figures. In small numbers were all manner of items, from metates and leggings, to old flintlock guns and riding gear, to altar cloths and santos.[78]

Some items are conspicuously absent. Beaded watch fobs are lacking; in the next decade Candelario would sell hundreds of them. Jewelry and other metalwork is barely represented, and only one item is identified as Indian-made: a single silver earring listed at $0.25. One "silver tobaco box" was $2.50. The balance was 15 silver rings at $0.35 each, 10 silver rings set with stones at $0.40 each, and 5 brass rings at $0.05 each.[79]

When Gold took inventory, his and Candelario's business was based purely on friendship. The partnership was not defined legally until July 22, 1902. At that time Candelario agreed to provide space and capital necessary to run the business; and for 25 percent of the net proceeds Gold agreed to devote all of his time to management, including buying, pricing, marking, selling, packing, and shipping. Candelario reserved the right to terminate the partnership with one week's notice and to continue the business on his own.[80]

The third and fourth documents they generated represent daily purchases and sales from December 30, 1901, to June 27, 1903, when Candelario dissolved their partnership. Each maintained a separate ledger (figures 34, 35). Gold did all

*Figure 34. Jake Gold maintained daily records of purchases from December 30, 1901, to June 27, 1903, while he was a partner with J. S. Candelario. These pages include his entries for May 24 to June 5, 1902. J. S. Candelario Collection, Fray Angélico Chávez History Library, Palace of the Governors, Department of Cultural Affairs, Santa Fe.*

Figure 35. J. S. Candelario maintained daily
records of sales from December 30, 1901, to June 27,
1903, while he was a partner with Jake Gold. These
pages include his entries for September 16–22,
1902. J. S. Candelario Collection, Fray Angélico
Chávez History Library, Palace of the Governors,
Department of Cultural Affairs, Santa Fe.

of the buying, and his ledger shows the flow of goods into the shop from walk-in vendors and from wholesalers elsewhere. Although the terms of their partnership indicate that Gold also did all of the selling, Candelario recorded the sales and itemized them in his ledger. Because the business was a reincarnation of Gold's shop in the late nineteenth century, the ledgers provide more detail about Gold's practices than any other documentary source.[81]

Gold's daily purchases are sometimes itemized and sometimes not, so an entry that reads simply "war clubs" and a cost of $1.00 must be interpreted to mean that four clubs were purchased, based on a price of $0.25 each, which is established elsewhere in the record. The same holds true for most objects. For Tesuque rain gods, usually listed as idols or "idles," Gold typically paid $0.05 each, though occasionally he paid a fraction of a cent less when buying in quantity. In some entries Gold lumped together the purchase from a vendor, such as "potry war clubs 6.65" on June 3, 1902. If that entry were solely for small pieces of pottery at his typical purchase price of $0.05 apiece, then it would have represented 133 pieces; and if it were for clubs alone, it would have represented at least 26 clubs.

Even if we ignore most mixed entries, the volume of purchases is impressive. In just the first six months of 1902, purchases of locally made goods appear to have included at least 30 rattles, 60 bows and arrows, 100 clubs or tomahawks, 100 drums, 144 pipes, more than 400 small pots, and nearly 800 rain gods. The items purchased most frequently — in fact almost daily — were arrowheads. One contemporaneous dealer said they were made of obsidian, agate, and flint and were "picked up from the old ruins," adding that some were "no doubt made by the Indians of to-day, as they have not forgotten the art."[82]

Gold ordered thousands of beads from S. A. Frost and placed orders for other goods with George Eastwood in Denver; Henry S. Beach, Arthur A. Kline, and W. G. Walz in El Paso; The Curio in Phoenix (the business of J. W. Benham); and the Hyde Exploring Expedition in New York. Some orders were sizable. Payments to Beach (probably for Mexican carved leather) and Walz (probably for Mexican pottery) on January 26, 1902, totaled $326.83.

Gold identified a few peddlers by name, but usually only by their given names. He made several payments to Julian Padilla, who was his most important supplier of antique goods. If in Gold's mind he actually had "agents" collecting for him, Padilla certainly would have qualified as his most important. Payments for Padilla's consignments totaled more than $300 during the period covered by

the ledger. Christian (C. G.) Kaadt, a Santa Fe photographer, apparently supplied all of Gold's and Candelario's photographs.[83]

Candelario's ledger is simpler to follow, because his penmanship and spelling were better than Gold's. Nevertheless many line items are confusing due to unreadable text and the use of colloquialisms. The entry of May 20, 1902, represents a busy day of walk-in sales:

| | | |
|---|---|---|
| 1 Drum | ip | .75 |
| 1 Pr Silver Pitchers | rru | 4.50 |
| 5 Purses | 2/up 3/su | 5.00 |
| 1 Hair Ornament | dn | 1.00 |
| 1 Pr Earrings | ie | .75 |
| 1 large Beaded bag | [?] | 3.00 |
| 1 Basket | rpn | 2.50 |
| 9 Photos | in | .75 |
| 12 arrowhead | or | .50 |
| 1 Tombe | ru | .50 |
| 1 War Club | ru | .50 |
| 2 Pipes | each n | .50 |
| 1 Mex pot | ud | .75 |
| 1 War Club | ru | .50 |
| 2 Idols | each u | .20 |
| 1 Pipe | u | .10 |
| 1 Whip | ru | .40 |
| 1 Photo | [?] | .10 |
| 3 Purses | sp ou rp | 1.25 |
| 1 Cradle with Papoose | oun | 2.00 |
| 2 Pr Moccasins | 1/oup 1/sp | 3.00 |
| 1 Quirt | ru | .40 |
| 1 Rattle | rp | .35 |
| 1 Hair Rope | ru | .50 |
| JSC | | $29.80 |

Between each description and sales price is a code representing cost, which was a common retail practice. A retailer chose ten letters that were simple to remember, possibly in a word. The word used years later by curio dealer Julius Gans was

"previously." Starting with *p*, a numeral was assigned to each letter: *p*=1, *r*=2, *e*=3, *v*=4, *i*=5, *o*=6, *u*=7, *s*=8, *l*=9, *y*=0. Gans used the letter *b* to double a digit. Thus $0.75 was *ui*, $1.00 was *pyb*, and $11.00 was *pbyb*. The code was written on the price tag with the retail price, so the cost was readily available when taking inventory.[84]

The letters that Gold and Candelario used were *a*, *d*, *e*, *i*, *n*, *o*, *p*, *r*, *s*, and *u*. The letter *x* was used only as the last of a three-letter code, and only following the middle letter *p*. Gold wrote the key to the code on one of the preliminary leaves of his ledger. It is as follows: *o*=1, *r*=2, *i*=3, *s*=4, *u*=5, *e*=6, *d*=7, *n*=8, *a*=9, *p*=0. He noted that *x*=*r*, by which he meant that *x* indicated repetition of the prior numeral. The code may have been a mnemonic device, perhaps representing the first letters of the words of a familiar expression, but that is not clear. By substituting values for letters, one can see that the cost for a pipe was $0.05, the cost for a club was $0.25, and the cost for the "cradle with papoose" that sold for $2.00 was $1.58. Immediately it becomes clear that cost was half or more of retail.

Candelario recorded walk-in sales as well as payments from wholesale buyers. So we find sales of $100.02 to the Hyde Exploring Expedition on March 10, 1902; $39.62 to E. Mehesy, Jr. on March 24; $19.75 to L. W. Stilwell of Deadwood, South Dakota, on March 31; $127.70 to Amos Gottschall on April 3; $38.70 to the Fred Harvey Company on April 28; $149.30 to Gottschall on May 9; and so on.

In a matter of months Jake Gold was able to reestablish his reputation, his contacts, and his business, and Candelario had the perfect mind and disposition to be a worthy successor. On June 27, 1903, they parted amicably, and they remained in touch. In December Gold referred a buyer in Colorado Springs to Candelario, opening the letter with "Friend Candelario," and closing it with an appeal: "Now Friend I am broke, and if any of the debts have been Collected Please Send me my share regards Jake." In 1904 Gold entered into a partnership with another curio dealer, Pedro Muñiz, but Gold was losing his mental faculties due to complications of syphilis and he was shortly thereafter committed to the Territorial Insane Asylum at Las Vegas, where he died in 1905.[85]

*J. S. Candelario Invents Himself as Santa Fe's Original Curio Dealer — and Succeeds*

If Jake Gold's story is difficult to tell because of the limited amount of direct evidence, Candelario's is nearly impossible to tell because of the overwhelming volume of it. Candelario kept every scrap of paper, including letters critical of his business practices, depositing them in the basement of his building. As space ran

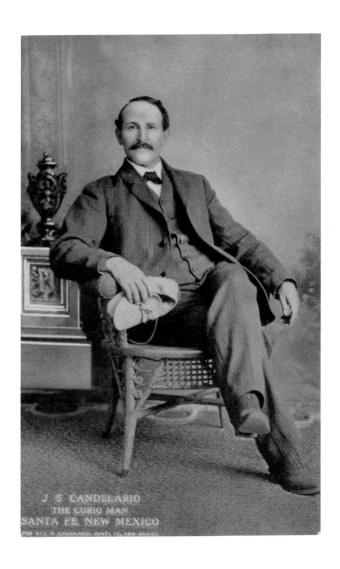

*Figure 36. J. S. Candelario published this postcard of himself in about 1910. He projected himself as successful; the moccasins in his hand imply his authority on Indian arts. Private collection.*

out and he needed room for more recent documents, he would dispose of older papers. The resulting record is incomplete and uneven, but it constitutes the largest collection of papers from any early curio dealer. Reading the thousands of repetitious orders and other documents, one can gain a sense of the patterns of his business, as well as its strengths and weaknesses.[86]

When he assumed the business, Candelario was not satisfied to establish himself as the proprietor and an authority on curios. Candelario wanted to create the impression that he was the original curio dealer in Santa Fe. So whereas Aaron Gold had used the expression, "Established 1855," which was the year he first arrived in Santa Fe, and Abe and Jake used the dates 1859 and 1862 in the same manner, Candelario used the expression "Established 1603." It was nonsense, but it sounded good; he had it painted on the front of his store and claimed that the curio business had been in his family continuously since that date. He named his shop The Old Curio Store, and later, The Original Old Curio Store.[87]

1903 was a propitious time to enter the business. Curio stores had been conspicuous throughout the Rockies and Southwest for twenty years, but new businesses were emerging at an astonishing rate, and the demand for artifacts was almost impossible to meet. In the late nineteenth century H. H. Tammen had promoted collecting through his publication, *The Great Divide*, boosting his curio business. Now curio collecting was so popular that by 1903 in Denver there were eight curio stores, and by 1908 there were twenty-six, many of them within blocks of each other. Between 1901 and 1910 Candelario sold or consigned goods to thirteen curio dealers in Denver alone.[88]

"Would you please send me your price list. Saw your 'ad' in the men's waiting room at the A. T. & S. F. Depot here," wrote Joseph Fentiman of Topeka to Candelario in November 1905. Advertisements for curio stores were commonplace in the early twentieth century, and like most leading curio dealers, Candelario advertised widely, often trading goods for ads. Candelario seems to have gone for geographic distribution rather than for specific audiences. He placed ads or enquired about placing them in the *Albuquerque Booster*, the *Boys Magazine* (Des Moines), the *Chicago Collectors Monthly*, the *Commercial Bulletin and Northwest Trade* (Minneapolis), *DIRT* (La Grange, Indiana), the *Independent* (Nauvoo, Illinois), the *Inter Ocean* (Chicago), the *Philatelic West* (Superior, Nebraska), the *Saturday Evening Post* (Burlington, Iowa), *Sunshine* (Albuquerque), and others.[89]

In October 1906 a new magazine commenced publication in Denver, and in the first issue of *The Great Southwest: A Magazine of Romance, History and Progress* was announced a forthcoming "department" called "The Curio Shop." The author of the column was to be A. L. McIlhargy, an Albuquerque journalist who purportedly had "lived among and studied the artistic creations of the primitive peoples of the Southwest." McIlhargy's columns, which ran until August 1907, promoted the curio trade in Albuquerque and the Fred Harvey Company. In January 1907 he claimed that Albuquerque had "become one of the greatest museums of pottery in the Southwest."[90]

Candelario advertised in *The Great Southwest* from September 1907 to May 1909, under an agreement requested by the publishers by which they would exchange advertising for "a supply of your small blankets." In 1907 the publishers purchased a large Navajo rug for $45.00 from one of Candelario's consignees, a Mrs. W. S. Fitch of Colorado Springs. Fitch sold the rug on Candelario's behalf, and instead of paying cash, the publishers credited the price to Candelario's advertising account.[91]

Of Candelario's consignees who did not have stores (and there were many), Mrs. Fitch and her husband, William, an employee of the Department of the Interior, were his most sophisticated. Candelario signed a contract with the Fitches on March 29, 1907, and on the following day shipped his first consignment of goods. The Fitches placed ads in both of their local papers and had 5,000 folding cards printed to promote sales. They arranged their house at 627 North Weber Street as a curio store and had "Indian and Mexican Curios, Navajo Rugs," painted in gold on one of their front windows. Mrs. Fitch laid out the stock in the house, and her husband reported back to Candelario on May 4, "On my return to Colo. Springs a day or two ago I found that my wife had the Navajo rugs laid out and things pretty well arranged. Our house looks like a wigwam. It certainly looks fine and I wish you could see it."[92]

Sales were off to a slow start, which Fitch attributed to the competition: "There are a good many in the curio business in Manitou and here also." On August 1, he sent Candelario the first accounting of sales. Of 38 items sold, almost all were things made in the Santa Fe region for Candelario, principally pottery. According to Fitch's accounting, the items cost $14.14 and sold for $35.95. Candelario and the Fitches split the profit of $21.81, which represented approximately half of the Fitches' income from what became ten months of

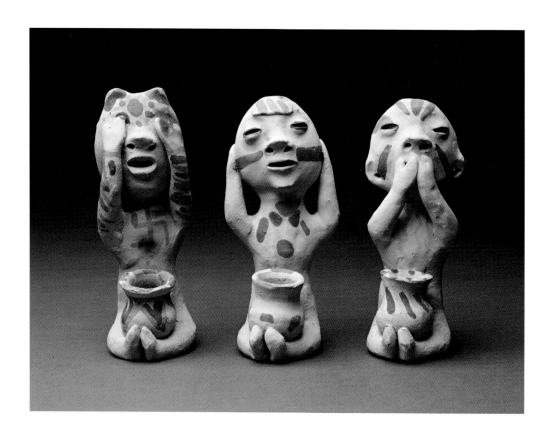

*Figure 37. This trio of Tesuque rain gods represents the Japanese maxim, "See no evil, hear no evil, speak no evil." Rain gods remained in the basement of Candelario's shop years after he retired; that was almost certainly the source of this pristine group. Height 6.75 inches. Girard Foundation Collection, Museum of International Folk Art, Department of Cultural Affairs, Santa Fe, A.1979.53.716V.*

work. They eventually sold some goods at cost to one Samuel Dickens and returned the balance to Candelario.

Candelario was relentless finding curio dealers to whom he could consign goods, and finding others whom he could turn into curio dealers. He would write to postmasters to ask for the names of dealers, and some postmasters obliged. Many consignees learned about Candelario from his advertisements and wrote to him voluntarily. After making contact with a potential consignee he would ask a fellow dealer for a reference or would contract with Dun and Bradstreet to obtain a credit report.[93]

By focusing on consignments Candelario grew the business well beyond its size under Jake Gold's management, turning it into a predominantly wholesale operation. Like Aaron and Jake Gold before him, Candelario supported the production of nontraditional objects and invented new ones. He also established sources that he probably misrepresented as Indian. His records show that he sold thousands, and possibly tens of thousands, of some types of object. A review of his retail and wholesale trade should begin with the Tesuque rain god (figure 37).

Candelario's sales ledger of 1902–1903 contains the only records of over-the-counter sales of rain gods to walk-in customers. Rain gods sold reasonably well during the higher-traffic months of summer, but their sales dropped off during the rest of the year. If we assume that Gold and Candelario needed two months to get settled in business, then the twelve-month period March 1, 1902, to February 28, 1903, should represent a typical year of retail business. During that period they sold 122 rain gods over the counter in 54 transactions. From that we can estimate that from 1890 to 1910 Gold and Candelario sold well over 1,000 rain gods in retail transactions alone.[94]

Jake Gold wholesaled rain gods to H. H. Tammen and other dealers starting in the 1880s. Rain gods, like all pottery, were shipped in barrels. Rain gods were shipped 100 to a barrel, and in 1905 Candelario charged $6.50 per barrel, representing a markup of about 1.5 cents per rain god. Documentation of Candelario's wholesale orders for 1902 through 1904 is partially lacking, but most orders from 1906 through 1910 exist. Candelario shipped barrels of rain gods to M. J. Kohlberg, the H. H. Tammen Company, and Woodend Curio Company in Denver; the Fred Harvey Company in Albuquerque; Francis E. Lester in Mesilla Park, New Mexico; and many others.[95]

In 1906 Candelario shipped more than 900 rain gods, and in 1907 he shipped more than 1,000. Potters of Tesuque sold rain gods to several other curio dealers in Santa Fe, so it is obvious that they made many thousands of them. When sales were at their peak the demand made it difficult for potters to shape and fire them properly, and also for Candelario to pack them adequately. He received many complaints about poorly made rain gods and careless packing.[96] B. A. Whalen of Los Angeles may have been the most incensed by a shipment of 1903:

> ...the Moki gods are the worst lot you ever sent us. Most of them are in pieces. They were wretchedly made, not half baked, and many of them much smaller than the usual size.[97]

A recession in 1908 caused all curio sales to drop off, and by the time the economy recovered the rain god had declined in popularity. Sales gradually slowed, and though Candelario shipped barrels of them for years to come, many wholesale orders were for only one to ten. At that time the hottest items on the curio market were Navajo and Chimayo pillow covers, or pillow tops, which were usually square and approximately twenty inches on a side (figures 38–40). Gold and Candelario had always sold significant numbers of Chimayo textiles, and Candelario became one of the leading sources of Chimayo pillow covers. Candelario shipped them all over the country, especially in the West, and their numbers eclipsed those of rain gods. In 1917 alone Candelario shipped at least 1,200, and his records identify several other wholesalers of them. As was the case with rain gods, the makers were pushed to their limits, so Candelario did his best to create new weavers, buying and supplying their looms.[98]

If the need for makers was an issue, so was the need for materials. Not enough cattle and horses could have been butchered locally to provide all the tails necessary for clubs and rattles, so the question arises whether some hides or scraps were shipped to Santa Fe from Denver or Kansas City, where there were large slaughterhouses. No surviving letters to Candelario document this, but in October 1899 Denver curio dealer G. D. McClain broached the subject with Hyman Lowitzki. McClain enclosed a payment to Lowitzki and asked him to send more clubs and drums. He added, "If you find difficulty in getting steer tails down your way how would it do for me to ship them from here in the raw wet state and have the Indians make them up."[99]

Candelario also retailed and wholesaled goods acquired from other dealers, especially Navajo textiles. Like dozens of other dealers, he bought rugs by the bale, usually 100 to 200 pounds at a time. C. N. Cotton of Gallup offered Candelario at least 4,000 pounds of rugs between April 1911 and August 1912. In April 1911, Cotton offered 1,000 pounds at $0.85 per pound, and Candelario placed the order. When he paid, he applied a discount, and Cotton wrote to inform him that although he would let it pass, his prices were net. Candelario had been chastised before. In October 1903, R. T. F. Simpson of Farmington complained to Candelario about picking from a bale of blankets and returning the balance; Simpson advised him that he did not send blankets on approval.[100]

Candelario constantly sought ways to lower his costs. In early 1907, after buying Mexican crafts heavily from W. G. Walz and others in El Paso, he was able to buy all of the remaining inventory of El Paso dealer M. Schaper, who told Candelario he was retiring from the business. Candelario had bought drawnwork and other fiber arts from Schaper for years, and now he bought everything, including pottery, filigree jewelry, and silk shawls. Candelario asked Schaper if he would divulge his sources, and Schaper obliged, providing detailed information on their specialties and their locations in Mexico.[101]

Candelario handled some goods that were neither Indian nor Mexican. One such class of items was braided horsehair, including bridles, quirts or whips (described at least once by Gold in his purchase ledger as *cuartas*), lariats or ropes, cinches, watch chains (fobs), and hat bands. Gold listed most of those items in his 1889 and 1892 catalogs without any attribution to a culture or to Mexico — the only handmade items in the catalogs without such attribution. When Gold took inventory in 1901 a mere handful were present, but once he began buying, a fairly steady supply came through the door. In 1902 he bought at least 220 hair quirts, in every instance buying at least one dozen at a time and paying $3.00 per dozen, or $0.25 apiece.[102]

In addition to quirts he bought an occasional hair hat band, and in 1902 he purchased three hair bridles for $3.50 each and one for $3.70. Those were impressive prices, befitting fine workmanship. In no instance did Gold suggest they were Indian-made. His purchase on September 16, 1902, of unidentified "Hair goods from Old Mexico" for $6.50 suggests Mexico as a source, but the volume he purchased from Mexico was small.[103]

On December 29, 1902, he purchased "2 Bridle & 5 Whip from Pen $6.00," and that is the clue to their origin. The state penitentiary was the source.

*Figures 38—40. Navajo pillow covers, ca. 1900—
1910. These colorful and whimsical examples were
woven with cotton warps and Germantown yarn
wefts. Traders provided those materials to eliminate
the need to shear, wash, card, dye, and spin yarns,
enabling weavers to speed their output. Navajo
weavers produced thousands of pillow covers for the
curio trade. Each is approximately twenty inches
square. Private collection.*

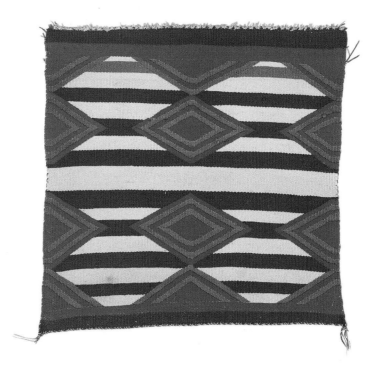

Hair goods made by inmates were probably peddled well into the twentieth century, but that source became inadequate to meet the demand that Candelario created. In 1906 he solicited quotes from the Alamo Art Leather Company and from Katool and Farris' Oriental Bazaar, both in San Antonio, Texas. The latter company shipped eighteen dozen hair quirts of unknown origin to Candelario between August 1906 and March 1907.[104]

Again Candelario sought a way to lower cost and meet demand. He began supplying horsehair to inmates by the pound, and from 1907 to 1912 inmates at Santa Fe and at Deer Lodge, Montana, offered him completed hair goods by mail. Candelario purchased from several men and made his largest purchase from J. C. Smith, an inmate at Santa Fe, in September 1910. Smith sold him 78 quirts at $0.25 each, 53 hat bands at $0.30 each, and 10 hat bands at $0.50 each, for a total of $40.40.[105]

Fred L. Roemer of Yuma, Arizona, offered hair goods to Candelario and assured him they would be better than those from "the Pen. there." As proof, he said he supplied "most of the larger Curio stores in the West," including Benham Indian Trading Company, the Fred Harvey Company, Francis E. Lester, and W. G. Walz. Roemer wrote twice, but Candelario did not respond. In July 1911, M. J. Kohlberg of Denver rejected some hair goods that Candelario sent on approval, saying they "cannot be compared in quality with the ones we get from Yuma." In other ways Kohlberg's letter was a typical critique of a shipment: "There are very few things in the lot that we can use. The Navajo silver bracelets are all brand new, with the exception of two, and I told you particularly to send me only old ones.... The Chimayo blankets are very thin and flimsy and mostly poor color. There are but very few amongst them that we can use at all."[106]

The new bracelets may not have been Navajo. Between 1911 and 1913 Candelario purchased silver jewelry made by inmates at the penitentiary in Canon City, Colorado. He even visited the prisoners himself, delivering 48 turquoise stones to them shortly before June 1911. Writing on May 15, 1912, inmate Harry Lewis told Candelario that he had planned to send 2,000 pieces of jewelry that month but would not be able to complete the group until the following month. He had sent a group of rings to Candelario the prior day, and had begun setting turquoise in another order, which he planned to send the following week. Lewis said that the lot of 2,000 pieces would cost ten cents per piece. Even if all of the pieces were rings, that would have been a bargain price for Candelario, especially if he sold them as Indian or did not divulge that they were non-Indian.[107]

Another non-Indian craft was burned leather, sometimes with painted detail; one variant was leather that was airbrushed with color. Pyrography was a popular craft fostered by the Arts and Crafts movement, and just as adherents of the movement embraced Indian arts, it was inevitable that the curio trade would embrace pyrography. The H. H. Tammen Company developed a line of painted and burned leather items, primarily hides and pillow covers featuring Indians, cowboys, burros, and other stereotypical western subjects, illustrating them in catalogs at least as early as 1901 (figure 41). Denver instantly became a center for burned hide goods, and within a few years several companies had lines of goods or made them to order.

Candelario latched onto the concept quickly, conceiving two pillow covers that he could sell as distinctly Santa Fean. The burned designs were to represent the San Miguel Church and the "Ben-Hur Room." The former is a chapel on Old Santa Fe Trail, a short distance south of the Santa Fe River, which was built in the early seventeenth century. It has been a tourist destination for well over a century, billed as the oldest church in the United States. The Ben-Hur Room is the room in the Palace of the Governors in which Governor Lew Wallace purportedly wrote at least a portion of his famous novel, *Ben-Hur: A Tale of the Christ*, while he served as governor of New Mexico (1878–1881). *Ben-Hur* was published in 1880 and became one of the most popular novels of the nineteenth century.

Candelario contracted with the H. H. Tammen Company to make his first pillow covers, but shortly thereafter the company decided to make and sell only their own designs. In June 1904 Candelario began working with W. B. Phillips of Denver, who made "burnt leather novelties" and also dealt in all of the same natural curiosities, Navajo blankets, Mexican drawn work, and other items handled by other curio dealers. Candelario's business with Phillips was two-directional. Phillips ordered and received a barrel of pottery from Candelario and also asked to handle a complete line of Candelario's Indian goods. Candelario contracted with Phillips to make his pillow covers, and Phillips advised him that the same skilled burner who had done the work when Tammen was his supplier would be doing the work for Phillips.[108]

No sooner had Candelario contracted with Phillips than he wrote to Winslow Bros. & Smith Company in Denver, requesting samples of skin for "burnt work." Phillips had told him that he was still waiting to receive the skins needed for his pillow covers, because "high water in Kansas and Nebraska" had delayed shipment. Candelario was either impatient or had decided to produce

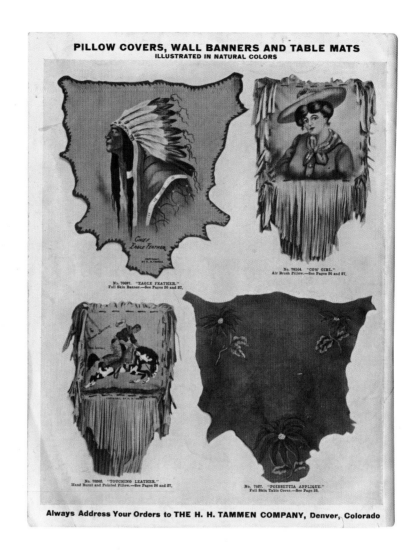

Figure 41. Back cover of the H. H. Tammen Company's General Catalog, 1908. They offered burned and painted hides and pillow covers at least as early as 1901 and produced J. S. Candelario's first leather pillow covers. Collection of Chad and Erika Burkhardt.

pillow covers himself. Winslow Bros. & Smith advised him that they supplied Tammen and Kohlberg with skins, but that they could not fill orders for less than five dozen skins of any color. Candelario apparently abandoned the idea, and after receiving his first order from Phillips, ordered again, requesting "2 Dozen Old Church and 1 Doz. Ben Hur" pillows. After Phillips shipped them on October 4, 1904, Candelario predictably disputed the pre-agreed cost, and Phillips was forced to write two long letters, defending his prices. Their business relationship ended, and maneuvering through various transactions, Candelario found other companies to make his pillow covers.[109]

Postcards were authorized by Congress for private mailing in 1898, and almost immediately real-photo and other elaborate cards pushed the postcard beyond its original business-oriented use. Curio dealers recognized the potential immediately. The H. H. Tammen Company produced a line of hundreds of images, offering many in their catalogs of the early twentieth century. Whereas photographs had cost between three and five cents apiece wholesale, postcards could be printed for less than one-tenth that cost, and they could be mailed as a form of advertising.

Candelario started his own line of postcards. He was an amateur photographer, and though his images are not attributed, he probably took many of the photographs on his postcards (figure 42). Candelario's ad on the back cover of the October–November 1912 issue of *Post Card Monthly* states, "Post Cards Exchanged." Candelario became an avid collector of postcards, exchanging them with people all over the world. No doubt he took every opportunity to promote his business in those friendly trades.[110]

Candelario published many broadsides and folding catalogs (figure 43). In his advertisements he described his catalogs as "price lists," but almost all of his catalogs have printed prices only for Navajo and Chimayo blankets, rugs, portieres, and pillow tops. He listed all other items in columns with enough space to write prices on request. Most of his catalogs had the same content, but one, which is an interesting period piece, is his only catalog for which precise documentation exists.

In January 1905, P. A. Speckmann, editor of the *Estancia News* of Estancia, New Mexico, sent Candelario a proof of a "folder" for which Candelario had sent him text and the "cut," or wood-mounted metal plate for the image. At the time, cuts were sent back and forth between business owners and printers constantly,

*Figure 42. Dolorita Vigil of San Ildefonso poses with her pottery on this postcard, published by J. S. Candelario. Candelario was an amateur photographer and probably took the photograph himself. Private collection.*

*Figure 43. Printed in 1904, this is probably J. S. Candelario's earliest surviving catalog. J. S. Candelario Collection, Fray Angélico Chávez History Library, Palace of the Governors, Department of Cultural Affairs, Santa Fe.*

as naturally as digital files for advertisements are e-mailed today. Candelario made several changes to the layout before Speckmann printed the final version for him (figures 44, 45). Speckmann charged $6.00 to set the type and quoted a price of $2.00 for a thousand, or $2.75 for two thousand and $0.75 for each additional thousand, printed on white newspaper stock. He also offered to print it on yellow broadside paper for $3.00 per thousand, $4.00 for 2,000, or $7.00 for 5,000. Candelario opted for printing on newsprint, but the number that he ordered is not documented. Speckmann may have accepted curios as payment, because he eventually accepted goods on consignment, selling them for Candelario.[111]

The sheet was intended to be folded in half vertically, and on its inside are offered nine different "corners," or pre-selected collections, starting with twenty pieces for $6.00. Each corner from $10 to $50 included the content of the prior corner plus additional objects. Here Candelario repeated the practice established by Jake Gold in catalogs as early as 1889, only with added reference to the "Indian corner," which was a popular feature of Victorian homes. Every item included in the corners was made in quantity for Candelario, which ensured the highest profit possible.

If Candelario was a storyteller, it was not evident in his catalogs. His catalog texts are simple and straightforward, and unlike some of his contemporaries Candelario did not play up the vanishing-race theme. In one of his catalogs of about 1911, he said,

> Owing to the well known fact that the Indian goods will soon be a thing of the past, as the new generations are adopting our habits and abandoning those of their ancestors in weaving and pottery making, I am now reaching for more trade and can assure all my friends and customers that I shall continue with the assistance of my *native* brethren to treat them the same as in the past, if not better.[112]

From all things Indian and Spanish New Mexican, to live burros and maguey purses, Candelario sold every conceivable curio of his time. Jake Gold's shoes would have been difficult to fill, but Candelario's quick wit made him a legend. The best compilation of Candelario lore was written by "Bee Bee" Dunne for *New Mexico Magazine* in 1948, a decade after Candelario's death.

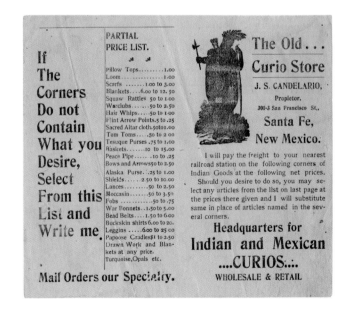

Figures 44, 45. In 1905, P. A. Speckmann of the Estancia
News, Estancia, New Mexico, printed this catalog in which
J. S. Candelario offered progressively priced collections of objects,
which he sold as "Indian corners." This is one of a handful of
curio catalogs whose printing histories have survived. Here are
a marked-up proof and the printed catalog. J. S. Candelario
Collection, Fray Angélico Chávez History Library, Palace of the
Governors, Department of Cultural Affairs, Santa Fe.

Again we shall think of J. S. Candelario, with black mustache, his keen twinkling eyes, his sarcastic smile, boiled white shirt, his heavily pressed black suit, his high, black, buttoned shoes, his four shiny turquoise-silver rings. We shall miss J. S. in person, however, especially in those moments of generosity when he mischievously handed out a fistful of jumping beans to any tourist who had been a liberal spender — buying Indian drums....

Presidents, those who "also ran", cabinet officers, railway executives, diplomats, scientists, artists, writers, socialites, clubmen, and school children — from the U.S.A. or the other Americas, listened to Candelario's amazing stories. And royalty from Europe and Siam visited Candelario's. That store was a "must". Even Teddy Roosevelt once hurried his breakfast coffee to see and hear Candelario in action.[113]

Candelario's treasures included the skull of Henry Ward Beecher "when he was a boy," Ben-Hur's trunk, and the "oldest bells in the world," dated 1300 and 1364. When visiting the store, William Jennings Bryan murmured that older bells existed in Moscow, and Candelario told him that the dates were B. C., not A. D.[114]

Candelario admitted, with his sarcastic smile, and his eyes twinkling, that he owned the rope used to hang a woman who had smuggled booze into Pancho Villa's camp in Old Mexico. That was a famous story. There are rumors that a million feet of that "hair rope" had been sold to tourists from Maine to California, from the Everglades of Florida to the snow-capped peaks of Alaska. And possibly over in Puerto Rico.[115]

Candelario retired in 1936, but elements of his store are preserved in its original location, now called The Original Trading Post.

*A Gentleman in Española: Thomas S. Dozier*

Thomas Dozier never had the public exposure that the Golds, Candelario, or some of their counterparts elsewhere in the country had, so he has become nearly forgotten. Thomas Sublette Dozier was born in 1857 in St. Louis, Missouri. The child of poor parents, Dozier hoped to be a statesman, and he realized that an education would be essential for a successful career. With only a high-school education Dozier was already teaching before enrolling at Westminster College in Fulton, Missouri. There he excelled in algebra, Greek, and Latin and continued to teach as a substitute. He resumed full-time teaching after graduating, studying law in his spare moments. At the age of thirty he was admitted to the Missouri Bar.[116]

Dozier had not practiced law for long when he took a civil service exam, and the Department of the Interior notified him that he had been placed on a list of people eligible to teach in the Indian Service. In a matter of days the Indian Service offered him a position at Santa Clara Day School. He accepted the position immediately and arrived at Santa Clara Pueblo in spring 1893. In 1896 he married Locaria Gutierrez of Santa Clara, and together they had eleven children, of whom two died in childhood. One of their sons was the anthropologist Edward P. Dozier, "Edwardo de Pascua," born on Easter Sunday 1916.[117]

Due to what Dozier called his "constitutional tendency to nervousness" he quit teaching in 1898 and devoted himself for several years to the curio trade. Dozier began working in 1898 for G. W. Bond & Bro. of Española, a company he stayed with for more than fifteen years. In at least some of his early years with the company he ran a curio department, but he also dealt in curios on the side. At first he was a regular employee, but by April 1902 he reduced his commitment to either part-time or a contractual position and commenced dealing actively on his own.[118]

Dozier was drawn to the curio business by the craze for collecting Indian artifacts. He described the phenomenon in a letter of August 1902 to Charles A. Patton of Missouri:

> Indian corners & Indian rooms are getting to be "fat" among the wealthy & well-to-do & it is well to accommodate them & indirectly do business as well. Should you or any of your friends want anything genuinely Indian or Mexican will be glad to get the directions of getting it for you or them.[119]

Dozier's letters are thoughtful and thorough; the educator in him could not help but explain things. Dozier was personable, and the satisfaction of his clients was important to him. One readily senses the care with which he wrote and the honesty with which he represented his goods. Most importantly, Dozier's letters are a source of definitive information about artifacts and the curio trade that can only be inferred from other dealers' records.

Dozier wrote several letters introducing himself to people in the trade. One of his first was to Richard Wetherill on August 2, 1902:

> Dear Sir: — Having been for some years connected with the Pueblo Indians as Govt. Teacher and of late as a clerk in the two stores at Española, but having now given up my position as a regular employee of G. W. Bond & Bro. I have concluded to devote some time to Indian Curio Collections.
>
> I do not expect, owing to governmental restrictions, to pay much attention to the products of the ancient ruins, of which there are large numbers here about, but think I can find ample & profitable opportunity among the living Indians.
>
> There are many things which they are still making & also many long since discarded but now rusting & moulding away, all of which have considerable commercial value. For instance, I have had [word obliterated] & now in course of making a number of quivers. In the same way I have a number of tom-toms many of which I have bought that were very old ones. Again, I bought the other day at a pretty stiff price an old buffalo [shawl?] decorated with ceremonial figures — a real & valuable curio. So, likewise, there may be had many things of the same commercial value as gold.
>
> Should you wish anything of this kind, pottery or anything I may be able to find among the Indians of today I shall take it as a great favor if you would write me as it might turn out to be of material & financial interest.
>
> As I am just beginning & have no financial standing I shall be glad if you will call the attention of any others who may have an interest in such things. I think I may be able to get most any thing obtainable and will be greatly obliged to receive

suggestions from any one, requiring only prompt payments for my articles delivered or its immediate return if not suitable.[120]

Wetherill replied, referring Dozier to the Navajo Indian Blanket Store Company of Denver, which had been recently incorporated with Wetherill as president, Al Wetherill as secretary, and Fred F. Horn as vice-president and manager. The company sold a variety of curios, but their emphasis was Navajo textiles. In a letter to J. L. Hubbell in July 1902 they requested two thousand pounds of Navajo blankets, which they promised to market aggressively, as they already supplied "seven of the largest stores in this city and outside business is increasing daily."[121]

On August 29, 1902, Dozier replied to an inquiry from the company, describing some of the goods he could supply:

> In reply to yours of the 25th will say that I can get you quivers made from tanned goat or sheep skin at $1.50 each containing one pueblo bow. This is a cheaper bow than the Apache or Navajo in that it is not sinew backed. The cord, however, is sinew & the quiver is sewn with sinew or buck skin. Buckskin or Buffalo skin are real curios & are very high. I only have them made by my Indian friends when specially ordered.
>
> War clubs (cowtails with the skin and stretched & sewn about a round stone) $4.00 per Dz.... Tesuque makes the Idols (Rain Gods) I have 200 of them now which I can let you have at $8.75 per 100. This is 75c lower than I have known them to be quoted heretofore. Large decorated water Jars—of such size that three will go in to a bbl—50c each; good, well-made black same price. Very large Jardiniers, owing to expense of packing are correspondingly much higher—from 3.00 to 6.00 each. A bbl. should contain from 30 to 50 pieces & is worth $3.75 to $5.00 F.O.B. Espanola, weighing about 90#. Rain Gods when they go alone must be boxed & shipped per Exp.
>
> Metates—corn grinding stones—from $3.00 to $5.00 each. Cheese-box drums, single .50 to 1.00, double $1.50 to 2.00 each.

Can you use any Chimallo blankets? Can furnish you 15 x
30 single at 9.25 per Dozen; 21 x 43 single $17.50; 36 x 72 dou-
bles, Navajo designs, $7.00 to $8.50.... [122]

Whether the company placed an order is unknown. They published a mail-order
catalog in 1903 but went out of business shortly thereafter (figure 46).

Dozier also explored new markets for his goods, as he explained in a letter
of February 1904 to the superintendent of the school at Fort Shaw, Montana:

> Dear Sir: — am sending out Indian pottery — freight — in bbls.,
> 12 pieces to a bbl., each piece different, to many normal,
> preparatory, & Indian schools of the country. This pottery,
> made by the Pueblo Indians of New Mexico, makes excellent
> models for class-room drawing — I select the pieces with this
> specific object in view, & guarantee against breakages in transit.
> price $4.00 per bbl. Here — pay when you get the pottery —
> Please order at once.[123]

Dozier's idea succeeded. In his reply, superintendent Fred C. Campbell said "we
might be able to use several barrels of the goods you speak of. We frequently
have visitors who desire something of this kind and there are employees here
who would no doubt desire something of the kind."[124]

Dozier's search for materials — both for making objects and for shipping
them — is illuminating, and his descriptions of objects are invaluable. Writing to
A. B. McGaffey of Albuquerque on August 7, 1902, Dozier explained that he had
bought ten dozen cow tails and was "having them made up into war clubs and as
I am personally superintending the job expect to have a more salable article." He
offered them to McGaffey, who was out of town. By the time McGaffey replied,
Dozier had sold the entire lot, but he had "just got hold of a lot of cowtails again,
as I bought them cheaper. I intend to make up these for $4.00 per Dz. They can
be got by the 13th.... " Dozier shipped four dozen war clubs to McGaffey, and on
September 15 he advised the Hyde Exploring Expedition that he was having two
dozen war clubs made for them. Those letters demonstrate that in just two
months Dozier sold nearly 200 war clubs.[125]

Figure 46. The Navajo Indian Blanket Stores Company of Denver was founded by Richard and Al Wetherill. The offerings in their 1903 catalog included textiles; Mexican carved leather goods, which they probably acquired from the Beach-Akin Curio Company; and spiders, horned toads, and other preserved creatures. Collection of Kathleen L. Howard.

Gold and Candelario mentioned shields infrequently, but Dozier had them made for several clients. On August 22, 1902, he explained to John Frederick Huckel of the Fred Harvey Company's Indian Department that he was unable to get old shields. He knew of only one, on which the price was "out of sight." He asked if he couldn't interest Huckel in some "good imitations from heavy bull hide." Huckel eventually ordered some, and on November 7, 1903, Dozier told him "the shields will not [be] ready for a day or two, perhaps a week when I shall forward them..."[126]

Just as he had predicted sales of pottery to schools, Dozier wrote to dealers in Colorado in 1903. In an undated letter to a store in Canon City, he said

> I am shipping to Colorado tourist points large quantities of Id'n pottery this spring. I ship usually in bbls containing from 30 to 50 pieces costing purchaser from $4.50 to $5.50 per bbl F. O. B. Espanola. I quote you Indn Idols (Rain Gods) $7.50 to $8.00 per 100 lots. 90c & $1.00 per Dz lots. Indn pipes 75c per Dz.... War Clubs $2.00 to $3.50 per Dz.[127]

One cannot help but wonder where the hundreds of barrels used to ship pottery and rain gods came from. Dozier's sales grew to such a degree that in June 1903 he wrote to merchants outside Española to acquire them. He asked one in Santa Fe, "What can you sell me empty beer bbls. for? I want about 50. I am paying 15c & 20c each here." He told another in Tres Piedras that the barrels "must have good bottoms and good hoops. Am not particular about the tops but when convenient put them inside barrel." In January 1904 he renewed his quest, writing to merchants in Abiquiu, El Rito, and Truchas. He asked El Rito Mercantile Company, "Have you any empty beer, candy or other similar bbls.? I pay 25c for same...."[128]

In his pamphlet, *About Indian Pottery*, which he published in 1904, Dozier explained why the tops of drums were not important: "Usually I pack in barrels, with cloth tops, containing from fifteen to thirty pieces, according to size." The cloth was nailed to the wooden staves. A similar question might arise about the packing material used to protect pots. Wood shavings were found in at least one nineteenth-century Cochiti figurine, and C. G. Wallace, a famous twentieth-century trader at Zuni, used newspaper, much of which was shipped to him by a friend in Denver who worked for the U. S. Postal Service.[129]

In *About Indian Pottery* Dozier illustrated the contents of a typical barrel. The halftone illustration in the booklet was made from a photograph by Christian Kaadt, who was not only a photographer but a curio dealer (figure 47). In a series of letters to Kaadt in March 1904, Dozier said that he wanted to send a barrel of pottery to include in the photograph because it was too hard to explain what he wanted in writing. In his final instructions he stated that he was shipping three-fourths of a barrel and asked Kaadt to augment the selection from his own inventory. Dozier asked him to add one or two good San Ildefonso water jars, one or two black Santa Clara water jars, and a "well shaped San Ildefonso bowl or plate.... I should like to have you put in this picture about thirty good, representative pieces." Dozier also ordered a half gross (six dozen) of the photos of pottery and another half gross of Kaadt's other views.[130]

In November 1903 Dozier wrote to the G. M. Harris Curio Company of Denver, to whom he had recently shipped a barrel of mixed pottery, a barrel of rain gods, and some Chimayo blankets. He was now sending them some drums, including two large dance drums, but he commented on the smaller ones made from cheese rings: "Our supply of cheese boxes down here is limited and can not send you many of the cheese box kind at a time. However the number of drum buyers is limited and would not advise you to buy too many."[131]

In a letter of May 1904 to Francis E. Lester of Mesilla Park, Dozier explained rattles in detail:

> There are two kinds of dance rattles. One is a stick thrust through a gourd and filled with pebbles. It is sometimes bound with raw hide. There is another kind, made almost exclusively at the pueblo of Tesuque. This is a conical [shaped] affair with a horse tail sewed into the small end. The first kind is the real dance rattle that the Indians of Santa Clara and of San Juan and of Taos use in their dances. I do not think the second kind, the ones with horse hair, is generally used by the Indians, although it's much more ornamental.[132]

He told Lester that he could not furnish real dance rattles, but that he could furnish Tesuque rattles at $3.75 per dozen "if I can get them." On that very day Dozier wrote to Candelario to request his price for Tesuque rattles, which

*Figure 47. C. G. Kaadt photographed the content of a "typical" barrel of Pueblo pottery for Thomas S. Dozier, who published the image in* About Indian Pottery, *1904. Private collection.*

implies that Candelario had a monopoly on the rattles that may have been defined by something as simple as a trading relationship with the makers, perhaps established years before by Jake Gold.[133]

Of all the nuggets that can be mined from Dozier's letters, some of the most interesting relate to pottery. In January 1906 Dozier wrote to B. G. Wilson of Albuquerque. He said that he had Wilson's letter referring to

> Drinking Cups. I presume that your friend means by this term what I call "Double Bottle Necks." I have them illustrated in a small folder, two of which I am mailing to you under another cover. These are shown in the cut as Nos 15, 17, and 22. They have been fancifully named, by those inclined to poetry and sentiment, "Love Cups."[134]

Because Dozier had lived at Santa Clara Pueblo for more than a decade, his comments could not be a more definitive dismissal of the lore of what is now called a "wedding jar."

One of the most surprising things that Dozier did was enhance pots with leatherwork. In a letter of December 1905 to Henry J. Arnold of Denver, Dozier explained that

> Many...old pieces are found now in the old pueblo houses, covered with dust, some of them cracked and slightly chipped.
> Many of these pieces, for their better preservation, I have reinforced with raw-hide or buck skin. The peculiar manner of mending is very curious and adds to their effect...."[135]

Several Pueblo pots sold by Dozier, including one with his rawhide enhancement, were acquired by the Colorado State Normal School at Greeley, Colorado (now University of Northern Colorado). Edgar Lee Hewett purchased one group and shipped it to the school himself; Dozier shipped the second group in February 1904 (figures 48, 49).[136]

One of Dozier's greatest efforts in the curio trade was closing out the inventory of Gold's Old Curiosity Shop, Abe Gold's business at his brothers' famous location at Burro Alley. After Abe's death in August 1903, Mary Gold

*Figure 48. Martina Vigil and Florentino Montoya were among the most skilled potters of San Ildefonso, and later of Cochití, where they moved around 1904. Martina shaped and Florentino painted their pots; on this example he painted a design adapted from a Mescalero Apache parfleche. Thomas S. Dozier sold the pot to the Colorado State Normal School, Greeley, in 1903 or 1904. Diameter 14 inches. Colorado Springs Fine Arts Center, 6652, on permanent loan from the University of Northern Colorado.*

*Figure 49. Thomas S. Dozier reinforced some
Pueblo pots with leather, explaining that the "pecu-
liar manner of mending is very curious and adds to
their effect." This pitcher by Martina Vigil and
Florentino Montoya is also an example of Dozier's
handiwork. He sold it to the Colorado State
Normal School, Greeley, in 1903 or 1904. Height
11.5 inches. Colorado Springs Fine Arts Center,
6655, on permanent loan from the University of
Northern Colorado.*

*Figure 50.* Thomas S. Dozier published
Statement to the Trade for 1907 *in late
1906, when Mary Gold hired him to manage Gold's
Old Curiosity Shop. Private collection.*

began to settle his accounts with other curio dealers. She temporarily operated the shop on her own, but in June 1905 she leased the space for a year to Edwin Winter and A. R. Gibson. Her contract with them did not mention inventory, so Winter and Gibson may have operated their curio business with their own inventory. They were unsuccessful and mortgaged their inventory twice — once to Mary Gold, and once to Winter.[137]

In August 1906 Dozier took over the shop for Mary Gold, though he told W. G. Walz that it had "attained the distinction of getting into the hole pretty badly and is in general run-down condition." He anticipated "some difficulties owing to the black eyes the business has gotten by the ignorance and mismanagement of the recent owners." In addition to selling old inventory, Dozier was able to sell his own goods, and by October he was preparing to publish a small flyer promoting his new venture (figure 50).[138]

In March 1907 Dozier sold out the remaining inventory of Gold's Old Curiosity Shop to the Benham Indian Trading Company in Albuquerque. Here ended the legacy of the pioneering Gold family in Santa Fe, as well as Dozier's career as an independent curio dealer. Dozier returned to the mercantile company in Española, by then renamed Bond & Nohl Company, where he again ran their curio department briefly.[139]

*Southern New Mexico: Francis E. Lester*

When Francis E. Lester retired from the curio business in the late 1920s, he moved to Watsonville, California, where in 1937 he began planting roses among the redwoods in Browns Valley.[140] Roses and gardening had been Lester's life-long passion, and in his 1942 book, *My Friend the Rose*, he remembered his childhood with fondness:

> Many years ago there was a certain tiny plot of ground some four feet square in a little town of England's beautiful Lake District that, by wise parents, was set aside as soon as I could walk, as my flower garden. It was my own garden, the private domain of my earliest years, a place in which to play and work and adventure and imagine. From a bare spot of earth it grew to be a precious possession filled with hopes and joys and disappointments.... It taught me many things in a manner more

> lasting and efficient than any school-room ever succeeded in doing: patience and thoroughness, the trick of cooperating with Nature, and above all the love of a garden.[141]

Lester took his love of gardening with him to Mesilla Park, New Mexico, when he moved there in 1891 to become librarian, college clerk (registrar), and secretary of the faculty of the newly formed College of Agriculture and Mechanic Arts at what is today New Mexico State University. Lester also taught stenography, but he spent free time in the garden (figure 51). In 1901 a garden party at the Lester house was spoiled by a dust storm, but the garden was still "a luxuriant mass of fragrant blossoms," and the interior of the house was decorated with "banks" of sweet peas of great "brilliancy and beauty." At the time, Lester was said to have been experimenting with the culture of sweet peas for six years. *My Friend the Rose* was not Lester's first publication on flowers or gardening. His fine 1902 monograph, "A Southern New Mexico Flower Garden," was one of the first published articles on desert gardening, and between 1924 and 1946 he wrote at least twelve articles for the *American Rose Annual*.[142]

Schooled in England, and formerly a businessman there, Lester was as unique a curio dealer as any. According to stationery that he printed shortly after 1900, he established his curio business in 1899, though no documentation of it at that early date has survived. No doubt he was merely dabbling in the business, but in 1906 he resigned from the college to pursue his curio business full-time.[143]

As early as 1903 Lester adopted the slogan, "My business is to make homes more beautiful." He emphasized home decoration and personal fashion, and in his first few years in business his sales were almost exclusively of textiles. His advertisements, targeting women and middle-class households, appeared in many publications, including *Country Life in America*, *The Designer*, and *The Modern Priscilla*. Lester began publishing mail-order catalogs no later than 1902. His first two catalogs have not been located, but his third and fourth catalogs, published in October 1903 and March 1904, have. These were twenty and thirty-one pages respectively (figure 52).[144]

Much of what we know about Lester's business is documented by his mail-order catalogs. The H. H. Tammen Company had been one of the great mail-order marketers for twenty years when Lester published his first catalog, but while from 1900 to 1910 the Tammen Company published seven large catalogs,

Figure 51. Francis E. Lester, at right, poses with the first class in stenography and typewriting at the New Mexico College of Agriculture and Mechanic Arts (now New Mexico State University), 1895. Photographer unidentified. New Mexico State University Library, Archives and Special Collections Department, Las Cruces.

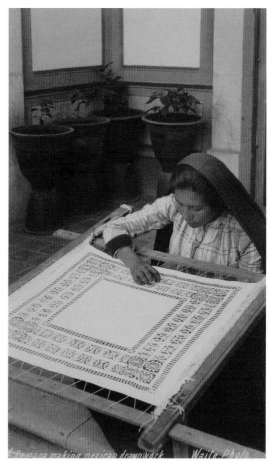

Figure 52. Francis E. Lester's fourth catalog, March 1904. Lester emphasized Mexican drawnwork and his own line of Pueblo Indian rugs. Collection of Kathleen L. Howard.

Figure 53. "Ramona making Mexican drawnwork," ca. 1905. Photograph by C. B. Waite. A young Mexican woman at an unidentified location makes drawnwork, known in Mexico as deshilado. Autry National Center, Southwest Museum, Los Angeles, P.26456.

Lester eventually published multiple catalogs annually, literally bombarding his clientele. With many of his catalogs and other mass-mailings, Lester included promotional flyers and chatty letters printed by the process known as mimeograph. The character of Lester's catalogs and letters, and indeed of his inventory, evolved rapidly.[145]

Like dealers in nearby El Paso, Lester founded his business on Mexican drawnwork. Known by the names drawnwork, drawn work, drawn-work, and drawn thread work, the craft dates back hundreds of years in Europe but became especially popular in Mexico. Its popularity as a domestic craft spread to Anglo-American women, who both made and collected it. Thread companies published pattern books, and in 1889 the Priscilla Publishing Company of Boston printed Kate McCrea Foster's book, *Fifty Designs for Mexican Drawn Work, with Directions for Working*.[146]

Drawnwork was made from linen in which the character and count of warps and wefts were equal. The piece of linen to be worked was stretched in a frame. The pattern was created by cutting and pulling out selected threads from a portion of the cloth, and then manipulating remaining warps and wefts and securing them with needle and thread (figure 53). In the most intricate types of drawnwork, darning was used to draw together threads and to insert additional elements of patterns.

Lester devoted the first half of his October 1903 catalog to drawnwork (figure 54). Almost all of the featured pieces — doilies, centerpieces, napkins, and tray cloths — were intended for fashionable entertaining. He explained that the demand for Mexican drawnwork was great, and that availability was sometimes limited. As demonstrated by a photograph that he reproduced on the cover of his fifth catalog in autumn 1904, the demand was met in Mexico by the employment of very young girls (figure 55). In the same catalog Lester announced his acquisition of the American-Mexican Importing Company of San Antonio, Texas. With his purchase of their inventory of drawnwork he acquired the names and addresses of 16,000 clients. Drawnwork was conspicuous in Lester's catalogs as long as he published them.

Lester also supported — and probably created — a cottage industry among one or more local Tiwa families who wove rugs that he marketed, not incorrectly, as "Pueblo Indian." Some Tiwas and other Puebloans had fled New Mexico with the Spanish at the time of the Pueblo Revolt of 1680, and in the

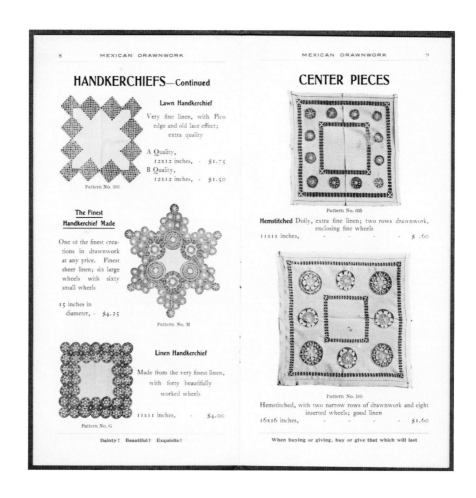

## HANDKERCHIEFS—Continued

### Lawn Handkerchief

Very fine linen, with Pico edge and old lace effect; extra quality

A Quality,
12x12 inches, - $1.75
B Quality,
12x12 inches, - $1.50

Pattern No. 200

### The Finest
### Handkerchief Made

One of the finest creations in drawnwork at any price. Finest sheer linen; six large wheels with sixty small wheels

15 inches in diameter, - $4.25

Pattern No. M

### Linen Handkerchief

Made from the very finest linen, with forty beautifully worked wheels

11x11 inches, - $4.00

Pattern No. G

Dainty!    Beautiful!    Exquisite!

## CENTER PIECES

Pattern No. 035

Hemstitched Doily, extra fine linen; two rows drawnwork, enclosing fine wheels
11x11 inches, - $ .60

Pattern No. 105

Hemstitched, with two narrow rows of drawnwork and eight inserted wheels; good linen
16x16 inches, - $1.60

When buying or giving, buy or give that which will last

*Figure 54. Mexican drawnwork illustrated in Francis E. Lester's third catalog, October 1903. Private collection.*

Figure 55. The cover of Francis E. Lester's catalog of autumn 1904 features a Mexican workshop, where very young girls made drawnwork. Lester probably sold tens of thousands of pieces of drawnwork. Private collection.

products. This fact insures more artistic and regular work-manship, as well as economy in the matter of cost to the

A Typical Single Loom

purchaser. Moreover, the purchaser of Indian rugs is thus enabled, through me, to have his exact wishes for special orders carried out.

**What They Are**   My rugs are made by the Pueblo Indians of Southern New Mexico, whose art in rug weaving has been handed down for generations. The rugs

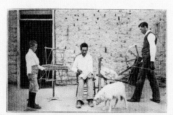

Carding and Spinning the Wool

Each one of my rugs represents days of patient toil

are very similar to the Navajo Indian rugs, with similar yarn, although slightly lighter in weight. They are superior for many purposes, however, to the Navajo rugs, their some-what lighter weight making them far better adapted to such uses as portieres, and the colorings being better blended and more harmonious. The inharmonious contrasts of many Navajo rugs are well known. My rugs are all made with constant regard to harmony in color effects.

Nothing could be more hand-made than are my Indian rugs—unless some one should devise a means of making the wool by hand! **How They Are Made** The wool in the first place, which is a very fine grade of Angora wool, is clipped by hand. It is then most thor-oughly hand-cleaned, carded by hand, and spun by hand

One of the Larger Looms—Father and Son working side by side

on the old-fashioned spinning wheel. After being dyed with those absolutely fast colors which are characteristic of Indian work, the spun yarn is woven into rugs on heavy, primitive, and hand-made wooden looms. The weaving is a slow and painstaking process. For many designs as many as thirty and more changes of color must be made in weaving a single thread across the rug. Some of my designs require

You can buy cheaper rugs than mine, but none better

*Figure 56. The Tiwa weavers who worked for Francis E. Lester, shown in his third catalog, 1903; they were also featured in many subsequent catalogs. The weavers, perhaps a single family, used a spin-ning wheel and a horizontal loom similar to that employed by Spanish New Mexican weavers in northern New Mexico. Private collection.*

nineteenth century Tiwas, Piros, and Mansos began to resettle in the Mesilla Valley. It was among those people that Lester found skilled weavers.

As illustrated in his October 1903 catalog, a man and his two sons spun their wool on a spinning wheel and wove on a treadle loom (figure 56). They wove several standard patterns, to which Lester assigned numbers. Some patterns were available in more than one size, and prices ranged from $2.75 to $26.00, which included prepaid shipping. The prices were comparable to those of better quality Navajo rugs of the time, though Lester insisted that, "Those who look into the quality of my Indian rugs will find it is impossible to duplicate my prices with any rugs of equal quality." Lester featured the textiles in catalogs until at least 1911 and undoubtedly sold hundreds of them. They were important enough to his business that when he first incorporated in December 1903, he named his corporation the Pueblo Indian Textile Art Association. (Six months later he renamed it the Francis E. Lester Company.) Only one documented example of those textiles has come to light (figures 57, 58).[147]

In 1904 Lester began expanding into other Native American and Mexican arts aggressively. One of the most important connections that he made that year was through his esteemed colleague and friend Elmer Ottis (E. O.) Wooton, one of America's leading botanists and a member of the college faculty. In July 1904 Wooton began a fifty-five-day botanical expedition through New Mexico. In 1915, partially as a result of that expedition and in collaboration with his student Paul C. Standley, Wooton published *The Flora of New Mexico*, a monograph from the United States National Museum that would stand as the major reference for sixty-five years.[148]

While in Santa Fe in August, Wooton visited Candelario, advising him of Lester's business and then advising Lester of Candelario's. On August 26, Lester wrote his first letter to Candelario, replying to a note Candelario had sent three days prior:

> My friend Professor [Wooton] has already written me in regard to your business. I notice your prices and these appear to be satisfactory. We are loaded up with tom toms just now but use a good many and will want more later in the season. Can you supply at all times?[149]

*Figure 57. This page from Francis E. Lester's 1907 catalog,* The Indian Blanket, *shows his Pueblo Indian rug, pattern number 20. Private collection.*

*Figure 58. This Pueblo Indian rug was sold by Francis E. Lester, probably as an example of his pattern number 20. Length 93 inches. Formerly in the Zane Grey Collection. The Durango Collection®, Center of Southwest Studies, Fort Lewis College, Durango, Colorado.*

After explaining that it was the slow season (as Candelario certainly knew) Lester requested a "sample lot, including two or three Hair Whips and one or two of the Chimayo pillow tops, also a few assorted articles." He further explained that he would be publishing a fall catalog and might want to feature some of the items.[150]

On September 3 he wrote Candelario again, saying that Wooton had returned from his trip and had assured him that Candelario could offer exceptional values on Chimayo blankets. Lester asked for a detailed price list, as well as any photographs of "different puebloes, pueblo houses, Indians, snake dance, looms, family groups, and such similar pictures to get details from in illustrating" his forthcoming catalog. He was anxious, holding up production of his catalog while awaiting a reply. On September 12 he wrote again, explaining that he would keep everything Candelario had sent with the exception of the largest Chimayo blanket, a war bonnet, and some purses from Santa Clara (presumably beaded). He also said, "We are also going to push the Rain Gods vigorously, and will advertise them."[151]

From then on the relationship was lucrative for both, but strained. On November 1, Lester complained that Candelario's shipment of Chimayo pillow tops was late: "You will remember that we asked you definitely as to whether the supply of these was certain, and upon your representations that it was, we have gone to considerable expense — that is to say, to an expense of from $50 to $75 — to push this particular article." On January 11, 1905 Lester complained that three barrels of pottery just received were "unsatisfactory indeed." The pieces were small, several were broken, and the prices were too high. He reminded Candelario that former shipments of pottery were much better.[152]

Lester's autumn 1904 catalog was larger in format than his prior catalogs and was forty pages long. He emphasized Mexican drawnwork and Pueblo Indian rugs but included many items acquired wholesale from other curio dealers. Among them were Mexican serapes and silk shawls, feather cards, filigree, and carved leather; Navajo rugs and pillow covers; Navajo bracelets and spoons; Pueblo, Mescalero Apache, White Mountain Apache, and Pima baskets; and Sioux Moccasins. He undoubtedly acquired the featured Hopi pottery from J. L. Hubbell, and probably acquired Acoma or Laguna pottery from Simon Bibo of Laguna. In one illustration he included an example of almost every type of item from Candelario (figure 59).[153]

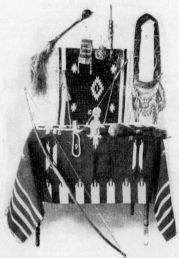

1.  War Club.    2 and 3.  Beaded Purses.    4.  Beaded Needle Case.    5.  Apache Hunting Bag and Horn.
6.  Navajo Bow and Arrows.    7.  Hair Quirt.    8.  Indian Pipe.
9.  String of Wampum.    10.  Rain God.    11.  Pueblo Dance Rattle.

## Miscellaneous Indian Goods

**Indian Wampum.**  Genuine Indian Wampum, or Indian native necklaces, in strings.  Prices according to the quality, which is governed by the thinness and evenness of the beads, and amount on each string.  Single string, plain Wampum of good quality.  Each............$ 2.25
Larger Wampum Necklaces, containing several strings, some containing pieces of turquoise and other stones.  Prices, $4.50, $6.50, $8.00 and...............................10.00

**Dance Rattles.**  Used by various tribes of the Indians of New Mexico in their religious dances.  Made of rawhide, nicely sewn and figured, with steer's tail.  Each...............$0.75

**War Clubs.**  Wooden handle with head consisting of round stone sewn in buckskin or rawhide; some bead-work; finished with steer's tail.  Each.....................................$0.75
Finer War Clubs; Apache made, buckskin covered, nicely beaded.  Each, $1.50, $2.50 and 4.50

**Hair Quirts or Whips.**  Woven from horse hair in different colors, by hand; very durable and fine.  Two grades.  Each, 75 cts and ..........................................$1.50

**Rain Gods.**  Made of pottery and figured by hand.  Each...........................$0.75

**Bow and Arrows.**  With sinew thong.
Pueblo, small size, figured bow and two arrows.  Per set ..............................0.75
Same, full size, per set .............................................................1.00
Navajo Bow and Two Arrows, sinew bound, strong and well made.  Per set............3.00
Same, old and very fine, per set .....................................................5.00

**Arrow Heads.**  Flint.  Each, 5 cts.; per dozen.............................................50

**Apache Hunting Bag and Horn.**  Very fine bag, made of buckskin, beaded.  Complete 5.00

**Beaded Purses.**  Sioux and Apache.  75 cts , $1.00, $1.50, $2.00 and................2.50

**Indian Pipes.**  Made of pottery, with wooden stem.  Each...............................50

*Figure 59. This illustration from Francis E. Lester's autumn 1904 catalog includes several objects from J. S. Candelario. Note the Chimayo blanket draped over the table, Chimayo pillow cover mounted as a backdrop, Tesuque war club at upper left, and Tesuque rain god and rattle on the table. Lying on the table to the left of the rain god is a Tesuque pipe, and standing on end behind the pipe is a braided horsehair quirt. Private collection.*

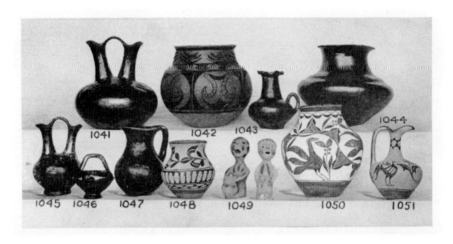

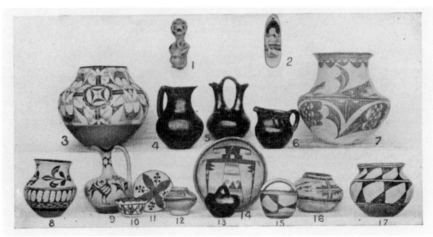

*Figure 60. Detail of Pueblo Indian Pottery from Francis E. Lester's annual catalog of 1907. The large, rounded water jar at top center, number 1042, is an example of Black-on-red ware by Dominguita Pino of San Ildefonso, which Lester probably acquired from J. S. Candelario. Collection of Kathleen L. Howard.*

*Figure 61. Detail of Pueblo Indian Pottery from Francis E. Lester's annual catalog of 1907. The water jar at upper right, number 7, is by Martina Vigil and Florentino Montoya, or possibly by their niece, Dolorita Vigil. Lester probably acquired it from J. S. Candelario or Thomas S. Dozier. Collection of Kathleen L. Howard.*

Lester also initiated a practice in his 1904 catalog that he continued for years. Printed throughout are more than seventy testimonials from happy customers. These are similar enough in style and content (perhaps suspiciously so) that one suffices as an example. On July 15, 1903, "Mrs. F. L. B." of Pittsburgh wrote,

> The rug arrived yesterday, and I wish to thank you for your promptness in sending it. It is very satisfactory; in make and coloring truly artistic, making a pretty spot in my room, not shamed by the Oriental rugs lying near it. I shall take pleasure in showing my rug to my friends. Again thanking you.[154]

Lester and Candelario needed each other, but they were like oil and water. Candelario endured Lester's occasionally forceful letters and continued shipping him goods, and Lester visited him in August 1905. Also that month, Candelario shipped a Santa Clara water jar to Mrs. Wooton, no doubt commemorating the year since he had met her husband and established the profitable relationship with Lester. Professor Wooton wrote a gracious letter, thanking Candelario and then asking what he might have in the way of old "Moqui" style blankets and Navajo blankets in natural colors.[155]

In September 1905 Lester asked Candelario if he could acquire a bell for him, which he wanted to place on a new building he was planning: "I am building a new store, and it is in the Mission style, I want to hang in the proper place an old bell of the softest and sweetest tone possible." In June 1906, having heard nothing about the bell, he enquired, "How about the bell? Your thieves do not seem to be very active."[156]

Whether in response to Lester's request or not, in 1907 Candelario asked Francisco Naranjo of Santa Clara Pueblo to find out whether the governor of the pueblo would sell a bell, undoubtedly that which hung in the bell tower of the pueblo's church. On September 25, 1907, Naranjo wrote Candelario:

> This evening I thought I would write a few lines to you, and let you know that I am well, and all your friends are all well. I spoke the Governor of Santa Clara about the Bell just as I came back from Santa Fe and he told me that he will let me know about it. And he just let me know yesterday he said that he dont

want to Sold the bell. This will be all for this time, my best regards to you and family. Your friend Francisco Naranjo.[157]

The financial crisis of 1908 hit Lester hard, and Candelario had little patience dealing with creditors. Candelario threatened to issue a draft against Lester, and Lester begged for patience. On March 14, Lester sent Candelario $250, a sizable amount at the time, assuring him that the balance would be sent the following week. Due to Lester's inability to collect on accounts, as well as his wife's serious illness, which forced him to relocate temporarily in Chicago, his payments were delayed by many months. He eventually paid off his debt and in 1911 attempted to reestablish business with Candelario, but it is unclear whether Candelario filled any orders.[158]

As businesslike as most transactions were between curio dealers, they did their share of gossiping. Lester and Dozier corresponded many times, and in November 1906 Dozier wrote an angry letter to Lester about Candelario and his manipulation of the market for Chimayo textiles:

> I have yours of the 21st, ordering Chimallos. There has been such wild quotations made on these blkts. by Candelario of this place that I deem it best to quote my price before attempting to get you up these blkts. This man has made offers to the trade which he cannot fulfill, [expecting] to cheat the makers to give an advantage to the dealer and thereby [advertise] his business. This has put us all in the hole with ref to Chimallo blkts. I have simply held off and let [him] have all the rope he could get. I am only filling a few orders and as soon as his neck is well broken, I shall be prepared to go ahead again. I beg to hand you a [statement] of the cost of your order. Let me know if you can pay this price.[159]

Lester's relationship with Candelario had little bearing on his own career. Starting with the holiday season of 1904, his publishing expanded to include multiple annual and even monthly catalogs of different types and formats. The number and variety of catalogs is bewildering, even though many have not survived or have not come to light. Although he may not have published every type of cata-

log in every year, by 1904 he ended each year with a holiday catalog, and in 1905 he initiated an annual spring sale catalog. In addition he published specialty catalogs on furs and fur rugs, cacti, and gems.[160]

In 1906 Lester published the first of at least six summer catalogs featuring Mexican sombreros, Panama hats, and other styles of hat, together with drawn-work and other crafts (figure 62). In his 1907 sombrero catalog, Lester claimed that in order to meet the demand created by his 1906 catalog, his company had "purchased more than 25,000 Mexican sombreros . . . and from present indications the Mexican sombrero will be seen at every summer resort and in every town on the continent." The sombrero catalog of 1908 was the most beautiful period piece he ever published (figure 63), while the catalog of ca. 1911 was clearly aimed at the vacationing American: adorning the cover is a woman in a sombrero, holding an oar, and standing on a giant sombrero that is resting on a dock (figure 64).[161]

In 1907 Lester introduced a series called *Lester's Handicraft Talk*. Volume 1, number 1 was a catalog titled, *The Indian Blanket*, illustrated with color plates of Pueblo Indian rugs, Mexican serapes, and Navajo rugs (figure 57). Lester boasted of his abilities to supply rugs:

> I make no extravagant claims concerning this modest booklet, but I do believe that it is the first successful attempt to emphasize the possibilities of the Indian blanket as an article of interior furnishing for the home. I believe that we possess the only facilities in the United States for supplying the customer with an Indian blanket woven to order for his exclusive use, in any *size, color, or design*. This fact removes the only objection that has been raised to the more general use of the genuine Indian blanket for the furnishing of the home, since our plan insures harmony in the color schemes followed in each individual case. I believe that if the beauty and the durability and the economy of the genuine Indian blanket were properly recognized, it would be found in every home in the land.[162]

Volume 1, number 2 of *Lester's Handicraft Talk* was the summer 1907 sombrero and Panama hat catalog. The series ended with that installment, but handicraft was a

Figure 62. Francis E. Lester's first catalog of
Mexican hats, 1906. J. S. Candelario Collection,
Fray Angélico Chávez History Library, Palace of
the Governors, Department of Cultural Affairs,
Santa Fe.

Figure 63. Francis E. Lester's third annual catalog
of Mexican sombreros and Panama hats, 1908.
Collection of Kathleen L. Howard.

*Figure 64. Although undated, this is probably
Francis E. Lester's sixth annual catalog of Mexican
and Panama hats, 1911. Private collection.*

topic on which Lester dwelled for several years. In his 1907 general catalog he railed against the proliferation of burned leather and other novelties that had flooded the market:

> I suppose that nothing has been so excessively imitated as Indian handiwork. Certainly no other line of handicraft has been so badly imitated with such a mass of trash and trinkets. Visit the average curio store and see for yourself the burned leather and wood rubbish unblushingly called "Indian handiwork." The Indian who would own to creating such stuff doesn't live. Indians are self-respecting beings. The best Indian will have nothing to do with imitation stuff. The Navajo works with no metal but pure silver. A Pima basket weaver never yet turned out a basket that would not last a life-time. We do not buy and we will not sell this "curio trash." We would kick it out of the back door first.[163]

Lester probably hoped that his most faithful clients had forgotten that for several years he had marketed a burned leather banner of precisely the type he despised.[164]

Also for his 1907 catalog he wrote a brief essay titled, "On the Decorative Value of Indian Handicraft." Here he hoped his offerings would resonate with advocates of the Arts and Crafts movement:

> First in usefulness for interior decoration comes the Indian blanket, a fact that has been recognized in the many machine made imitations produced in the eastern states. Any one who has seen a Mission style interior furnished with a Navajo blanket of suitable design and colors, or a Pueblo blanket woven to order, and with Indian blankets for portieres, hung flat and drawn lightly back, cannot fail to have been impressed with the harmony of the scheme.[165]

Lester's catalog, *The Indian Blanket*, was among the earliest blanket or rug catalogs to be published, and his emphasis on rugs as decorative art was original. Although Lester probably purchased many of his rugs from C. N. Cotton, he

may also have inspired Cotton to publish, years later, a catalog titled, *The use of Navajo Blankets as a home decoration*. There Cotton promoted Navajo textiles as "Adapted for portieres, tapestry, couch covers, blankets, or floor coverings," and explained his ability to provide patterns, colors, and sizes "to meet any need" (figures 65, 66).[166]

Lester probably published more than forty catalogs, but none appears to postdate 1914. His business from the time he ceased publishing mail-order catalogs until he moved to California — a period of fifteen years — is undocumented. Although Lester was a consummate businessman, the texts that he wrote for his catalogs display a lack of passion for the material he sold. When he left Mesilla Park for California to pursue his love of roses, the roadsides near his building were littered with his business correspondence and curio catalogs, and there they rotted.[167]

*Figure 65. Detail from C. N. Cotton's catalog,* The use of Navajo Blankets as a home decoration. *Cotton captioned the illustrated rug, "Above design cannot be furnished," to empha-size the fact that each rug was unique. Collection of Jerry and Deanna Becker.*

*Figure 66. The rug featured in C. N. Cotton's catalog,* The use of Navajo Blankets as a home decoration. *During a career that spanned nearly fifty years, Cotton supplied thousands of Navajo rugs to curio dealers and other retailers. Length 65 inches. Collection of Jerry and Deanna Becker.*

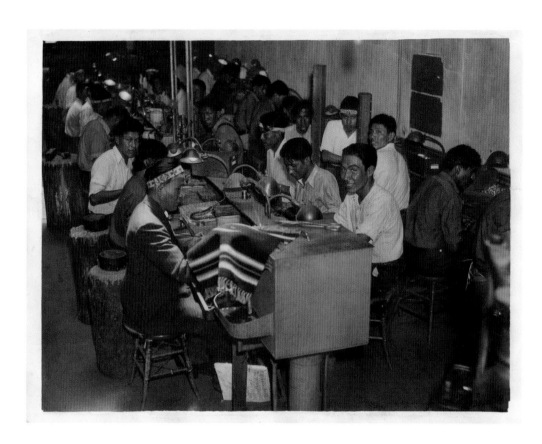

*Figure 67. Silversmiths at Maisel's Indian Trading
Post, 1935. Photograph by Hanna & Hanna,
Albuquerque. Collection of Mr. and Mrs. S. L. Maisel.*

# PART II

# COME SEE OUR INDIAN SILVERSMITH

# AT WORK

etween 1900 and 1925 Indian silver jewelry rapidly became both curio commodity and demonstration art. Its appearance in the curio trade was sudden, and its rise was meteoric. Basketry, pottery, and textiles remained popular in the curio trade, but observing a silversmith at work and acquiring a piece of jewelry became an integral part of the touristic experience in New Mexico and other locales.

With silver came several changes to the conduct of the curio trade. Whereas pottery and other crafts were cottage industries, and curio dealers acquired them through barter or purchase, curio dealers brought silversmithing under their control and in most cases under their roofs. And whereas Pueblo and Navajo women produced the principal curio commodities of the late nineteenth and early twentieth centuries, Pueblo and Navajo men, with few exceptions prior to World War II, went to work as silversmiths, and many relocated to urban settings to earn a wage. With silversmiths performing for the public on their premises and in their windows, curio stores made authenticity self-evident, at least to most consumers.

In the 1930s silver jewelry became a hotly contested topic. "Indian" jewelry was made by a wide range of businesses, individuals, and techniques, much of it

with the aid of machinery. The differences never occurred to the average consumer, but false representation and the undermining of Native traditions and economies, particularly of the Navajos, led to the establishment of organizations and agencies to foster and protect Indian arts and Indian traders, as well as to a lawsuit filed by the federal government against the largest mechanized silversmithing shop, Maisel's Indian Trading Post of Albuquerque.

Museum curators, Indian school administrators, and founders and organizers of events such as the Gallup Intertribal Indian Ceremonial (Gallup Ceremonial) established and enforced standards and procedures to preserve traditional jewelry. Nevertheless, styles of jewelry and methods of manufacture that had been developed in curio shops gradually penetrated the boundaries of tradition and were embraced.

Silversmithing in some curio shops had benefits. Among the most important was gainful employment for hundreds of young Pueblo and Navajo men during the Great Depression, even if the wages were poor. Many smiths took pride in their work, and some ultimately earned fame as artists and educators, applying the skills learned in curio shops to their own businesses or to classrooms. Directly or indirectly, jewelry made in curio shops became inextricably linked with the persona of the Southwest and became an important element of the Pueblo and Navajo economies.

### Silver Becomes a Demonstration Art and Enters the Curio Trade

In 1900 Navajo and Pueblo silversmithing was a recently adopted art, learned from Mexican smiths in about 1870. Compared to the ancient arts of basketry, pottery, and weaving, silversmithing barely constituted a tradition, and most early ethnologists took little notice of it. Washington Matthews was the first to publish on silversmithing. His article, "Navajo Silversmiths," printed in the *Second Annual Report* of the Smithsonian's Bureau of Ethnology in 1883, provided a comprehensive description of methods and materials. The earliest smiths melted silver coins into ingots, and, utilizing techniques borrowed principally from blacksmithing, they wrought, chiseled, and filed objects of adornment for people and their horses. Several early smiths were itinerant, trading their wares and even the knowledge of their art for livestock.

By 1880 Navajo silversmiths, particularly those in proximity to military forts and railroad depots, were making objects such as spoons, letter openers, and watch fobs (figures 68, 69). In researching his work, Matthews observed a silversmith named Jake, who also delivered the mail between Fort Wingate, New Mexico, and Fort Defiance, Arizona. Noted ethnologist Frederick Webb Hodge knew Jake as well, and wrote that he "plied his trade in a hogan on the edge of Fort Wingate in the winter of 1886–1887, where he met the demands of the army officers and of visitors to the posts." Jake is the presumed maker of several objects that were intended for an external market and that can be linked to Fort Wingate (figure 69).[168]

Whether the making of spoons and watch fobs within little more than a decade of the origins of Navajo silversmithing can be said to constitute commodification of the art is questionable. If commodification is a deliberately negotiated response, then the first such silver was probably jewelry made beginning in 1899 according to specifications or suggestions from Herman Schweizer of the Fred Harvey Company. Schweizer had begun his career with the company in 1887 at the age of sixteen, running the Harvey lunch room at Coolidge, New Mexico. Even then Schweizer acquired artifacts from the Navajo and resold them to travelers. He later was appointed manager of the company's Indian Department and became famous for his knowledge, taste, and business skills.[169] In 1940 Schweizer described the commercialization of silver to John Adair:

> This was before our office had been set up here [Albuquerque] — we were still in Kansas City. We used to sell a little pawn [jewelry] there. But a lot of the pawn was too heavy for the tourists' taste, so at that time I started in having silver made up to order. It was in 1899 that the turquoise from the north — Nevada and Colorado — began to come in here. I was the one who got a mine owner by the name of [William Petry] in Nevada . . . to cut the stones for Indian use, cutting flat square and oblong stones. The first trader to make silver for me was a trader at Thoreau [New Mexico]. From there we branched out to Sheep Springs and the surrounding regions.[170]

Figure 68. Silver watch fob by an unidentified Navajo silversmith, ca. 1880–1890. Each of the large panels has a loop on its back, with which it is attached to a strap of leather. Length 6.5 inches. Wheelwright Museum of the American Indian, 2008.2.1, gift of George Taylor Anderman.

Figure 69. Silver spoons and letter opener attributed to the Navajo silversmith, Jake, who worked at Fort Wingate, New Mexico, in the 1880s. Length of letter opener 5 inches. Letter opener: collection of Harold J. Evetts. Spoons: Wheelwright Museum of the American Indian, 2002.13.31, 2002.13.22, the Carl Lewis Druckman Collection.

In 1902 the Fred Harvey Company completed the Alvarado Hotel at Albuquerque, and among its earliest employees there was a silversmith. At least as early as August 1903 the Harvey Company employed silversmiths and other artisans at the Alvarado, many of whom were sent there by J. L. Hubbell, the noted trader of Ganado, Arizona. Many Navajo individuals and families came and went from the company's employ. Most were anonymous to the public, and almost all were uncomfortable being away from home. Making the transition to long-term residence in a city was difficult for all but a few. As if cultural differences did not make adjustment difficult enough, physical appearances were scrutinized by management. Writing to Hubbell in February 1905, Schweizer said, "Mr. Huckel [John Frederick Huckel, founder of the company's Indian Department] does not like the appearance of the Long Man very well, and if you could possibly arrange it, would like to send him back in a month or so, and then send the silversmith and his wife in his place."[171]

Entrepreneurship was not tolerated. A Navajo silversmith named Taos demonstrated at the Louisiana Purchase Exposition in St. Louis before going to Albuquerque. In April 1905 Huckel wrote Hubbell that Taos had been "spoiled" in St. Louis; "we cannot control him." Taos was making silver for other Indians, who were selling it in competition with the company. Taos was sent back on May 5, and on May 31 Schweizer wrote Hubbell that another smith, to whom he referred only as "the old silversmith," wanted to return home. On July 20 Schweizer wrote Hubbell, saying, "I think [Huckel] wrote you that he did not need a Silversmith at Albuquerque."[172]

In the same letter, Schweizer described to Hubbell the importance of having a silversmith on-site at the Grand Canyon: "We find that if we have a silversmith at the Canyon it helps very largely the sale of Navajo silver."[173] The presence of Indians was essential to the Harvey Company's business mission, but the company insisted on controlling their appearance and behavior. Schweizer wrote to Clinton J. Crandall, superintendent of the Santa Fe Indian School in August 1905, complaining about the company's inability to control some of the Indians selling their wares on the railroad platform. In the course of explaining, Schweizer said:

> I believe that I explained to you once that when the new depot
> and grounds were built the R. R. Co. had decided to keep all
> Indians off the platform and right of way for a number of

reasons. However, when we opened our Indian Building and Museum here we asked the Railroad Company to reconsider their decision as we considered that the Indians would add to the picturesness [sic] of the place. . . . [174]

Schweizer then detailed a number of incidents and issues, asking the superintendent to help institute a process whereby the number of people from Santo Domingo and Isleta Pueblos would be limited to a daily maximum, and all of them would be required to register at the Harvey Company's Indian Building. Only then could proper control be enforced. As for Huckel, he may not have needed or wanted a silversmith at Albuquerque in July 1905, but it was not a permanent situation; silversmiths came and went from the Harvey Company's employ at Albuquerque for years.

## One Harvey Silversmith Who Stayed

The first silversmith to take up long-term residence in Albuquerque was Joshua Hermeyesva, a Hopi from the village of Shungopovi on Second Mesa. Hermeyesva's father, Tawahongniwa, learned silversmithing from the first Hopi silversmith, Sikyatala, and presumably Hermeyesva learned from his father. In 1906 Tawahongniwa, Hermeyesva, and several other Hopi men were involved in a dispute at the Third Mesa village of Oraibi and were arrested. Tawahongniwa was imprisoned at Florence, Arizona, and Hermeyesva and eleven others were enrolled at Carlisle Indian School in January 1907. All of the men were adults; many were married, and Hermeyesva had at least three children. They arrived at the school as prisoners of war, "garbed in discarded khaki army uniforms and blue army overcoats, and none of them could speak a word of English."[175]

Hermeyesva was a model student, and though he gave the appearance of converting to Christianity and admiring the "White Father" in Washington, he clung to his Hopi roots. He was said to be a leader of the Flute Dance, and in May 1912 he sang Hopi songs and told traditional Hopi stories at the University Museum of the University of Pennsylvania; while there he also painted a group of shields for the museum's collection. Hermeyesva was not alone in receiving attention in the press. One of his classmates, Lewis Tewanima, made his name as one of the world's greatest distance runners, though his fame as a Native Amer-

ican athlete was overshadowed by that of his contemporary, Jim Thorpe. Tewanima finished ninth in the marathon in the 1908 Olympic Games in London, competed in the Boston Marathon in 1909, and took the silver medal in the 10,000 kilometer race at the 1912 Olympic Games in Stockholm.[176]

Silversmithing was taught at Carlisle, but Hermeyesva did not study it. Instead he learned shoemaking, and though it was the trade to which he was recommended when he left Carlisle in 1912, he did not pursue it. After leaving the school he worked as a storekeeper at Shungopovi, but he soon found his calling in silversmithing, and in 1915 he demonstrated the art at the Panama-California Exposition in San Diego. Hermeyesva was one of nearly 300 southwestern Indians who lived temporarily in the Painted Desert, a ten-acre living-history recreation of the Southwest, which was sponsored, built, and promoted by the Atchison, Topeka & Santa Fe Railway.[177]

In November 1915 Hermeyesva wrote to Oscar H. Lipps, superintendent at Carlisle. Hermeyesva was enjoying his experience at the Painted Desert: "I think I stay next year I'm not go home." He wrote his note on letterhead of the Fred Harvey Company, and it must have been in San Diego that he initiated a relationship with them that lasted several years. Hermeyesva moved to Albuquerque, where in 1918 he was rooming at the "rear" of the YMCA and working as a silversmith for the Harvey Company. By 1920 he had taken up residence with his son and two daughters at 118 East Central, a block from the Alvarado Hotel. In the same building were several other Harvey employees, including the noted Navajo couple, Tom and Elle of Ganado, and their family; and another Navajo couple, Charlie Ganado and his wife, who also worked as a silversmith and weaver for the company.[178]

In 1924 Hermeyesva became the first Indian silversmith to be listed in an Albuquerque city directory, then residing at 115 West Iron, a few blocks south of the Alvarado Hotel. He moved several more times, last appearing in a directory in 1933, living alone at his residence and "studio" at 1001½ South Second Avenue. No affiliation with an employer was ever indicated in directories, though Hermeyesva may have continued making jewelry for the Harvey Company. Regardless of how he sold his work, he was a prosperous silversmith. Whereas other smiths residing in Albuquerque in 1930 paid rent of $10 or less per month, Hermeyesva paid $45. By comparison, in 1930 Herman Schweizer paid rent of $65 per month for his apartment.[179]

Hermeyesva was probably the first independent Native smith to live permanently in an urban setting in the Southwest. The only documented example of his work is a belt, said to have been made before 1934.[180]

*Silver Becomes Machine-Made*

Navajo silverwork debuted in the mail-order curio trade in 1902. As mentioned above, in that year J. L. Hubbell expanded his business beyond the Navajo reservation to include the Hopi villages by acquiring the Tusayan Trading Post from Thomas V. Keam. Immediately following that purchase Hubbell published a fourteen-page catalog, *Navajo Blankets & Indian Curios*, in which he featured traditional (and expensive) Navajo silver, Navajo textiles, and other Native arts, particularly those of the Hopi (figure 70). Whereas a Navajo silver concha belt cost from $30.00 to $40.00, and a plain bracelet cost a minimum of $1.25 per ounce, a Pima basket could be had for as little as $0.50, a Hopi katsina doll for as little as $0.35, and a prehistoric pot for as little as $2.50.[181]

In 1906 J. B. Moore of Crystal, New Mexico, published *Illustrated Catalogue of Navajo Hand-Made Silverwork*, a small but handsome production of the Indian Print Shop at the Indian Industrial School in Chilocco, Oklahoma. In that catalog Moore explained that he employed two silversmiths full-time, and his attempt to market silver had at least limited success (figures 71, 72). Francis E. Lester began offering Navajo silver in 1904, and in 1907 he offered and illustrated spoons that he had acquired from Moore. Purchases of silver by curio dealers in New Mexico were steady, but their volume was practically negligible compared to baskets, pots, and rugs.[182]

Silverwork initially failed to become popular in the curio trade due to the cost of the material and the amount of labor required to make even a small item. The point is illustrated by a letter of December 1909 from S. E. Aldrich of Manuelito, New Mexico, to J. S. Candelario. Candelario would not accept that Aldrich could not discount silver, and Aldrich wrote,

> My son tells me that he wrote you in regard to silverware. It is
> just like this: there is very little in it for us. We pay the Indians
> a dollar an ounce cash and we sell it for a dollar an ounce. If the
> Indian chooses to trade back any of the cash we pay him, as a

*Catalogue and Price List*

# Navajo Blankets
# & Indian Curios

res
3ut
ak-
00

t-
e,
)0

# J. L. HUBBELL
*INDIAN TRADER*

Ganado, Apache County, *Arizona*
Branch Store: Keam's Cañon, Arizona

*Figure 70. In 1902, J. L. Hubbell offered the first
Navajo silver and the first Hopi pottery and
katsina dolls to be featured in a curio catalog. He
also offered a wide range of Navajo textiles, includ-
ing portieres woven in matching pairs. Collection
of Chad and Erika Burkhardt.*

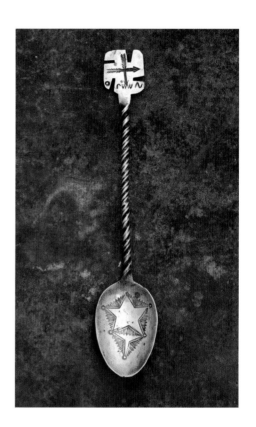

*ILLUSTRATED CATALOGUE OF*
NAVAJO HAND·MADE
SILVERWORK

*Manufactured and sold by*
J. B. MOORE
*Indian Trader and Collector*
CRYSTAL, NEW MEXICO

*Compiled by J. B. Moore and done into print by The
Indian Print Shop, Chilocco, Oklahoma, in the year '06*

*Figure 71. In 1906, J. B. Moore published the first illustrated cata-
log devoted exclusively to Navajo silver. In it he stated that he
employed two silversmiths full-time; illustrated examples of their
work include spoons, bracelets, stick-pins, rings, and other objects.
Collection of Kathleen L. Howard.*

*Figure 72. Silver spoon by one of J. B. Moore's smiths. The twisted
handle and star in the bowl are identical to those on spoons illus-
trated in Moore's 1906 catalog. Length 6.375 inches. Wheelwright
Museum of the American Indian, 2002.13.43, the Carl Lewis
Druckman Collection.*

matter of course we make the profit on the goods, but if he packs the cash away you can readily see, taking it all into consideration, we [won't] fetch to exceed ten per cent on our sales of silverware. We usually give thirty days net and for the reason that there is so very little in it we cannot give a discount on silverware.

I make this explanation as my son stated that he did not think you understood the situation.[183]

Predictably, Aldrich had to chastise Candelario only three months later for applying a discount when paying for a shipment of silver.[184] Aldrich's silversmiths most likely made a profit on their work by using Mexican *pesos*, which at the time were much cheaper than dollars, though their silver content by weight was similar.

The solution to the problem of cost, from a commercial point of view, was to increase the output of Indian-style jewelry by mechanizing its production and using less metal. While on a trip to the Navajo reservation around 1900, jewelry designer and manufacturer Frank F. Hurd of Denver learned from traders that they had difficulty getting Navajo silversmiths to make small silver buttons and round silver beads. In 1900 Hurd began mass-producing buttons and beads, which he sold exclusively to traders on the Navajo reservation. In 1932 Herman Schweizer said that Hurd was still selling those items to traders, and that "many of the buttons and beads in old necklaces and pouches used by the Indians themselves were made by Hurd." In 1940 Hurd still sold small quantities, but the business ceased with his death in 1941.[185]

After only a few years of making buttons and beads, Hurd expanded into Indian-style jewelry, which he "sold to retailers at a good profit." In 1906 the H. H. Tammen Company took over Hurd's Indian jewelry line (or according to Hurd stole his idea), and their jewelry and other items, made from commercial sheet silver with the aid of machinery, debuted in their *General Catalog* of 1908 (figures 73, 74). Tammen's silver shop was in operation for at least a half-century, and though some Native Americans worked in it, Tammen employed mostly non-Indians.[186]

By the 1920s Hurd's and Tammen's system of shop-based silversmithing had spread to Albuquerque and Santa Fe. The growth of this industry, and its

## SOLID SILVER INDIAN BRACELETS

These bracelets are open in back and can therefore be adjusted to fit any lady's arm perfectly.  We mention below sizes, whether ladies'
or children's.   Illustrations are one-half actual size; for instance, No. 17625 (center of bottom row) is ¾ inch wide.

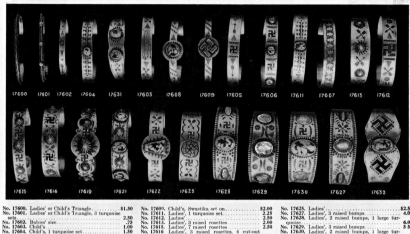

| No. 17600. Ladies' or Child's Triangle..........$1.50 | No. 17609. Child's, Swastika set on.............$2.00 | No. 17625. Ladies'.........................$2.50 |
|---|---|---|
| No. 17601. Ladies' or Child's Triangle, 3 turquoise | No. 17611. Ladies', 1 turquoise set............2.25 | No. 17627. Ladies', 3 raised bumps..........4.00 |
| sets.........................2.50 | No. 17612. Ladies'.........................2.50 | No. 17628. Ladies', 2 raised bumps, 1 large tur- |
| No. 17602. Babies' size....................75 | No. 17613. Ladies', 3 raised rosettes..........2.00 | quoise.......................6.00 |
| No. 17603. Child's........................1.00 | No. 17615. Ladies', 7 raised rosettes..........2.50 | No. 17629. Ladies', 3 raised rosettes.........5.50 |
| No. 17604. Child's, 1 turquoise set............1.50 | No. 17616. Ladies', 3 raised rosettes, 4 cut-out | No. 17630. Ladies', 2 raised bumps, 1 large tur- |
| No. 17605. Ladies'........................1.75 | Swastikas.....................3.00 | quoise.......................9.00 |
| No. 17606. Ladies', 3 turquoise sets..........3.00 | No. 17619. Ladies', 5 raised rosettes..........3.00 | No. 17631. Child's, 2 turquoise sets..........2.00 |
| No. 17607. Ladies'........................2.50 | No. 17621. Ladies', 6 raised rosettes,3 turquoise sets 5.00 | No. 17632. Ladies', 2 Swastikas cut-out, 1 large |
| No. 17608. Child's, 1 turquoise set............3.00 | No. 17622. Ladies', 1 large turquoise..........5.00 | turquoise.....................6.00 |

## SOLID SILVER INDIAN TEA SPOONS

Illustrations are about one-half actual size.   Exact length of spoons given below.   Bowls are regular teaspoon size.

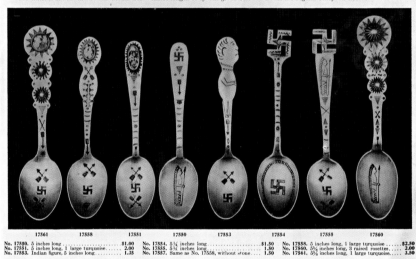

| No. 17550. 5 inches long.....................$1.00 | No. 17554. 5¼ inches long..................$1.50 | No. 17558. 5 inches long, 1 large turquoise .....$2.50 |
|---|---|---|
| No. 17551. 5 inches long, 1 large turquoise......2.00 | No. 17555. 5¼ inches long..................1.50 | No. 17560. 5⅝ inches long, 3 raised rosettes.....2.00 |
| No. 17553. Indian figure, 5 inches long..........1.35 | No. 17557. Same as No. 17558, without stone....1.50 | No. 17561. 5⅝ inches long, 1 large turquoise.....3.50 |

*Figure 73. The H. H. Tammen Company's line of*
*Indian-style silver debuted in their* General Catalog,
*1908. Collection of Chad and Erika Burkhardt.*

*Figure 74. Two spoons from the H. H. Tammen Company's early silver line, as illustrated in their* General Catalog, *1908. Blanks for bracelets, spoons, and other items were probably stamped from sheet silver with a punch press or drop hammer. Length of spoon on right 6 inches. Wheelwright Museum of the American Indian; left: 47/1310, gift of Susan Brown McGreevy; right: 2003.37.43, gift of Mary G. Hamilton.*

gradual expansion to Gallup and other locations, competed with and threatened the survival of traditional silversmithing on the Navajo reservation and in the pueblos. Silversmithing in the shops required little or no prior experience and was often taught on-site. The workforce included young Pueblo and Navajo men from neighboring Native communities, but it also included many who had been exposed to the outside world through the Indian schools and were willing to relocate to the cities.

## A Young Man's Journey to the Silver Shops

Manuel Naranjo, born at Santa Clara Pueblo on the Fourth of July, 1909, went to work as a silversmith in the curio shops during the Great Depression. As one of the hundreds of young Pueblo and Navajo men who moved to the cities, his story is enlightening.

When Manuel was still an infant his father, Nestor Naranjo, and mother, Juanita Pino, took him and his older siblings to Manitou Springs, Colorado. Every summer families from Santa Clara went to the Cliff Dwellings at Manitou and to other attractions in the vicinity of Colorado Springs. Some performed dances for the tourists, while others worked at Manitou's popular hotel, the Cliff House, or demonstrated crafts. Few people from other pueblos made this journey, but the presence of people from Santa Clara became a tradition. The origins of the link between Santa Clara and Colorado Springs are hazy, and the roots may lie simply in the fact that the southern terminus of the Denver & Rio Grande Railway was at Española, near the pueblo.[187]

Like all Tewa men in the early twentieth century, Nestor was a farmer, and like most adult Tewas of his time he spoke perfect Spanish and good English. When it came time to enroll them in school, Nestor's and Juanita's children attended the Santa Fe Indian School. The school year and subsistence farming were often at odds. Nestor needed his sons to help harvest crops and gather hay. So in 1924 Nestor asked the school's superintendent to allow his oldest son, Emilio (Emil) to stay at the pueblo until November; and in 1930 he wrote to explain that Manuel's younger brother, Avelino (Al), would be fifteen days late for school.[188]

Such long absences were unusual, because attendance was rigorously enforced and correspondence from administrators was often harsh, even dicta-

torial. On the other hand, Nestor was a source of aggravation for the school, criticizing administrators, physicians, and instructors for everything from poor instruction and communication, to failing to provide clean, dry clothes for his children.[189]

In 1917 Nestor's and Juanita's oldest child, Anacita, stayed home until October to care for her mother, who was ill. Nestor also wanted Emil to stay at home, but he consented to send him to Santa Fe at the start of the school year. However on the day that the train carrying students departed Española, the Indian Agency physician went to the Naranjos' house and found Emil there. Writing to the superintendent, the physician described Nestor and Juanita as liars and "impudent," said that his own request for Anacita to remain home should be rescinded, and that both students should be taken to Santa Fe "*immediately*."[190]

Conditions at the school were difficult in other respects. Clara D. True, writing to superintendent John DeHuff in 1926, described the diet: "the bread all winter was unfit to eat and the food generally of insufficient amount and poor quality." Her letter was sent in defense of Manuel and four other boys from Santa Clara, who had broken through a plastered wall in the domestic science building and stolen several cases of canned and preserved fruit and salmon, valued at thirty-five dollars.[191]

In a letter to C. J. Crandall, who had become superintendent of the Northern Pueblos Indian Agency, DeHuff singled out Manuel for possible expulsion. Manuel was targeted, no doubt, because Nestor had predictably written to DeHuff about the incident, blaming the school's administration and staff for not properly educating his son and other students about the evils of theft.[192]

Clara D. True, a respected educator in the Pueblo day schools, may have had a calming effect on DeHuff:

> I can recall in my boarding school experience climbing out a dormitory window and looting a Jew's goose corral, a preacher's melon patch and the school store room for hams all the same night. My companions were not Indians but daughters of eminent Presbyterian clergymen and we were well fed at school. The head of the expedition is now the chief executive of one of the great missionary organizations of the world, apparently no worse for the temporary departure from rectitude.[193]

Manuel graduated in June 1926. Late in life he had no recollection of the escapade.

Following graduation Manuel went to Manitou Springs to work at the Cliff House, driving a tour car. Three other boys and two girls from Santa Clara worked there, including in the hotel laundry. After one summer in Colorado, Manuel labored on a railroad in Texas. He returned to the Cliff House in late summer 1929, but it was closing for the season, so he and a friend from San Juan Pueblo, Ray Archuleta, went to work harvesting sugar beets on a farm between Brighton and Hudson, Colorado.[194]

Sugar-beet farming was labor-intensive, and sugar companies sought the cheapest labor possible. Manuel had never worked in the beet fields, and whether or not Ray Archuleta had, they would have heard about beet farming. Beet farmers in Colorado and Kansas annually recruited labor from the Indian schools. In 1910 for example, fifty-nine boys from the Santa Fe Indian School worked in beet fields after school got out for the summer. In most years thirty to thirty-five boys from the school went to the fields, but in summer 1925 only one student went, earning the paltry sum of $21.69. Superintendent B. L. Smith felt that the "educational value" of the experience outweighed the poor compensation (figures 75, 76).[195]

Letters between S. A. M. Young, Superintendent of the Charles H. Burke School at Fort Wingate, and George LeMieux, Overseer of Indian Employment at the Department of the Interior's Indian Field Service in Phoenix, document the ambivalence of school administrators toward the use of Indian youths for heavy labor. LeMieux favored the practice, but with the caveat that no boy under fifteen years of age or under one hundred pounds weight be allowed to sign on for work at the camps.[196]

In 1929 LeMieux filed an unfavorable report with the Commissioner on Indian Affairs on the performance of students from the Burke school who worked that summer at a camp at Lamar, Colorado, for the American Beet Sugar Company. Noting that students were not paid an hourly rate, but a rate based on acreage worked, LeMieux explained that the Burke students were sent home a month early when they were outperformed by those from the Albuquerque Indian School. He said they "could have done better if they had worked a little harder." Young wrote to the commissioner to argue against labor in the fields and attached a form detailing each student's wages and the physical condition in

*Figure 75. White Mountain Apache boys from the Theodore Roosevelt School at Fort Apache, Arizona, at their camp at a beet farm near Cheraw, Colorado, where they worked from May 20 to July 22, 1927. A note on the back of the photograph indicates that they earned nothing for their work. National Archives and Records Administration, Rocky Mountain Region, Denver.*

*Figure 76. White Mountain Apache, Navajo, and possibly Hopi boys working in a beet field at Swink, Colorado, 1927. National Archives and Records Administration, Rocky Mountain Region, Denver.*

which he returned. Young's list shows that for two months' labor, twenty students from Burke earned a total of $316.28, or an average of $15.81 each, ranging from a low of $0.30 for Henry Cuddy Eye Begay, to a high of $44.14 for Sidney Nez. Every student lost weight, ranging from one to thirteen pounds, and averaging more than five pounds each.[197]

Unfortunately even for Indian school graduates such as Manuel and Ray, few opportunities existed for employment other than manual labor. Their stint on the beet farm was short-lived. They had gone to the fields after the summer heat had subsided, and neither could cope with the cold weather. So together they headed for Albuquerque, where they applied at and were hired by a business that gave preference to Indians.[198] In fact all of the laborers at Maisel's Indian Trading Post were Indians, and all were engaged in silversmithing.

Manuel did not recall why they had gone to Maisel's shop, but he likely learned about it from his brother-in-law, David Taliman, who worked there in 1928. Taliman, who married Manuel's sister, Anacita, was a skilled Navajo silversmith from Oak Springs, Arizona. Nestor once said that Taliman had taught silversmithing to Manuel, Al, and their younger brother, Paul, but Manuel denied this. He claimed instead that he learned smithing in Maisel's shop.[199]

### Maisel's Indian Trading Post

Maurice M. Maisel was born in Germany in 1888 and immigrated with his parents at age two. In 1911, while working as a telegrapher for Western Union, Maisel was diagnosed with tuberculosis and told he had three months to live. He moved to Silver City, New Mexico, where he married; and then he and his wife, Cyma, relocated to Albuquerque. He became manager of Western Union Telegraph Company and then vice-president of Citizen's Bank. On January 23, 1923, Maisel bought out Henry D. Rothman, whose music and jewelry store at 117 South 1st Street was directly across the street from the Harvey Company's Alvarado Hotel.[200]

Like Herman Schweizer, Maisel recognized the public's interest in Indian jewelry and saw potential in it. At the time he considered Indian jewelry "heavy, crude, and expensive," and he believed that if he made lighter, more delicate, and inexpensive jewelry, demand for it would be much greater. He also wanted to build a business that could support wholesale marketing. At first the Maisels

Figure 77. The flagship store of Maisel's Indian Trading Post at 510 West Central, Albuquerque, designed by John Gaw Meem and completed in 1939. Photograph by Brooks Studio, Albuquerque, probably in 1939. A hunt scene by the Navajo painter Ha So De (Narciso Abeyta) is centered over the doors. Collection of Mr. and Mrs. S. L. Maisel.

Figure 78. Maisel's Indian Trading Post's management and office staff, 1930. Photograph by Sun Photo Service, Albuquerque. Front row, third to fifth from left: Charles H. Stewart, foreman (later production manager); Maurice M. Maisel; Louis Pitluck, general manager. Back row, far left: Ola Belle Parker, salesperson (later retail store manager); far right: Stella Dobbs, bookkeeper (later office manager). Identifications by S. L. Maisel. Collection of Mr. and Mrs. S. L. Maisel.

designed jewelry and had their own Indian silversmiths produce it. They took jewelry on the road themselves, mostly in New Mexico, but possibly also in Colorado. Gradually they built a workforce and added traveling salesmen to the payroll (figure 78).[201]

Indians began working at Maisel's Indian Trading Post (Maisel's) under supervision in 1923, and the shop was mechanized around 1927. Manuel Naranjo recalled that in 1930 about thirty-five young Pueblo and Navajo men worked there (figure 79). The workforce grew to an estimated sixty in 1932 and seventy in 1934. Details of the workforce were also recalled by Joe Anzara of Isleta, who was employed by Maisel's for twenty-nine years starting in 1930; and by Josephine Lente of Isleta, who started working as a stone setter for Maisel's in 1941. In addition to Josephine and Anzara's wife, Dorothy, two sisters from Sandia Pueblo — Rufina and Candelaria Lucero — worked for Maisel's prior to the war.[202]

No cast silver ingots or hand-drawn wire were used in the shop. Maisel's purchased commercially produced silver, both coin and sterling, and in the form of sheets and wire, from Handy & Harman in Los Angeles. Among the shop's machinery were at least two rolling mills, one of which was a triple-geared, hand-operated mill, and the other an electric mill. Workers used these to reduce the thickness of sheet silver and to roll out sheets from melted scraps and filings collected in the shop. All machinery was kept concealed from public view, and all of it was operated by Indian workmen. In addition to the rolling mills, the shop had hand- and foot-operated punch presses, a power drop press (often called a drop hammer), a power hack saw, and rotary shears. All items — bracelets, conchas, rings, pins, etc. — and all domed elements or ornaments that were soldered onto them, were made with the drop hammer or punch presses. As many as one hundred different dies were used in the machines to punch out jewelry blanks, to raise them, and to punch holes through them (figures 80–82).[203]

Silversmiths, including Manuel Naranjo, worked at a common bench. At each bench position was an acetylene torch, to which gas was piped, and a scrap drawer, into which the smith brushed scrap and filings (figure 67). The smiths received the pieces stamped out by the drop hammer or punch presses and assembled and finished them by filing, stamping designs, soldering on small elements, polishing, and mounting turquoise. The smiths' duties rotated every couple of weeks to prevent boredom and so that each became adept at all skills. In Manuel's time two Indian workmen cut and polished turquoise in the shop, but shortly

Figure 79. Some of Maisel's Indian Trading Post's silversmiths, 1930. Photograph by Sun Photo Service, Albuquerque. This and the photograph in the preceding figure were taken in front of the Harvey Company's Alvarado Hotel, which was across the street from Maisel's original location. Collection of Mr. and Mrs. S. L. Maisel.

Figure 80. This foot press, or "punch press," made by Famco Machine Company, delivers four tons of pressure and was in use at Seligman's in Albuquerque by 1946; it was still in use in 2007 at Indian Silver Crafts, Inc. Famco first made this model in 1943. Courtesy of Armen Chakerian.

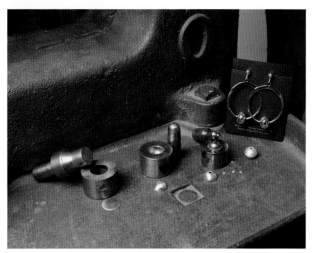

*Figure 81. Armen Chakerian demonstrates the Famco foot press. The blanks for small conchas are punched quickly and with ease from commercial sheet silver. Courtesy of Armen Chakerian.*

*Figure 82. The dies used to make half of a half-inch silver bead on the Famco foot press. The first die punches out a 5/8-inch circular blank, the second die domes the blank, and the third die punches a hole in it. The earrings were made in 2007 by silversmiths at Indian Silver Crafts, Inc., using parts made with these dies. Courtesy of Armen Chakerian.*

afterward the company set up a cutting plant, where the cutters were all non-Indian. In the 1920s and through most of the 1930s, Maisel's smiths cut bezels by hand from sheet silver, but by the late 1930s they stamped them out with punch presses. Turquoise was cut to match copper templates (figures 83, 84).[204]

John Adair described the working conditions in 1938:

> [Maisel] shows me through his shop, doing this hurriedly. He walks down the aisle and says, "This boy is filing, this boy is setting stones, this boy is making housings," etc. It looks like an automobile assembly line. Each boy has a place at the long bench. He says he is employing 60 Indian smiths. (Most of them look like Pueblos.) Poor light, no sunlight or skylight of any sort, only an electric bulb for each smith to work by. When we got to the back of the room he very testily [led] me around the bench and back towards the door — deliberately avoiding the huge presses that are at the very back of the shop.[205]

Maisel's silversmiths made jewelry at the 1st Street location until 1940 or 1941, and the space remained a retail location until it was vacated in 1948. In 1933 Maisel's opened another retail location a few blocks away, at 324 West Central, and in 1938 they moved that operation another block, to 402 West Central — the corner of 4th and Central. The following year Maisel's opened another, much grander, retail location at 510 West Central. The building, now on the National Register of Historic Places, was designed by New Mexico's famous architect, John Gaw Meem (figure 77). In the entryway are frescoes by several of the finest young Native American painters of the time, including Harrison Begay (Navajo), Joe Herrera (Cochiti), and Pablita Velarde (Santa Clara). Centered over the doors is a magnificent hunt scene by Navajo painter Ha So De (Narciso Abeyta). The moves onto Central Avenue took into consideration far more than space. In the years since Maisel founded the business, tourism had changed dramatically. Travel had shifted from trains to automobiles, and whereas the original shop was situated at the railroad station, the locations on West Central were on Route 66. The company operated out of all three locations for several years.[206]

Maisel's store at 510 West Central became the most famous destination to watch silversmiths at work. An opening in the floor, surrounded by a railing,

Figure 83. A master gauge for turquoise sizes from Maisel's Indian Trading Post, 1930s, with 107 numbered bezels. Stone sizes and bezels were standardized and numbered to facilitate the production process. Width 14 inches. Collection of Armen Chakerian.

Figure 84. Turquoise cutting gauge for several of Maisel's sizes, including 218; a piece of turquoise on a dop stick, cut to size 218; and a bezel template for Maisel's size 218. Turquoise was cut until it fit the hole in the gauge. To make a bezel, a silversmith used the slot on the front of the bezel template to mark and cut the correctly sized strip of sheet silver, and then wrapped it around the top of the stem. This turquoise gauge and bezel template were used as late as the 1950s at Bell Trading Post, which adopted Maisel's stone sizes as their standard. Width of turquoise gauge 5.25 inches. Collection of Armen Chakerian.

allowed visitors to observe silversmiths finishing pieces at benches in the basement below them. John Adair described the shop in 1940:

> Went into Maisel's big store on Central Avenue, just to look around. This new store just proves that Maisel is about ten steps ahead of anyone else in the silver game. It is a regular department store displaying all kinds and quality of Indian and Mexican curios. The whole thing is done in beautiful taste, with frescoes by Indian artists on the façade, well arranged show cases, and to top it all off—to use the words of Diego Abeita [a silversmith from Isleta]—"they have a regular glass-bottom boat" through which you peer down at Indians at work, apparently all doing hand work; that is they are finishing up the silver, soldering on rain drops, and filing, and doing work which essentially is hand work even in Maisel's shop. A sales girl informed me that from 85 to 100 smiths are now employed, and that the shops run clear back to the alley, and that the public sees only a very few of the craftsmen (this she sort of boasted about). A sign in the window proclaims, in very small print, that the silver is made with "drop presses, blanks, and rollers."[207]

Maurice and Cyma Maisel may have designed some of their shop's earliest jewelry, but designs came from many sources. Their son, S. L. (Bud) Maisel recalled that "a couple" of the shop's silversmiths designed jewelry, and in that regard he specifically recalled a Navajo named John Johnson, known in the shop as "Johnnie." Johnson worked for Maisel's from at least 1931 to 1973, and then retired and returned to the reservation.

The shop also liberated designs from other shops and individual silversmiths. In 1940 John Adair visited a Mr. Smith, who ran the trading post at Pinehaven, New Mexico. At the time Smith had forty to fifty smiths working for him; most were Navajo, but some were Zuni. Smith explained to Adair how Maisel acquired some of his designs:

> Maisel certainly is a slick guy. My wife and myself took our silver over to Albuquerque to show it to some buyers, and while

we were there Maisel contacted us and said that he wanted certain of the pieces [i.e., the styles] if they were sold to our other customers. I didn't want to do business with Maisel, but finally I decided that his money was as good as anyone else's and I sold him some pieces. He did not pay me cash for these at the time. He said that he wanted some good reservation [silver] for his cases. Three months later he returned the bulk of the silver to me and the money resulting from his keeping a few pieces. The original amount which he kept was $300 worth, and he paid for only $40.00 when he sent what he didn't want back to me. In the meanwhile he had had the silver copied because sometime after that when I was in his store, I saw exactly the same pieces, which he had made in imitation of my stuff.[208]

Adair later learned that Maisel and J. T. Michelson of Bell Trading Post copied designs from Pacific Jewelry Manufacturing Company of Santa Barbara, California, and one must assume that many of the shops copied designs from other shops.[209]

In 1938, prior to discussing Maisel's copying of designs with traders, Adair had direct experience with the practice, though at the time he merely suspected it. He visited Maisel November 2 and wrote the following:

He [Maisel] takes my bracelet, and asks me where I bought it. I say Gallup. He runs back into the rear of the shop, saying "My Navajo smith back here can probably tell what tribe and individual made it." He is gone for some 5 minutes. Probably sketching off the design and measurements for their use. Some outfit! When he comes back he says, "The boy says it is strictly hand made but it is impossible to tell what tribe it is from." Can you imagine the nerve?[210]

Maisel's purchase from Pinehaven was modest, but he bought significant quantities of jewelry from traders on the Navajo reservation and at Zuni, including John Kirk, Mike Kirk, and Robert Wallace. Here Maisel acknowledged that the buying public wanted a variety of choices. In his store he segregated their jewelry

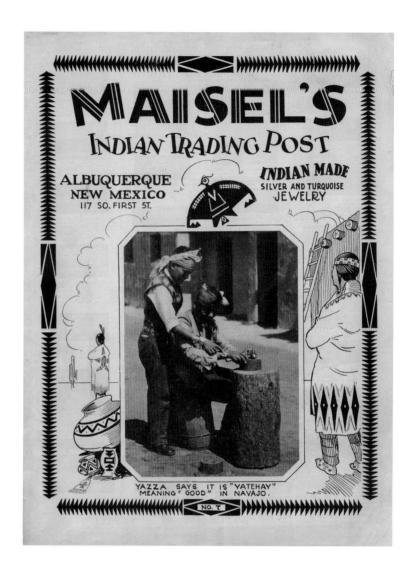

Figure 85. Maisel's catalog 7 was probably published ca. 1928–1930. It includes their machine-assisted silver jewelry line; some hand-made silver items, especially earrings; and the typical offerings of baskets, pottery, textiles, katsina dolls, and other goods. Private collection.

from that made in his own workshops. However in his catalogs of ca. 1928–1932 he sometimes illustrated machine-made and handmade items on the same pages. Maisel did not distinguish between them, though price differences were dramatic (figures 86–87).[211]

Maisel's sold handmade jewelry from at least one silversmith at Isleta who had his own shop. This was Jose Jaramillo, whom John Adair interviewed in 1938:

> I go to see Jose Jaramillo—who I saw last year—this man is the oldest smith (by far) working in the village today. I should say that he is a man in his late 50s or early 60s maybe.... He works for Maisel, my interpreter tells me, doing hand-made silver for him here in the Pueblo, which Maisel sells in his shop.[212]
> (See figure 88)

Another Isleta gold- and silversmith who may have sold his work to Maisel's was Patricio Olguin. Olguin made a style of earring that was featured in Maisel's catalogs between 1928 and 1932. When shown this illustration, both Manuel Naranjo and Joe Anzara recognized the earrings as handmade, and Anzara stated that Olguin had made earrings in that style. However several smiths in New Mexico made these elegant, distinctive earrings, and the ones featured in Maisel's catalogs could have been made by a smith other than Olguin (figure 89).[213]

Although a few traders and independent smiths sold work to Maisel's, all of the company's silversmiths labored in its shop. Some smiths from Isleta and Sandia commuted to work in the 1930s. Both pueblos are close to Albuquerque—Isleta immediately south and Sandia immediately north. The main road going north from Isleta becomes Broadway Boulevard in Albuquerque, and the drive was direct and relatively short; Joe Anzara's car was usually loaded with commuters. Anzara said that Maurice and Cyma Maisel sometimes made the trip down to Isleta to visit him and his family, as well as the families of other Maisel's silversmiths. He added, "He was very good to us."[214]

Many Indian silversmiths resided in Albuquerque, and whether or not they worked for Maisel's, almost all of them lived within a few blocks of 1st and Central (see appendix). Many shared rooms or lived in the same boarding houses or apartment buildings. Several were married; a few became homeowners. If they did not work for Maisel's, most of them worked in other curio stores, including

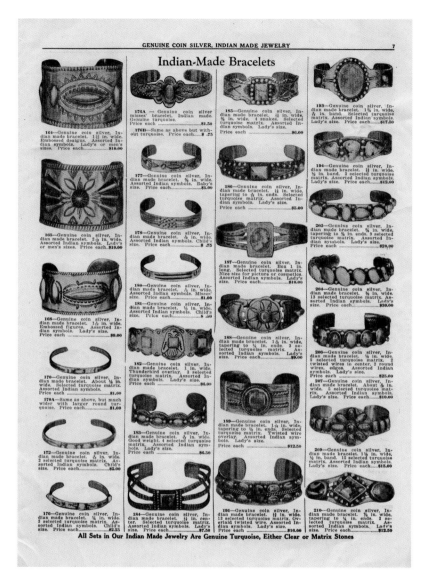

*Figure 86. Bracelets made at Maisel's and featured in catalog 8, published ca. 1930–1932, range in price from $1.50 to $60.00. As production methods evolved, Maisel's lowered their prices. Collection of Kathleen L. Howard.*

## INDIAN-MADE EAR RINGS

The white metal pierceless top on these Indian made earrings is manufactured and furnished to the Indian, as he is unable to make it. Pierceless tops furnished in either white metal at prices quoted, or in Sterling Silver for $1.50 per pair additional.

512—5 selected turquoise matrix. Indian made from coin silver. Price per pair....$13.50

513—2 selected turquoise matrix. Indian made from coin silver. Price per pair....$8.50

514—1 selected turquoise matrix. Indian made from coin silver. Price per pair $3.50 Up

516—3 selected turquoise matrix. Indian made from coin silver. Price per pair.......$4.00

516A—Indian made from coin silver. Price per pair.............................$2.50
516B—Indian made from coin silver. Same, as above, with turquoise on each bird. Price per pair.............................$3.20

517—4 selected turquoise matrix. Indian made from coin silver. Price per pair....$8.00

518—1 selected turquoise matrix. Indian made from coin silver. Price per pair..$10.00

519—3 Selected turquoise matrix. Indian made from coin silver. Price per pair..$11.00

520—Indian made from coin silver. Made of heavy coin silver wire with three silver beads. Price per pair.............$3.00

501—We furnish an imported turquoise for these. Price per pair.......................$3.50
502—In these we use the lumps which are brought in to us by Indians. Price per pair..........................................$6.00
503—As shown in picture for pierceless ears. Drop hangs from silver bead. Made by the Indians from coin silver. Price per pair.......................................$9.00
504—We furnish an imported turquoise for these. Price per pair.......................$3.50
505—Made by Indians from coin silver. Price per pair.....................................$15.00
506—Made by Indians from coin silver. Price per pair.....................................$10.00
507—In these we use the lumps which are brought in to us by Indians. Price per pair..............................$3.50 to $5.00
508—Made by the Indians from coin silver. Price per pair.......................................$3.50
509—Made by the Indians from coin silver. Price per pair.....................................$15.00
510—Made by the Indians from coin silver. Price per pair.....................................$12.00

**All Sets in Our Indian Made Jewelry Are Genuine Turquoise, Either Clear or Matrix Stones**

Figure 87. Some earrings illustrated in catalog 8 were made at Maisel's and priced as low as $2.50 per pair. However the pair at lower left, priced at $15.00, were handmade. The fact that Maisel's promoted them implies that an unidentified silversmith supplied them on a regular basis. Collection of Kathleen L. Howard.

Figure 88. This sheet was stamped with dies that Jose Jaramillo of Isleta used on his jewelry. Jaramillo worked at home and sold much or all of his work to Maisel's. Width 6 inches. Collection of Robert Bauver.

Figure 89. Silver earrings in this style were made by
several smiths in New Mexico, both Native
American and Spanish New Mexican. The poet
Witter Bynner collected this unattributed pair
from a Navajo woman. Length 3.375 inches.
Museum of Indian Arts & Culture/Laboratory of
Anthropology, Department of Cultural Affairs,
Santa Fe, 40417/12.

*Figure 90. These silver letter openers and pin can be matched to illustrations in Maisel's catalogs 7 and 8. No silver items made at Maisel's prior to World War II are hallmarked. Greatest length 6.5 inches. Wheelwright Museum of the American Indian; letter openers: 47/1311, 47/1312, gift of Susan Brown McGreevy; pin: 47/3, Gift of Byron Harvey III.*

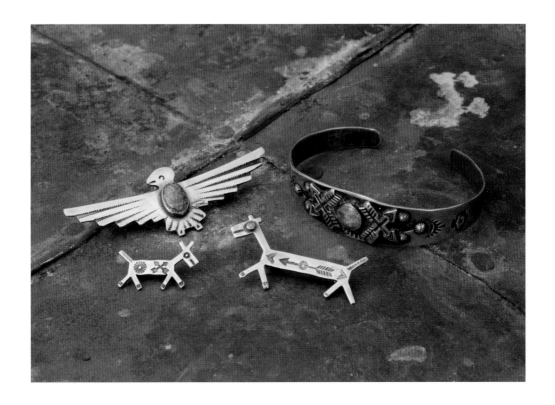

*Figure 91. Silver thunderbird pin, bracelet, and "Hopi horse" pins, all illustrated in Maisel's catalogs of the 1930s. The blanks were stamped from sheet silver with a punch press or drop hammer; the crossed arrows and "raindrops" on the bracelet were also stamped out with a punch press and soldered on. Width of pin 2.5 inches. Wheelwright Museum of the American Indian; thunderbird pin: 47/822, gift of Clare Mizen; bracelet: 47/1284, gift of Susan Brown McGreevy; horse pins: 2003.37.33, 2007.37.37, gift of Mary G. Hamilton.*

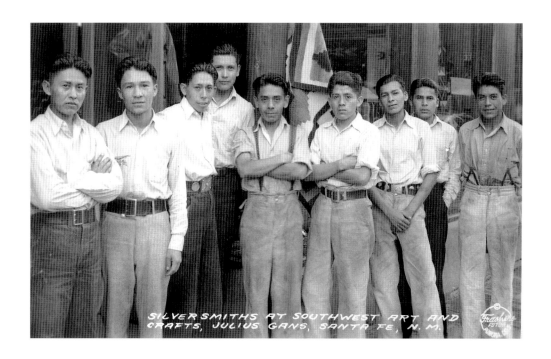

SILVERSMITHS AT SOUTHWEST ART AND
CRAFTS, JULIUS GANS, SANTA FE, N. M.

Figure 92. Some of Southwest Arts & Crafts' silver-
smiths pose in front of the store, 1935. Photograph by
Burton Frasher. Left to right: Albert Hardy, Mark
Chee, Claudio Perez, unidentified, Perfecto
Herrera, Silviano Quintana, unidentified, Aloysius
Pecos, Elfego Herrera. Pomona Public Library
Special Collections, Courtesy of Frashers Fotos.

Bell Trading Post (403 West Copper), the War Bonnet (220 West Central), Western Indian Traders (104 North 4th), and White Eagle Trading Post (207 West Central). However the presence of an Indian silversmith had come to be identified so closely with the conduct of business in Albuquerque that in the 1932 city directory we find John Willie, presumably Navajo, working as a silversmith and also residing at New Mexico Carpet Cleaners, 1806 North 4th.[215]

### Julius Gans and Southwest Arts & Crafts

By 1915 the formula for Candelario's and other early curio shops in Santa Fe had become dated, and as in Albuquerque, more tourists traveled by car. The end of the road in Santa Fe had become the downtown plaza, rather than West San Francisco Street. Santa Fe's curio trade was open to fresh ideas, and they came in the form of Julius Gans.

Gans, born in 1888, was raised in Chicago, where his father was in the salvage business. Buildings then were dismantled, rather than demolished, and Gans Salvage prospered. Julius attended Yale University and Columbia Law School. He practiced law in Chicago, specializing in estates and trusts, but he quickly tired of "groping nephews and grieving widows." On a vacation to New Mexico in 1916 he fell in love with Santa Fe and became fascinated by the Indian curio trade.[216]

Gans promptly moved to Santa Fe and opened a curio store, Southwest Arts & Crafts, on the east side of the plaza. In their early years in business, Julius and his wife, Elsie, often drove to Gallup, where they conducted business, especially purchasing jewelry and rugs.[217] His earliest surviving order for inventory, dated October 14, 1916, is addressed to Roman Hubbell at Gallup. It demonstrates not only Gans's instantaneous grasp of the business, but his aversion to consignments, on which Candelario and other dealers had depended for decades. It starts, "Dear Friend,"

> The job lot of baskets I bought from you when I was in Gallup
> about a month ago has gone fine. Have sold about a half dozen
> of them, so far. . . . So you see, goods well bought are half sold,
> and if you make right prices, I handle a lot of goods for you—
> always for cash.

I am writing now for second mesa [sic] baskets. I don't want any plaques, but baskets. Recently, one of the curio dealers here put in a large stock of second mesa work, all consigned goods. You remember we had a talk about this consignment business, and both you and I expressed ourselves pretty forcibly on the question of handling consigned goods, that is, doing business on other people's capital, and returning some of the goods shopworn or not remitting at all.

Please send this letter to one of your stores, and have them send me, as soon as possible, about $25.00 worth of Second Mesa baskets, but not to include any plaques. Have as many small baskets as possible, some with lids, and as many as can be with designs of animals or men. If you make the prices right, I will not only put a crimp in this consignment business in Santa Fe, but I will, when I come to the Navajo country next spring or winter, buy at least twice as many.[218]

Gans's business was an immediate success. By 1918 he had moved to larger quarters on the south side of the plaza. In 1923 or 1924 he bought the building, and in 1931 or 1932 he built a three-story addition to its south side (figure 93).[219]

Through the 1920s and 1930s Gans bought much of his pottery directly from Pueblo artists, driving to their homes to trade. His son, Harold, described the bartering as almost ritualized behavior and specifically recalled buying rain gods at Tesuque. He said that upon entering a house Julius deliberately avoided looking at the rain gods arranged on a table, though he could tell they were there. For some time he would engage in small talk: "How is the family?" "How was the corn crop this year?" After going through that exercise he would acknowledge the figurines: "Oh, I see you have some pottery. I really don't need any this year." And the negotiations would begin.[220]

Julius drove to Tesuque, San Ildefonso, Santa Clara, and San Juan to buy pottery, even from Maria Martinez. He would carry one-dollar and five-dollar bills and empty boxes. He bought all that he could and paid cash on the spot. Tewas still took their pottery to Santa Fe to sell, but by the 1930s that source would have been erratic at best. Tourists increasingly bought pottery in the pueblos, directly from the makers, so by going to the potters Gans ensured a supply.[221]

*Figure 93. Southwest Arts & Crafts in the location
that it occupied on the south side of the Santa Fe
plaza starting about 1918. Like J. S. Candelario,
Julius Gans was an amateur photographer and took
many of the photographs that his company pub-
lished on their postcards. Private collection.*

Although he never learned any Pueblo languages, Gans learned enough Navajo to communicate with independent Navajo traders, who brought rugs by the truckload from Gallup. After the price, based on weight, had been negotiated, the truck was filled with the rugs that Gans wanted and was driven to the railyard to be weighed. The truck was then unloaded at the shop and driven back to the railyard to be weighed empty. Harold would cash a check for the purchase at the bank, and payment, usually $300 or more, was made in twenty-dollar bills. Rugs were stacked high on a thirty-foot-long bench in the shop.[222]

Southwest Arts & Crafts (SWAC) became a leading producer and wholesaler/retailer of Spanish New Mexican blankets and of clothing and accessories made from blanket-based textiles. By the 1930s, 125 Spanish New Mexican weavers in Cundiyo, Las Trampas, Truchas, and other towns worked at home for the shop. The weavers drove from the mountain towns to deliver finished work and to pick up yarn, which was issued on a credit system. The shop would sell yarn to weavers and keep those transactions on the books. When the shop bought finished work from a weaver it would provide credit for the cost of the yarn.[223]

The store's weaving department was started by an employee, Ollie McKenzie. McKenzie invented the "Chimayo purse," which at first was folded; purses later had zippers and handles. Chimayo vests and jackets followed. McKenzie invented the Chimayo jacket in 1930, and she pioneered the use of flannel or corduroy for the sleeves of jackets. Weaving and tailoring occupied the second floor in the expanded building on the south side of the plaza. The shop purchased virgin wool yarn for all of the weaving in 100- to 120-pound burlap sacks from Crescent Woolen Mills in Three Rivers, Michigan. Although cotton warps had been used in textiles marketed by some earlier curio dealers, Gans insisted on the use of wool yarns for both warps and wefts.[224]

The sewing room was equipped with about twenty-five sewing machines and several cutting tables, and there the staff produced Chimayo jackets and coats, broomstick skirts, and "squaw dresses." Chimayo jackets and coats were not made from blankets. They were cut from a "mat," which was woven with a large patterned area to make up the back and side panels, plus an extra unpatterned area at one end which was cut to make the sleeves. Velveteen and other light fabrics were stack-cut, but mats were cut individually. The shop eventually acquired three-needle sewing machines to sew rickrack onto squaw dresses.[225]

Weaving was one of the demonstration arts that the shop provided for tourists. Manuel Muller, whom Harold Gans described as "an aristocratic Spaniard," became one of the company's most popular public attractions. Muller moved to Santa Fe from Mexico and wove for the company for several years. He first worked at a loom in a window on the ground floor, weaving fabric for neckties, but eventually he wove on a larger loom on the sales floor, making beautiful, large patterned textiles.[226]

Julius Gans built Southwest Arts & Crafts into the largest retail curio operation in Santa Fe. There was practically no skiing in Santa Fe in the 1930s, and except in the summer, walk-in business was very slow. Summer hours were long — 7:30 a.m. to 9:00 p.m. — to take advantage of tourist behavior. Tourists would drive to destinations such as the pueblos and prehistoric ruins during the day and return to the plaza in the evening. If Gans saw people in the plaza and nobody was in the store, he would ask one of the women employees to go around to the front of the sales counter and pretend to shop.[227]

The wholesale trade was essential to the health of the shop. The wholesale business was launched early, and the Fred Harvey Company became a major client, at one point accounting for as much as 25 to 30 percent of Gans's business. Eventually the two largest accounts were at Yellowstone and Glacier National Parks. Julius annually went to Santa Monica, California, to the headquarters of Hamilton Stores, Inc., one of the two major concessionaires at Yellowstone, with six retail outlets in the park. There he prepared the annual order on-site. Also annually he traveled to St. Paul, Minnesota, to prepare the annual order for the Glacier Park Company, a subsidiary of the Great Northern Railway. In time three agents marketed SWAC's products. One covered the region from Chicago to Wisconsin Dells, one covered the Rocky Mountain states, and one covered the west coast.[228]

Traveling sales were arduous, and Harold received his first lesson in 1936 at the age of fourteen. He took a sales trip with Buford Thomas, a SWAC salesman who also taught Harold to hunt, fish, and drive, because Julius never had time. Harold took the train to Flagstaff, where Thomas picked him up in the company car. They first went to Yosemite and returned to Gallup, then headed north to Cedar City, Salt Lake City, Yellowstone National Park, Glacier National Park, and Great Falls. On the way through Wyoming they stopped at Sheridan and

Cheyenne, and while heading south through Colorado they visited clients at Rocky Mountain National Park, Denver, Manitou Springs, and Colorado Springs.[229]

The quantities sold wholesale were immense. Speaking figuratively, Harold said, for example, that they sold "a ton" of Chimayo blankets to Verkamp's at Grand Canyon.[230]

Julius Gans used the expression, "the best of the genuine," which he printed as a running head on the pages of some of his catalogs and on his letterhead. Julius ran the wholesale operation and insisted on the handmade. Elsie ran the retail operation and believed that they should offer less expensive items. While their business philosophies differed, each made concessions to the other. Jewelry offered in the store serves as an example: It took one of SWAC's silversmiths a long time to cut out, file, stamp, and polish a pair of earrings that sold for four dollars. On the other hand, machine-made earrings from Maisel's, made at the rate of "thirty a minute," as Harold said, could be purchased wholesale for six dollars per dozen. Elsie purchased jewelry from Maisel's and after 1940 also from Bell Trading Post; some was sterling, but most was nickel silver or copper.[231]

Gans introduced his own line of silver jewelry in 1927. Writing to Lorenzo Hubbell on October 12, he thanked him for his remittance of $175 for Chimayo blankets. He then described the new venture:

> At this time we are making some genuine hand made Indian silver. We employ Pueblo Indians in the work. The materials are sterling silver or Mexican Pesos and we are using the best turquoise available. It occurs to me that you might use some of this silverware trading it with the Navajos and the Hopis. The next time we need any Navajo Rugs or Hopi Baskets or Pottery, I am going to write you the proposition of sending you some silverware for your approval, and you to send us Navajo rugs or Baskets in exchange. In the meanwhile, think the matter over. I am sure we can both profit by this.
>
> In the meantime I wish you would let me know whether you would prefer the silver oxidized or "Aged" or whether you would want it white just as it comes from the silversmith.[232]

Hubbell ordered some bracelets, and Gans responded with enthusiasm:

> I returned yesterday from my trip and I selected the best Cer-
> rillos [turquoise] stones we have and put the silversmiths to
> work on them. It will be a week or ten days before we can get
> them out because they are going to be well made and made by
> hand. We selected good size stones of fine quality and as they
> are rather heavy, the bracelets are going to cost something, but
> if you are not satisfied you will, of course, be at perfect liberty
> to return them as we can always sell them here in the store.
>
> ... No doubt we will be able to sell you a good deal of
> Indian silver once we get started.[233]

Gans wrote Hubbell with pride on December 24:

> At last we have gotten out the bracelets of which I spoke. We
> did not oxidize them or finish them in any way but they are
> white just as they came from the silversmiths' hands. We
> absolutely guarantee this silver to be sterling silver which is as
> you know much better than the Mexican Pesos.... The price,
> to a tourist who has been buying the imitation Indian jewelry
> might seem high, but to me or you or anyone else who knows
> Indian handicraft, and the value of beautiful turquoise, the
> prices are very reasonable. You said you wanted something with
> class and here it is.
>
> ... As for paying for these bracelets, it is immaterial at this
> time whether you send us a check or Blankets. Our stock in
> Navajo rugs today is probably the lowest since I started in busi-
> ness so we can use blankets.[234]

If Gans used *pesos* in his operation in 1927, as he told Hubbell, he soon abandoned
the practice. By about 1935 he purchased silver from Handy & Harman in orders of
around 500 ounces at a time. Sheets of different gauges, bead wire, triangular wire,

and strips for bezels were delivered by Railway Express, an armored car service. As at Maisel's, each bench position had a tin-lined drawer in which smiths collected filings and scrap, which were packed in heavy cartons and returned to Handy & Harman for credit based on weight. With the possible exception of melted *pesos* early in the operation, ingots were never cast and wire was never drawn, though occasionally wire was drawn down to a smaller gauge. Square wire was made by running round wire through a roller. The shop also ordered findings — clasps, pin-backs, and the like — but their source has been forgotten (figures 94–96).[235]

Because of its value, silver was controlled carefully. A screen separated the shipping department from the silversmithing shop, and Joe Gomez, the shipping clerk, worked behind the screen. Only Gomez and other key employees had access to a vault in the shipping department, where the silver was kept. A silversmith was given an order on a 5 x 8 sheet of paper, and he took it to Gomez, who estimated the type and amount of silver necessary and weighed it before checking it out to the smith. After the order was completed, Gomez weighed the completed items and scrap to ensure that all silver was accounted for.[236]

Jewelry designs came from many sources. Reed Newport, who was foreman at least as early as 1928, created several of the shop's designs, as did two or three now-forgotten silversmiths. In addition, according to Harold Gans, they "stole every pattern" they could find, duplicating the practices of Maisel's, Bell Trading Post, and probably every other shop in the business. Newport made all of the dies — the largest from railroad spikes — and these were kept in a steel cabinet with the designs facing out. According to their assignments, smiths selected the ones they needed from the cabinet.[237]

The silversmithing shop, on the first floor of the expanded operation, had two rows of benches with twenty-four positions. Each silversmith owned his own tools, though Gans ordered them through the shop. A smith bought them at cost and marked his initials on them with a file. The inside of each scrap drawer had a bar on which to hang tools. Unlike Maisel's operation, where blanks for bracelets, pins, and rings were stamped out by machine, a silversmith at SWAC started by using a zinc template and a sharply pointed scriber to outline the forms of the objects he was making on a sheet of silver. He then cut out each piece with a jeweler's saw, filed it, and stamped the designs on it.[238]

Soldering was done at a separate bench, which was lined with fire bricks and had four torches. Rough finishing was done with EEE emery paper, and polishing was done on a 220-volt machine with two buffers. A smith polished a

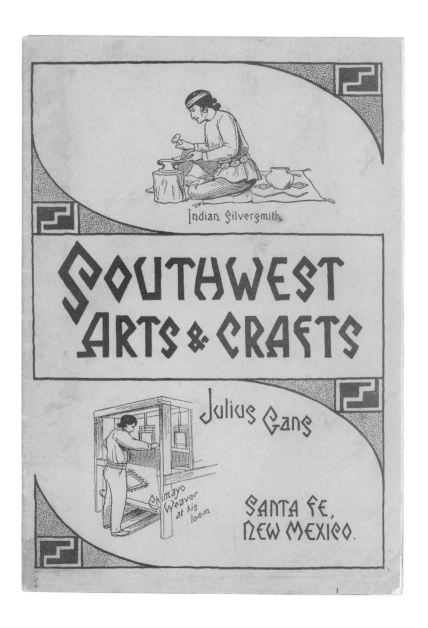

*Figure 94. Southwest Arts & Crafts' catalog 16, ca. 1934. The covers of almost all of the company's large catalogs of the 1930s were the same, though the color of each was different. Private collection.*

# Indian Silver Jewelry

The jewelry illustrated we guarantee to be hand-made by Navajo and Pueblo Indians, using either sterling silver or Mexican Pesos and the finest turquoise matrix available.

## Bracelets

No. 2000. Hand-made Triangular Indian Silver Bracelet, size of cut _____ $1.25

No. 2001. Hand-made Triangular Indian Silver Bracelet, size of cut, set with one superior grade matrix turquoise, weighing approx. 1-3 carat ___ $2.25

No. 2003. Hand-made Triangular Indian Silver Bracelet, size of cut, set with three superior grade matrix turquoise, weighing approx. 3 carats _____ $3.00

No. 2033. Three-strand Triangular Wire Bracelet. Same as No. 2032 except consisting of three strands _____ $3.75

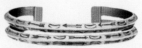

No. 2032. Like our No. 2000, except consisting of two strands _____ $2.50

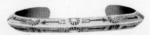

No. 2030. Heavy Triangular Wire Silver Bracelet. Size of cut. Assorted designs _____ $2.25

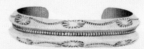

No. 2031. Two-strand Heavy Triangular Wire Bracelet with bead wire between strands _____ $4.50

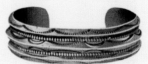

No. 2034. Same as No. 2031, except made up of three strands of triangular wire with the bead wire in between each strand _____ $5.00

No. 2004. Not illustrated. Snake design made of heavy triangle like No. 2030 but rounded over top and ends, shaped for head and tail, eyes set with seed Turquoise.
Price $3.50

*Figures 95, 96. Some of Southwest Arts & Crafts'
line of silver jewelry, as illustrated in catalog 16.
Private collection.*

The jewelry illustrated we guarantee to be hand-made by Navajo and Pueblo Indians, using either sterling silver or Mexican Pesos and the finest turquoise matrix available.

No. 2408. Bracelet. This, like the No. 2047 is a reproduction of an old style bracelet. Can be had in different widths. 7-strand as illustrated ____ $8.50

No. 2418. 4-strand (not illustrated) ____ 5.00

No. 2428. 3-strand (not illustrated) ____ 4.00

No. 2370a. This bracelet, size of cut, is beautifully decorated in deeply stamped designs. It is medium weight, resembling fine old silverware ..$4.50

No. 2371. Set with a 5 carat turquoise, otherwise same as preceding ____ $7.00

No. 2373. Same, but set with a 5 carat turquoise in center, a 3 carat turquoise on each side ____ $11.00

No. 2370. (Not illustrated). 1½ in. wide bracelet, similar to No. 2370a, except center flat, not raised ____ $4.00

No. 2037. For those who are fond of twisted wire work, size of cut. Set with a 5 carat stone ____ $6.00

No. 2047. Bracelet. This is a reproduction of an old style bracelet. Size of illustration. Center concho and side parts raised as shown. A very good number for parties looking for antique bracelets but at the prices of modern jewelry ____ $9.00

No. 2406. Heavy triangular wire bracelet (size of cut) with 5 oblong stones as illustrated, attractively set with Indian "Rain Drops" between each set $9.00

Not Illustrated.

No. 2057. Heavy triangle, similar in design to No. 2406. Set with 8 oval stones. Each ____ $7.50

No. 2403. Bracelet. Note cut out on the sides with suggestion of arrowpoint in the back. This is a very unique style bracelet, set with three turquoise as shown, total weight of which are about 12 carats. Price ____ $14.00

No. 2041. (Not Illustrated). 1¼ in. wide bracelet with cut-out arrow design. Set with about 5 carats superior grade turquoise matrix. Very pretty and unusual ____ $7.50

Figure 97. Ashtrays from Southwest Arts & Crafts, 1930s. The head, tail, and legs on the copper bird at left are nickel silver. Mark Chee is shown forming a copper bird of the type at upper right in figure 105. Harold Gans stated that of all the items in the shop's line, the cowboy-hat ashtray was the most time-consuming to make; this example is silver, but in catalogs the type was offered only in copper. No jewelry or other metalwork made at Southwest Arts & Crafts prior to World War II is hallmarked. Width of bird at upper right 4 inches. Wheelwright Museum of the American Indian (in order as described), 47/1388, 47/1385, 47/1344, gift of Susan Brown McGreevy.

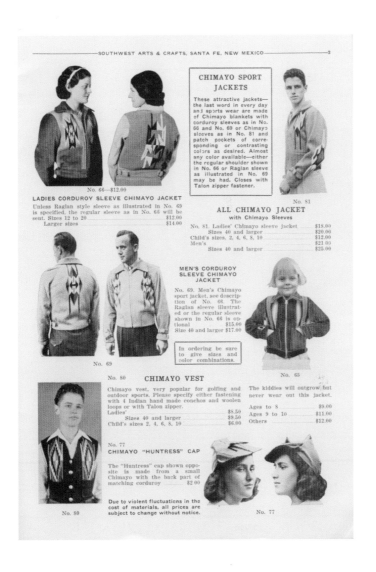

No. 66—$12.00

**LADIES CORDUROY SLEEVE CHIMAYO JACKET**

Unless Raglan style sleeve as illustrated in No. 69 is specified, the regular sleeve as in No. 66 will be sent. Sizes 12 to 20 _____ $12.00
Larger sizes _____ $14.00

## CHIMAYO SPORT JACKETS

These attractive jackets—the last word in every day and sports wear are made of Chimayo blankets with corduroy sleeves as in No. 66 and No. 69 or Chimayo sleeves as in No. 81 and patch pockets of corresponding or contrasting colors as desired. Almost any color available—either the regular shoulder shown in No. 66 or Raglan sleeve as illustrated in No. 69 may be had. Closes with Talon zipper fastener.

No. 81

**ALL CHIMAYO JACKET**
with Chimayo Sleeves

No. 81. Ladies' Chimayo sleeve jacket _____ $18.00
Sizes 40 and larger _____ $20.00
Child's sizes, 2, 4, 6, 8, 10 _____ $12.00
Men's _____ $21.00
Sizes 40 and larger _____ $25.00

**MEN'S CORDUROY SLEEVE CHIMAYO JACKET**

No. 69. Men's Chimayo sport jacket, see description of No. 66. The Raglan sleeve illustrated or the regular sleeve shown in No. 66 is optional _____ $15.00
Size 40 and larger $17.00

In ordering be sure to give sizes and color combinations.

No. 69

No. 80

No. 65

**CHIMAYO VEST**

Chimayo vest, very popular for golfing and outdoor sports. Please specify either fastening with 4 Indian hand made conchos and woolen loops or with Talon zipper.
Ladies' _____ $8.50
Sizes 40 and larger _____ $9.50
Child's sizes 2, 4, 6, 8, 10 _____ $6.00

The kiddies will outgrow but never wear out this jacket.

Ages to 8 _____ $9.00
Ages 9 to 10 _____ $11.00
Others _____ $12.00

No. 77

**CHIMAYO "HUNTRESS" CAP**

The "Huntress" cap shown opposite is made from a small Chimayo with the back part of matching corduroy _____ $2.00

Due to violent fluctuations in the cost of materials, all prices are subject to change without notice.

No. 80

No. 77

*Figure 98. Southwest Arts & Crafts' catalogs were homegrown affairs. This page from catalog 19, published about 1939, shows family and staff modeling clothing. At upper right is Harold Gans, and below him is Alice McKenzie, youngest daughter of Ollie McKenzie, who ran the company's weaving department. At bottom left is Harold Gans, and at lower right is his sister, Marjorie. Private collection.*

piece before mounting turquoise, because the polishing wheel could throw it and break the stones.[239]

Turquoise was purchased both cut and raw from peddlers from all over the Southwest, who visited frequently. The shop had a lapidary saw to cut stones, and Newport made a series of cutting gauges so that consistently-sized round and rectilinear stones could be cut. Most of the turquoise was cut by two or three of the smiths, and a few others did nothing but set turquoise. Ollie McKenzie's first job was to use tweezers to "pick" turquoise for the smiths, and especially to match the cut and color of stones that were set in pieces with multiple bezels.[240]

In the 1930s the shop used some petrified wood, a much harder stone than turquoise, which was already cut and polished when it was purchased; most of it was supplied by vendors in Tucson and Phoenix. The noted jeweler Frank Patania, whom Harold Gans considered "as good a designer as I've ever known," was the first in Santa Fe to use the stone in his shop. Patania's smiths also used coral and obsidian, but those were never used at SWAC.[241]

Most of Southwest Arts & Crafts' silversmiths were Pueblo Indians, but some were Navajo. Whereas Maisel's Pueblo smiths were principally from Isleta, most of those at SWAC were from Cochiti, and several were from the Tewa pueblos (figures 99–105). Gans encouraged smiths to make jewelry in styles specific to their cultures or communities, allowing them a degree of creative freedom that machinery precluded. So SWAC's Navajo silversmiths made heavier, simpler bracelets, and the occasional smith from Zuni would make pieces set with multiple turquoise stones.[242]

Harold Gans learned some silversmithing in the shop in about 1932 at age ten, first practicing on copper and then making silver buttons and earrings; over the next few summers when a smith was absent he sometimes filled in. The experience served him well. On one occasion, when he visited me in my office to answer a new set of questions, I had a concha belt by the great contemporary silversmith Perry Shorty laid out on my desk. Shorty had recently made the belt, and it was the first one he had made using silver ingots, cast from melted coins. On entering the office Gans made a beeline for the belt, which he admired, commenting on the tremendous amount of work that had gone into it.[243]

Gans remembered the names of only a few silversmiths who worked in the shop. One who stood out in his mind was Manuel Naranjo's brother, Al. Gans had a bench next to Naranjo's, and Naranjo taught him a few words of Navajo, which he undoubtedly had learned from his brother-in-law, David

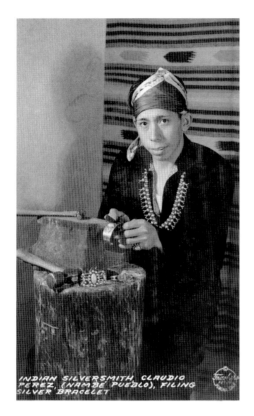

INDIAN SILVERSMITH, CLAUDIO
PEREZ, (NAMBE PUEBLO), FILING
SILVER BRACELET

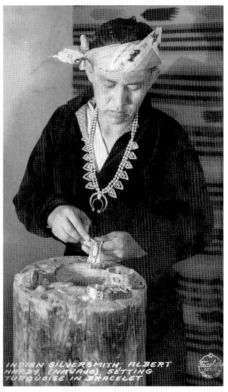

INDIAN SILVERSMITH, ALBERT
HARDY, (NAVAJO), SETTING
TURQUOISE IN BRACELET

*Figures 99, 100. Claudio Perez and Albert Hardy at
Southwest Arts & Crafts, 1935. Photographs by
Burton Frasher. Pomona Public Library Special
Collections, Courtesy of Frashers Fotos.*

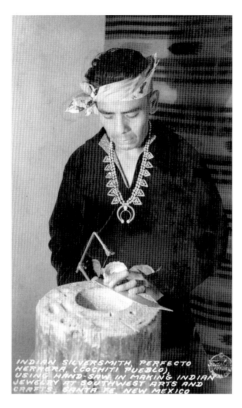

INDIAN SILVERSMITH, PERFECTO
HERRERA (COCHITI PUEBLO)
USING HAND-SAW IN MAKING INDIAN
JEWELRY AT SOUTHWEST ARTS AND
CRAFTS, SANTA FE, NEW MEXICO

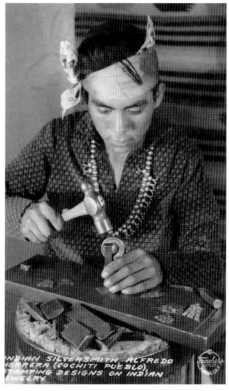

INDIAN SILVERSMITH ALFREDO
HERRERA (COCHITI PUEBLO)
STAMPING DESIGNS ON INDIAN
JEWELRY

*Figures 101, 102. Brothers Perfecto and Elfego
Herrera at Southwest Arts & Crafts, 1935. Photo-
graphs by Burton Frasher. Frasher identified Elfego
as "Alfredo." Pomona Public Library Special
Collections, Courtesy of Frashers Fotos.*

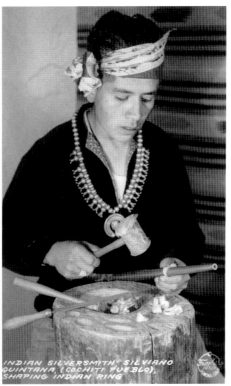

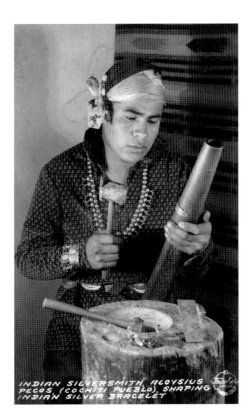

*Figures 103, 104. Aloysius Pecos and Silviano Quintana at Southwest Arts & Crafts, 1935. Photographs by Burton Frasher. Pomona Public Library Special Collections, Courtesy of Frashers Fotos.*

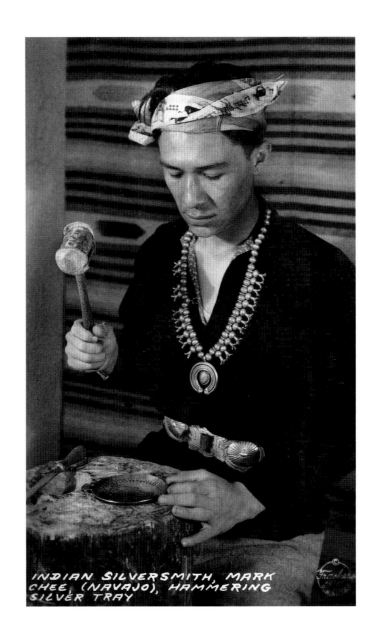

INDIAN SILVERSMITH, MARK CHEE, (NAVAJO), HAMMERING SILVER TRAY

*Figure 105. Mark Chee at Southwest Arts & Crafts, 1935. Chee forms a copper ashtray of the type illustrated in figure 97. Photograph by Burton Frasher. Pomona Public Library Special Collections, Courtesy of Frashers Fotos.*

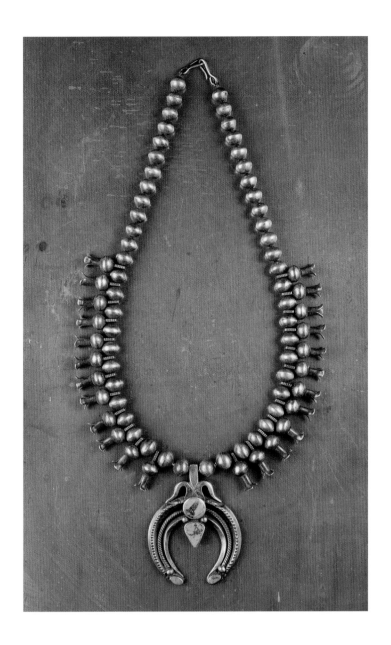

Figure 106. Mark Chee became an accomplished jeweler. He was awarded a blue ribbon for this silver and turquoise necklace at the 1946 Gallup Intertribal Indian Ceremonial. His hallmark, on the back of the naja, is the name, Chee, enclosed in the profile of a bird's head and upper torso. Length as shown 16 inches. Wheelwright Museum of the American Indian, 47/750, gift of Mr. and Mrs. Arthur W. Rogers in honor of Mark Chee.

Taliman. Gans's knowledge of Navajo amounted to little more than "one, two, three, greetings," but Naranjo instructed him to say it whenever a tourist entered the shop to watch them at work. Naranjo would then tell them, "He's an albino." Naranjo also taught Harold to hunt, fish, and skin animals. Manuel's brothers Al and Paul both worked briefly for SWAC, as did David Taliman; in 1934 all three worked there.[244]

Benchwork continued in the shop until 1941, counter to the wishes of Reed Newport. Newport wanted to mechanize the shop, and Gans refused. In about 1938 Newport left SWAC and went to work for Maisel's as a foreman. Vidal Chavez of Cochiti, who started working at SWAC in 1935, never liked Newport. Under Newport, "You had to be ahead all the time." He added, "He don't give a damn about Indians." The silversmiths at Maisel's didn't like Newport either. Louis Pajarito, a smith from Santo Domingo Pueblo, told John Adair that Newport "wouldn't let the boys talk to each other while they were at work."[245]

Chavez, born in 1913, was recruited by another young man from Cochiti, who visited him at home and told him, "They want to see you." People at the shop may have learned about Chavez from his cousin, Perfecto Herrera. Herrera began working for SWAC in about 1930, while he was living at St. Catherine Indian School. In later years he lived at various addresses with his wife, Maria. Harold Gans remembered Perfecto with fondness; his name was the first that came to mind when asked if he recalled any smiths by name (see figure 101).[246]

Chavez started as a polisher, working exclusively on nickel-silver clasps for Chimayo purses. But he watched the other smiths at work and learned the basics of silversmithing purely by observation. He was soon given the job of silversmith and worked on silver immediately; he did not start on copper. He made everything in the Gans line, including boxes and spoons.[247]

A few of the young men at Cochiti owned cars, and for his first few years on the job Chavez commuted with them. In 1938 he moved to Santa Fe with his wife, Teresita, and eventually they bought a home there. After moving to town, he continued to work at the shop, but in 1939 he began working at home on a piecework system that Gans initiated that year or perhaps in 1938.[248]

Harold Gans and Chavez both described the system. Each order for a stated quantity of a specific item was put into a cigar box, together with the necessary silver, turquoise, and other materials. The zinc template for the pieces was attached to the order. Turquoise was used to create the bezel but was left unmounted, and finished pieces were left unpolished, because most of the smiths

did not have polishing wheels at home. The pieces were polished and the turquoise was mounted in the store.[249]

In order to calculate a silversmith's compensation, the amount of time required to make every item in the jewelry line was determined by observing a smith doing every step in the process. The smith was paid an hourly rate based on the number of items in the order, and the amount to be paid per piece was stated on the order. The shop calculated the cost of finished pieces based on the wage, plus materials and 15 percent overhead for shop time for polishing and mounting stones.[250]

The piecework system appealed to many smiths, who could work other jobs or tend their fields at the pueblos and work on silver at their leisure. Some were able to earn a higher wage working at home while working fewer hours. In about 1937 Louis Pajarito and Francisco Teyano, both of Santo Domingo, earned twelve dollars per week at SWAC, working fifty-four-hour weeks. But in 1940 Joe Quintana of Cochiti earned up to seventeen dollars per week, and up to one thousand dollars per year, working at home. Quintana was one of four Cochitis who worked at home on SWAC's piecework system.[251]

SWAC's arrangements with smiths seem to have varied. Buford Thomas said in 1940 that all smiths who worked at home were required to own their tools, though the shop provided their gas for soldering. Vidal Chavez said that SWAC owned the tools he used, and Joe Quintana told John Adair that "his bench belongs to Gans," which also implies that SWAC owned his tools.[252]

In 1941, on break for the summer from the University of Southern California, Harold Gans was given the task of dismantling the silversmithing shop and turning it into a wholesale showroom. From that point on, all silver was made by the piecework system.[253]

Several of SWAC's smiths shared rooms in Santa Fe, and many lived together in the same neighborhoods. The city directory of 1938, for example, shows several silversmiths residing in a duplex at 152 Duran. At the rear resided Mark Chee; also living there were Albert Hardy and his wife Dottie, and Jose or Joseph Lee. In another unit at the same address resided Silviano Quintana and his wife Mensia. Across the street at 147 Duran resided Antonio, Bernabe, and Claudio Perez. Nearby at 124 Duran lived Vidal and Teresita Chavez. By 1940 fifteen of SWAC's twenty-five smiths worked at home (including those from Cochiti mentioned above), and as many as five shared one residence in Santa Fe working on the piecework system.[254]

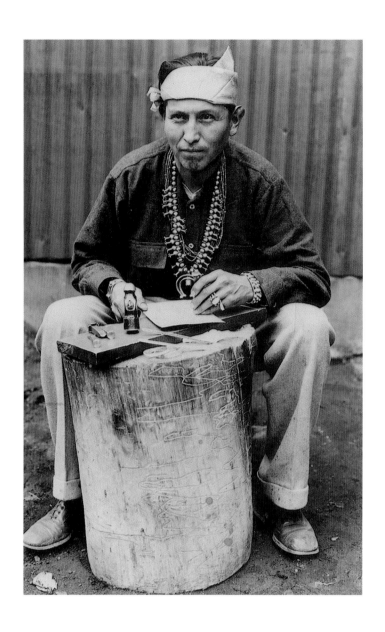

*Figure 107. David Taliman, ca. 1935. Photograph by Mack Photo Service, Santa Fe. Taliman worked in several shops in Santa Fe and Albuquerque before World War II. Following the war he enjoyed a successful career as an independent silver-smith. Naranjo Family Collection.*

*Figure 108. David Taliman made this silver box,
bracelet, and ring, all set with turquoise, in the
1950s or 1960s. All are hallmarked,* D. TALIMAN,
*and the box is also stamped,* HAND MADE STER-
LING. *Width of box 8.25 inches. Bracelet and ring:
Naranjo Family Collection. Box: Wheelwright
Museum of the American Indian, 47/589, gift of
Byron Harvey III.*

Figures 109, 110. These lead sheets were stamped in August 1932
for Frederic H. Douglas of the Denver Art Museum. One sheet
was stamped with dies used by Ambrose Roanhorse, David
Taliman, and an unidentified silversmith. The other, marked
"GANS," was stamped with dies used by silversmiths at Southwest
Arts & Crafts. Width of each 12 inches. Denver Art Museum,
1966.258, 1966.259.

*Figure 111. Ambrose Roanhorse at Fort Wingate,
ca. 1940. Photograph by John Adair. Wheelwright
Museum of the American Indian, John Adair
Collection.*

There was a sense of camaraderie in Gans's shop. In the 1930s it had its own baseball team, the Gans Silversmiths.[255]

## Silversmithing in the Indian Schools

In August 1933 Julius Gans wrote to Chester E. Faris, superintendent of the Santa Fe Indian School, to complain about the dangers of some of the earliest proposed government regulations to control the marketing of jewelry made in the curio shops. Southwest Arts & Crafts was among the businesses targeted by proposed legislation, and in defending the silversmithing methods in his shop, Gans pointed out an irony:

> As you know, all our work is done by hand by Indians. There could be no better recommendation of our methods than the fact that your own school, when they wanted an instructor in Indian silversmithing, chose Ambrose Roans who learned his trade in our shop.[256]

Ambrose Roans, who later changed his name to Roanhorse, became one of the most influential Navajo silversmiths of the twentieth century. He was hired October 1, 1931, as the first silversmith at the Santa Fe Indian School.[257]

The Indian School began developing plans for an arts and crafts program in 1930 and in fall of that year polled students on their potential interest in the arts. Among girls the greatest number were interested in learning embroidery (34), followed by pottery (26), blanket weaving (6), and basketry (6). Among boys the greatest number were interested in learning silversmithing (25), followed by painting (17) and wood carving (12). By December 1, 1931, Regina Cata of San Juan Pueblo, the school's assistant seamstress, was teaching embroidery and basket weaving, and she was preparing to teach weaving and pottery. Although other instructors had not been hired, tools and equipment for silversmithing and wood carving had been ordered.[258]

Roanhorse taught his first silversmithing class in academic year 1931–1932. His students that year were Thomas Castellano, Santiago Coriz, Albert Hardy, Felix Hayatzin, Herbert Herald, Wesley Kazhe, Douglas Laughing, Ramos Pacheco, Logardo Pajarito, Dooley Shorty, Santiago Tafoya, Teofilo Tafoya, Hosteen Thompson, and Justin D. Yazza.[259]

Those in Roanhorse's class the following year were Luterio Aguilar, Jack Antonio, Ned B. Begay, Antonio Jose Chavez, Juan Chavez, Mariano Chino, Juan Isidro Coriz, Marcus Coriz, Reyes Coriz, George Dempsey, Albert Hardy, Herbert Herald, Walter Joshongeva, Felix H. Miller, Ramos Pacheco, Dooley Shorty, Santiago Tafoya, Santiago Tenorio, and Chester Yellowhair.[260]

From those classes two names stand out. Dooley Shorty, a Navajo from Cornfields, Arizona, came to be Roanhorse's assistant and a master silversmith in his own right. He worked briefly for SWAC and was hired as the silversmithing instructor at the Charles H. Burke School at Fort Wingate in fall 1935. Chester Yellowhair, a Navajo from Sand Springs, Arizona, came to be equally well respected. He too worked for SWAC before being hired as the silversmithing instructor at the Albuquerque Indian School, also in 1935.[261]

Roanhorse experimented with traditional techniques that he did not learn at SWAC. In 1933 or 1934 he began teaching tufa-casting. Roanhorse, Shorty, and Yellowhair drove to Sunrise Springs, Arizona, a few miles from Shorty's home, to collect tufa, and they returned to the school with "about 300 pounds." Yellowhair made the first cast ornament, described as "a bracelet of an open cross pattern," and several other students tried their hands at the technique.[262]

In June 1934 Brice Sewell, who leased the Cerrillos turquoise mine from its owner, Cerrillos Gem Company of Boston, sold 200 carats of turquoise to the school for twenty-five cents per carat. In March 1936 A. J. Hall sold the school two pounds of turquoise from his Villa Grove mine in Colorado for $24.75 each. Roanhorse stressed the use of old silver designs, but turquoise was conspicuous in student work, as illustrated in a document created by the silversmithing class in academic year 1935–1936. That was Roanhorse's fifth year running the program, and students had mastered jewelry design and had a firm grasp of both traditional styles and styles promoted by the curio trade. Interspersed with belts and buckles are a watch fob with an arrowhead pendant, a brooch and a watch fob with thunderbird patterns, and a swastika brooch. Those and some other designs were marked "No Good," possibly by Roanhorse (figures 112–114, 120).[263]

Three students from Roanhorse's first class took first-place awards at the 1932 Gallup Ceremonial: Dooley Shorty for a man's silver necklace, Hosteen Thompson for a bracelet without turquoise and for a match holder, and Ramos Pacheco for a man's silver belt. At the 1933 Gallup Ceremonial, Roanhorse and his students took many prestigious prizes. Hosteen Thompson was awarded a

*Rings*

*Rings*

*Rings*

*Joe Wilcox*

Figure 112. Jewelry designs by Joe Wilcox, drawn
for Ambrose Roanhorse's class at the Santa Fe
Indian School in academic year 1935–1936.
Wilcox, a Navajo student, became skilled enough
that within three years he was appointed instructor
in silversmithing at the Leupp Boarding School in
Winslow, Arizona. Wheelwright Museum of the
American Indian, John Adair Collection.

Figure 113. Jewelry designs by Sam Roans, drawn for Ambrose Roanhorse's class at the Santa Fe Indian School in academic year 1935–1936. Wheelwright Museum of the American Indian, John Adair Collection.

Conchos belt with dap out buckle

Conchosbelt with cast buckle

Buckle

W.H. Jones
ete

*Figure 114. Jewelry designs by Wilfred H. Jones, drawn for Ambrose Roanhorse's class at the Santa Fe Indian School in academic year 1935–1936. After graduation Jones was appointed instructor in silversmithing at Shiprock Indian Boarding School, but he soon returned to Santa Fe as Roanhorse's successor. Wheelwright Museum of the American Indian, John Adair Collection.*

special blue ribbon for a bridle, a first place for a ring with a turquoise set, and a second place for a *gato* (an archer's wrist guard, which became a popular item of attire for Navajo men, usually made of heavy leather with a cast or tooled silver panel). Chester Yellowhair took first place for a necklace with turquoise sets and second place for a ring with a turquoise set. Santiago Tafoya took first place for a bracelet without turquoise. Roanhorse took second place for a necklace without turquoise.[264]

Santa Fe Indian School was one of at least three Indian schools to start silversmithing programs in 1931. The first instructor at the Charles H. Burke School at Fort Wingate, New Mexico, was Fred Peshlakai, a Navajo silversmith who is well known for jewelry that in later years he made in his shop on Olvera Street in Los Angeles. Peshlakai was hired October 1, 1931, the same day that Roanhorse started at Santa Fe, but unlike Roanhorse's program, Peshlakai's is poorly documented.[265]

The Albuquerque Indian School's first silversmithing instructor, also hired in 1931, was Haske Johnson Burnside, a Navajo born at Tall Pine Tree, Arizona, in 1900, 1904, or 1906, the dates stated in different sources. He occasionally signed his name Johnson Haske Burnside, and though he usually went by either Haske or Johnson, some people misunderstood his name to be Huskie or Husky.[266]

Burnside attended school at Fort Defiance before enrolling at the Albuquerque Indian School in 1921. There he consistently had good grades, and in 1924 the superintendent of the school described him as "one of our best boys, a booster for the school, a fine fellow." While in his early teens Burnside served in the New Mexico National Guard, and in all ways he was resourceful and self-sufficient. In the summer of 1929, just prior to his junior year of high school, he worked on campus for a month, then worked for two months on the new hospital at Fort Defiance, and then went home and in a matter of days built a new house for his mother.[267]

Burnside studied farming for a year and carpentry for two, but he especially wanted to learn automobile mechanics and applied unsuccessfully to Haskell Institute in 1926 for that purpose. Finally during his senior year in Albuquerque in 1930, he was able to study auto mechanics, and he took another brief course during the 1935 summer session at the Santa Fe Indian School. He learned well, for in 1936, while working at the Cañoncito Day School, he ordered piston rings, valves, valve guides, and other parts necessary to rebuild the engine of his V8 Ford.[268]

Burnside's brother and an "old uncle" taught him silversmithing when he was quite young, and he practiced silversmithing for three years on the reservation prior to attending the Albuquerque Indian School. He did not practice smithing again until he went to work for Maisel's in 1929, prior to his graduation from high school. Maisel hired Burnside at six dollars per week for a sixty-hour week, but when he learned that Burnside was able to run a lathe, he put him in the machine shop at twenty-five dollars per week. Burnside quit after he was disciplined for injuring himself and after Maisel did not make good on a promise to increase his wage to forty dollars per week.[269]

Burnside returned to the reservation briefly after quitting Maisel's, but in October 1931 he became the first silversmithing instructor at the Albuquerque Indian School. He held the position for four years, but documentation of the course, its students, and its progress appears to be lacking.[270]

## Authenticity, Competition, and Tradition

By 1930 the mechanization of silversmithing in curio shops was perceived by many to have reached crisis level. Three issues were of particular concern:

· Mass production constituted damaging competition for independent Navajo and Pueblo silversmiths and for traders on or near the Navajo reservation who represented Navajo smiths. Invariably those smiths employed traditional methods and simple hand tools, and their silver was necessarily more expensive than that made with or with the assistance of machinery. Traders reported dramatic declines in sales and some even ceased selling traditionally made jewelry, indirectly putting silversmiths out of work. Ironically many traders were forced to purchase jewelry from Maisel's or other shops in order to offer goods at competitive prices.

· The infiltration of curio-shop methods, particularly the use of sheet silver, into the Indian Schools and festivals such as Gallup Ceremonial was abhorred by some and promptly corrected.

· Representation of wholly or partially machine-made jewelry as "Indian made," as Maisel's claimed in their sales literature, was potentially a violation of federal law as prosecuted in similar cases.

Compounding those concerns were the agendas of various "purists," some of whom were self-proclaimed authorities on Native arts. Those individuals believed that only silver worked by archaic, laborious methods could be construed as "traditional," even though the tools and methods of Navajo and Pueblo silversmithing had evolved constantly since the art was adopted. Their expectations were particularly unrealistic, as they would slow an artist's production to such a degree that one could hardly create enough work to make a living.

The federal government inserted itself into the crisis, though its attempts to legislate a solution were off to a rocky start. The first legislation which directly affected those in the business of making and selling jewelry, either traditional or machine-assisted, was written by John Collier, executive secretary of the American Indian Defense Association, and James W. Young, a member of the board of the association and an advertising executive by profession. The legislation, introduced in February 1930 in the Senate by Lynn Joseph Frazier of North Dakota and in the House of Representatives by Scott Leavitt of Montana, would create the United States Indian Cooperative Marketing Board.[271]

The United States Indian Cooperative Marketing Board would be authorized to create a corporation, organized under the laws of the District of Columbia, which would promote "the production and sale of Indian products" and be "endowed with adequate powers to buy, sell, and deal in Indian products and materials used therein and in connection therewith." The corporation would be authorized to issue stock, would employ agents or inspectors to certify the "genuineness, description, and quality" of Indian crafts made in the United States and affix to them "suitable marks, symbols, or devices" as proof of government certification, and would have exclusive control over government certification of Indian arts.[272]

Herman Schweizer, in bringing the bill to the attention of traders and dealers, pointed out not only its impracticality, but the possible interpretation that the bill would establish a private corporation with a monopoly on the Indian trade with government sanction. Schweizer had been among the first to learn of Collier's and Young's intentions, as Young had visited Schweizer on January 6, 1930, claiming to be investigating the establishment of an organization "for the better sale of Indian curios particularly Navaho blankets."[273]

Schweizer may have been less surprised than other traders, but all of them bristled when they saw copies of the bill, sent February 13 with a memo from the

American Indian Defense Association over Collier's signature as executive secretary and that of Haven Emerson, its president. Collier and Emerson asserted that the "Administration unreservedly favors the bill." Schweizer described the bill to Lorenzo Hubbell as "a hell of a piece of legislation for the benefit of two or three John Colliers and his ilk."[274]

A meeting about the bill was held on April 5 in the Santa Fe office of Herbert J. Hagerman, the Bureau of Indian Affairs' Special Commissioner to the Navajo. In attendance were Young, traders including Schweizer and Wick Miller (of San Ysidro, New Mexico, near Zia Pueblo), and others. By the end of the meeting only Young was still in favor of the bill.[275]

On April 10 Schweizer sent telegrams to congressmen, and to William Randolph Hearst, George G. Heye, S. C. Simms of the Field Museum, and several traders. His words were promptly communicated to others. Carl Litzenberger, president of the H. H. Tammen Company, quoted the content of the telegram to W. R. Eaton, congressman from Colorado:

> Certain interests apparently trying to railroad bill for marketing Indian products presumably for benefit of Indian which purpose I am convinced it will not accomplish. On the contrary I am convinced it will hurt them in the long run. Measure in all essentials unconstitutional creating private monopoly with exclusive right to use government labels most unheard of. Proceeding comes up in Washington sixteenth. Suggest wire your senator congressman.[276]

The senate and house bills were sent to committee but neither came up for a vote.

At the 1931 Gallup Ceremonial traders began discussing a movement to go after Maisel's, SWAC, Tammen, and others who mass-produced jewelry. On September 13, 1931, in a meeting at Fort Defiance, they assembled—100 strong—and formed the United Indian Traders Association (UITA). Elected were Berton. I. Staples of Coolidge, president; R. C. Master of Zuni, vice-president; Tobe Turpen, Gallup, secretary; and C. N. Cotton, Gallup, treasurer. Those present adopted a measure in the form of a redrafted Frazier-Leavitt bill and stated their intent to submit it to the Bureau of Indian Affairs for action.[277]

Figure 115. The H. H. Tammen Company illustrated these spoons in catalogs at least as early as 1917; they may have remained in production as late as the 1930s. Length of spoon on right 5.5 inches. Wheelwright Museum of the American Indian, 2003.37.16, 2003.37.27, 2003.37.17, gift of Mary G. Hamilton.

Figure 116. The H. H. Tammen Company made this silver and turquoise pin and illustrated it in catalogs at least as early as 1917. Width 2.25 inches. Wheelwright Museum of the American Indian, 47/1356, gift of Susan Brown McGreevy.

If the bill as introduced by Frazier at the next session of Congress, on February 4, 1932, reflects UITA's changes, they amounted to only a few words. Specifically, in Section 6, in which was stated the corporation's authority to establish advisory committees, to the original language, "composed of representatives of Indian groups," was added "and groups of Indian traders." Again the bill did not pass, but UITA set its sights on Maisel's Indian Trading Post and undoubtedly influenced the Federal Trade Commission (FTC) to institute proceedings against the company in May 1932.[278]

The FTC's focus on Maisel's was in response to the company's use of the slogan "Indian Made Jewelry" in its mail-order catalogs and in other contexts, while the company admittedly used machinery for much of its production. The H. H. Tammen Company was not prosecuted because they described their line as "Indian Design Jewelry" and in 1931 marked each piece of jewelry, "Not made by Navajos" (figures 115, 116). Gans was not prosecuted, perhaps because his shop was not nearly as mechanized as Maisel's; but the use of sheet silver was scrutinized in the Maisel case, and Gans must have watched closely.[279]

The FTC was prepared for Maisel's. In 1931–1932 the commission had engaged in two cases dealing with misrepresentation of products as Indian-made. In 1931 it initiated proceedings against Beacon Manufacturing Company of Bedford, Massachusetts, makers of Beacon Indian Blankets. The case was based on promotions of Indian blankets with a poster that showed an Indian weaver, though the text made no claims that blankets were woven by Indians. A cease-and-desist order against Beacon was issued June 28, 1932. On September 21, 1932, the Jeffrey Jewelry Company of Chicago agreed to a cease-and-desist order, prohibiting them from using the words *Indian* or *Navajo*, or in any other way implying their goods were made by Indians.[280]

Prior to prosecution of the Maisel case, well-attended hearings were held at Gallup, Santa Fe, and Albuquerque, and testimony was offered by Navajo silversmiths who utilized traditional techniques, traders from the Navajo reservation who sold the work of smiths who worked in traditional techniques, museum administrators, and many others involved in Indian affairs. Testimony suggested that many consumers understood the expression, "Indian Made," in relation to jewelry to mean that the silver had been wrought by hammering from an ingot of silver. The flooding of the market with inexpensive jewelry made by or with the assistance of machinery had wreaked havoc with the market for traditionally made silver. Some Navajo smiths were unable to sell their jewelry made from

hand-forged silver for more than the wholesale prices for pieces of similar size or design from Maisel's.

During the trial Haske Burnside was one of the many witnesses called to testify. After he quit working for Maisel's in 1931 he went after the company with a vengeance. He told John Adair that he and a friend who quit Maisel's at the same time, Herbert Brown Carey of Acoma, placed an ad in the Albuquerque newspaper exposing Maisel's production methods. Burnside must have complained about the Maisel's affair to anybody who would listen, even going to the home of Albuquerque curio dealer Charles Wright one evening to bend his ear about it. In 1934 a representative of the *Albuquerque Journal* talked to the superintendent of the Albuquerque Indian School, wanting Burnside to quit "bothering" them to print his writings about Maisel's.[281]

On August 21, 1933, the FTC published its findings and issued an order to cease and desist. In the findings, Maisel's competitors, "to-wit curio dealers throughout the United States," were identified as either "Indian traders who buy jewelry made by Indian silversmiths or employ Indian silversmiths and sell the products of said Indians," and who designate their merchandise as "Indian" or "Indian Made"; and others "engaged in the manufacture and sale of silver jewelry not made by Indians, but made in styles similar to those employed by Indians," and who "designate their products as 'Indian Design' jewelry."[282]

The FTC found that with regard to traditional Indian silver items described as "Indian" or "Indian Made,"

> The public have long known and purchased the said exclusively hand-made jewelry produced by the Indians under these terms, constantly understanding by said terms that the product has been, not merely made by Indians, but made by Indians by hand. The jewelry sold to the public under the said terms has acquired a reputation for beauty, artistic character, individuality and wearing qualities and a wide popularity, demand and distribution. The Indians and Indian traders have a valuable good-will in the said terms as applied to products hand-hammered and fashioned exclusively by hand tools and processes. This good-will is greatly enhanced by a widespread sentiment in favor of the Indians and products of their arts and crafts.[283]

The FTC found that Maisel's practices were damaging not only to traditional smiths and the traders who sold their work, but to Maisel's competitors, such as Tammen, who designated their products as "Indian Design."

The order to cease and desist included the following language:

> IT IS NOW ORDERED that respondent, its agents, representatives and employees, shall cease and desist from designating, describing or offering any of its silver jewelry products, made partly by machinery, for sale in interstate commerce by label, stamp, catalogue, advertisement or otherwise, as "Indian" or "Indian Made," either with or without the addition of the word "jewelry" or the addition of a word or words for the class of article, as "bracelet", "ring", "concha belt", or the like, unless the label, stamp, catalogue or advertising shall clearly and expressly state, in immediate context with the said descriptive terms in conspicuous lettering at least three-quarters as high and three-quarters as wide as the lettering of said descriptive terms, either that the jewelry so designated, described or offered (a) has been rolled by machine, or (b) has been pressed by machine, or (c) has been partly ornamented by machine, or (d) that there has been used in its production a combination of rolling, pressing and/or partial ornamentation by machine.... [284]

Maisel refused to comply with the order, and the FTC applied for a decree enforcing it. The decision of the court of appeals, issued May 1, 1935, included modifications to the language in the original order that weakened it and indicated some misunderstanding of the processes used by Maisel's. The FTC disagreed with the court's decision and filed for a re-hearing and modification, which was granted.[285]

Maurice Maisel submitted three reports to the commission on steps taken to comply with the order, including the adoption of the expression "press cut and domed blanks" to describe the company's jewelry. The commission rejected all of his reports, maintaining that the description was not adequate to explain to a consumer that the jewelry was machine made. On December 6, 1935, Maisel reported to the commission that his company would not meet their require-

ments. In July 1936 the court of appeals ruled that the steps taken by Maisel met the requirements imposed by the court order, and an effort to take the matter to the Supreme Court failed.[286]

During the company's peak, Maisel's employed up to 165 Indian silversmiths and machine operators at one time. Following the war Bud Maisel mechanized the operation further, installing 110-ton presses and a continuous, conveyor-belt, controlled-atmosphere brazing furnace (page vi). In that type of furnace, oxygen could be eliminated, thus preventing the formation of "fire scale" — oxidized copper which forms on the surface of silver alloys during open-air soldering, and which makes polishing much more time-consuming. Some pieces were polished with a buffing wheel, but most were polished in tumblers. The company changed the description of its jewelry to read, "Guaranteed Indian Made. Made by using press or drop hammer or by casting, furnace soldered, finished by tumbling."[287]

### Jewelry in the National Parks

Buoyed by the prosecution of Maisel's, on June 11, 1933, the UITA board of directors appointed a committee "to take action to stop the sale of imitation Indian arts and crafts in the National Parks." Although the Park Service could not legislate, it had the authority to control sales by concessionaires in the parks; and as demonstrated by the experience of Southwest Arts & Crafts, sales to concessionaires were huge. Such a ban could have serious implications for manufacturers and wholesalers.[288] Two days later the chair of the committee, E. B. Dale,

> wrote a letter addressed to Mr. Harold L. Ickes, Secretary of the Department of the Interior, Mr. John Collier, U. S. Indian Commissioner, and Mr. Horace M. Albright, Director of the National Park Service, stating such a committee had been appointed; that investigation in various Parks had disclosed sales of fakes as genuine Indian made articles; that such misrepresentations were misleading to buyers and unfair to Indians; that the situation was creating a widespread feeling of distrust and dissatisfaction concerning Indian made arts and crafts and was undermining the confidence of the buying public; and requested, in fairness to Indians and Park visitors, that a ruling be put into effect limiting and controlling the sale of such arti-

cles to the end that imitation Indian made articles be prohibited from sale in the Parks or be separated from the genuine and plainly labeled as imitation.[289]

On June 22, 1933, Secretary Ickes issued an order prohibiting the sale of Indian-design jewelry in the National Parks that was not actually hand-made by Indians. The order was to go into effect July 1, and in the meantime all other jewelry was ordered to be marked as imitation. UITA embraced Ickes's decision as "the greatest victory won so far" in the fight against machine-made jewelry.[290]

John Frederick Huckel had been concerned about the Harvey Company's sale of imitation silver for nearly two years. On September 14, 1931, he was shown examples of a product line, "Lucky Indian Jewelry," which was being marketed by the F. W. Woolworth Company, and he wrote Schweizer about it.[291] Schweizer replied:

> Woolworths [sic] have been selling this sort of thing for over a year in a lot of their stores, including Albuquerque. We had several cases a number of months ago where Indians bought bracelets at Woolworths [sic] for 15 cents and sold them to tourists on the [railroad] platform for $1.50, and we had the police get after the Indians and threaten to put them in jail if they continued.[292]

From that date forward, Huckel repeatedly expressed concerns about imitation jewelry to Schweizer, but Schweizer continued to purchase silver from the H. H. Tammen Company. When Huckel learned of Ickes' order of June 1933, he wrote to Schweizer again:

> I telephoned you this morning asking that you withdraw from sale immediately all imitation Indian merchandise and throw it away. This includes Grand Canyon, Albuquerque, La Fonda [Hotel, in Santa Fe] and any other places where we have it on sale.
>
> As the files will show, I have been opposed to our handling imitation Indian articles and have asked whether there wasn't some way to eliminate its manufacture. It not only low-

ered the integrity of the Indian business, but it deprived the Indians of at least part of their livelihood.[293]

Schweizer believed that the company had only $150 worth of Tammen's silver at Albuquerque and Santa Fe, and he sent a copy of Huckel's letter to F. C. Spencer at the Grand Canyon so Spencer could return to Albuquerque any inventory that was there. Spencer advised Schweizer that he had about $500 worth of Tammen jewelry to return, adding, "Since handling this stock we have sold many hundreds of dollars worth of it and from this standpoint alone Mr. Litzenberger should be glad to make an exchange."[294]

Schweizer was stunned by the revelation and wrote Spencer again saying, "I am very much surprised that you loaded up on this to this extent, and Mr. Huckel will have a fit if he finds out that we carried that much." In a subsequent letter to Huckel, Schweizer understated the value of the silver that was being returned to Tammen, saying it amounted "to some $350.00."[295]

On May 14, 1935, the Harvey Company, which formerly provided a sizable portion of Gans's silver business, removed SWAC's silver from sale at the Grand Canyon and ceased buying silver from them. On the other hand, Oscar Verkamp, another trader at the Grand Canyon, who as noted above purchased vast quantities of SWAC's textiles, continued to buy their silver; Gans had assured Verkamp in writing that SWAC's jewelry line could be sold in the parks. In May 1935 Arthur E. Demaray, assistant director of the National Park Service, asked Miner Raymond Tillotson, superintendent of Grand Canyon National Park, to ascertain where Verkamp acquired his Indian silver. Learning the source, Demaray instructed Tillotson to tell Verkamp to cease purchasing silver until the matter could be investigated.[296]

Immediately SWAC's foreman, Reed Newport, went to Washington to petition Ickes for permission to sell in the parks. Newport pointed out that Ickes's 1933 ban on the sale of certain jewelry lacked any description of standards. Nevertheless in June 1935 the National Park Service banned the sale of SWAC's jewelry in the national parks; the ban did not apply to their textiles or textile-based products. Ickes ordered all concessionaires to report in writing where they purchased their silver. All were also required to acknowledge receipt of the memo banning SWAC's silver.[297]

Gans was left with no choice but to adopt practices enforced by traders on the Navajo reservation. It had been many years since American silver coins were melted into ingots, and Navajo and other smiths had instead used Mexican *pesos* for their jewelry. However by 1935 there was an embargo on Mexican silver coinage, and it had been removed from circulation in the United States. In place of silver coins, traders distributed silver slugs, which their smiths had to pound out. Each slug was coin silver (.900 fine), eight gauge in thickness, and one ounce in weight. Gans ordered slugs from Handy & Harman, and all jewelry that was made for sale in the parks was made from them.[298]

In the course of the Maisel's prosecution, testimony revealed that some Indians working with traditional methods had begun to use rolling mills to roll out ingots or other silver. Only a few rolling mills were known to be in use on the reservations in the early 1930s, and these were on the Navajo reservation and at the pueblos of Zuni, Isleta, and Santo Domingo. In time the Park Service allowed the use of a rolling mill to flatten and thin the silver slugs. So although slugs were initially hammered out on steel plates in Gans's shop, they were eventually run through a rolling mill (figure 117). By 1940 most items made by smiths at SWAC were made from sheet silver and were sold everywhere but the national parks. The jewelry made by smiths at home in the pueblos, for example by Joe Quintana, was intended for sale in the parks and was made from slugs; these were marked with a small "s" (figures 118, 119).[299]

Harold Gans recalled that making jewelry from slugs increased the company's cost by about 20 percent per piece. He described a situation that resulted. His contact at Hamilton Stores, Inc., which had stores in Yellowstone National Park, complained that tourists would tell them that a bracelet that cost eight dollars in their stores could be purchased just outside the park in West Yellowstone for five dollars. Gans replied that this was correct, as the store in West Yellowstone was run by Smith & Chandler, which company was also a client. The bracelet sold by the former was made from a coin silver slug, while that sold by the latter was made from sheet silver.[300]

In the late 1930s Maurice Maisel used the regulation requiring the use of slugs to his advantage. He purchased pure silver from the refinery and mixed his own alloy. Presumably he milled sheets of this alloy, because he stated openly in advertising that his smiths used it. However he also began to cast one-ounce

*Figure 117. This rolling mill, made by the W. W. Oliver Manufacturing Company of Buffalo, New York, was used at Southwest Arts & Crafts at least as early as the 1930s. Many of the shop's silversmiths used it, especially to roll out coin-silver slugs, which were required by the National Park Service in the making of jewelry sold in the parks. Height 44.75 inches. Collection of Cippy Crazyhorse.*

Figures 118, 119. This pin is stamped with an s, which indicates that it was made from a silver slug under Southwest Arts & Crafts' piecework system for sale in the national parks. The slugs are the type used in many shops to comply with regulations of the National Park Service. Height of pin 1.75 inches. Slugs: collection of Harold J. Evetts. Pin: Wheelwright Museum of the American Indian, 47/1384, gift of Susan Brown McGreevy.

slugs from it. Whereas Gans and other traders paid refineries $0.45 or more for a slug, Maisel sold his own slugs directly to Indian jewelers for $0.50 each and still made a profit.[301]

### Trouble in the Indian Schools

Some purists looked askance at the use of a rolling mill but virtually condemned the use of sheet silver. Ambrose Roanhorse ordered a rolling mill for the silver-smithing shop at the Santa Fe Indian School in April 1932, and at that time he ordered eight-gauge sheet silver, which probably would have been milled down. However Roanhorse and his students also worked with thinner-gauge sheet silver until at least 1935.[302]

Roanhorse was criticized for the practice. Michael Harrison, an employee of the Indian Field Service who served at the Grand Canyon and in Santa Fe, considered himself an authority on Navajo silversmithing and was called as a witness for the prosecution in the FTC's case against Maisel's.[303] On September 22, 1935, Harrison wrote to Frederic H. Douglas of the Denver Art Museum:

> I hope you weren't one of the silver judges at Gallup. I didn't see the exhibit of silver from Santa Fe sent to Gallup, until after it had been returned. I happened out to the school a couple of weeks ago, and saw a bit of silver in a case, and raised hell with Roans for using sheet silver. It was evident what it was immediately... and then he broke the news that some of the pieces I was looking at were given *first prizes* at Gallup by the judges. That certainly is a joke on so-called judges, when they can't recognize silver jewelry made of [sheet silver], and especially hanging first prizes on them, in the face of the Maisel decision.[304]

After 1935 all of Roanhorse's orders for silver were for slugs, rather than sheets, and Roanhorse taught forging. Wilfred H. Jones, yet another skilled Navajo smith who began studying with Roanhorse in the third academic year, wrote an article published in 1936 in the school paper, *Teguayo*, titled, "How I Make a Silver Navajo Ring." Jones described and illustrated the process in detail, but importantly he explained how he started by pounding out his silver to even thickness, which he measured with a gauge or judged by eye.[305]

Figure 120. Jewelry designs by Anslem D. Begay,
drawn for Ambrose Roanhorse's class at the Santa
Fe Indian School in academic year 1935–1936.
Note the comments, "no good," possibly in
Roanhorse's hand, on the swastika and thunderbird.
Wheelwright Museum of the American Indian,
John Adair Collection.

In April 1933, Commissioner of Indian Affairs Charles J. Rhoads wrote E. B. Dale, superintendent of the Burke School, enquiring "as to the method used in teaching silversmithing in our schools. Will you inform us as to the tools used, the metals, and any other details which you believe would be helpful?" Dale replied with an upbeat description of the program, though describing some mechanized processes that had been criticized in the Maisel's case.[306]

Several months later Fred Peshlakai fell victim to the criticisms of Michael Harrison, who on February 7, 1934, sent a memo denouncing Peshlakai's program:

> The man in charge (Fred Peshlakais [sic]) formerly owned a curio store in Gallup, where he manufactured and sold Navajo jewelry. There is no doubt in my mind that Mr. Peshlakais is well qualified to work in the shop of any manufacturing jeweler, but I do not feel that this would qualify him for teaching silver-smithing in an Indian School. It should be ascertained whether or not Mr. Peshlakais can teach the art of silversmithing using the hand process common to the reservation. If this is possible, he should be retained; if not, he should be dismissed and a competent silversmith employed.
>
> I find in the shop, electric buffers, motor driven grind-stones for polishing turquoise, gasoline torches, ascetylene [sic] tanks, portable forges, French draw plates, [engraver's] blocks, precision tools and so on. The presence of equipment such as this, is absolutely at variance with the order of the Secretary of the Interior lately issued, which provides that no jewelry (Indian) machine processed will be sold on any Government Reservation under the jurisdiction of the Department of the Interior.[307]

Harrison continued, "Copper is furnished by the Government, with the result that the showcases are full of the most hideous excuses for hand craftsmanship I have ever seen." He offered a long list of suggestions, including one that sales should not undersell those of traders in the vicinity; that swastika, thunderbird, and arrow dies be eliminated; and that students travel to examine collections of early silver, including that at the Laboratory of Anthropology.[308] He then stated,

It certainly is not fair to have the UITA waging a fight on con-
cerns like Maisel who threaten the life of the silvermaking
industry among the Navajo, and then to have the Indian School
equip silver shops that approximate Maisel in Albuquerque and
Gans in Santa Fe, in exact working conditions. In other words,
we are fitting our boys to leave here and work for Maisel and
Gans; we are not fitting them to work for themselves.[309]

Peshlakai left the school in June 1935, though it is unclear whether it was directly
as a result of Harrison's criticisms. The school had been paying him $100 per
month, but it reduced his salary, and he later explained to John Adair that he had
quit in response to the salary reduction.[310]

Some of Harrison's criticisms may have been accurate, but others were
unfounded. The tools described in the shop do not constitute the type of machin-
ery used at Maisel's. Harrison was apparently unaware that Peshlakai was the
son or nephew of—and a student of—the celebrated master, Slender Maker of
Silver. As will be seen, Harrison and other "purists" would have imposed impos-
sibly high standards under which no silversmith could have competed in the
marketplace. Some would have prohibited the use of apprentices, though Pesh-
lakai told John Adair that Slender Maker of Silver had a "regular silver shop and
paid more than ten men to help him with his work."[311]

### The Indian Arts and Crafts Board's Silver Program

John Collier had been willful in his attempts to press legislation that would
advance the cause of Native American arts, but his heart was in the right place.
Collier believed that economic success of the arts was the key to Native self-
direction and cultural preservation. He held his beliefs deeply and passionately,
and his opportunity to advance them came in April 1933, when Franklin D. Roo-
sevelt appointed him Commissioner of Indian Affairs. Immediately Collier
devoted his efforts to the formation of a Committee on Indian Arts and Crafts,
whose role would be to turn New Deal policy into an action plan for Native arts.

The political reality of creating a board, developing a plan, and securing
funding through Congress consumed three years of precious time, during which
Collier must have felt that the mass-production and trivialization of Native

American arts were fast eroding any future opportunities at revival. In early 1936, with Roosevelt's signing of the legislation that created and funded the Indian Arts and Crafts Board, Collier faced the even greater challenge of finding a general manager. It was September before René d'Harnoncourt took the position. Swiss born, and with a lifelong interest in the arts, d'Harnoncourt had all of the desired administrative and marketing skills. More importantly, he had played a key role in the revival of traditional arts in Mexico and had helped to create and travel a major exhibition of Mexican folk arts.[312]

The purpose of the Indian Arts and Crafts Board (IACB) was the revitalization and promotion of traditional Native American arts, and d'Harnoncourt had been director for only a few weeks when the IACB took on silversmithing as one of its most urgent matters of business. On October 5, 1936, the IACB held its first meeting to establish government standards for Navajo, Pueblo, and Hopi silver. No silversmiths were invited to attend, but present were dealers, traders, "manufacturers," and museum personnel. It was generally agreed that a "genuine" product should be made by a single artist, though the assistance of apprentices was a sticking point, and unanimity was not reached. No consensus could be reached on whether to allow the use of sheet silver, but the use of machine-cut stones was favored by most of those present.[313]

The meeting, held at the Harvey Company's Alvarado Hotel, was summarized in a report written for the National Association of Indian Affairs' field office in Santa Fe. Judging from some of the language in it, the report must have been intended for internal use only. The comments of two participants, Berton Staples of the UITA and Julius Gans, illustrate the problems regarding standards to which some would hold silversmiths:

> *Staples,* at the direct request of someone, made his usual sanctimonious speech about 'the good of the Navajos' and said that on this basis, he and other traders were much opposed to sheet silver, since it eliminated an important process in manufacture which would result in further unemployment of Indians. He also stated that in his opinion, Navajo silversmithing should be developed according to the methods common before the coming of the Anglo-Saxon.

*Gans* first of all pointed out that in his opinion Indians other than Navajo should be considered by the meeting, and while Mr. Staples possibly talked for the Navajos, he was chiefly concerned with the Pueblos. He took exception to Staples' last remark, and quoting Washington Matthews as an authority, said this would eliminate the use of the file, emery paper, and other tools which he was sure Staples advocated. He then presented the case for sheet silver on the basis of its saving the Indian time, and made special reference to the effect this would have on any Indian working in town. He also raised the question of the welfare of his employees.[314]

The ambivalence over the use of sheet silver is illustrated by an early draft of standards resulting from meetings at the home of Mrs. Ina Cassidy, who in 1935 had been appointed director of the New Mexico Federal Writers' Project, apparently upon the recommendation of Collier. The use of sheet silver was approved in that draft. Further meetings, including a three-day meeting in Albuquerque in February 1937, led to the adoption on March 9 of printed standards, in which sheet silver was prohibited. The standards were signed by Collier and approved by Harold L. Ickes, Secretary of the Interior.[315] Collier's statement announcing the standards, "Navajo, Pueblo, and Hopi Silver," is lengthy but important:

> In announcing its standards for the Government mark for Navajo, Pueblo, and Hopi silver and turquoise products, the Indian Arts and Crafts Board makes the following statement:
>
> Navajo, Hopi, and Pueblo silverwork, as an art and as a product with a "quality" market, has been overwhelmed by machine production. The Indian craftsman, struggling to compete in price with the machine-made and factory-made imitations, has in turn been forced to adopt a machine technique, while at the same time his wages or earnings have been depressed to the "sweat-shop" level. Quality has been sacrificed to that extreme where Indian jewelry has become hardly more than a curio or a souvenir.

There is being produced, though in relatively small quantity, Indian silver and turquoise work as fine as ever produced in the older days. And there are many Indian craftsmen who, if a quality market can be restored, will eagerly and capably produce work as good as the best of earlier times.

They cannot, however, produce it in price competition with factory output, machine output, and "bench-work" semi-machine output.

The Arts and Crafts Board has studied the situation thoroughly and has sought the counsel of Indians, of Indian traders, and of specialists in the marketing of craft products. The Board has reached the conclusion that the Government mark should be applied only to the finest quality of wholly genuine, truly hand-fashioned, and authentic Indian silver and turquoise products.

Use of the Government mark is not obligatory on any Indian, any factory, or any merchant. The Board has no power or purpose to forbid such production by time-saving methods and with machine stereotyped and stinted materials as now supplies the curio market. But for that production which is worthy of a fine Indian tradition, the Board will make available the Government certificate of genuineness and of quality; and the Board will seek to widen the existing "quality" market and to find new markets for such output as deserves the Government mark. In the measure of its success, the Board will help to bring about a larger reward for a greater number of Indian craftsmen, and to save from destruction a noble, historic art, which under right conditions can have a long future.[316]

"Standards for Navajo, Pueblo, and Hopi Silver and Turquoise Products" are as follows:

Subject to the detailed requirements that follow, the Government stamp shall be affixed only to work individually processed and to work entirely hand-made. No object produced under conditions resembling a bench-work system, and no object in

whose manufacture any power-driven machinery has been used, shall be eligible for the use of the Government stamp.

In detail, Indian silver objects, to merit the Government stamp of genuineness, must meet the following specifications:

(1) *Material.* — Silver slugs of 1 ounce weight or other silver objects may be used, provided their fineness is at least 900; and provided further, that no silver sheet shall be used. Unless cast, the slug or other object is to be hand hammered to thickness and shape desired. The only exceptions here are pins on brooches or similar objects; ear screws for ear rings; backs for tie clasps and chain, which may be of silver of different fineness and mechanically made.

(2) *Dies.* — Dies used are to be entirely hand-made, with no tool more mechanical than hand tools and vice. Dies shall contain only a single element of the design.

(3) *Application of Dies.* — Dies are to be applied to the object with the aid of nothing except hand tools.

(4) *Applique elements in design.* — All such parts of the ornament are to be hand-made. If wire is used, it is to be hand-made with no tool other than a hand-made draw plate. These requirements apply to the boxes for stone used in the design.

(5) *Stone for ornamentation.* — In addition to turquoise, the use of other local stone is permitted. Turquoise, if used, must be genuine stone, uncolored by an artificial means.

(6) *Cutting of stone.* — All stone used, including turquoise, is to be hand-cut and polished. This permits the use of hand- or foot-driven wheels.

(7) *Finish.* — All silver is to be hand polished.

For the present the Arts and Crafts Board reserves to itself the sole right to determine what silver, complying with the official standards, shall be stamped with the Government mark.

Kenneth M. Chapman of the Laboratory of Anthropology in Santa Fe served as a special consultant to the IACB and assumed responsibility for its silver program. Chapman had been affiliated with institutions in Santa Fe for more than thirty years. He was a respected authority on southwestern Indian arts, particularly Pueblo Indian pottery. In the early 1920s he had been instrumental in the founding of the Indian Arts Fund, whose purpose was the collecting of traditional arts, particularly of the Pueblo and Navajo. The Indian Arts Fund and the nearly simultaneously established Indian Fair (later Indian Market), created an atmosphere in Santa Fe in which the living arts could thrive. Chapman's philosophy, his efforts to promote the arts, and his familiarity with and proximity to the centers of silver production made him an obvious choice for Collier and d'Harnoncourt.

Chapman single-handedly developed an identification system, examined and approved silver jewelry, and had each piece of approved jewelry stamped with dies that he controlled. He assigned a number to each Indian school that had or was likely to develop a silversmithing program, as well as to each trader who participated in the program. Every approved piece of jewelry was stamped with two dies. These included "US," followed by a tribal identification — Navajo or Zuni — and a number identifying its source (figures 121, 122).

The first numbers were assigned and stamped on jewelry under Chapman's supervision on April 5, 1938, and the occasion was considered momentous enough that in attendance were d'Harnoncourt and Kenneth Disher, assistant manager of the IACB. Gallup Mercantile Company was assigned the identification Navajo 1; other traders were to follow in sequence. Indian Schools were assigned numbers as follows: Tuba City, 10; Shiprock, 20; Crownpoint, 30; Fort Wingate, 40; Albuquerque, 50; and Santa Fe, 60 (figure 123). Ambrose Roanhorse made the first dies, and on the afternoon of the 5th he stamped a bridle, a belt, two bracelets, two buckles, two buttons, and a ring. Chapman did not indicate in his notes the source of those items, but they may have come from the Santa Fe Indian School.[317]

Figure 121. Juan de Dios, a Zuni smith, made the cast silver knifewing pins for C. G. Wallace. They are stamped with the Indian Arts and Crafts Board's identification, U. S. ZUNI 1. Juan de Dios is also known to have made crucifixes of the type shown, though this example is stamped with the board's other identification for Wallace, U. S. NAVAJO 2. Height of crucifix 3.25 inches. Pins: Collection of Mike and Allison Bird-Romero. Crucifix: collected by John Adair, 1938; Colorado Springs Fine Arts Center, 3102, gift of Alice Bemis Taylor.

Figure 122. Back of large knifewing pin illustrated in figure 121, showing the Indian Arts and Crafts Board's stamp, U. S. ZUNI 1.

Figure 123. Upper left: silver buckle by Wilfred Jones; lower left: chiseled and stamped button by Sam Roans; upper right: silver button by Anslem D. Begay; and center: silver button set with turquoise by John Benally. These are stamped with the Indian Arts and Crafts Board's identification for the Santa Fe Indian School, U. S. NAVAJO 60. The two delicate floral buttons are the work of Dooley Shorty or one of his students at Wingate Vocational High School and are stamped U. S. NAVAJO 40. Width of buckle 3 inches. All were collected by John Adair, 1938. Colorado Springs Fine Arts Center; buckle: 3127; buttons (in order as described): 3128, 3129, 3132, 3130, 3131, gift of Alice Bemis Taylor.

Figure 124. An unidentified Navajo smith made these silver bracelets for C. G. Wallace. They are stamped with the Indian Arts and Crafts Board's identification, U. S. NAVAJO 2. Greatest diameter 2.5 inches. Collection of Mike and Allison Bird-Romero.

Chapman initially inspected jewelry on the road and made his first trip with Ambrose Roanhorse in April 1938. The following day at Gallup, Chapman inspected and Roanhorse stamped forty-eight bracelets and three necklaces from C. G. Wallace, who was assigned the numbers Navajo 2 and Zuni 1. Also that day they stamped a single spoon from Berton Staples, who was assigned Navajo 3. Already Chapman found a flaw in the system: about 100 of Wallace's bracelets were made in such a way that Roanhorse could not stamp them.[318]

That evening Chapman approved more than 300 bracelets from Gallup Mercantile. The following morning Chapman approved another 231 bracelets and 77 rings from the same establishment, and over the following three days he continued to work there, inspecting Navajo and Zuni silver. For its Zuni jewelry, Chapman assigned Gallup Mercantile the designation Zuni 11, explaining in his notes that he left numbers Zuni 2 through 9 "for resident traders at Zuni, & others in Gallup who place orders with Zuni traders & have more or less control of type & quality." He left Zuni 10 for possible future work from the school at the pueblo.[319]

On Saturday April 16 Chapman went to Zuni, where from 2:00 to 5:00 he and Roanhorse approved and stamped 142 pieces at Wallace's shop. From 7:00 to 11:00 p.m. they graded and stamped another 226 pieces, and the following day they stamped another 155 Zuni pieces and 164 Navajo pieces. On the 18th they returned to Gallup Mercantile to inspect and stamp, and on the way back to Santa Fe, Chapman visited the Fred Harvey Company in Albuquerque.[320]

By late August Chapman had assigned Navajo 4 and Zuni 4 to Fred Harvey, Navajo 5 and Zuni 5 to Kelsey Trading Company, Navajo 6 and Zuni 6 to Zuni Trading Post (Robert Wallace's business), and Navajo 11 to J. M. Drolet. In March 1940 Chapman assigned Navajo 70 to the nascent Navajo Arts & Crafts Guild at Fort Wingate, but it appears that no other numbers were assigned.[321]

On a single inspection trip in May 1938 Chapman drove 1,000 miles. His time at the Harvey Company's Hopi House at the Grand Canyon seems to have been the least cost-effective. There he inspected several hundred pieces of silver, but after eliminating old pawn jewelry and pieces with lapidary-cut stones, he approved only fifteen pieces for stamping. Chapman must have sensed that the system was excessively time-consuming, and by the end of that month he was accepting almost all silver by mail.[322]

### Failings of the Indian Arts and Crafts Board's Silver Program

When the IACB jewelry program was conceived, the presumed incentive for traders to participate was improved sales. On January 15, 1938, the IACB issued an amendment to its silver regulations that read, "Every dealer offering for sale silver bearing the government mark may display in a prominent place a placard setting forth the standards and these regulations, such placard to be furnished by the Indian Arts and Crafts Board."[323]

Response to the program was mixed. C. G. Wallace found merit in it, and of 1,351 pieces approved and stamped between January 1 and September 4, 1939, more than 850 were from him. Herman Schweizer on the other hand, who had bought $1,000 worth of the stamped silver from Wallace, concluded that the program was a failure. When the jewelry purchased from Wallace did not sell, Schweizer had the poor quality hand-cut stones in some pieces replaced with machine-cut turquoise. He then reduced prices to a total of about $750 and mixed the jewelry in with the rest of the company's inventory. He explained to Chapman that the IACB had not advertised the program as it had promised, and the traveling public knew nothing about it. When their attention was drawn to the program and the identifying stamps, they became suspicious of the unmarked silver in the store, even though it was often superior to the stamped silver. Schweizer ceased selling the IACB-stamped silver by late 1938, and he told Chapman that the program could not continue unless lapidary-cut turquoise was permitted.[324]

Other opposition, including from Indian silversmiths, cropped up. Patricio Olguin wrote to John Collier on March 10, 1937, complaining about several of the standards adopted by the IACB. He pointed out that no Indian silversmith could make a draw plate, because none would have the appropriate steel and tools to do so. Hand-cutting of the finest hard turquoise was impossibly time-consuming and "completely impractical." As he explained, "I know, because I have tried this and it was such hard work that I was almost crippled, and then I cut only half a stone a day working all day and part of the night." And as for finish, hand-polishing could not provide "a high enough finish to please the public."[325]

Collier replied that Olguin was welcome to continue making jewelry as he had done, and that he was not obliged to follow the IACB standards. But Olguin wanted the government stamp on his jewelry, because to him it represented a form of protection; as he said, "the white man is only counterfeiting our art."

Diego Abeita of Isleta wrote to d'Harnoncourt on May 30, 1938, complaining that the silversmiths could not get their work stamped, but the traders could. He pointed out that the board did not have an Indian artist among its members, and he asked that the IACB repeal its standards.[326]

In 1939 the IACB presented a groundbreaking exhibition of Native American arts at San Francisco's Golden Gate International Exposition. From the success of the sales shop in the exhibition, d'Harnoncourt knew there was a potentially large market for handmade silver jewelry, and he admitted that the IACB standards for silver had not solved the "fundamental problem" of silver production. In 1940 the board contracted with John Adair—who in 1938 had completed the fieldwork for his landmark book on Navajo and Pueblo silver—to examine the situation. Collier was shocked by the results. Adair reported that only 23 percent of silver was made on reservations and was entirely Indian-made. The rest was made partly by machine, and partly by non-Indians.[327]

In conducting the research for his report to the IACB, Adair interviewed dozens of reservation traders, curio dealers, and Indian silversmiths. Every individual had an opinion about the IACB program, usually negative. Among the most insightful comments were those of Diego Abeita. Abeita was certainly aware that silversmiths had not been invited to some of the IACB's early meetings regarding silver, and he had learned about the sales at the Golden Gate International Exposition. Adair wrote,

> [I] went down to Isleta and saw Diego Abeita.... Diego, as ever, was bitter on the subject of the Arts and Crafts Board. He said that when the Board was originally set up it was supposed to help the Indian craftsmen as a whole, economically, and not just a selected few who happen to be the best craftsmen. He said that the [IACB] notably failed to perform this function at the [Golden Gate International Exposition], where they showed only work of high quality made in the Indian Schools. He said they should have collected work from independent craftsmen working on the reservation. He cites another example of the inadequacy of the Government in letting Maisel obtain a contract for the concession of selling silver at the airport—where thousands of dollars of Federal money was expended. He said it

would have been a perfect place to advertise genuine silver made by hand methods.

Diego says the [IACB] cannot benefit equally the traders and the Indians. He said, "You cannot serve God and Devil too." He says it must be either one or the other who will receive the benefits in the long run, and the [IACB] was not designed to help the traders. He said that the stamping of silver according to such rigid regulations was "archaic," and would not work out. For one reason: the [IACB] personnel was not extensive enough to stamp the silver when silver needed stamping. 2) The ignorant tourist did not like to see lettering impressed on the inside of a bracelet—their immediate reaction is that such silver is fake, and they wonder what is being put over on them, and ask why all of the silver doesn't have such a stamp. . . .

Diego is all for a cooperative, or some form of guild run by the Indians, in which there is Indian production for Indian benefit. He says that such an organization, to get around legal complications has to be nominally in the hands of (run by) Indians. He says the [IACB] by-law states that the Board cannot directly enter into business. He seems to think that the break should be made suddenly, that any attempt to gradually ease the trader out by revising the standards or stamping silver, is doomed to failure. . . .

I argued with Diego on this point, saying that the traders have a strong hold on the Navaho, and if antagonized would spread anti-Government propaganda among the silversmiths which would throw a monkey wrench into any cooperative that might be set up. Diego came back with the argument that the traders are going to be antagonized anyway, and it's better to antagonize them than to irk any further the Navaho people.

Diego told me that at a meeting of the All-Pueblo Council sentiment was expressed which favored recommending to the Indian Office taking away the appropriation for the Arts and Crafts Board. He said the Indians realize that billions

going for munitions means a readjustment of appropriations for the Indians, and that they are afraid of withdrawal of funds which they really need.[328]

In the conclusions to his report to the IACB, Adair focused on the physical character of worked silver, which had been at the heart of the controversy for a decade. Kenneth Chapman had devised a tool that could detect irregularities in the thickness of a bracelet and therefore determine whether it had been wrought by hand or made from sheet silver, but Adair believed that all well-finished pieces of jewelry looked similar. Adair recommended that the regulations of the IACB be dropped in favor of a requirement that a piece be "handmade, well-finished, of substantial weight, with good design and good turquoise." By that time Adair had accrued more knowledge and experience about Indian silver than all but a handful of non-Indians. Nevertheless, his report was ignored.[329]

Members of the United Indian Traders Association also had concerns about the IACB program, and in May 1938 they met to discuss them.[330] On March 2, 1940, M. L. Woodard, secretary of UITA, wrote d'Harnoncourt to express the association's dissatisfaction:

> Indian craftsmen, traders and dealers in genuine handmade Indian jewelry are very much discouraged because of the handicaps they face under present market conditions. In their opinion the silver standards set up by your Board have been of very little benefit except in a few isolated instances. Many believe that the present practice of marking an extremely small amount of the total production of genuine Indian handmade jewelry casts a reflection upon the other legitimately made products and thus hinders and hampers the craftsmen, traders and retailers who prefer to make and sell the genuine.[331]

Through Woodard's letter, UITA proposed its own set of standards, allowing the use of manufactured draw plates, lapidary-cut stones, and polishing by power equipment by either the jeweler or the trader/dealer selling his work. Woodard added,

Traders believe that the first silver standards of your Board as established under Mr. L. C. West have been given more than a fair trial and that they have proven beneficial in some instances but that they are entirely inadequate. We further believe a con-census of opinion of Indian craftsmen would be identical with that which we have heretofore expressed.

UITA proposed that the government adopt their standards and then issue traders adhesive tags, which could be attached to finished silver. Woodard attached a sample to the letter, which reads, "Indian Reservation Hand Made from Coin Silver Slugs." He explained that in 1939 two dealers had attached approximately 100,000 of the tags to finished work.[332]

The IACB silver program slowed dramatically with the outbreak of war, and the last record of it in Chapman's papers is of three pieces received from the Santa Fe Indian School on June 1, 1943. Due to their lack of mention in Chapman's notes, it appears that the schools at Tuba City, Shiprock, Crownpoint, and Zuni never submitted silver for approval.[333]

Shortly following the war UITA initiated its own silver program, with standards and identification stamps. The UITA program was centered on the Navajo reservation, though Southwest Arts & Crafts participated in it. The SWAC identification is UITA 21.[334]

### Redemption in the Indian Schools

Back in Santa Fe, Dooley Shorty graduated in June 1934 but stayed during the summer session for treatment of trachoma. He remained on campus through the following academic year, working as Roanhorse's assistant. On October 8, 1935, he succeeded Fred Peshlakai as the instructor in silversmithing at the Charles H. Burke School, and Roanhorse accompanied him on his journey there. Shorty ordered tools for the shop the next day (figure 125).[335]

If his recordkeeping is any indication, Dooley Shorty was the most meticulous silversmith and teacher of all. He maintained documents of his activity — purchases of materials and sales of jewelry — in painstaking detail. Though his teaching methods and students are not all identified, the quality of his and his students' work is. Chapman approved jewelry by Wingate students several times,

Figure 125. Dooley Shorty (right) with silver-smithing students at Wingate Vocational High School (formerly the Charles H. Burke School), Fort Wingate, New Mexico, 1938. Photograph by John Adair. Wheelwright Museum of the American Indian, John Adair Collection.

and in March 1939 he approved 107 pieces that Shorty delivered to the Laboratory of Anthropology.[336] The next month in an article in *Teguayo*, the student newspaper of the Santa Fe Indian School, titled "Santa Fe Indian School Trained Silversmiths Teach Successfully," Roanhorse's triumph was made clear:

> Among graduates of the School who are teaching silversmithing are Dooley Shorty at Wingate, Chester Yellowhair at Albuquerque [successor to Haske Burnside], John Bernally at Tuba City, Joe Wilcox at Winslow, and Wilfred Jones at Shiprock.
>
> A few weeks ago Mr. Shorty brought 107 pieces of student work to be government stamped at the School. Kenneth Chapman, judge for the Arts and Crafts Board pronounced this the best work that had been brought in for stamping.
>
> Mr. Ambrose Roans, leading instructor in silversmithing, says, "Dooley uses the best of the old designs, and the old way of making jewelry. He is improving as time goes by."
>
> Reports from the other teachers show that they are also doing well in their work. Mr. Roans says concerning them, "I am certainly glad that these former students of the School are doing so well as teachers on their home reservations. I hope that many other students who are now in school will do as well as they have done."[337]

In Santa Fe, Roanhorse's program had succeeded admirably. Visiting the school in November 1938, John Adair was impressed by what he saw:

> I went out to the Santa Fe school this AM and photoed silver. After seeing thousands of pieces of silver all summer the work turned out at this school still looks much the best of any I have seen — as a collection. This silver has a finish to it that is very perfect & design that is [especially] fine, which is of course the most important of all. Any silver that is not perfect technically doesn't reach the sales case — but is remelted — something the trader rarely does.[338]

In 1939 Ambrose Roanhorse joined Shorty at Fort Wingate. In that year the Educational Division of the Navajo Service established the Fort Wingate Arts and Crafts Guild, whose purpose was to provide employment for Navajo craftsmen who had graduated from the school at Wingate or who lived on nearby parts of the reservation. Roanhorse was selected as director of the project, which in 1941 became a larger enterprise, the Navajo Arts and Crafts Guild. He and Dooley Shorty collaborated on some projects, and in September 1941 they collected charcoal for the silversmithing shop from a timber fire near the Fort Wingate ordnance area.[339]

Roanhorse did some silversmithing at Wingate, though his other responsibilities generally kept him away from the bench. His orders for tools and material are clearly indicated to be for the "Arts and Crafts Guild," while all of Shorty's are for the "Silver Smith Shop." Roanhorse distributed supplies for silversmithing and other crafts on the reservation and collected the artists' completed work; at first he was assigned a 1937 Ford sedan, but it was inadequate, either for its limited capacity or for its ability to travel rough reservation roads, and in August 1941 he requested a truck.[340]

Roanhorse and Shorty were both involved with the Museum of Modern Art's 1941 exhibition, *Indian Art of the United States*, which was organized by René d'Harnoncourt and Frederic H. Douglas of the Denver Art Museum, in collaboration with architect Henry Klumb, a former associate of Frank Lloyd Wright. The sophisticated installation was a perfect environment for Roanhorse's striking, contemporary work (figures 126, 127).

Shorty went to New York to work at the museum for several days in January 1941. His hand-written itinerary documents his journey by the minute and every taxi fare to the penny. He traveled so efficiently and inexpensively that officials later questioned the accuracy of his numbers. Accompanying Shorty on the trip and to some social events was Hopi painter Fred Kabotie. In his autobiography Kabotie described a dinner at the Rothschild home prior to the opening, and his escape from the opening with Shorty and another friend: "The museum was so crowded that you could hardly see anything. Nobody paid any attention to the paintings or exhibits. Everybody was talking real loud. . . . " In a few days Kabotie was to meet Eleanor Roosevelt, but for that night they returned to their rooms at the YMCA — another stunning reminder of the cultural divide.[341]

Figure 126. Detail of the installation of southwestern Indian jewelry in the exhibition, Indian Art of the United States, at the Museum of Modern Art, 1941. Two silver cups by Ambrose Roanhorse, including the one illustrated here, are visible at right. Denver Art Museum, Native Arts Department.

Figure 127. Silver cup by Ambrose Roanhorse, ca. 1937. Roanhorse made this unsigned piece for the Indian Arts and Crafts Board "as one of several possibilities for new forms in Navajo silverwork." It is visible in the photograph reproduced in figure 126. Height 3.375 inches. Denver Art Museum, 1953.293, museum purchase from the Indian Arts and Crafts Board.

*Figure 128. Silver necklace by Ambrose Roanhorse, probably 1950s. Roanhorse's hallmark on the back of the naja is a stylized rocking horse incorporating the letters A and R. Length as shown 18 inches. Wheelwright Museum of the American Indian, 47/1200, gift of Susan Brown McGreevy and Tom McGreevy.*

In April 1941, Shorty offered to send three students to Santa Fe to work at Southwest Arts & Crafts. In a cordial reply the following day, Elsie Gans asked that they bring their own tools, as "we are anxious to start these boys to work at once." After all of the controversy over methods in the curio shops, and all of Roanhorse's and Shorty's efforts to create educational programs that embraced traditional methods, Shorty still saw value in employment in a shop. Like Patricio Olguin, Roanhorse and Shorty would obviously have questioned some of the standards and methods imposed on silversmiths by non-Indian "purists"; and as we have seen, John Adair would have sided with them. Shorty's students were among the very last silversmiths to work at SWAC before its benches were dismantled.[342]

One last controversy was resolved by students at the Santa Fe Indian School. Ambrose Roanhorse was a successful teacher and mentor to Navajo students, but many sources indicate that he did not like teaching what he considered a Navajo art to Pueblo students. In November 1939, shortly after he left the Santa Fe Indian School for Fort Wingate, students from Santo Domingo took three pins that they had made into the school, inspiring a new movement. Following the students' examples, Alfreda Ward, Head of Arts and Crafts, and Wilfred Jones, a former student who had just succeeded Roanhorse as the silversmithing instructor, adapted pottery designs in Kenneth M. Chapman's book, *The Pottery of Santo Domingo Pueblo*, for use on jewelry. Eight students from Santo Domingo were in the class at the time, and they made dies based on Ward's and Jones's adaptations. They entered examples of their new style at Gallup Ceremonial in 1940 (figures 129–131).[343]

### The Seligmans and Jerry Chakerian

At 1503 Central Avenue NW in Albuquerque today stand the remains of Bell Trading Post, the most highly mechanized jewelry shop of all from 1946 to 1974. As of this writing, the building is undergoing renovation and conversion into condominiums and retail space. Across the street is an unmarked building where an unassuming silver shop still operates. There a small number of Navajo silversmiths ply their trade much the way that smiths did in Maisel's shop in the late 1920s. Working with commercial silver sheet and wire, they make jewelry in patterns and according to methods that represent the merging of two early Albuquerque shops — those of the pre-war Bell Trading Post and of Seligman's.[344]

Figure 129. Silver pins by Tony Aguilar, student at the Santa Fe Indian School, 1941. These and the pieces in the next two figures are examples of a style of jewelry invented by students from Santo Domingo Pueblo in academic year 1939–1940. Width of bird pin 2.75 inches. Denver Art Museum, 1941.127, 1941.126, purchased by Frederic H. Douglas from the Santa Fe Indian School's craft shop.

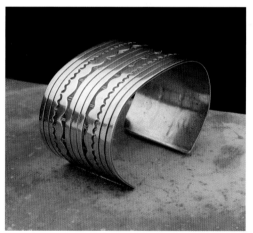

Figure 130. Silver Santo Domingo-style jewelry by students at the Santa Fe Indian School, 1941. Top left: pin by Jose Valencia García; top right and bottom left: buttons by Balardo Nieto; bottom right: pin by Santiago Bailon. Width of pin at bottom right 2.125 inches. Denver Art Museum (in order as described), 1941.133, 1941.130, 1941.129, 1941.132, purchased by Frederic H. Douglas from the Santa Fe Indian School's craft shop.

Figure 131. Silver Santo Domingo-style bracelet by Jose Valencia García, student at the Santa Fe Indian School, 1941; greatest diameter 2.75 inches. Denver Art Museum, 1941.134, purchased by Frederic H. Douglas from the Santa Fe Indian School's craft shop.

In 1935 Bell Trading Post, founded by J. T. Michelson and located at 403 West Copper, was a small operation with at least seven Pueblo and Navajo smiths. Bell Trading Post made silver in the manner employed at SWAC, and Michelson wanted to mechanize the operation. In January 1940 Michelson went to New York and placed an ad in the New York Times: "DIE MAKER: Good on novelty jewelry dies. Looking for exceptionally good die maker able to leave immediately for New Mexico.... Apply... J. Michelson, Edison Hotel...." M. J. "Jerry" Chakerian, a native New Yorker, responded to the ad. In his hotel room Michelson laid out some machine-assisted Indian-style jewelry and asked Chakerian if he could duplicate it. When Chakerian replied that it would be simple, he was hired on the spot.[345]

Chakerian mechanized Bell Trading Post, making it similar in operation to Maisel's. He worked for Bell until 1956, when he went to Denver and worked briefly for the H. H. Tammen Company, developing a plan to reinvigorate their ailing jewelry business. Chakerian's plan for Tammen assumed a workforce of 100, which he admitted the company was not prepared to employ, because rebuilding the company's market would take time. Interestingly he insisted that traditionally made jewelry should not suffer from the competition of machine-made goods, and he suggested that the company commit to an authentic Navajo handmade line:[346]

> The genuine hand-crafted Indian jewelry should not become victimized by the manufactured product. This is essential for the future health of Indian jewelry since, in the final analysis, it is the Indian designer himself who should develop and determine the trends of jewelry design for the future.
>
> A special department can be set up consisting of craftsmen capable of turning out a fine hand made product. Both lines can complement each other and under proper management and sales there is no reason why this craft cannot prosper more than ever and provide considerable employment to those particularly suited.[347]

Chakerian also suggested that the company employ Navajos to run the mechanized operation, so that it could describe its product as "Indian made." He

believed that at that time, $3,000,000 worth of jewelry at wholesale prices was sold annually by the four largest manufacturers, and he estimated that with population growth, completion of federal "super-highways," and increased tourism, the market for jewelry could double within the succeeding five or six years. It is unclear whether the Tammen company implemented any of Chakerian's recommendations, but its silver shop continued to run, at least at a modest level of operation.[348]

Chakerian's biggest venture was his acquisition in 1959 of Seligman's, a business founded around 1882 by Nathan and Simon Bibo in Bernalillo, fifteen miles north of Albuquerque. Bibo & Company was a mercantile house which traded with regional residents of the Rio Grande Valley, including people of several pueblos. Nathan's and Simon's nephews, Siegfried and Julius Seligman, began working for them in about 1902, and the company was flourishing when the young Seligmans bought it in about 1904.[349]

The Seligmans renamed the business Bernalillo Mercantile Company and almost immediately opened a branch store at Thornton (later renamed Domingo), just east of Santo Domingo Pueblo. As Julius's son, Randy, said, the company "sold everything but locomotives." The main store in Bernalillo comprised about 12,000 square feet, stocked with hardware, groceries, dry goods, lumber, and even coffins. They ran cattle, which they butchered themselves, and they had a steam-powered flour mill, fired with coal (figure 132).[350]

The Seligmans engaged in pawn and trade to a limited degree, and they maintained a small "banking" business, storing cash in their vault for customers. They had three apartments, equipped with fireplaces and bedding, which they provided for Pueblo Indians who came to town in wagons to trade for a six-month supply of food, dry goods, and other necessities. The Indians would usually arrive late and spend the night before unloading their wagons. They operated on credit, and their load of hides, pelts, and artifacts was used to pay off their prior six-month debt. They would then leave with another six-month supply, taken on good faith.[351]

By the early twentieth century the weaving tradition in the Rio Grande pueblos was faltering, and one of the Bibos' services was to supply traditional women's mantas. They ordered them from J. L. Hubbell's son, Lorenzo Hubbell, who in turn acquired them in trade from the Hopi, and the requirements were strict: they had to be large and new, or the Pueblos would not buy them. The

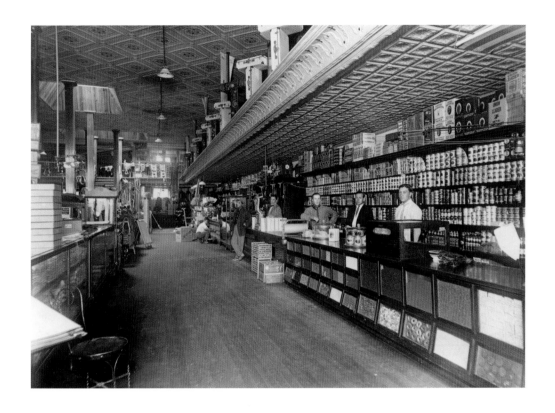

*Figure 132. Interior of Bernalillo Mercantile Company, 1920s. Courtesy of Susan Seligman Kennedy.*

Bibos ordered them in increasing quantities through 1903, and Bernalillo Mercantile continued to order them until 1918.[352]

Trade with the Pueblos resulted in the inevitable expansion into the marketing of Indian artifacts. Julius is well known for his involvement in a revival of pottery at Santo Domingo around 1910. In the early 1930s he opened an "Indian shop" in Bernalillo, across the street from the main store, in the location of what is now the Range Café. It was there where Frederic H. Douglas learned about the pottery revival and purchased a large collection for the Denver Art Museum; he later published an article on the important development.[353]

In the 1930s the Seligmans introduced a line of jewelry. Siegfried was the principal designer, though Julius created some designs (figures 133–136, 138). Up to 1939 the shop had only two silversmiths, but the operation was expanded that year to include a foreman, and by 1940 there were twelve smiths — eleven Navajos and one Pueblo. One Navajo was from Cañoncito and one from Shiprock, both in New Mexico, and one was from Chambers, Arizona; the rest were from the Gallup area. Five of the Navajos were Indian School graduates with some training in silversmithing. Seligman had a lenient arrangement with them, compared to other shops. They would work for five weeks and then could return to their homes for two weeks. Their wage was a minimum $15.60 per week and went as high as $17.50.[354]

No machinery was used in the shop except buffers, and each smith had his own workbench, of which there were fifteen. Some casting was done using French sand, which is a mixture of fine sand and clay, and in which an impression can be made. This is unlike tufa-casting, which requires painstaking preparation. Nevertheless, casting in any of the shops at the time was uncommon. All finished pieces had keyhole-shaped adhesive tags that said, "Genuine Indian Jewelry Handmade from Sterling Silver by the Navaho Indians." The Seligmans traded finished silver for rugs from wholesalers in Gallup, and they also sent silver to the national parks. Seligman sold wholesale through three salesmen, one working out of Florida, one out of Chicago, and one covering the West.[355]

Julius ran the shop in Bernalillo until about 1946, when he moved it and his family to Albuquerque. Seligman's, at 2309 West Central, handled all types of Indian arts and produced a distinct line of jewelry. The core of the silversmithing operation was two Navajo smiths, Merejildo Chavez and John Dennison.

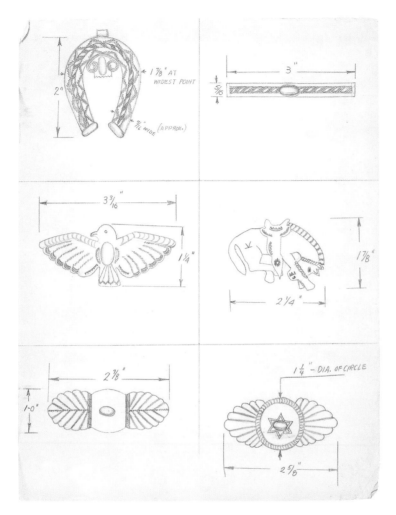

Figure 133. Jewelry designs by Julius Seligman, drawn by Siegfried Seligman in the 1930s or 1940s. Collection of Julia Y. Seligman.

Figure 134. Silver pin from one of Julius Seligman's shops, 1940s or 1950s. A drawing of this pin by Seligman can be seen in figure 133. None of Seligman's jewelry is hallmarked. Width 2.25 inches. Collection of Armen Chakerian.

*Figure 135. Jewelry designs by Julius Seligman,*
*drawn by Siegfried Seligman in the 1930s or 1940s.*
*Collection of Julia Y. Seligman.*

*Figure 136. Jewelry designs by Julius Seligman,*
*drawn by Siegfried Seligman in the 1930s or 1940s.*
*Collection of Julia Y. Seligman.*

Chavez, from Cañoncito (now Tohajilee), had worked for Bell Trading Post. His wife, Bessie; son, Sam; daughter, Helen Platero; and son-in-law, Joe Platero, also worked there. Some of the most successful pieces in the jewelry line, designed by Siegfried and made with twisted wire, were specialties of Merejildo and his family. Those designs were illustrated in Seligman's catalog of ca. 1949, and a photograph of John Dennison was reproduced on the cover (figures 137–139).[356]

Merejildo did almost all of the casting, which included bracelets, ketohs, rings in ketoh patterns, and pins. One specialty product was a squash-blossom-like necklace, based on a tufa-cast necklace that Julia Seligman had purchased from trader Tobe Turpen. Julius admired and re-designed it, modifying the elements to adapt it to the commercial casting process.[357]

Again reflecting the Seligman family's style of conducting business, they built hogans behind the shop so silversmiths could live on the property, and the smiths and their families were allowed to return to the reservation for family, ceremonial, and community activities.[358]

When Jerry Chakerian bought the business it was partially mechanized with a four-ton foot-operated punch press and tumblers for polishing. Some blanks were cut and domed on the press, but complex shapes were outlined on silver with templates and cut out with jeweler's saws. The processes, some of which can be traced back to the 1920s, have remained virtually intact at Indian Silver Crafts, Inc. under the direction of Chakerian's son, Armen; the tools and equipment are among the oldest surviving examples still in use in New Mexico (figures 80–82, 140–142).[359]

Figure 137. Catalog for Seligman's, Albuquerque, ca. 1949. John Dennison, a Navajo silversmith who worked for many years for Seligman's, and later for M. J. Chakerian, is shown at work. Private Collection.

Figure 138. John Dennison made this silver bracelet at Seligman's in the late 1940s. Julius Seligman's designs for bracelets of this type can be seen in figure 135. Width 2.5 inches. Collection of Julia Y. Seligman.

Figure 139. Four silver bracelets made at Seligman's with twisted or braided wire by the Navajo silversmith Merejildo Chavez, possibly with assistance from members of his family, late 1940s. Three of these styles were illustrated in Seligman's catalog of the late 1940s. Width of braided wire bracelets, 2.5 inches. Collection of Julia Y. Seligman.

Figure 140. Copper, zinc, and aluminum templates
used by Julius Seligman's silversmiths in the 1950s
(some possibly as early as the 1930s) to outline jewelry
patterns on sheet silver. Height of Navajo man with
hat 2.25 inches. Collection of Armen Chakerian.

*Figure 141. Silver pin made at Seligman's, with the template used to outline the pattern on sheet silver. The pin was illustrated in Seligman's catalog of ca. 1949. Width of pin 2.125 inches. Template: collection of Armen Chakerian. Pin: Wheelwright Museum of the American Indian, 47/1372, gift of Susan Brown McGreevy.*

*Figure 142. Scales used to weigh silver at Seligman's
in Albuquerque from 1946 to 1959, and probably
used in Julius Seligman's shop in Bernalillo from
the 1930s to 1946. They are still used at Indian
Silver Crafts, Inc. Collection of Armen Chakerian.*

Figure 143. Manuel Naranjo at Kohlberg's,
Denver, 1950s. Photographer unidentified. Manuel
is at the workbench that he made around 1950 after
Erich Kohlberg invited him to return to the shop.
Naranjo Family Collection.

## Manuel Naranjo Moves to Denver

In 1930 Maisel's foreman, Clarence Johnson, moved to Denver to start his own shop, Johnson Jewelry Company. Manuel and a Navajo smith, John Yazzie, liked Johnson and left Maisel's in 1931 to work for him. In addition to making jewelry the Johnson company did repair work, and one of the shops for which they did repairs was Kohlberg's.[360]

Erich Kohlberg was a second-generation curio dealer. He joined his uncle, Moritz (M. J., also Morris), in business in 1903. Moritz Kohlberg was born in Westphalia, and like many of his generation, he and his older brother, Ernst, immigrated to the United States to avoid obligatory service in the Prussian army. Ernst moved to El Paso first; his journey was later fictionalized by Tom Lea in his book, *The Wonderful Country*. With experience as a tobacconist, in 1881 Ernst founded a business selling cigars. Moritz temporarily remained in the East, living at Watertown, Connecticut, but he soon joined Ernst in El Paso and became a partner with him in Kohlberg Brothers, wholesale and retail dealers in cigars and tobacco.[361]

The business was so successful that in 1886 they founded the International Cigar Factory in El Paso, but also that year Ernst bought out Moritz's interest (or according to Erich Kohlberg, Moritz won a lottery in Louisiana). Moritz promptly established a curio store in Ciudad Juarez called The Famous. In 1896 Moritz moved to Denver, where he became manager of the Mexican and Indian Curio Company, a branch operation of Arthur A. Kline's company of the same name in El Paso. Kohlberg eventually purchased the business, and with his death in 1931, his nephew Erich took it over.[362]

One day in 1933 — and Manuel recalled specifically that it was a Friday or Saturday — he was asked to deliver a repair to Erich Kohlberg. They got to talking, and Kohlberg offered Manuel fourteen dollars per week to become his silversmith, with the potential for a raise to fifteen dollars if it worked out. That was more than Johnson paid him, so he took the job and stayed with Kohlberg until shortly before the war. Manuel worked daily at the shop but also made jewelry on the side. Around 1940 he made some jewelry for E. Rosalia Callahan, a curio dealer on 17th Street in Denver. A few pieces that were still in the Callahan family's possession many years later are the only documented examples of his work from that era (figures 144–146).[363]

*Figure 144. Manuel Naranjo made this matching set of silver brooch, bracelet, and ring, all set with moss agate, in about 1940 for Denver curio dealer E. Rosalia Callahan. He made the bezels without backs so light could pass through the stones. Naranjo did not sign any of his work before World War II, and he made all of his jewelry with commercial silver sheet and wire. Greatest diameter of bracelet 2.75 inches. Naranjo Family Collection.*

*Figure 145. Manuel Naranjo made this silver brooch set with petrified wood, and ring and bracelet set with jasper, in about 1940 for Denver curio dealer E. Rosalia Callahan. Width of pin 2.25 inches. Naranjo Family Collection.*

*Figure 146. Manuel Naranjo made this silver pin and ring, set with turquoise, in about 1940 for Denver curio dealer E. Rosalia Callahan. Width of pin 2.5 inches. Naranjo Family Collection.*

Manuel's work is illustrated on at least two pamphlets that Kohlberg distributed. This type of folder, printed by the thousands by the H. H. Tammen Company, has a photograph of a young Navajo girl on the front and the title *Indian Symbols*. Inside is a chart of Indian symbols and their meanings, and in one lower corner is the lettering, "H. H. T. CO." Tammen printed these as generic items, and either Tammen or other printers customized them for businesses by printing their name and selected illustrations on the outside back panel. On one of Kohlberg's pamphlets is Manuel's jewelry with the statement, "Beautiful Silver Jewelry made by 'Thunderbird' our Indian Silversmith. Come and watch him at work" (figure 147).

Manuel's Tewa name is untranslatable and is a reference to rustling leaves. He was never known as Thunderbird, not even at Kohlberg's. Here Kohlberg repeated a practice seen in various forms in the 1930s. Working in the window, Manuel lent authenticity not only to his jewelry, but to the shop. And as a living exhibit, Manuel also rejected anonymity. However neither his Tewa name nor his Spanish name would have been recognized by the public as an Indian name, so Kohlberg simply invented one.[364]

During the war Manuel worked in a munitions plant on Denver's west side and at Rocky Mountain Arsenal. For a few years after the war he worked for the Tammen Company, stamping designs on machine-made blanks, just as he had done at Maisel's; and in the summer of 1949 he worked as a silversmith at Seven Falls, a tourist attraction in the foothills of the Rockies on the edge of Colorado Springs. But Manuel lost interest in jewelry and temporarily worked as a house painter.[365]

In the early 1950s Erich Kohlberg invited Manuel to return to his shop, and this time Manuel went to stay. Manuel needed a workbench, so he fashioned one from the base of a treadle sewing machine, covering the top with sheet metal and mounting the corners with stamped copper ornaments. He worked at the bench in the store's window until the death of Erich Kohlberg's widow, Paula, in December 1993, when he was forced to retire (figure 148).[366]

In his many years in Kohlberg's window, Manuel became a local celebrity. Mayors of Denver and governors of Colorado watched him at work. More vivid in his memory, though, were visits by entertainers. Bob Hope and Ed Sullivan watched him together from the sidewalk; they did not enter the shop, keeping the window between themselves and Manuel. Greer Garson, Ginger Rogers, and Jane

Russell all went into the shop to observe. Vincent Price visited with Manuel, and Manuel knew that Price represented the Indian Arts and Crafts Board, which acquired his jewelry (figure 149). John Wayne made the biggest impression. He entered the store, approached Manuel, watched with interest and took the time to introduce himself and engage in conversation.[367]

Manuel never sensed any prejudice and never felt exploited. He enjoyed his job and considered it important, and he did not retire until the age of eighty-four. But when asked late in life what he had done for a living, he never replied that he was a silversmith. Instead he would answer, "I am an Indian."[368]

Manuel wanted to leave Santa Clara when he was young; "There was nothing to do there." That sentiment was expressed to me by elders from several pueblos, though in most cases those who lived outside their pueblo of birth retained strong ties to it, and in some cases returned to it later in life. Even in his eighties Manuel often went back to Santa Clara to hear and speak his language and to participate in dances.[369]

Manuel was a fine singer and drummer, and every weekend during summers in the 1950s he would go to Lookout Mountain, west of Denver, to drum and sing Tewa songs for the tourists. Though in his youth he yearned to leave the pueblo, in his old age he remembered his childhood with fondness. Asked what he recalled, he spoke at length about games, rising from his chair and using his cane to demonstrate the swing of a shinny stick.[370] Manuel Naranjo brought life to a neglected episode in history. He passed away April 9, 2004.

**Beautiful Silver Jewelry made by
"Thunderbird" our Indian Silversmith
Come and watch him at work**

Large Assortment of Chimayo Indian Blankets
Table Throws, Pillow Tops and
**Authentic Navajo Rugs**
**A N T I Q U E S**

**K O H L B E R G'S**
429 Seventeenth St.
**Denver**

Dependable Dealers in
Indian and Mexican Goods—since 1888

*Figure 147. Back panel of pamphlet of Indian symbols, printed by
the H. H. Tammen Company for Kohlberg's, Denver, 1930s. The
jewelry is by Manuel Naranjo, who is identified as "Thunderbird,"
a name made up by Erich Kohlberg. Private Collection.*

*Figure 148. Manuel Naranjo's workbench, which
he made on the base of a treadle sewing machine
around 1950. He worked on this bench in the
window of Kohlberg's for forty years. Height 33.5
inches. Wheelwright Museum of the American
Indian, 2007.30.1, purchased by the Wheelwright
Museum Collectors' Circle.*

Figure 149. Manuel Naranjo made this pair of silver cuffs at Kohlberg's in 1969. Although he developed a distinctive style, these resemble the jewelry that he would have made at Maisel's forty years earlier. Neither cuff is signed. Length of each 2.125 inches. Purchased by the Indian Arts and Crafts Board from Kohlberg's, 1969. National Museum of the American Indian, Smithsonian Institution, 257419.000.

# NOTES

*Abbreviations have been used for the following archives and archival collections:*

ASM-TSD   Dozier Papers, MS 23. Subgroup 1: Thomas S. Dozier Papers (1885–1919). Arizona State Museum Archives, Tucson.

COH-MAM   Martha A. Maxwell Collection, MS 762. Stephen H. Hart Library, Colorado Historical Society, Denver.

DAM-NA   Files of the Native Arts Department, Denver Art Museum.

HM-FH   Fred Harvey Collection. Billie Jane Baguley Library and Archives, Heard Museum, Phoenix.

MNM-JG   Jake Gold Collection. Fray Angélico Chávez History Library, Palace of the Governors, Department of Cultural Affairs, Santa Fe.

MNM-JSC   J. S. Candelario Collection. Fray Angélico Chávez History Library, Palace of the Governors, Department of Cultural Affairs, Santa Fe. Unless otherwise noted, all letters are located in the business correspondence file for the year in which they were written.

MNM-KMC   Kenneth M. Chapman Papers. Laboratory of Anthropology Archives, Museum of Indian Arts & Culture/Laboratory of Anthropology, Department of Cultural Affairs, Santa Fe.

NAD-BIA   Record Group 075, Records of the Bureau of Indian Affairs. National Archives and Records Administration, Rocky Mountain Region, Denver.

NADC-BIA   Record Group 075, Records of the Bureau of Indian Affairs. National Archives and Records Administration, Washington, DC.

NADC-FTC   Federal Trade Commission Papers. National Archives and Records Administration, Washington, DC.

NMRC   New Mexico State Records Center and Archives, Santa Fe.

NMRC-SFC   Santa Fe County Contracts. New Mexico State Records Center and Archives.

NMRC-LD   1959–137, New Mexico Letters & Diaries. New Mexico State Records Center and Archives, Santa Fe.

NMRC-TA  Territorial Archives of New Mexico. New Mexico State Records Center and Archives, Santa Fe.

PU-AAIA  Association on American Indian Affairs Records, 1851–1995. Seeley G. Mudd Manuscript Library, Princeton University, Princeton, NJ.

RBHPC  Rutherford B. Hayes Presidential Center, Fremont, Ohio.

SFCC  Santa Fe County Courthouse, Santa Fe.

SFCC-D  Santa Fe County Deeds. Santa Fe County Courthouse, Santa Fe.

UA-HTP  Hubbell Trading Post Records, 1882–1968, AZ 375. University of Arizona Library, Special Collections, Tucson.

UNM-CW  Charles Wright Diaries, 1914–1936. Center for Southwest Research, Zimmerman Library, University of New Mexico, Albuquerque.

UNM-TBC  Thomas B. Catron Papers, MS 29. Center for Southwest Research, Zimmerman Library, University of New Mexico, Albuquerque.

UTEP  C. L. Sonnichsen Special Collections Department, University Library, University of Texas at El Paso.

UTEP-KF  Kohlberg Family Papers, MS 369. C. L. Sonnichsen Special Collections Department, University Library, University of Texas at El Paso.

WMAI-JA  John Adair Collection. Wheelwright Museum of the American Indian.

1. *Santa Fe New Mexican*, April 20, 1893. In these notes *Santa Fe New Mexican* refers to the daily paper regardless of its name at the time the cited article was printed.

2. Harold Gans, interview with the author, September 10, 2001.

3. Henry Russell Wray's article, "A Gem in Art," was first printed in the *Philadelphia Ledger* and was reprinted in the *Weekly New Mexican Review* on June 21, 1894. Candelario is quoted in Dunne 1948:11.

4. Gottschall 1894: 10, 13.

5. Gottschall 1894: passim. For the "vanishing red man" as a sales tactic, see Batkin 1999: 294.

6. Gottschall 1924: 3–4.

7. Ibid., 4.

8. Gottschall 1924: 35. Gottschall was well acquainted with the Santa Fe market. In one letter to J. S. Candelario he specified that he wanted "Quivers (no sheepskin)." He also asked, "Where is Jake? Can you tell me where and under what circumstances Abe died." Gottschall to Candelario, June 22, 1905, MNM-JSC. The date of Schmedding's purchase is in Schaefer 1974: vi. The number of pots is in Schmedding 1974: 314–315. The date of Keam's sale to Hubbell in May 1902 is in Graves 1998: 227.

9. Riggs et al., ca. 1897. His description of the exhibition is on page 31. The title of the booklet was appropriated from an earlier work; see Farrar 1879.

10. The poem as quoted here is from an insert stapled into Riggs 1897. It differs only slightly from that printed in *Camp Life in the Wilderness*.

11. Riggs 1899, 1897. I have found no evidence that Riggs served in the Spanish-American War.

12. *The Great Divide* was published from 1889 to 1893. It was a popular magazine and an advertising platform for Tammen's huge curio business.

13. Boswell 1874.

14. For a biography of Maxwell, see Benson 1986. The contributions by Coues and Ridgway are in Dartt 1879: 217–237.

15. James to Martha Maxwell, September 1, 1873, COH-MAM.

16. Glass to Maxwell, February 20 and 26, 1874, COH-MAM.

17. Maxwell to Dascomb, October 26, 1874, copied from an original in the Oberlin College Archives, COH-MAM. Dascomb was Principal of the Female Department at Oberlin for two terms ending in 1870 and then served on the Ladies' Board until her death in 1879. Oberlin College Digital Collections.

18. Maxwell to Dascomb, November 15, 1874, COH-MAM.

19. "Boulder and Sunshine, Two of Colorado's Most Beautiful Cities. The Rocky Mountain Museum: How Collected and What It Contains.... "; *Kansas City Journal*, July 23, 1875, COH-MAM. *Colorado Farmer*, prior to July 30, 1875, when it was quoted in the *Boulder News*.

20. "Boulder and Sunshine, Two of Colorado's Most Beautiful Cities. The Rocky Mountain Museum: How Collected and What It Contains.... "; *Kansas City Journal*, July 23, 1875, COH-MAM. The photograph, in Benson 1986, can no longer be located. Its date is deduced from a marginal note in a letter from Maxwell to her daughter, Mabel, October 18, 1875: "I am talking of having some pictures of the museum taken, if I do I will send you some.... "; COH-MAM.

21. "A Modern Diana. Sketch of the Life and Experiences of the Rocky Mountain Huntress — The Pursuit of Science under Difficulties," *Philadelphia Press*, August 11, 1876, COH-MAM.

22. *Daily Central City Register*, July 17, 1876; Dartt 1879: 119–123.

23. Corbett, Hoye & Co. 1873 gives his location as "G, bet. Larimer and Holladay." Corbett, Hoye & Co. 1874 and 1875 locate him at 219 16th, while Blake 1875 and 1876 locate him at 245 16th. Blake 1877 locates him at 389 Larimer, after which listings cease. For Hamilton's career as a Presbyterian, see Murray 1947.

24. Corbett, Hoye & Co. 1874, 1875. Achert also dealt in cigars and tobacco.

25. "Importing English Sparrows," *Rocky Mountain News*, February 3, 1875.

26. Corbett, Hoye & Co. 1877; Baskin & Co. 1880: 618.

27. *Denver Daily Times*, February 24, 1881.

28. Ibid.

29. Baskin & Co. 1880: 426–427; Corbett, Hoye & Co. 1878–1880; Corbett & Ballenger 1881, 1882–1887; *Cheyenne Daily Leader*, September 23, 1887.

30. Corbett & Ballenger 1885–1887; Ballenger & Richards 1890–1892, 1896–1898, 1899, 1900; "Loved Animals: George Taylor, Pioneer in Taxidermy Dies at the County Hospital," *Rocky Mountain News*, April 30, 1901.

31. Tammen's given name and early life are from Stern 1989b: 10. Tammen's position at the Windsor Hotel is in *Rocky Mountain News*, June 23, 1880. The article on St. Jacob's Oil is "Denver Sentiment upon Questions Other than Politics and the Location of the Capital [sic]," *Rocky Mountain News*, October 29, 1881.

32. Tammen's and Stuart's first business listing is in Corbett & Ballenger 1882. Tammen's and Stuart's 1882 catalogs (Tammen 1882a, 1882b) are described in Batkin 2004: 42–45. The dissolution of their partnership is in *Rocky Mountain News*, January 1, 1885.

33. The descriptions of Tammen's business are in Ives & Co. 1885, 1889.

34. The article was first published in the *Denver Daily Tribune* in 1881. Tammen reproduced it on the inside front cover of his catalog, *Relics from the Rockies* (Tammen ca. 1887).

35. Tammen 1882b. An obituary article claims Litzenberger immigrated in 1892 (*Denver Post*, September 26, 1953), but the city directory for 1891 places him in Tammen's employ (Ballenger & Richards 1891). For Tammen's publishing ventures, see Stern 1989a, 1989b.

36. Rackliff & Wainey 1885: 5–6.

37. Gould & Co. 1886; Walz 1888, 1906.

38. Nolan 1992: passim; "Edgar Walz: Autobiography," NMRC-LD; "Last Summons to Mrs. Catron: Passed into Sleep of Death at an Early Hour This Morning," *Santa Fe New Mexican*, November 8, 1909.

39. Probate records numbers 1933 and 1937 for William G. Walz, El Paso County, Texas, UTEP. Information on incorporation is in UNM-TBC, Box 2, Series 801, Folder 14. Julia's undated letter and a shipping manifest dated December 23, 1907, are in UNM-TBC, Box 33, Series 103, Folder 3.

40. Worley & Co. 1899; Walz to Julia Catron, September 15, 1900, UNM-TBC, Box 2, Series 801, Folder 14. Information on Beach and Akin is from Worley & Co. 1898, 1899; El Paso Directory Co. 1900, 1902; Worley & Co. 1903, 1904.

41. Louis's first license was issued March 2, 1858, NMRC-TA, microfilm reel 51. That he left Santa Fe and returned is in a letter from John M. Kingsbury to James Josiah Webb, March 14, 1858 (Elder and Weber 1996: 85). Aaron claimed 1855 was the year he first arrived in Santa Fe in *Santa Fe Weekly Democrat*, January 6, 1881; in 1880 he advertised his business as "Established 1855." That he was working as a clerk is in Census of Santa Fe, June 26, 1860, NMRC. Abe and Jake claimed to have established their businesses in 1859 and 1862, respectively.

42. Purchase of the houses and the partnership are in SFCC-D, D: 100–101; 377–385. The ad, which includes the description of the business, is in *Santa Fe Weekly Gazette*, August 17, 1867.

43. Purchase of the grist mill is in SFCC-D, D: 442–444.

44. Aaron's business licenses are in NMRC-TA, microfilm reels 51, 52. U. S. v. Aaron Gold, "Selling Liquor to Indians," Territory of New Mexico Supreme Court Cases 7, 79, NMRC. Dike 1958.

45. Gambling in 1849 is described in Powell 1931: 74. The insurance map is in Sanborn Map Company 1883. The dance and fines are in *Santa Fe New Mexican*, March 25, 1876.

46. Stevenson 1883: 421–422. Their licenses are in Santa Fe County License Book, 1876–1884, NMRC.

47. Arrival of the train is in *Weekly New Mexican*, February 14, 1880. The fact that printing of the daily paper resumed on February 27, 1880, is proven by the statement, "Volume 1, Number 1," on the masthead.

48. Perea is identified as the owner of the property in 1880 in SFCC-D, C: 267–269 (purchaser in 1861) and L: 432–433 (seller in 1887). Picayune is defined in Oxford Universal Dictionary 1955.

49. From an unidentified newspaper clipping in R. B. Hayes Scrapbook, Volume 78, pp. 147–154, RBHPC.

50. Ibid. The pottery at RBHPC was not cataloged until decades after the Hayes's trip to New Mexico, and it is unclear which pieces, if any, were collected by Lucy Hayes.

51. See Batkin 2004.

52. *Weekly New Mexican*, August 2, 1880. The article is long and includes considerable detail about the two dancers.

53. Gold's initial success is in *Weekly New Mexican*, June 21, 1880. The article is devoted to a young Native American named Jesus de los Relles, said to be Apache, then working for Gold. Rumor had it that de los Relles was a descendant of Victorio and that Gold had agreed to provide the young man an education, but Aaron would not comment. Jake Gold leased the rooms from Paul F. Herlow for one year with an option to extend the lease for a year; SFCC-D, R2: 111–113. The rooms were drawn on the lease agreement, allowing them to be matched to the 1883 Sanborn Map of Santa Fe (Sanborn Map Company 1883), which shows that the rooms were in the present location of Santa Fe's municipal parking garage. The directory listing is in McKenney & Co. 1882. Arizona Historical Society dates the directory to 1883, but an advertisement for the Burlington & Missouri River R. R. states that their new route to Denver will be "open for business July 1, 1882." Bandelier's comment is in Bandelier 1966: 238.

54. Ads in the *Santa Fe New Mexican* identify Jake as manager of Aaron's store until late May 1883 and as proprietor starting in early June. Wray, "A Gem in Art," *Weekly New Mexican Review*, June 21, 1894.

55. The guest register is MNM-JG. It was used as a scrapbook by Hyman Lowitzki, who ran a curio business in the space after Gold abandoned it.

56. For Pueblo trade of ceramics from Spanish Colonial times to the 1880s, see Batkin 1999: 282–283.

57. Davis 1938: 83; Meline 1867: 231, 156.

58. Jake's "feed" room is identified in the 1886 Sanborn Map, where his operation appears to have expanded since the 1883 map was issued (Sanborn Map Company 1886). Candelario's correspondence from his first years in business show that groceries and dry goods constituted his primary business and his curio operation was a sideline.

59. Their trip to Cochiti is in Bandelier 1966: 340–341.

60. Wray, "A Gem in Art," *Weekly New Mexican Review*, June 21, 1894. The broadside is illustrated in Nathanson 2007: 9.

61. For further information on the rain god, see Batkin and Lange 1999; Anderson 2002.

62. The function of a cheese ring was clarified in a personal communication from Harry Palmiter, circa 1994. Bandelier's account of borrowing the drum is in Bandelier 1970: 152–153. The manuscript and accompanying atlases of maps and drawings are in the Vatican Library; see Bandelier 1969: 10, 111.

63. Beaded purses and the sources of beads are discussed in more detail below. Some old women's moccasins from Santa Clara have a beaded strip over the back of the ankle. Examples are illustrated in Hill 1982: figures 25, 26.

64. This catalog is undated, and its date has been deduced from various evidence.

65. "The Curio Man. Jake Gold's Enlarged Free Museum. A Hustler and His Wonderful Collection of Curios," *Santa Fe New Mexican*, July 1, 1893.

66. UA-HTP, Box 84: "W. G. Walz Company."

67. Cotton's letters are in UA-HTP: "Cotton Letter Book, November 1888–March 1889."

68. That Gold ordered from Campbell is supported by a letter from Campbell dated August 29, 1899, MNM-JG. That Campbell was a source for spiders and nests is documented in Campbell 1898.

69. Gold 1892: 5–6.

70. Batkin 1998: 74.

71. Batkin 1998: 76. Abe successfully sued Jake and J. S. Candelario for using the Gold name and printed the court's decision on the back of his letterhead; see, for example, Abe Gold to J. L. Hubbell, October 22, 1903, UA-HTP, Box 33: "Gold's Old Curiosity Shop." Abe worked in El Paso from at least 1891 to 1896 as a clerk and later manager for an ice and beverage company named Houck & Dieter. This is supported by letters still in the possession of his descendants, for example Gold to his nephew and niece, Ike and Juanita, May 23, 1891, and by directory listings in El Paso (El Paso and Juarez Directory Co. 1892; Evan and Worley 1896). His obituary was printed in the *Santa Fe New Mexican* the day he died, August 14.

72. Candelario's attempts to gain a pardon for Gold are in MNM-JSC, Business Correspondence 1901. Some details of Candelario's early life are in Doyle 1968, but the reader is advised that many statements in that publication are incorrect or unsubstantiated. His licenses as a

pawnbroker and his first business license, taken out in his wife's name, are in NMRC-TA, microfilm reel 51.

73. The original spelling and punctuation are preserved. E. Mehesy, Jr. was a curio dealer of Los Angeles and Salt Lake City; see, for example, his advertisement in the June 1902 issue of *Out West*. Gold's and Candelario's correspondence is in MNM-JSC, Business Correspondence 1901.

74. MNM-JSC, Business Correspondence 1901.

75. In his letter of October 22, Gold indicated that he had forty-four days left in prison, which would have meant his release was scheduled for December 5. On December 6 he drafted a two-page list in his ledger headed, "comision [sic] to pay Jake Gold %," which presumably refers to transactions that Gold and Candelario completed as partners. The ledgers are in MNM-JSC, Box 31; see notes 77 and 81.

76. For information on the term *tilma*, see Lucero and Baizerman 1999: 38–39; 192, n. 44.

77. Gold's inventories of groceries and curios, 1901, and his records of purchases, December 30, 1901, to June 27, 1903, are in a ledger with the inscription on the cover in his hand, "Dec 30 – 1901, Jan 1 1902, Curiosities"; MNM-JSC, Box 31.

78. Ibid.

79. Ibid.

80. NMRC-SFC, B: 393–395.

81. Gold's purchases are in the same ledger as his inventories; see note 77. Candelario's sales record is in two ledgers. The first has the cover title, "Sale. Curio Book No 1 from Dec. 30 1902 to June 11–1903," and the second has the title, "Curio Book No. 2 J. S. C. Apr. 6 1903"; NMN-JSC, Box 31.

82. Dozier 1906: 2.

83. Lucero and Baizerman (1999: 38) discuss Padilla, Pedro Muñiz, and Juan Olivas, all of whom had peddler's licenses, and all of whom are mentioned in the Fred Harvey Company's textile ledgers at the Museum of International Folk Art as suppliers of blankets. Lucero and Baizerman propose that the three acquired old textiles for Jake Gold. As mentioned in this text, Muñiz was briefly a partner with Gold in 1904. Juan Olivas eventually ran his own curio store in Santa Fe for several years.

84. Harold Gans, interview with the author, September 10, 2001.

85. Candelario published a broadside notice of the forthcoming separation on June 20, which he must have mailed to clients (Candelario 1903). Gold's letter to Candelario is dated December 11, MNM-JSC. His partnership with Muñiz, February 1904, is in NMRC-SFC, B: 435. Gold's commitment to the asylum and his death on December 16 are in his obituary in *Santa Fe New Mexican*, December 20, 1905.

86. Candelario's papers were found in the basement of the building by the late Bob Ward, who donated them to the Museum of New Mexico.

87. Candelario made the claims about the family business and the date of founding, and that he was born in Santa Fe, rather than Albuquerque, in Peterson 1912. A proof of the page submitted to him for his approval is in MNM-JSC, Business Correspondence 1911.

88. Ballenger & Richards 1903–1908. Candelario's dealings with Denver dealers are throughout his business records; some were never listed in directories as curio dealers.

89. Fentiman to Candelario, November 13, 1905; *Commercial Bulletin* to Candelario, October 3, 17, 24, and 31, 1904; other publishers to Candelario, 1904 to 1912; MNM-JSC.

90. The spellings McIlhargy and McIlhargey both occur in the magazine. In his only listing in the Albuquerque city directory (Citizen Publishing Company 1907), his name is spelled McIlhergy.

91. The publishers failed to purchase a nearly identical rug and later became "anxious to have" it, fixating on it and writing Candelario three times in an effort to acquire it. Mrs. Fitch had sold it, and because Candelario no doubt acquired both rugs in a shipment from a trader on or near the Navajo reservation, he made no effort to acquire a similar piece. Correspondence from the magazine is in MNM-JSC, Business Correspondence 1907 and 1908.

92. Correspondence with the Fitches is in MNM-JSC, Business Correspondence 1907 and 1908.

93. Postmasters of Phoenix and San Francisco, for example, replied on Candelario's original letters, dated February 13 and 14, 1905; MNM-JSC.

94. Twenty-five transactions were for single rain gods, while twenty-one were for two or three, and seven were for four to six. In a single transaction in September they sold twelve. Those sold for $0.72, so they must have been small or damaged, because this was barely over cost; J. S. Candelario's curio sales books, MNM-JSC, Box 31.

95. MNM-JSC, Business Correspondence 1906 to 1910.

96. Ibid.

97. The date reads March 23, 1913, but it was probably written in 1903; MNM-JSC, Business Correspondence 1904.

98. MNM-JSC, Business Correspondence 1908 to 1913, and Consignment Book 1917–1922. Several Chimayo pillow covers are illustrated in Lucero and Baizerman 1999: 46, 58. The authors also discuss Candelario's relationships with Spanish New Mexican weavers, as well as the numbers of weavers who supplied him and other dealers in the early twentieth century (1999: 53–57).

99. McClain to Lowitzki, October 17, 1899, MNM-JG.

100. Cotton to Candelario, April 3 and 5, 1911; May 20, 1911; August 12, 1912; Simpson to Candelario, October 5, 1903; MNM-JSC.

101. Schaper to Candelario, February 11, 14, and 20, 1907, MNM-JSC.

102. Gold 1889, 1892. Gold's purchases, December 30, 1901, to June 27, 1903, in Gold's ledger, MNM-JSC, Box 31.

103. In Gold's ledger, MNM-JSC, Box 31.

104. Ibid.; MNM-JSC, Business Correspondence 1906, 1907.

105. William Smith to Candelario, February 24 and March 17, 1907; Inez Valenzuela to Candelario, February 23, 1910; David Cullen to Candelario, February 23, 1910; J. C. Smith to Candelario, September 26 and October 5, 1910; Magdaleno Ceballos to Candelario, February 19, 1912; Harry Lewis to Candelario, May 15, 1912; MNM-JSC.

106. Roemer to Candelario, April 30, 1906, and October 14, 1907; Kohlberg to Candelario, July 12, 1911; MNM-JSC.

107. Dan McKinney to Candelario, June 11, 1911; Harry Lewis to Candelario, May 15, 1912, and March 18 and April 2, 1913; and Curtis [T.?] Day to Candelario, June 17, June 26, and October 6, 1913; MNM-JSC.

108. Phillips to Candelario, June 7, July 30, and September 28, 1904, MNM-JSC. That Candelario formerly obtained his pillow covers from the Tammen Company is in Phillips's letter of July 30.

109. Winslow Bros. & Smith Co. to Candelario, July 16, 1904; Phillips to Candelario, October 4, 7, and 14, 1904; The Rocky Mountain Gem Co. to Candelario, October 21 and 31, and November 6, 1905; MNM-JSC.

110. The history of postcards is related by numerous sites on the Internet. Candelario's collecting of postcards is documented by correspondence throughout his collection. The issue of *Post Card Monthly* is in MNM-JSC, Curiosities 1904–1914.

111. Speckmann to Candelario, January 29, 1905, with attached proof; Candelario to Speckmann, September 13; Speckmann to Candelario, September 16 and 20, 1905; MNM-JSC.

112. Candelario ca. 1911.

113. Dunne 1948: 11.

114. Ibid.

115. Dunne 1948: 39.

116. Anonymous typescript, ASM-TSD, Series 1: Business Correspondence 1904–1912, Folder 3.

117. Anonymous typescript; Dozier to L. C. Toney, December 1919; ASM-TSD, Series 1: Business Correspondence 1904–1912, Folder 3. Dozier's wife's name was spelled Locadia in their marriage announcement in *Santa Fe New Mexican*, October 3, 1896.

118. Dozier to Toney, December 1919; Dozier to John [unreadable surname], August 2, 1902; Dozier to A. B. McGaffey, October 1, 1902; ASM-TSD, Series 1: Business Correspondence 1904–1912, Folder 3; and Series 7: Business Letter Books.

119. Dozier to Patton, August 13 [?], 1902, ASM-TSD, Series 7: Business Letter Books.

120. Dozier to Wetherill; Dozier to Navajo Indian Blanket Store, August 14, 1902; ASM-TSD, Series 7: Business Letter Books.

121. The Navajo Indian Blanket Store to Hubbell, July 2, 1902, UA-HTP, Box 62: "The Navajo Indian Blanket Stores Co." Per a letter to Hubbell, July 14, 1902, the name had changed to the Navajo Indian Blanket Store Company; per a letter to Hubbell dated September 8, 1903, it was the Navajo Indian Blanket Stores Company.

122. ASM-TSD, Series 7: Business Letter Books.

123. ASM-TSD, Series 2: Business Records (1890–1914).

124. Ibid.

125. Dozier to McGaffey, August 7, September [unreadable date], and October 1, 1902; Dozier to Hyde Exploring Expedition, September 15, 1902; ASM-TSD, Series 7: Business Letter Books.

126. ASM-TSD, Series 7: Business Letter Books.

127. Ibid.

128. Dozier to Henry [unreadable surname], June 4, 1903; to a merchant in Tres Piedras, June 11, 1903; and to Henry Grant, Abiquiu; Sargent Bros., El Rito; a merchant in Truchas; and El Rito Mercantile Co., January 26, 1904; ASM-TSD, Series 7: Business Letter Books.

129. Dozier 1904: 12. The wood shavings were in the Cochiti figurine of an acrobat or tumbler (figure 16). C. G. Wallace, conversation with the author, July 1985.

130. Dozier to Kaadt, April 2, 4, and 12, 1904, ASM-TSD, Series 7: Business Letter Books.

131. Dozier to Harris Curio Co., November 9, 1903, ibid

132. Dozier to Lester, May 17, 1904, ibid.

133. Dozier to Lester, and Dozier to Candelario, May 17, 1904, ibid.

134. Dozier to Wilson, January 22, 1906, ibid.

135. Dozier to Arnold, December 26, 1905, ibid.

136. The southwestern collections of the University of Northern Colorado are on permanent loan to the Taylor Museum of the Colorado Springs Fine Arts Center.

137. Mary Gold to J. L. Hubbell, August 17, 1903; Winter and Pond to J. L Hubbell, September 6, 1905; UA-HTP, Box 33: "Gold's Old Curiosity Shop." Mary Gold's contract with Winter and Gibson is in NMRC-SFC, B. Dozier to J. G. Hatton, January 7, 1911, ASM-TSD, Series 7: Business Letter Books.

138. Dozier to Francis E. Lester, and Dozier to W. G. Walz, August 11, 1906; Dozier to A. B. Renehan, August 27, 1906; Dozier to C. M. Bryan, October 31, 1906; ASM-TSD, Series 7: Business Letter Books.

139. Letters from Dozier to Benham Indian Trading Company, March 1 through March 12, 1907, ibid. Dozier did not immediately return to Bond & Nohl, but recovered for nearly a year from an illness that required hospitalization in 1907; Dozier to L. C. Toney, December 1919; ASM-TSD, Series 1: Business Correspondence 1904–1912. That Dozier returned to Bond's

company is in Dozier to J. L. Hubbell, May 21, 1909, on letterhead of Bond & Nohl Co., UA-HTP, Box 25: "Bond & Nohl Co."

140. The date that Lester moved to California has not been determined. The 1927 Sanborn map for Las Cruces shows the "Francis E. Lester Co. Mexican & Indian Souvenir Distributor" in the location it had been since 1907. Lester's obituary in the *Las Cruces Citizen*, December 13, 1945, states that he moved to California "about sixteen years ago." For a brief history of Lester's gardening near Watsonville, see Ritch *n.d.*

141. Lester 1942: ix.

142. Details on Lester's early career are from Doña Ana County Historical Society 1983. The garden party is in "Mrs. Lester's Tea," *Rio Grande Republican*, June 7, 1901. See also Lester 1902. I have not included Lester's articles in *The American Rose Annual* in the list of references cited. They were published in 1924, 1928, 1929, 1931, 1932, 1934, 1938, 1939, 1940, 1942, 1944, and 1946.

143. Doña Ana County Historical Society 1983, and letterhead in various collections.

144. Lester 1903, 1904a. The dates of publication are based on letters from Lester that were inserted in the catalogs when they were mailed.

145. Three of the Tammen Company's catalogs from 1901 to 1908 are "supplements," which are themselves substantial catalogs.

146. Foster 1889. For examples of pattern books published by thread companies, see Butterick Publishing Company 1896; Dollfus-Mieg & Compagnie *n.d.*

147. He first incorporated on December 5, 1903 and changed the name June 20, 1904; NMRC-TA, microfilm reel 33.

148. For background on Wooton, see Allred 1993.

149. MNM-JSC, Business Correspondence 1904.

150. Ibid.

151. Ibid.

152. MNM-JSC, Business Correspondence 1904 and 1905.

153. Lester 1904b.

154. The testimonials are similar enough that one cannot help but wonder if Lester wrote them. Few letters of this type are in Candelario's extensive correspondence, and even if Lester was more satisfaction-oriented than Candelario, it is hard to believe that he received thank-you letters in this quantity.

155. Lester to Candelario, August 26, 1905; Wooton to Candelario, September 2, 1905; MNM-JSC.

156. Lester to Candelario, September 23, 1905, and June 14, 1906, MNM-JSC.

157. MNM-JSC, Business Correspondence 1907.

158. Lester to Candelario, February 3, March 14, August 10, October 6, November 3, and November 10, 1908; and October 20, 1911; MNM-JSC.

159. Dozier to Lester, November 23, 1906, ASM-TSD, Series 7: Business Letter Books.

160. Lester mentioned the 1904 "Holiday Circular" in 1905a: 15; no copy has been located. Several of Lester's catalogs are known only from their mention in advertisements or correspondence.

161. Lester 1906a, 1907b, 1908, and ca. 1911. The date ca. 1911 is based on testimonials in it dating as late as November 1910.

162. Lester 1907a: 1.

163. Lester 1907c: 71.

164. Lester offered the banner, with a depiction of a burro, in a flyer that he inserted in several catalogs and other mailings as early as 1903.

165. Lester 1907c: 72.

166. Cotton *n.d.*: 5, 9. Cotton may have published this catalog as late as 1924, the date written by his secretary, Florence Turner, on her personal copy of the catalog, which is in a private collection.

167. That Lester's correspondence and catalogs were scattered on the roadsides was stated by William M. Smith of Mesilla Park in a conversation with the author, January 28, 1994.

168. Information on Jake is from Falkenstien-Doyle 2006, and from Falkenstien-Doyle's text for the exhibition, *Tradition and Tourism, 1870–1970*, Wheelwright Museum, May 27–October 21, 2007.

169. For Schweizer's early career see Howard 1986; Howard and Pardue 1996: 10.

170. WMAI-JA, Fieldnotes 1938, Book 6, November 2. Adair spelled Petry's name phonetically; several sources identify him as a turquoise miner.

171. February 14, 1905, UA-HTP, Box 36: "Fred Harvey Company, January–June 1905."

172. Huckel to Hubbell, April 21 and 26, 1905; J. Snively to Hubbell, May 6, 1905; Schweizer to Hubbell, May 31, 1905; ibid.

173. Schweizer to Hubbell, May 31, 1905, ibid.

174. Schweizer to Crandall, August 1, 1905, NAD-BIA, E83 FY 90, Northern Pueblos Agency, Box 72: "904 Industries and Employment, Native Arts and Crafts, 1905–1932."

175. Nequatewa 1936: 74, 76; Wright 1972: 12–16.

176. According to articles in Hermeyesva's student file, he was one of twelve Hopis enrolled at Carlisle at the same time. That he was a leader of the Flute Dance and spent several days at the University Museum is in a clipping from a Philadelphia paper dated May 28, 1912: "Hopi Indian Singing and Telling Stories for University Students." Hermeyesva's shields and the reimbursement of his expenses are in J. M McHugh, assistant treasurer of the University Museum, to Moses Friedman, superintendent at Carlisle, July 3, 1912. Tewanima is mentioned

in other articles in Hermeyesva's file; in one he was said to have "won the main Marathon event" at the Olympic Games of 1910, though no Olympic Games were held that year: "Will Carry a Message Back: Twelve Hopi Indians to Leave Carlisle School this Summer." Tewanima's achievements are documented in many sources on the Internet. The foregoing are in NADC-BIA, Carlisle Indian School, Student Files, File 1327: "Joshua Hermeyesva."

177. For a silversmithing class at Carlisle and some of its workmanship, see Kline 2001: 55; the illustrations are from Carlisle Indian School ca. 1910. Hermeyesva's recommendation as a cobbler is in "Information Regarding Returned Students … Joshua Hermeyesva," and his work as a storekeeper is in letters of September 2, 1912, and March 6, 1913, to Moses Friedman; NADC-BIA, Carlisle Indian School, Student Files, File 1327: "Joshua Hermeyesva." For discussion of the Painted Desert, see Kropp 1986. Hermeyesva's granddaughter told Margaret Wright that he demonstrated at the Painted Desert for one week (Wright 1972: 16).

178. Hermeyesva to Lipps, November 23, 1915, NADC-BIA, Carlisle Indian School, Student Files, File 1327: "Joshua Hermeyesva." His residence at the YMCA is from his World War I Draft Registration Card, September 12, 1918, Bernalillo County, New Mexico. Information on his residence and occupation in 1920 is from Fourteenth Census of the United States, 1920. At the time he was described as a laborer in a curio store, but he undoubtedly worked for Harvey as a silversmith. For details on his children see appendix .

179. Hudspeth Directory Company 1918–1940, for the years 1924–1934. On his Draft Registration Card, Hermeyesva indicated that he did not know his age but stated that he was over 45. He also identified his nearest relative as Mrs. Joshua Hermeyesva of Shungopovi, Arizona. Wright (1972: 16) stated that Hermeyesva married a woman from Isleta and died in New Mexico. Edmund Nequatewa (1936: 133, n.49) stated that Hermeyesva went to Isleta and later returned to Shungopovi. Records show that Hermeyesva never lived at Isleta and had no wife in New Mexico. Rents are in Fifteenth Census of the United States, 1930, where Hermeyesva's age was given as 50. For details on his residences see appendix .

180. Wright 1972: 15.

181. Hubbell 1902. For Keam's sale of his trading post to Hubbell, see Graves 1998: 227.

182. Moore 1906; Lester 1904b, 1907c. The spoons Lester illustrated are identical to those illustrated by Moore in 1906.

183. Aldrich to Candelario, December 25, 1909, MNM-JSC.

184. Aldrich to Candelario, March 31, 1910, MNM-JSC.

185. The origins of Hurd's business are recounted in "Imitation Navaho Silver," Herman Schweizer to J. F. Huckel, September 29, 1932, HM-FH, RC 39(1): 1.10, Indian Department Correspondence 1932. Buford Thomas of Southwest Arts & Crafts told John Adair in 1940 that Hurd was doing very little business; WMAI-JA, Fieldnotes 1940: 78. Hurd's obituary is in the *Denver Post*, December 30, 1941. It states that he had been a resident of Denver since 1901, but directories show that he was employed in Denver at least as early as 1896, first working as a designer for J. W. Knox (Ballenger & Richards 1896).

186. "Indian Silver," Schweizer to Huckel, September 24, 1931, HM-FH, RC 39(1): 1.9, Indian Department Correspondence 1930–1931; "Imitation Navaho Silver," Schweizer to Huckel, September 29, 1932, HM-FH, RC 39(1): 1.10, Indian Department Correspondence 1932; Carl Litzenberger, "Statement of Facts Re: Indian Design Coin Silver Jewelry Manufactured by the H. H. Tammen Company," HM-FH, RC 39(1): 1.11, Indian Department Correspondence 1933. Hurd continued to make his jewelry line, claiming that the Tammen Company had copied him. The two lines were similar and even to Herman Schweizer were almost indistinguishable. I have found no information on Hurd's shop or jewelry line, except that in some Denver directories his business is described as "Manufacturers of Indian type silver jewelry." That the Tammen Company hired without regard to ethnic background is evident from scanning Denver city directories.

187. Manuel Naranjo, interview with the author, October 14, 2001. The fact that people of Santa Clara went to the Colorado Springs area is from many sources and is common knowledge at the pueblo.

188. Manuel Naranjo, interview with the author, October 14, 2001; NAD-BIA, Northern Pueblos Agency, E47, Santa Fe Indian School, Student Records, Box 10, 5/10/2:6: "Naranjo, Aniceta," and Box 30, 5/10/4:2: "Naranjo, Avelino."

189. NAD-BIA, Northern Pueblos Agency, E47, Santa Fe Indian School, Student Records, Box 10, 5/10/2:6: "Naranjo, Aniceta," and Box 30, 5/10/4:2: "Naranjo, Avelino," and "Naranjo, Manuelito."

190. NAD-BIA, Northern Pueblos Agency, E47, Santa Fe Indian School, Student Records, Box 10, 5/10/2:6: "Naranjo, Aniceta." The emphasis is present in the original letter.

191. NAD-BIA, Northern Pueblos Agency, E47, Santa Fe Indian School, Student Records, Box 30, 5/10/4:2: "Naranjo, Manuelito."

192. DeHuff to Crandall, March 2, 1926, ibid.

193. True to DeHuff, April 22, 1926, ibid.

194. Manuel Naranjo, interviews with the author, October 14, 2001, and September 29, 2002.

195. C. J. Crandall, "Report on Outing Pupils 1910"; J. DeHuff to Samuel F. Stacher, August 3, 1926; NAD-BIA, Northern Pueblos Agency, FY 90, General Correspondence 1904–1937, Box 72: "900 Industries and Employment 1912–32."

196. LeMieux to Young, February 8, 1930, NAD-BIA, Charles H. Burke Indian School, Box 98: "981.1 Employment of Indians—Beet Fields."

197. LeMieux to Young, June 18 and September 1, 1929; Young to Commissioner of Indian Affairs, September 14, 1929, with "List of Boys sent to the beet fields from Chas. H. Burke School"; ibid.

198. Manuel Naranjo, interview with the author, October 14, 2001.

199. WMAI-JA, Fieldnotes 1938, Book 6, November 7; Manuel Naranjo, interview with the author, October 14, 2001.

200. S. L. Maisel, interview with the author, September 6, 2001. Rothman was initially Maisel's partner, but Maisel bought him out after six months.

201. S. L. Maisel, interview with the author, September 6, 2001.

202. Maurice Maisel told John Adair that the company began making jewelry in 1923; WMAI-JA, Fieldnotes 1940: 67. That Indians worked as silversmiths under supervision from the outset is from S. L. Maisel, interview with the author, September 6, 2001. The date of mechanization is from Maisel's response to the FTC: "In the Matter of Maisel Trading Post, Inc. Docket No. 2037. Findings as to the Facts and Conclusions," HM-FH, RC 39(1): 1.11, Indian Department Correspondence 1933. The estimate of a workforce of thirty is from Manuel Naranjo, interview with the author, October 14, 2001; the estimate of sixty is from Schrader 1983: 54; the estimate of seventy is from "Excerpts from Volume 3, Morning Session of November 22nd, Pages 359 to 365 inclusive, Conference of Superintendents and Field Officers National Park Service, Washington, D. C., November 19 to 23, 1934," p. 362, HM-FH, RC 39(1): 1.12, Indian Department Correspondence 1934. Additional details from Joe Anzara and Josephine Lente (nee Padilla), interviews with the author, February 24, 2003.

203. The source of silver is from S. L. Maisel, interview with the author, September 6, 2001. Information on machinery is from "In the United States Circuit Court of Appeals for the Tenth Circuit. September Term, 1934. Federal Trade Commission, Petitioner v. Maisel Trading Post, Respondent.... Brief for Petitioner," pp. 20–21, HM-FH, RC 39(1): 1.12, Indian Department Correspondence 1934. Maisel's foreman, C. H. Stanley, testified here that the shop referred to the machine used to punch out blanks as a "cutter"; this was probably a drop hammer dedicated to the purpose of cutting blanks. WMAI-JA, Fieldnotes 1940: 11, 67–70.

204. S. L. Maisel, interview with the author, September 6, 2001; Manuel Naranjo, interview with the author, October 14, 2001.

205. WMAI-JA, Fieldnotes 1938, book 6, November 2. Adair did not specify whether this was at the 1st Street or 4th and Central location.

206. S. L. Maisel, interview with the author, September 6, 2001. Years later the 510 West Central shop changed hands, but in the 1980s Maurice Maisel's grandson, Skip Maisel, reestablished an Indian arts business in it.

207. WMAI-JA, Fieldnotes 1940: 11.

208. WMAI-JA, Fieldnotes 1940: 21–22.

209. Ibid.

210. WMAI-JA, Fieldnotes 1938, Book 6, November 2.

211. WMAI-JA, Fieldnotes 1940: 68–70.

212. WMAI-JA, Fieldnotes 1938, Book 5, October 31.

213. Manuel Naranjo, interview with the author, September 29, 2002; Joe Anzara, interview with the author, February 24, 2003. Olguin was probably a silversmith prior to 1930, but around 1931 he moved to Santa Fe temporarily to learn filigree in J. S. Candelario's shop. Adair noted that in 1938 several women at the pueblo wore gold earrings that he made. Mary

Jane Jojola (Olguin's daughter), interview with the author, February 24, 2003; WMAI-JA, Fieldnotes 1938, Book 5, October 31.

214. S. L. Maisel, interview with the author, September 6, 1901; Agnes Dill, interview with the author, February 7, 2003; Joe Anzara, interview with the author, February 24, 2003.

215. Hudspeth Directory Company 1918–1940, for the years 1927–1940. The listing for New Mexico Carpet Cleaners indicates that they did "all kinds of rug and carpet cleaning, reasonable, we handle a complete line of curios."

216. Harold Gans, interview with the author, December 10, 2000.

217. Gans's original location was the space where Frank Patania later started his jewelry business. Julius and Elsie Gans were married in 1917. Harold Gans, interviews with the author, December 10, 2000, and September 10, 2001.

218. UA-HTP, Box 75: "Southwest Arts & Crafts."

219. Gazetteer Publishing and Printing Co. 1918; Harold Gans, interview with the author, December 10, 2000.

220. Harold Gans, interviews with the author, December 10, 2000, and September 10, 2001.

221. Harold Gans, interview with the author, December 10, 2000.

222. Harold Gans, interviews with the author, September 10, 2001, and June 10, 2002.

223. Harold Gans, interview with the author, December 10, 2000.

224. Harold Gans, interviews with the author, December 10, 2000, and September 10, 2001.

225. Ibid.

226. Harold Gans, interview with the author, September 10, 2001.

227. Harold Gans, interview with the author, June 24, 2002.

228. Harold Gans, interview with the author, September 10, 2001; WMAI-JA, Fieldnotes 1940: 77.

229. Harold Gans, interview with the author, June 24, 2002.

230. Ibid.

231. Ibid. Gans did not specify the date, but as discussed below Bell Trading Post was not mechanized until 1940.

232. UA-HTP, Box 75: "Southwest Arts & Crafts." Buford Thomas told John Adair that in 1940 they had been making silver for "twenty years," but no evidence supports a date earlier than 1927; WMAI-JA, Fieldnotes 1940: 77.

233. Gans to Hubbell, November 15, 1927, UA-HTP, Box 75: "Southwest Arts & Crafts."

234. Ibid.

235. Harold Gans, interview with the author, September 10, 2001.

236. Harold Gans, interview with the author, June 24, 2002.

237. Harold Gans, interview with the author, September 10, 2001.

238. Harold Gans, interviews with the author, December 10, 2000 and September 10, 2001.

239. Harold Gans, interview with the author, September 10, 2001.

240. Ibid.

241. Harold Gans, interviews with the author, September 10, 2001, and June 10, 2002.

242. The assignment of styles to silversmiths of different backgrounds is from Harold Gans, interview with the author, December 10, 2000.

243. Harold Gans, interviews with the author, September 10, 2001, and June 24, 2002.

244. Harold Gans, interviews with the author, December 10, 2000, September 10, 2001, and June 10, 2002. Until I explained who Al Naranjo was, Gans had assumed that he was Navajo; he had no recollection of Paul Naranjo or David Taliman. See appendix.

245. Information on Reed Newport is from Harold Gans, interviews with the author, September 10, 2001, and June 10, 2002; Hudspeth Directory Company 1918–1940, for the years 1938–1940; Hudspeth Directory Company 1928–1942, for the years 1928–1938; Vidal Chavez, interview with the author, January 27, 2003; WMAI-JA, Fieldnotes 1940: 79.

246. Vidal Chavez, interview with the author, January 27, 2003; Harold Gans, interview with the author, December 10, 2000.

247. Vidal Chavez, interview with the author, January 27, 2003.

248. Ibid.

249. Harold Gans, interview with the author, December 10, 2000. According to Gans the shop got empty cigar boxes from Capital Pharmacy. Some details of the process were verified by Vidal Chavez, interview with the author, January 27, 2003.

250. Harold Gans, interview with the author, June 10, 2002.

251. Harold Gans, interview with the author, December 10, 2000; WMAI-JA, Fieldnotes 1940: 79.

252. WMAI-JA, Fieldnotes 1940: 77. I assume that Adair's comment here that "they furnish the gas," refers to gas for a soldering torch, rather than gasoline for their cars. Vidal Chavez, interview with the author, January 27, 2003; WMAI-JA, Fieldnotes 1940: 79.

253. Harold Gans, interview with the author, June 10, 2002. Gans said this was in 1940 or 1941, but Adair visited the shop in late 1940.

254. Hudspeth Directory Company 1928–1942; WMAI-JA, Fieldnotes 1940: 77. Buford Thomas told John Adair that five Navajo smiths worked together in one house "that they rent," which might imply that Gans rented it. Harold Gans insisted that the company would never have rented the house.

255. Harold Gans, interview with the author, September 10, 2001.

256. August 4, 1933, NAD-BIA, Northern Pueblos Agency, E83 FY 91, Box 80: "904 Industries and Employment 1933–35."

257. Roans was appointed "laborer #36A" and hired at the salary of $1,080 per year; NAD-BIA, Northern Pueblos Agency, E83 FY 91; General Correspondence File, 1912–38, Box 22: "160.5 Officers and Employees/Changes in Employees/Report 1927–35, Changes in Civilian Personnel Santa Fe School November 11, 1931." In other personnel files, he was identified as a laborer, rather than an instructor. There is some question whether he worked as a silversmith at the school prior to his official employment. A document, "Silver Sales Fiscal Year 1932," shows a small number of sales of silver from the school as early as July 1931; NAD-BIA, Northern Pueblos Agency, E83 FY90, Box 72: "904 Industries and Employment Native Arts and Crafts 1905–32." Also, a number of orders for silver jewelry, placed by visitors to the Gallup Ceremonial in summer 1931, were still being filled by Roanhorse as late as November 1931; NAD-BIA, Northern Pueblos Agency, E83 FY91, Box 79: "Miscellaneous Educational Activities, Educational Exhibits 1930–35." Roans was identified in Hudspeth 1928–1942, for the years 1930–1931, as a silversmith working for Gans, and he was identified as a silversmith in Fifteenth Census of the United States, 1930. Only one Santa Fe directory preceded the 1930–1931 edition, and though he was not listed in it, he may have worked for Gans prior to 1930. See also in appendix.

258. Seymour E. Anderson, principal, to the Commissioner of Indian Affairs, December 1, 1930, NAD-BIA, Northern Pueblos Agency, E83 FY 90, Box 80: "904 Industries and Employment, Native Arts 1933–35."

259. NAD-BIA, Northern Pueblos Agency, E50, Santa Fe Indian School: "Santa Fe Boarding School Report of Attendance, Period ending December 31, 1931"; and "Santa Fe . . . ending June 30, 1932."

260. "Santa Fe Boarding School Report of Attendance, Period ending December 31, 1932"; "Santa Fe . . . ending June 30, 1933"; ibid.

261. NAD-BIA, Northern Pueblos Agency, E50, Santa Fe Indian School, Students' School Folders 1910–1934, Box 35 Salvador–Shutta (Boys): "Shorty, Dooley Navajo—Southern #36853." That he became Roanhorse's assistant is in *Teguayo* 5(1). Shorty's position at the Burke School is discussed further below. NAD-BIA, Northern Pueblos Agency, E50, Santa Fe Indian School, Students' School Folders 1910–1934, Box 39 Vigil–Zuni (Boys): "Yellow Hair, Chester." His employment at the Albuquerque Indian School is in Hudspeth Directory Company 1918–1940, for the years 1935–1938. See also in appendix.

262. *Teguayo* 3(5).

263. Sewell's sale is dated June 18, 1934; NAD-BIA, Northern Pueblos Agency, E83 FY 90, Box 72: "904 Industries and Employment, Native Arts 1916–34." At least one order for turquoise from another vendor was cancelled, and the administration went to great lengths to identify sources and mine owners. Cerrillos Gem Co. and Sewell, lessee, were identified in an undated letter from a writer named Louis with an illegible surname. He claimed the Cerrillos mine was "worked out and worthless." This and correspondence between A. J. Hall, H. C. Seymour, and others are in NAD-BIA, United Pueblos Agency, E99, Box 113: "General Correspondence File 1935–1943, Silver 1936–37."

264. Awards at the 1932 Gallup Ceremonial are in *Teguayo* 2(2). Awards at the 1933 Gallup Ceremonial are in "List of Prizes Awarded Santa Fe Indian School and Northern Pueblos, Gallup Intertribal Ceremonial 1933"; NAD-BIA, Northern Pueblos Agency, E83 FY 91, Box 79: "898 Miscellaneous Educational Activities 1926–34."

265. For Peshlakai's career in Los Angeles, see Pardue 2005. His date of hire is in "Changes in Civilian Personnel, Charles H. Burke School, Interior, Indian, Ft. Wingate, N. Mex. Nov. 2, 1931"; NAD-BIA, Charles H. Burke Indian School, Box 81: "160.5 Form 4-A Changes in Personnel."

266. NAD-BIA, Albuquerque Indian School, Box 16: "Burnsides, Huskie."

267. Ibid.

268. Ibid. Burnside's employment at Cañoncito and his order for engine parts are in NAD-BIA, Charles H. Burke Indian School, Box 74: "161 Haskie J. Burnside."

269. "Docket 2037; Testimony, pp. 1143–1145," NADC-FTC. Burnside's employment at Maisel's is in WMAI-JA, Fieldnotes 1938, Book 2, July 1. See also in appendix.

270. NAD-BIA, Albuquerque Indian School, Box 16: "Burnsides, Huskie."

271. Schrader 1983: 15–31.

272. "House Bill 9719, 71st Congress, Second Session, February 10, 1930"; "Senate Bill 3520, 71st Congress, Second Session, February 11, 1930"; HM-FH, RC39(1B:4), Indian Department Correspondence January–April, 1930.

273. Schweizer to multiple addressees, March 17, 1930; Schweizer to Huckel, January 7, 1930; ibid.

274. Memo, February 13, 1930; Schweizer to Hubbell, March 30, 1930; ibid.

275. Schweizer to Hubbell, March 10, 1930, ibid.

276. Ibid.

277. Discussions at Gallup Ceremonial are mentioned in a letter from James MacMillan to Schweizer, September 17, 1930; the September 13 meeting is in "Indian Traders are Organized," *Santa Fe New Mexican*, September 14, 1931; HM-FH, RC39(1): 1.9, Indian Department Correspondence 1930–1931.

278. "Senate Bill 3511, 72nd Congress, First Session, February 4, 1932," HM-FH, RC39(1): 1.10, Indian Department Correspondence 1932. The failure of the bill and UITA's influence on the FTC are in Schrader 1983: 53.

279. Huckel to Schweizer, September 19, 1931, HM-FH, RC39(1): 1.9, Indian Department Correspondence 1930–1931. The statement presumably was printed on attached labels. Huckel lamented the fact that the Harvey Company sold jewelry of this type.

280. Herman Schweizer to Lorenzo Hubbell, September 17, 1931, ibid. Schweizer claimed that Beacon expressed willingness to change their promotions, but the FTC proceeded with prosecution. Beacon Manufacturing Company and Jeffrey Jewelry Company are also dis-

cussed in Schrader 1983: 52. Jeffrey's jewelry was undoubtedly the "Lucky Indian Jewelry" sold in Woolworth's stores around 1930–1931. Although Jeffrey, the jewelry line, and the fact that the jewelry line was sold by Woolworth's are documented in Harvey Company correspondence, the fact that Jeffrey was the manufacturer of the jewelry line is not documented.

281. WMAI-JA, Fieldnotes 1938, Book 2, July 1. Burnside referred to Carey as Herbert Brown. He told Adair that the ad cost them thirty-seven dollars; I was unable to locate it. Burnside also claimed that Carey was from Laguna, but that was incorrect. UNM-CW, 1934, January 8 and 9.

282. "United States of America Before Federal Trade Commission.... In the Matter of Maisel Trading Post, Inc. Docket No. 2037. Findings as to the Facts and Conclusions, August 21, 1933," HM-FH, RC39(1): 1.11, Indian Department Correspondence 1933.

283. Ibid.

284. "United States of America Before Federal Trade Commission.... In the Matter of Maisel Trading Post, Inc. Docket No. 2037. Order to Cease and Desist, August 21, 1933," ibid.

285. "United States Circuit Court of Appeals, Tenth Circuit. No. 976 — April Term, 1935. Federal Trade Commission, Petitioner, v. Maisel Trading Post, Inc., Respondent. Application for the Enforcement of an Order of the Federal Trade Commission, May 1, 1935," HM-FH, RC39(1): 1.13, Indian Department Correspondence 1935. Schrader 1983: 56.

286. This passage is paraphrased from Schrader 1983: 57.

287. S. L. Maisel, interview with the author, September 6, 2001. In tumbling, silver items (prior to the setting of stones) are churned in a wet mixture with steel ball bearings and other materials.

288. "Special Bulletin from the United Indian Traders Association, June 26, 1933," HM-FH, RC39(1): 1.11, Indian Department Correspondence 1933.

289. Ibid.

290. "Order Bars Sale of Fake Indian Goods," *Santa Fe New Mexican*, June 27, 1933, ibid.

291. Huckel to Schweizer, September 14, 1931; K. McGinley to F. Clough, September 14, 1931; HM-FH, RC39(1): 1.9, Indian Department Correspondence 1930–1931.

292. Schweizer to Huckel, September 17, 1931, ibid. In this letter Schweizer states that Woolworth's was in violation of FTC regulations, and he encouraged Huckel to have his own attorney call the matter to the FTC's attention.

293. Huckel to Schweizer, July 1, 1933, HM-FH, RC39(1): 1.11, Indian Department Correspondence 1933.

294. Schweizer to Spencer, July 3, 1933; Spencer to Schweizer, July 6, 1933; ibid.

295. Schweizer to Spencer, July 8, 1933; Schweizer to Huckel, July 9, 1933; ibid.

296. L. E. White to Schweizer, May 14, 1935; F. C. Spencer to Herman Schweizer, May 8, 1935; HM-FH, RC 39(1): 1.13, Indian Department Correspondence 1935.

297. Schrader 1983: 87.

298. Schweizer to Huckel, May 9, 1935, HM-FH, RC 39(1):1.13, Indian Department Correspondence 1935; "Excerpts from Volume 3, Morning Session of November 22nd, Pages 359 to 365 inclusive, Conference of Superintendents and Field Officers National Park Service, Washington, D. C., November 19 to 23, 1934," p. 362; HM-FH, RC 39(1): 1.12, Indian Department Correspondence 1934; Harold Gans, interviews with the author, September 10, 2001, and June 10, 2002.

299. "In the United States Circuit Court of Appeals for the Tenth Circuit, September Term, 1934. Federal Trade Commission v. Maisel Trading Post, Inc., Respondent.... Brief for Petitioner," p. 11, HM-FH, RC 39(1): 1.12, Indian Department Correspondence 1934; Harold Gans, interview with the author, June 10, 2002, and undated notes from a conversation; WMAI-JA, Fieldnotes 1940: 77–79.

300. Harold Gans, interview with the author, June 10, 2002.

301. WMAI-JA, Fieldnotes 1940: 68.

302. The rolling mill was one of several items on "Standard Government Short Form Contract, April 18, 1932," NAD-BIA, Northern Pueblos Agency, E83 FY90, Santa Fe Indian School, Box 53: "502 Supplies and Farm Stock, Bids and Awards; Bids for Shop at Santa Fe Indian School, 1920–32." Also, order for sterling silver sheet from the G. W. Seifried Co., January 17, 1935, Box 80: "904 Industries and Employment, Arts and Crafts 1932–35"; and purchase order to G. W. Seifried Co., December 29, 1932, Box 81: "967 Manufacturing 1928–35"; NAD-BIA, Northern Pueblos Agency E83 FY91.

303. "In the United States Circuit Court of Appeals for the Tenth Circuit. September Term, 1934. Federal Trade Commission, Petitioner v. Maisel Trading Post, Respondent.... Brief for Petitioner," p. 16, HM-FH, RC 39(1): 1.12, Indian Department Correspondence 1934.

304. DAM-NA, "Michael Harrison, U.S. Dept. of the Interior."

305. Orders for slugs commenced April 18, 1936; NAD-BIA, United Pueblos Agency, E99, Box 113: "General Correspondence File 1935–1943, Silver 1936–37." Jones's enrollment is in NAD-BIA, Northern Pueblos Agency, E50, Santa Fe Indian School: "Santa Fe Boarding School Report of Attendance, Period ending December 31, 1933." In some contexts his name is misspelled Wilford. His article is in *Teguayo* 5(4).

306. E. B. Dale received the letter April 11; he replied to Rhoads April 18; NAD-BIA, Charles H. Burke Indian School, Box 37: "813 Industrial Training."

307. In the mid-1930s Harrison was employed by the school, but he addressed his memo to the "Supervisor in charge"; NAD-BIA, Charles H. Burke Indian School, General Correspondence, Box 97: "826 United Indian Traders Association."

308. Ibid

309. Ibid.

310. "Changes in Civilian Personnel. Interior-Indian-Charles H. Burke School, Fort Wingate, New Mexico, July 1, 1935," NAD-BIA, Charles H. Burke Indian School, Box 51: "160.5 Changes in Personnel (4a)"; WMAI-JA, Fieldnotes 1940: 52.

311. Adair 1944: 23. As Adair points out, in reckoning kinship the Navajo refer to father and father's brother with the same term.

312. Schrader 1983: 124–129.

313. This passage is paraphrased from Schrader 1983: 131.

314. PU-AAIA, Box 65, Folder 1.

315. Cassidy's appointment and role are discussed in Weigle and Fiore 1982: 50. "Silver Standards as Agreed Upon to Date at the Several Meetings Held at the Home of Mrs. Ina Cassidy," UA-HTP, Box 43: "IACB." The February 1937 meetings and adoption of standards are in Schrader 1983: 132.

316. HM-FH, RC 39(1): 1.14, Indian Department Correspondence 1936–1937.

317. "Indian Arts and Crafts Board. Record of Indian silver jewelry inspected by K. M. Chapman," p. 6, MNM-KMC, Indian Arts and Crafts Board, 89KC0.009.

318. Ibid., 8–9. Chapman did not specify what shape or other feature prevented stamping, but many styles of bracelet were made in such a way that they would have had no surface suitable for stamping.

319. Ibid., 9–12.

320. Ibid., 14–19.

321. Ibid., 20–21.

322. Ibid., 34.

323. "Circular No. 1, Supplement No. 1 to Regulations. Amendment to Silver Regulations, Section 8. January 15, 1938," MNM-KMC, Indian Arts and Crafts Board, 89KC0.009.

324. The number of pieces stamped for Wallace is from a count of Chapman's entries in "Indian Arts and Crafts Board. Record of Indian silver jewelry inspected by K. M. Chapman," ibid. Schweizer's comments are in a note in Chapman's hand dated November 18, [1938], MNM-KMC, Indian Arts and Crafts Board, 89KC0.12.

325. NAD-BIA, Northern Pueblos Agency, E99, Box 113: "General Correspondence File 1935–1943, Silver 1936–37."

326. Collier to Olguin, March 10, 1937; Olguin to Sophie D. Aberle, superintendent of the United Pueblos Agency, August 20, 1937; ibid. Abeita's letter is cited in Schrader 1983: 249.

327. Schrader 1983: 251–252.

328. WMAI-JA, Fieldnotes 1940: 8–10.

329. Schrader 1983: 252–253.

330. Ibid., 249.

331. UA-HTP, Box 81: "UITA."

332. Ibid.

333. The receipt and note of approval are on Indian Arts and Crafts Board letterhead. MNM-KMC, Indian Arts and Crafts Board, 89KC0.17.

334. The UITA silver program is poorly documented. The late Tom Woodard told me in the early 1990s that many of the association's papers were lost in a fire at the Gallup office of his father, M. L. Woodard. Harold Gans, interview with the author, September 10, 2001.

335. Memo from Shorty to student file, May 21, 1934, NAD-BIA, Northern Pueblos Agency, E50, Santa Fe Indian School, Students' School Folders 1910–1934, Box 35, Salvador–Shutta (Boys): "Shorty, Dooley Navajo—Southern #36853." "Dooley Shorty Goes to Burke," *Teguayo* 5(1). Shorty's employment is documented in "United States Department of the Interior, Temporary Employment for Emergency Work in the Field, October 8, 1935." It gives his birth date as June 4, 1910, and his starting salary as $960 per year. The following year his salary was increased to $1,200, per a note dated October 23, 1936, and signed by H. Bogard, Superintendent. This and Shorty's order for tools, "Tools needed in Silversmith Shop," in which he refers to stock numbers for William Dixon, Inc., are in NAD-BIA, Charles H. Burke Indian School, Box 71: "Shorty, Dooley," and Box 61: "8139 Silversmith."

336. "Indian Arts and Crafts Board. Record of Indian silver jewelry inspected by K. M. Chapman," MNM-KMC, Indian Arts and Crafts Board, 89KC0.009. Chapman listed the pieces but added incorrectly and entered a total of 127.

337. *Teguayo* 7(6).

338. WMAI-JA, Fieldnotes 1938, Book 6, November 7.

339. Adair 1944: 208–209. In 1936 the school's name was changed from Charles H. Burke School to Wingate Vocational High School. The name change is not reflected in the organization of the school's papers in the National Archives. Jerry N. Thompson, Principal, wrote on Roanhorse's and Shorty's behalf to Lieutenant J. G. Wilson of the Wingate Ordnance Depot to seek permission, September 11; NAD-BIA, Charles H. Burke Indian School, Box 69: "Arts and Crafts."

340. NAD-BIA, Charles H. Burke Indian School, Box 57: "Purchase Order Requests 1940, Fiscal Year July 1, 1939 to June 30, 1940"; Box 61: "8139 Silversmith." Roanhorse's request for a truck is in Jerry N. Thompson to E. R. Fryer, General Superintendent, Navajo Agency, August 27, 1941; NAD-BIA, Charles H. Burke Indian School, Box 69: "Arts and Crafts."

341. Shorty's responsibilities in New York are not documented. An undated note with the name Christine Chaney says, "$10.50 is so much lower than pullman to Washington, D. C. we were wondering—"; NAD-BIA, Charles H. Burke Indian School, Box 71: "Shorty, Dooley." Kabotie 1977: 70–72.

342. Elsie Gans to Shorty, April 23, 1941. The prior year superintendent Bogard asked Maurice Maisel to take students, but Maisel declined, claiming that they had no openings; Maisel to

Bogard, May 18, 1940, NAD-BIA, Charles H. Burke Indian School, Box 61: "8139 Silversmithing."

343. Details of this development were written by Frederic H. Douglas on catalog cards for the pieces illustrated here and stated in letters from Alfreda Ward to Douglas; DAM-NA, "Santa Fe School/Dorothy Dunn-Alfreda Ward." Additional details are in WMAI-JA, Fieldnotes 1940: 13.

344. A history of the Bell Trading Post building is in Carol J. Condie, Quivira Research Associates, "Bell Trading Post," 2004. Manuscript in the possession of Armen Chakerian.

345. Hudspeth Directory Co. 1918–1940, for the year 1935, includes the first listing for Bell Trading Post. Seven smiths were listed as working at the shop that year; see appendix. *New York Times*, January 22, 1940; Armen Chakerian, interview with the author, August 29, 2002.

346. Armen Chakerian, interview with the author, August 29, 2002; M. J. Chakerian, "Plans and Recommendations for Jewelry Manufacturing Facilities and Related Matters, November 1, 1956," manuscript in the possession of Armen Chakerian.

347. Ibid.

348. Ibid.

349. Randy and Jack Seligman, interview with the author, November 14, 2001. The Seligmans believe that their father and uncle purchased the business in 1902, but Bibo & Co. was still ordering from Lorenzo Hubbell in late October, 1903, or at least the company's letterhead was still in use.

350. Ibid.

351. Ibid.

352. This is documented in numerous letters from Bibo & Co. to Hubbell, and Bernalillo Mercantile to Hubbell; UA-HTP, Box 9: "Bernalillo Mercantile Co.," "Bibo & Co."

353. For information on the pottery revival, see Batkin 1987: 98–99. The location of the shop and date of establishment were explained by Randy and Jack Seligman in an interview with the author, November 14, 2001. Douglas 1941. The pots Douglas collected are aesthetically superb and in pristine condition. At least one institution, the University Museum of the University of Pennsylvania, has examples acquired from the Denver Art Museum in trade.

354. WMAI-JA, Fieldnotes 1940: 75. Seligman or his foreman told Adair that he "preferred Navajo because he considered them better craftsmen."

355. Ibid., 75, 76. With regard to Seligman's trading of jewelry for Navajo rugs, Bernalillo Mercantile Company issued a catalog of Navajo rugs (Bernalillo Mercantile Co., *n.d.*), but it is unclear whether it was published by Julius or issued prior to the opening of his shop. The catalog appears to be identical to one published by Gallup Mercantile Company after that company was acquired by the Charles Ilfeld Company in 1924 (Gallup Mercantile Co., *n.d.*), and based on typography and design it can date no later than the 1930s. The implication is that Gallup Mercantile supplied the Seligmans with rugs. For discussion of Ilfeld's purchase of Gallup Mercantile, see Parish 1961.

356. Julia and Milton Seligman, interview with the author, November 14, 2001; Julia Seligman, interview with the author, March 12, 2003; WMAI-JA, Fieldnotes 1940: 48. Julia Seligman worked at the shop from 1947 to 1951, and her recollections are extremely specific. She recalled the Chavezes specializing in these pieces.

357. Ibid.

358. Ibid. The Seligmans described this matter-of-factly. Given the working conditions of all other smiths, it seems remarkable to me.

359. Armen Chakerian, interview with the author, August 29, 2006. Two of the silversmiths, both women, have worked for the Chakerians for decades; one of them has worked in silver shops, including Bell Trading Post, for more than fifty years.

360. Manuel Naranjo, interview with the author, October 14, 2001. Manuel recalled that Johnson left Maisel's in 1931, but Johnson's business was first listed in Gazetteer Publishing and Printing Co. 1930. Manuel said that Johnson moved first, then Yazzie followed, and Manuel followed after that. Gazetteer Publishing and Printing Co. 1932 lists Yazzie as a smith at Johnson's, but does not list Naranjo.

361. The date that Erich joined Moritz in business is in an article by Joanne Ditmer, "Kohlberg's stands solidly on century of integrity," *Sunday Denver Post*, Contemporary section, February 22, 1987. Moritz's and Ernst's adventures are in Porter 1973: 3–6.

362. Ibid.; Rackliff & Wainey 1885; Gould & Co. 1886; Ballenger & Richards 1896–1898. That the Denver shop was a branch of Kline's operation is based on several pieces of evidence. Letterheads for the two locations, examples of which are in Candelario's business correspondence, are identical, and Moritz was identified as manager on the Denver letterhead for at least ten years. On June 13, 1906, Kline's company in El Paso quoted hair quirts to Candelario, noting, "Your letter to Kohlberg was referred to us"; MNM-JSC. Many details of the family are unknown, and Ernst and Moritz had little or no contact after Moritz moved to Denver; UTEP-KF. Porter (1973: 8) claims that Ernst and Moritz's brother, Siegmund, and his wife, Rosa Bernstein, never had any children, but Erich's "Application for a Social Security Account Number" identifies them as his parents; Social Security Administration, copy in the possession of the author. According to an article by Marjorie Barrett, "Kohlberg's Moving off 17th Street: New era for an old business," *Rocky Mountain News*, Festival section, July 23, 1972, Erich Kohlberg stated that M. J. died in 1931; I was unable to locate his obituary.

363. Manuel recalled going to work for Kohlberg "about '35"; Manuel Naranjo, interview with the author, October 14, 2001. His first listing in a Denver directory locates him at Kohlberg's in 1933. Gazetteer Publishing and Printing Co. 1941 lists him as a smith at Treasure Chest, a jewelry company that was only a few doors down the street from Kohlberg's; Treasure Chest was first listed in 1940, but by 1942 it no longer existed. Manuel had no recollection of working at Treasure Chest, and the directory listing may have been in error. Callahan's business location is in Gazetteer Publishing and Printing Co. 1940. Manuel's daughter, Evelyn Arnold, purchased the jewelry in the early 1970s from Callahan's daughter.

364. Information on Manuel's name is from a personal communication from Evelyn Arnold to the author, April 22, 2004.

365. Manuel Naranjo, interview with the author, October 14, 2001.

366. Manuel Naranjo, interview with the author, October 14, 2001. He recalled that a Navajo couple had worked at the store after the war, he as a smith and she as a weaver. He said that on vacation one year they went back to the reservation and never returned, and Kohlberg then asked Manuel to come back to the shop. A silversmith named Ned Netoh is listed in Denver directories for 1947 and 1948 as a smith at Kohlberg's, though no spouse is identified; I did not record the bibliographical details of those directories. Manuel's bench was sold by Paula Kohlberg's nephews at auction in the 1990s following her death and was originally purchased by Robb Lucas, manager of the Wheelwright Museum's Case Trading Post, as a prop for the store. Acquaintances of Manuel who visited the Trading Post in 2000 identified the bench as his.

367. Manuel Naranjo, interviews with the author, October 14, 2001, and September 29, 2002.

368. Manuel Naranjo, interviews with the author, October 14, 2001, and September 29, 2002. Manuel's response late in life is from a personal communication from Evelyn Arnold; date not recorded.

369. Manuel Naranjo, interview with the author, October 14, 2001. This sentiment was expressed by several other Pueblo elders. Vidal Chavez of Cochiti, for example, used almost the same words: "There was nothing doing there. You had to get out"; interview with the author, January 27, 2003.

370. Manuel Naranjo, interviews with the author, October 14, 2001, and September 29, 2002.

# Silversmiths who worked in curio shops of
# Albuquerque and Santa Fe before World War II.

The principal sources for these lists were city directories of Albuquerque and Santa Fe. Directories include information that was compiled by data collectors who walked door-to-door, working in the same manner as census-takers. Although they provide a wealth of information, directories include data that was current only on the day it was collected. Undoubtedly many silversmiths were never listed in directories, including those who worked in shops only seasonally or briefly.

Additional information has been gleaned from many sources, including federal Indian census rolls of the Pueblos and Navajos, the federal censuses of 1920 and 1930, and the Social Security Death Index. Much of this information is available on the Internet, but microfilm records, particularly of Indian census rolls and federal censuses, occasionally include listings that are not indexed on genealogical websites. Records of the Albuquerque and Santa Fe Indian Schools, now at the National Archives and Records Administration (NARA), Rocky Mountain Region, Denver, were also consulted.

Pueblo Indians have names given according to tradition, and to this day many Pueblo elders recall other people, especially the long-deceased, only by their Indian names. Recent generations of Pueblos have also adopted or been forced to adopt names structured after Euro-American practice, with given names and sur-names. Many surnames are Spanish or of other European origin, though some are

of Pueblo origin. Until recently many Pueblo people were known by their Indian names within their communities and by their Euro-American names when interacting with outsiders. Now most Pueblos are recognized within their communities by their Euro-American names. English has supplanted Spanish as the second language, and the Pueblos now pronounce their Spanish surnames with an American accent.

In some pueblos the use of Euro-American names dates back centuries, but in others their use dates back to the 1880s at the earliest. For example in an interview of February 7, 2003, Agnes Dill of Isleta explained that her father, who was from Laguna, first attended the Presbyterian school at Duranes, which was a settlement about a mile from Old Town, the historic core of Albuquerque. That school later moved and became the Menaul School. When he first enrolled, Tsawhytsireh still used his Indian name, which was spelled phonetically, but at the Menaul School in about 1885 he was required to choose a Euro-American name from a list of random names. He chose Paul Shattuck, and his family is still known by the surname Shattuck.

With the exception of Zuni Pueblo, where Indian names were in universal use well into the twentieth century, Indian census rolls of pueblos in New Mexico are alphabetized by the residents' Euro-American names.

Prior to World War II, most Navajos used only their Indian names. However, Euro-American surnames had been adopted by some Navajos, especially those who lived near Euro-American settlements, for example Cañoncito (now Tohajiilee), which is twenty miles west of Albuquerque. Some names may have been adopted or assigned through practices similar to those in the pueblos. Some Navajos adopted the names of famous Americans; William McKinley, who is listed as a silversmith at Maisel's in the 1931 Albuquerque directory, was probably among them. Others smiths listed in directories, for example Luke Yazza, have names that are undoubtedly Navajo, but unless other evidence identifies them, their tribal affiliations are not indicated.

Federal Indian census rolls of the Navajos were conducted in broad regions with no distinction between settlements. Thus Navajos residing at Thoreau and Cañoncito, New Mexico, separated by well over fifty miles, were listed with other Navajos throughout the region in a single census of the "Eastern Navajo." Several smiths listed below were included in censuses of the Eastern Navajo, and other documents provide no more specific information than that.

Several gaps in these lists, particularly tribal affiliations and dates of birth, can probably be filled in the future. The policy of NARA is to release files relating to individuals, for example students enrolled in the Indian schools, on the same schedule that is followed for the release of federal censuses. The federal census of 1940 will be released in 2010, and at that time individual files of students who enrolled in the Indian schools after 1930 will also be made available. Exceptions are made for families seeking information on relatives who were enrolled in the schools. I am grateful to the staff of NARA for making the files of Manuel Naranjo and his siblings available to me; these were requested by Manuel and his daughter, Evelyn Arnold, and their wish was granted. NARA staff also made available the files of instructors in silversmithing and of some of the students who became instructors.

Many records of the Indian schools other than student files, especially of the Santa Fe Indian School, are available. Those and directories demonstrate that several silversmiths who worked for Southwest Arts & Crafts (SWAC) were enrolled at the Santa Fe Indian School. Haske Johnson Burnside, Herbert Brown Carey, and Michael Gorman worked for Maisel's Indian Trading Post (Maisel's) while enrolled at the Albuquerque Indian School. Other silversmiths who worked for shops in Albuquerque undoubtedly were enrolled there, but available records do not help to identify them.

Some names were misheard and recorded in error, as demonstrated by the listing for Antonio Perez as "Candio" in the 1930 Santa Fe directory. Other likely examples are Hicuan and Bally Suina, who were each listed once in Santa Fe directories in the 1930s. Unless I have been able to prove otherwise, I have preserved names as listed. Oxidea Yazza, listed in the 1931 Albuquerque directory as working at Maisel's, is a highly improbable name. This may be another example of a name heard poorly, but it could also have been a Navajo silversmith's practical joke.

Dates of birth, exact or approximate, provide a sense of the age of silversmiths, who were often under twenty when they first went to work in a shop. Dates of death were located for only a small number of smiths and are not included.

Every person included in this appendix was identified in some source as a silversmith, stonecutter, or other worker involved in jewelrymaking. Unless otherwise noted, the source was a city directory, and the person was identified as a

silversmith by occupation. The name of the employer is provided when listed; "no affiliation" means the individual was identified as a silversmith, but no employer was identified; "no occupation" means the individual was listed in a directory but was not identified as a silversmith or by any other occupation. Individuals compiling data for directories in some years were more attentive to detail than those compiling it in other years. For example Joe Anzara worked for Maisel's for 29 years beginning in 1930, but his affiliation with Maisel's was given inconsistently in directories.

Spouses and the street addresses of residences are listed parenthetically in the years in which they are identified. I have not distinguished between *h* (home, implying ownership), *r* (resides), and *rms* (rooms; i.e., resides in a boarding house). The abbreviation *h* occurred extremely few times, and in some cases the address could be identified as an apartment building, so ownership was not possible. On the other hand, either rent or ownership and home value were sometimes detailed in the federal census of 1930 and are included here. In that census rent was listed only for individuals renting apartments; the rent paid by boarders in boarding houses was not listed. Only Mark Chavez unquestionably owned his home.

Details of an individual's full name, tribal affiliation, date of birth, relationship to another individual, and other facts were derived from multiple sources. Entries are not annotated, but all of those details can be located readily through the sources identified above.

A study of Albuquerque's demographics is beyond the scope of this work, but much could be inferred from the information in these lists. Almost all silversmiths lived in proximity to the curio shops, but this may have been for reasons other than convenience: the neighborhoods in which the curio shops were located were probably among the poorest.

The typical rent paid by a silversmith for an apartment was $5 to $10 per month. Joshua Hermeyesva paid rent of $45 per month in 1930. By comparison, Herman Schweizer, listed in the 1930 census as "Superintendent Harvey Museum and Curio," resided at 123 S. 8th where he paid $65 per month. Many silversmiths lived in boarding houses, but in 1930 so did Louis Pitluck, the manager of Maisel's.

## Silversmiths Who Worked in Albuquerque

Those who collected information for Albuquerque directories seem to have had different practices, or practices that were inconsistent. In the late 1920s and early 1930s one could enter a shop and ask employees for information. For example the directory listing for Felipe Anzara in 1927 states that he resided at Isleta. The conspicuous absence of Maisel's smiths in directories compiled after 1934 implies that the shop prohibited the interruption or interviewing of employees, perhaps in response to the FTC lawsuit against the shop. Almost all listings that give no affiliation or no occupation include street addresses, implying that those listings were based on information gathered at a residence.

In some instances no affiliation is noted, even though the compiler may have taken the information from a smith at his place of occupation, as in the case of Luke Yazzi in 1939. Yazzi likely worked at Powell Indian Trading Post, where he resided. On the other hand, in 1938 Mack Betsillie, who resided at Powell Indian Trading Post, was said to be working at Bell Trading Post.

Each silversmith is listed by his or her most complete or most commonly used name, even if it never appeared in a directory. The name as it was listed in a directory, if it varied from the more complete name or was abbreviated (for example Jno for John), is indicated parenthetically. I substituted Benjamin for Benj, Charles for Chas, George for Geo, James for Jas, John for Jno, and William for Wm, because those abbreviations are specific. I preserved Jos, an abbreviation for both Joe/Joseph and Jose.

Between 1933 and 1939 at least twelve silversmiths resided at 215 W. Coal. Through 1936 this was also the address for El Coronado Spanish Kitchen, which was owned by and was the residence of Louis Persiani; starting in 1937 it was solely the residence of Persiani and boarders. Between 1931 and 1937 five silversmiths resided at 114 W. Coal, which was the Denver Hotel.

Domingo Pajarito Abeita (Santo Domingo Pueblo, born ca. 1910). 1929: (listed as Domingo Abeita) Maisel's. According to the 1930 federal census of Albuquerque, Abeita was Pueblo, age 20, residing at 508 S. 2nd, the same address as Charlie Garcia, also a silversmith. In his fieldnotes of 1940 John Adair identified Abeita as being from Santo Domingo.

Jose M. Abeita (Isleta Pueblo, born 1906). According to the 1930 federal census of Isleta, Abeita was a laborer in a silversmith shop. In an interview of February 7, 2003, Isadora Sarracino of Laguna stated that he went by the name Joe M. Abeita and worked at Maisel's.

Daniel Almoki. 1931: Maisel's.

Felipe Anzara (Isleta Pueblo, born ca. 1908; brother of Joe Anzara). 1927: Western Indian Traders (residing at Isleta).

Joe Anzara (Isleta Pueblo, born 1910; brother of Felipe Anzara). 1930: (spelled Ansla) Maisel's; 1938: (spouse Dorothy) no affiliation (rear 1110 William); 1939: (spouse Dorothy) no affiliation (rear 1110 William). See also in text.

Juan Lorenzo Anzara (Isleta Pueblo, born 1912). 1931: (listed as Juan Anzara) Maisel's; 1934: (listed as Juan Anzara) Maisel's.

Ray Archuleta (San Juan Pueblo). 1931: Maisel's; 1932: Maisel's (205½ S. 1st); 1933: Maisel's; 1934: Maisel's (204 E. Central); 1936: (spouse Frances) no occupation (407 E. Mountain); 1937: (spouse Frances) no affiliation (330 E. Mountain); 1938: (spouse Frances) no occupation (330 E. Mountain); 1939: (spouse Frances) no occupation (613½ W. Iron); 1940: (spouse Frances) no affiliation (804 Rio Grande). Archuleta cannot be identified in censuses of San Juan with certainty. A Juan Reyes Archuleta, born in 1900 or 1901, was said to be residing "in the jurisdiction" in census rolls of San Juan compiled in the 1930s. See also in text.

Bill Arizona (Navajo, born 1912). 1934: Maisel's. According to the Social Security Death Index, Arizona last resided at Tonalea.

Mack Betsillie. 1937: Bell Trading Post; 1938: Bell Trading Post (1906 N. 4th [the address of Powell Indian Trading Post!]).

Edison Booth. 1931: Maisel's; 1932: toolmaker's apprentice, Maisel's (707 S. Arno).

Haske Johnson Burnside (Navajo; Tall Pine Tree, Arizona; born between 1900 and 1906). 1929: (listed as Jno Burnside) Maisel's. Burnside's student file from the Albuquerque Indian School proves that he worked for Maisel's prior to graduation. See also in text.

Hosteen Bustos. 1934: Maisel's.

Mariano Bustos. 1934: Maisel's; 1935: (listed as Max; spouse Carmen) no affiliation (rear 409 E. Cleveland); 1939: (spouse Carmen) no affiliation (711 N. John). According to federal Indian census rolls, Bustos, born ca. 1912, was from "Ysleta" and was "adopted by Mexicans by this name." He lived at Sandia, where he raised a family and had the name Mariano Z. Ortiz.

Tony C. Calabaza (Santo Domingo Pueblo, born ca. 1909). 1936: no affiliation (215 W. Coal).

Herbert Brown Carey (Acoma Pueblo, born ca. 1893–1896). 1929: (listed as Herbert Carrie; spouse Jennie) Maisel's (320 E. Marquette); 1930: (listed as Herbert Carey) Maisel's (residing at Albuquerque Indian School); 1931: (listed as Herbert Carey) Maisel's (residing at Albuquerque Indian School). Carey undoubtedly worked for Maisel's prior to graduation from the Albuquerque Indian School. John Adair recorded in fieldnotes of 1938 that Haske Burnside told him that when he quit working for Maisel's in about 1930, his "best friend" Herbert Brown of Laguna quit with him. Adair later learned that Brown was from Acoma. Herbert Brown, Herbert Carey, and Herbert Brown Carey are one and the same; his wife's name was Juana, though Jennie may have been a nickname.

Hiram Carey. 1931: Maisel's.

Jose Carpio (Isleta Pueblo, born 1910). 1930: (spelled Capiro) Maisel's; 1934: (spelled Caprio) Maisel's. According to the 1930 federal census of Albuquerque, Carpio was residing in the household of his brother-in-law, Rudolph Jojola (gardener on a private estate), age 22; Jojola's wife, Felici-

tas, age 20; their daughter Stella; and Jojola's cousin, John Lucero, a silver-smith. The entire household paid rent of $5 per month.

Marcus Cata (San Juan Pueblo, born ca. 1910). According to the 1930 federal census, Cata, age 19, was residing at 121½ N. 1st, the same address as Hugh Smith, also a silversmith.

Felix Chalma. 1938: no affiliation (215 W. Coal).

John Charles. 1931: Maisel's (412 E. Silver).

Sam Charley (Navajo; Cañoncito, New Mexico). In his fieldnotes of 1940 John Adair noted that Charley was then working for Maisel's.

Antonio Chavez. 1936: War Bonnet (107½ S. 1st); 1937: War Bonnet (117½ S. 1st); 1938: War Bonnet (100 W. Central). This could be either of at least two men of the same name: Antonio Jose Chavez, a Navajo from Cañon-cito, New Mexico, born ca. 1918, and a student at the Santa Fe Indian School at least from 1931 to 1934; and Antonio Chavez of Santo Domingo, born 1908.

Charles Chavez. 1931: Maisel's. This may be Carlos Chavez of Jemez, born 1909.

Clarence Chavez. 1929: Maisel's.

Geronimo Chavez (Sandia Pueblo, born 1916). 1934: Maisel's (204 E. Central).

Mark Chavez. 1937: White Eagle Trading Post (207 W. Central [the address of White Eagle Trading Post]). According to the 1930 federal census of Albu-querque, Chavez was Pueblo, age 23, residing with his spouse, Josefita, age 24; son, Richard, 11 months; and brother, Frank, age 12. Chavez owned his home at 703 Atlantic Avenue, then valued at $190, and had his "own shop," which the census taker described as a "silver mill."

Merejildo Chavez (Navajo; Cañoncito, New Mexico). 1938: Bell Trading Post. In his fieldnotes of 1940 John Adair noted that Chavez was still working at Bell Trading Post in August 1940. See also in text.

Ray Chavez. 1929: Maisel's. This may be Reyes Chavez of Santo Domingo, born 1906.

Frank Chee (Navajo; relationship to Joe and Mark Chee assumed). 1940: (spouse Mary) Maisel's (506½ N. Broadway; same address as Joe and Mark Chee).

Joe Chee (Navajo; Lukachukai, Arizona; brother of Mark Chee). 1940: (listed as Jos) no occupation (506½ N. Broadway; same address as Frank and Mark Chee).

Juan D. Chee. 1931: (listed as Juan D'Chee) Maisel's; 1932 (listed as Juan D'Chee) Maisel's; 1933: (listed as Juan D'Chee) Maisel's; 1934: (listed as Juan D. Chee) Maisel's; 1935: (listed as John Chee) no affiliation (215 W. Coal); 1936: (listed as John D. Chee) no affiliation (215 W. Coal); 1938: (listed as Juan Chee) no occupation (707 S. 1st [same address as Jesse Laughlin]); 1939: (listed as Juan D. Chee) Bell Trading Post (215 W. Coal).

Mark Chee (Navajo; Lukachukai, Arizona; brother of Joe Chee). 1940: no occupation (506½ N. Broadway; same address as Frank and Joe Chee). See also under Santa Fe.

Andres Chino (Acoma Pueblo, born ca. 1910). 1930: (spelled Anders) Maisel's (117½ N. 1st); 1931: Maisel's. According to the 1930 federal census of Albuquerque, Chino, age 20, was residing in a boarding house at 412 E. Silver, the same address as James Holma and Joe S. Pacheco. All three were said to be silversmiths in a "novelty store."

Juan Correa (Isleta Pueblo, born ca. 1912; brother of Mariano Correa). 1931: (spelled Corille) Maisel's.

Mariano Correa (Isleta Pueblo, born ca. 1910; brother of Juan Correa). According to the 1930 federal census of Albuquerque, Correa (spelled Carillo), resided at 117½ N. 1st in a boarding house with three other young Pueblo men: Frank Zuni, 21, a cook; Pete Johnson, 17, a baker; and Joseph Montoya, 22, no occupation given. Censuses of Isleta indicate that Correa was the oldest of three brothers, the youngest of which, Antonio, was born ca. 1914. By 1929 both of their parents had died, and at age 19 Mariano became head of the household.

Esquipula Coriz (Santo Domingo Pueblo, born ca. 1916). In his fieldnotes of 1940 John Adair stated that Coriz told him that he had worked for Maisel's as recently as October of that year.

Leo Coriz (Santo Domingo Pueblo, born 1914). 1936: no affiliation (215 W. Coal). Coriz became an accomplished silversmith.

Larry Cunnington (probably non-Indian). 1936: no occupation; 1937: Bell Trading Post (YMCA); 1938: no occupation (YMCA); 1939: no occupation (YMCA). As noted in the text, Joshua Hermeyesva resided at the "rear" of the YMCA in Albuquerque in 1918. However in the federal census of 1930, no residents of the YMCA in Albuquerque were Native American, and Cunnington therefore may have been Anglo.

Horace Curley. 1935: Bell Trading Post; 1936: Bell Trading Post; 1937: Bell Trading Post.

Lawrence Dennison. 1937: Bell Trading Post.

William Dennison. 1937: Bell Trading Post.

Ben Deschiney. 1940: Standard Jewelry Co. (315½ S. 1st).

Ernst Douglas. 1934: Maisel's (204 E. Central); 1935: (listed as Ernest Douglass) no affiliation (204 E. Central).

Narciso Duran (non-Indian). 1935: no occupation; 1936: no occupation; 1937: no affiliation (424 N. Arno); 1938: no affiliation (424 N. Arno); 1939: no affiliation (424 N. Arno); 1940: no occupation (424 N. Arno). According to the 1930 federal census, Duran, age 35, was native New Mexican, but not Native American. He had his own silversmithing shop and lived with his daughters Erlinda, 13, and Senaida, 11.

Charlie Garcia. According to the 1930 federal census, Garcia was Pueblo, age 19, residing at 508 S. 2nd, the same address as Domingo Abeita, also a silversmith. This is probably Charlie Garcia of Acoma, born ca. 1900.

George Garcia. 1935: Bell Trading Post (215 W. Coal). This may be George Garcia of Isleta, born 1909.

Michael Gorman. 1929: Maisel's; 1930: (spouse Mary) Maisel's (residing at Albuquerque Indian School).

Marvin Gowan. 1934: Maisel's; 1935: no occupation (214½ S. 2nd); 1937: Bell Trading Post.

Samuel Harrison. 1939: Powell Indian Trading Post (1906 N. 4th); 1940: (spouse Elizabeth) Powell Indian Trading Post (1906 N. 4th).

Joshua Hermeyesva (Hopi [Shungopovi], born ca. 1870–1880). 1924: no affiliation (115 W. Iron); 1926: no affiliation (420 N. 1st); 1927: no affiliation (245 E. Tijeras); 1928: no affiliation (245 E. Tijeras); 1929: no affiliation (703 W. Tijeras); 1930: no affiliation (703 W. Tijeras); 1931: no affiliation (703 W. Tijeras); 1932: no affiliation (703 W. Tijeras); 1933: studio 1001½ S. 2nd (residence same). Hermeyesva worked as early as 1915 for the Fred Harvey Company. According to the 1920 federal census of Albuquerque, Hermeyesva was residing at 118 E. Central with a daughter, Fay, age 18, and a daughter possibly named Maura, but whose name is illegible, age 17. Also living with him was his son, Joshua, Jr., age 15. According to the 1930 federal census he was said to be 50, living alone. Hermeyesva was obviously

successful as a smith; in 1930 he paid rent of $45 per month, while other smiths typically paid $10 or less. Hermeyesva's birthdate is probably indeterminable. See also in text.

George Herrera. 1931: Maisel's.

James Holma (Navajo; New Mexico). 1930: Maisel's; 1931: (spelled Holoma) Maisel's; 1932: (spelled Haloma) Maisel's. According to the 1930 federal census, Holma, age 20 and born in New Mexico, resided at 412 E. Silver, the same address as Andres Chino and Joe S. Pacheco.

Claudio (Clyde "Blue Sky Eagle") Hunt (Acoma Pueblo, born ca. 1900; brother of Wilbert Hunt). 1939 (spouse Vedna) Blue Sky Eagle Hunt Curios (423 S. 8th). In his fieldnotes of 1938 John Adair stated that Hunt learned silversmithing at Maisel's. Hunt was not listed in other Albuquerque directories, but in his fieldnotes of 1940 Adair noted that Hunt owned The War Bonnet, a shop at 220 W. Central, and had two silversmiths working for him, one of which was his brother, Wilbert. The War Bonnet was in operation at least as early as 1936. Hunt became a skilled silversmith, and Adair stated that in 1940 he had taken several prizes at Gallup Ceremonial.

Wilbert Hunt (Acoma Pueblo, born ca. 1907; brother of Claudio Hunt). In his fieldnotes of 1938 John Adair stated that Hunt learned silversmithing at Maisel's.

John B. Johnson (Navajo; Cañoncito, New Mexico). 1931: (spouse Josephine Hunt [Acoma Pueblo]) Maisel's (residing with Edward Hunt [Acoma Pueblo; brother of Josephine]); 1932: Maisel's; 1933: Maisel's; 1934: Maisel's; 1937: (spouse Josephine) no occupation (503 E. Manuel); 1938: (spouse Josephine) no occupation (113 Phoenix); 1939: (spouse Josephine) no occupation (113 Phoenix); 1940: (spouse Josephine) no occupation (113 Phoenix). In an interview of February 7, 2003, Agnes Dill of Isleta explained that Johnson and Hunt were her schoolmates at the Albuquerque Indian School, and she provided their tribal affiliations. In an interview of

September 6, 2001, S. L. Maisel stated that Johnson, known as "Johnnie Johnson" at Maisel's, was one of their principal silversmiths and worked for them for many years. Indeed, Johnson is listed in directories as a silversmith at Maisel's until 1973. Maisel also explained that Johnson was one of "a couple of smiths" who designed some of the shop's jewelry. In his fieldnotes of 1940 John Adair noted that Johnson was from Cañoncito. See also in text.

Peter Johnson. 1931: Maisel's. This is probably Peter Johnson of Laguna, born 1907.

Jose Abraham Jojola (Isleta Pueblo, born 1909). 1931: (listed as Abran Jojola) Maisel's (rear 114 W. Coal); 1932: Maisel's (rear 114 W. Coal); 1933: Maisel's; 1934: Maisel's. In an interview of February 7, 2003, Agnes Dill of Isleta stated that Abraham Jojola learned silversmithing at Maisel's before founding a shop of his own at the pueblo, where he made "beautiful jewelry." He served as governor of Isleta several times.

Juan Jojola (Isleta Pueblo). 1934: Maisel's. Several men of Isleta were named Juan Jojola, including one who, according to the 1930 federal census, was working as a busboy, residing in Albuquerque with his wife, Josie, at 109 W. Iron, where they paid rent of $4 per month.

Antonio Keryte (Isleta Pueblo, born 1912). 1930: (spelled Keryt) Maisel's (117½ N. 1st).

Jesse Laughlin. 1935: no affiliation (319½ S. 1st); 1936: no affiliation (215 W. Coal); 1938: no occupation (707 S. 1st [same address as Juan D. Chee]).

Alex Lee. 1935: (spouse Barbara) no affiliation (east side of Sawmill, two doors north of Mountain Rd.).

Frank Lee. 1938: Bell Trading Post.

Hoskie Lee. 1934: (spouse Myra) Maisel's (410 N. 2nd).

James Lee. 1937: Bell Trading Post.

Thomas Lee. 1936: Bell Trading Post; 1937: Bell Trading Post (114 W. Coal).

Felipe Lente (Isleta Pueblo, born 1907; brother of Louis Lente). 1928: (spelled Philip) Maisel's (524 S. 2nd); 1929: (spelled Philip) Maisel's (522 N. Broadway).

Louis Lente (Isleta Pueblo, born 1905; brother of Felipe Lente). 1929: Maisel's; 1930: Maisel's (117½ N. 1st); 1931: Maisel's.

Jim Lewis. 1931: Maisel's. A man by this name, presumably Navajo and born in 1904, died in 1989 on the Navajo reservation at Church Rock. This silver-smith is not Jim Fite Lewis of Zuni, also born in 1904, but who died in 1930 while teaching at the Indian School at Tuba City, Arizona.

David Lino (Acoma or Zuni Pueblo, married into Tesuque Pueblo; born ca. 1910). 1929: Maisel's; 1930: (spouse Virginia) Maisel's (310 E. Marquette). In the 1930 federal census, a silversmith in Albuquerque named David Lino is identified as Navajo, which is an error. Lino married Virginia Romero of Tesuque and eventually resided there. He is identified in Indian census rolls as either Acoma or Zuni. See also under Santa Fe.

Joseph Lolly. 1936: Bell Trading Post.

Frank Lovato. 1938: no affiliation (215 W. Coal).

Candelaria Lucero (Sandia Pueblo, born ca. 1911; sister of Rufina Lucero). In an interview of February 24, 2003, Josephine Lente (nee Padilla) of Isleta stated that two sisters from Sandia named Candelaria and Rufina were employed at Maisel's in 1941. They are identified in Indian census rolls.

John Lucero (Isleta Pueblo, born ca. 1909). 1930: Maisel's; 1931: Maisel's (524 S. 2nd). In the 1930 federal census, Lucero is shown residing in Albuquerque

in the household of his cousin, Rudolph Jojola, and with Jojola's brother-in-law Jose Carpio, also a silversmith.

Rufina Lucero (Sandia Pueblo, born ca. 1907; sister of Candelaria Lucero). In an interview of February 24, 2003, Josephine Lente (nee Padilla) of Isleta stated that two sisters from Sandia named Candelaria and Rufina worked at Maisel's in 1941. They are identified in Indian census rolls.

Damacio Lujan (Isleta Pueblo, born ca. 1879). In his fieldnotes of 1938 John Adair noted that Lujan worked for Maisel's but did not clarify whether he worked in the shop or at home. Given his age, he more likely worked at home than in Maisel's shop.

Escapula Lujan (Isleta Pueblo, born 1913). 1931: (spelled Esquipula) Maisel's.

Paul Lujan (Acoma Pueblo, born ca. 1914). 1938: War Bonnet (100 W. Central); 1939: War Bonnet (100 W. Central); 1940: War Bonnet (321½ W. Central). In his fieldnotes of 1938 John Adair noted that Lujan was from Acoma and learned silversmithing at Maisel's.

William McKinley. 1931: Maisel's.

Howard Y. Mike. 1937: Powell Indian Trading Post; 1938: Powell Indian Trading Post (1906 N. 4th); 1939: Powell Indian Trading Post (1906 N. 4th).

Sterling Y. Mike. 1940: Powell Indian Trading Post (1906 N. 4th).

Manuel Naranjo (Santa Clara Pueblo, born 1909; brother of Paul Naranjo and brother-in-law of David Taliman). 1931: Maisel's. See also in text.

Paul Naranjo (Santa Clara Pueblo, born 1912; brother of Manuel Naranjo and brother-in-law of David Taliman). 1938: Bell Trading Post. See also under Santa Fe.

George Nelson. 1930: Maisel's; 1931: Maisel's.

Alex Olguin (possibly non-Indian). 1938: (spouse Louise) gem cutter, Maisel's (317 Columbia). Olguin cannot be located in Indian census rolls. As stated in the text, stonecutters at Maisel's starting in the early 1930s were non-Indian.

Jose Rey Olguin (Isleta Pueblo, born ca. 1912). 1939: (listed as Joe R.) White Eagle Trading Post (residing at Isleta). Jose Rey Olguin was the son of Patricio R. Olguin, a noted silversmith and goldsmith of Isleta who had his own shop at the pueblo.

Andrew Ortiz. 1931: Maisel's; 1932: Maisel's (309 N. Arno).

Peter Pablo. 1935: Bell Trading Post (215 W. Coal); 1936: Bell Trading Post (215 W. Coal).

Jose Pacheco. 1929: Maisel's; 1930: Maisel's (412 E. Silver); 1931: Maisel's (412 E. Silver). In the 1930 federal census, Pacheco is identified as "Joe S.," a Pueblo, age 20, residing in a boarding house at 412 E. Silver, the same address as Andres Chino and James Holma, both silversmiths.

Josephine Padilla (Isleta Pueblo, born 1924). In an interview of February 24, 2003, Josephine Lente (nee Padilla) stated that she went to work at Maisel's in 1941, setting stones, mostly in so-called row bracelets.

Max Padilla. 1932: Maisel's (205½ S. 1st); 1933: Maisel's; 1934: Maisel's (503 N. 4th); 1935: no affiliation (503 N. 4th); 1937: (spouse Dolly) laborer (511 S. 1st [same address as Thomas Peter in 1938; residence of Mrs. Julia Sawtelle]); 1938: (spelled Padia; spouse Dolly) no occupation (310 E. Marquette); 1939: (spelled Padia; spouse Dolly) no occupation (310 E. Marquette).

Mariano Pedro. 1932: Maisel's. This is probably Mariano Pedro of Laguna, born 1911.

Roy Pedro (Laguna Pueblo, born ca. 1908). 1932: Maisel's. According to Indian census rolls, Roy Pedro was born at Laguna but later moved to Sandia, where he married and raised a family.

Michael Peshlakai. 1929: (spouse Ellen) Maisel's (314 W Tijeras); 1930: Maisel's (319½ S. 1st).

Peter Peshlakai. 1939: Bell Trading Post.

Thomas Peter. 1938: Bell Trading Post (511 S. 3rd [same address as Max Padia in 1937; residence of Mrs. Julia Sawtelle]); 1939: (listed as Tom) Bell Trading Post.

Judson Phillips. 1930: laborer Albuquerque Indian School; 1931: Maisel's; 1932: janitor 508 W. Silver (residence same).

Allen Platero (Navajo; Cañoncito, New Mexico; born 1912). In his fieldnotes of 1940 John Adair noted that Platero was then working at Maisel's.

Benjamin Platero. 1937: Bell Trading Post (114 W. Coal); 1938: Bell Trading Post; 1939: Bell Trading Post.

Cañoncito Platero (Navajo; Cañoncito, New Mexico). In his fieldnotes of 1940 John Adair noted that Platero was then working at Maisel's.

Frank Platero (Navajo; New Mexico; born ca. 1918; brother of John Platero). 1936: (spelled Platiro) Bell Trading Post; 1938: Bell Trading Post. Platero is listed in the Indian census rolls of 1935 among the Eastern Navajo. The location of the family's home is not provided.

John Platero (Navajo; New Mexico; born ca. 1915; brother of Frank Platero). 1936: (spelled Platiro) Bell Trading Post; 1937: Bell Trading Post; 1938: Bell Trading Post; 1939: Bell Trading Post. Platero is listed in the Indian census rolls of 1935 among the Eastern Navajo. The location of the family's home is not provided.

Riley Platero. 1935: (spelled Raleigh) Bell Trading Post; 1936: (spelled Platiro) Bell Trading Post; 1937: Bell Trading Post. This is probably Pablo Riley Platero, born ca. 1918 and listed in the Indian census rolls of 1931 among the Eastern Navajo. The location of his family's home is not provided.

William Platero (Navajo; Cañoncito, New Mexico; born ca. 1920). 1935: Bell Trading Post; 1937: Bell Trading Post. In his fieldnotes of 1940 John Adair noted that Platero was then working at Maisel's.

George Reano. 1936: no affiliation (215 W. Coal).

Homer Samuel (Navajo, born ca. 1913). 1935: Bell Trading Post (215 W. Coal). Samuel became an enrolled member of Tesuque Pueblo, where he married Emiliana Romero and raised a family. See also under Santa Fe.

Marito Sanchez (Navajo). 1931: Maisel's. In his fieldnotes of 1940 John Adair noted that Sanchez was foreman of a shop at Smith Lake, where Harry Boyd employed or purchased the work of as many as 100 silversmiths. Adair was also told that Sanchez was one of the best smiths who worked for Gallup Mercantile.

Silvestre Santiago. 1930: Maisel's (412 E. Silver).

Fred Silversmith. 1931: Maisel's (114 W. Coal).

John Silversmith (Navajo; Cañoncito, New Mexico). In his fieldnotes of 1940 John Adair noted that Silversmith was then working at Bell Trading Post.

Hugh Smith. 1930: Maisel's; 1931: Maisel's (rear 310 E. Marquette). According to the 1930 federal census of Albuquerque, Smith was Pueblo, age 17, residing in a boarding house at 121½ N. 1st.

David Taliman (Navajo; Oak Springs, Arizona; brother-in-law of Manuel and Paul Naranjo). 1928: (spouse Ada [Anacita]) Maisel's (111½ N. 1st). In his fieldnotes of 1940 John Adair noted that Taliman was then working at

Maisel's, but in at least some years between 1928 and 1940, Taliman worked at shops in Santa Fe. See also under Santa Fe and in text.

Gordon Tawyentewa. 1932: Maisel's; 1933: (spelled Tawyentwa) Maisel's; 1934: (spelled Tawyentwa) Maisel's.

Augustin Tenorio. 1936: no affiliation (215 W. Coal). This may be Augustin Tenorio of Santo Domingo, born ca. 1913.

Fred Tenorio. 1931: Maisel's. This may be Frederico Tenorio of Laguna (Paguate), born 1903.

George Tenorio. 1932: Maisel's; 1934: Maisel's (204 E. Central); 1935: (spouse Connie) no affiliation (219 S. Richmond); 1937: Bell Trading Post; 1939: Bell Trading Post.

Abel Toledo. 1937: Bell Trading Post; 1939: Bell Trading Post. This may be Abel Toledo of Jemez, born 1914.

Tom Thomas (Navajo; New Mexico; born ca. 1906). 1930: (listed as Thos Thomas) Maisel's. According to the 1930 federal census, Thomas resided at 523 S. 1st and was said to be a silversmith in a "curio store."

Raymond Thompson. 1930: Maisel's (412 E. Silver).

Tom Weahkee (Zuni Pueblo, born ca. 1917). 1937: (spelled Weakkel) Bell Trading Post; 1938: (spouse Carnation) Bell Trading Post (320 N Broadway); 1940: (spelled Weahkel; spouse Carnation) no occupation (313 N. Broadway). See also under Santa Fe.

John William (Navajo; Cañoncito, New Mexico). In his fieldnotes of 1940 John Adair noted that William was then working for Bell Trading Post. This is not the Navajo silversmith named John Williams, noted below, who was born in Arizona.

Daniel Williams. 1938: Bell Trading Post; 1939: Bell Trading Post.

John Williams (Navajo or Pueblo). 1929: Maisel's. 1930: (spouse Mary) Maisel's; 1931: Maisel's (rear 114 W. Coal); 1932: Maisel's; 1933: Maisel's (215 W. Coal); 1938: no affiliation (209 W. Coal); 1939: no affiliation (209 W. Coal). One or more of these entries may be for John William, described above, or for one of the men of the same name listed below.

John Williams (Navajo; Arizona). According to the 1930 federal census, John Williams, a Navajo born ca. 1895 in Arizona and working as a silversmith, was residing at 315 N. 7th with his spouse, Yekasupah, age 32; their sons Charlie, age 16; Guy, age 9; and Fred, under one year; and their daughters May, age 7; and Mable, age 4. Residing at the same address was John Yazza, also a silversmith (who is listed below, and who is known to have worked at Maisel's). Williams paid $10 per month in rent.

John Williams. According to the 1930 federal census, John Williams, a Pueblo Indian born ca. 1899 and working as a silversmith, was residing with his wife, Doleta, age 30; their daughter, Dorris, age 5; and son, John Jr., age 2½, at 850½ W. Tijeras, where they paid rent of $20 per month.

John Willie. 1931: Maisel's (310 E. Marquette); 1932: New Mexico Carpet Cleaners (residence same); 1935: Bell Trading Post. See also in text.

Jim Willito (Navajo; Cañoncito, New Mexico). In his fieldnotes of 1940 John Adair noted that Willito was then working at Bell Trading Post.

Charles K. Yazza. 1938: Bell Trading Post (216 Stover); 1939 (spelled Yazzi) Bell Trading Post.

Huskie Yazza. 1929: Maisel's.

Kee Yazza. 1929: Maisel's.

Oxidea Yazza. 1931: Maisel's.

Luke Yazzi. 1939: no affiliation (1906 N. 4th [address of Powell Indian Trading Post]).

John B. Yazzie (Navajo; Arizona). 1929: (listed as Jno Yazza) Maisel's; 1930: (listed as Jno Yazza) Maisel's (311 N. 7th). According to the 1930 federal census, John Yazza, born ca. 1910 in Arizona, was residing with his spouse, Margaret, also born ca. 1910, at 315 N. 7th, the same street address as the household of John Williams, who was also a Navajo silversmith. At the time, Yazza paid $10 per month in rent. This is probably the John Yazzie who went with Manuel Naranjo to Denver to work for Clarence Johnson. He continued to use the name Yazza until 1939, when he is listed in Denver directories as John Yazzie. In Denver his wife was not listed in a directory until 1937, when her name was listed as Mary. By 1941 Yazzie was working for the H. H. Tammen Company and was identified as John B. Yazzie. He was not listed in directories during the war, and following the war Mary was listed alone in directories. See also in text.

William Yellowcloud. 1934: (spouse Alberta) no affiliation (1600 S. Locust).

Chester Yellowhair (Navajo; Sand Springs, Arizona; born 1912). In his fieldnotes of 1940 John Adair noted that Yellowhair worked at Bell Trading Post for six months in 1940 after leaving the Albuquerque Indian School as instructor in silversmithing. Yellowhair was one of Ambrose Roanhorse's most successful students at the Sante Fe Indian School. See also under Santa Fe and in text.

Marcelino Yepa. 1929: Maisel's; 1930: (spelled Yeppa) Maisel's. This is probably Jose Marcelino Yepa of Jemez, born ca. 1910.

Marcelino Zuni (Isleta Pueblo, born 1905). 1931: Maisel's (524 S. 2nd); 1932: Maisel's.

## Silversmiths Who Worked in Santa Fe

For several years Santa Fe directories were compiled for two-year periods, presumably in the spring of the first year. For example the 1928–1929 directory was probably compiled in spring of 1928. No directory for 1939 could be located, and the subsequent directories that could be located were for 1940 and 1942. Therefore it is uncertain whether, beginning in 1938, the directory remained biennial and had only one year stated on the title page, or became annual and some directories remain unlocated.

The 1942 directory was copyrighted in 1941, and as noted in the text, Southwest Arts & Crafts' (SWAC's) silver shop was dismantled in summer 1941. It is unclear at what time in 1941 the directory data was collected. At least some smiths listed in the 1942 directory are known to have worked under SWAC's piecework system (for example Vidal Chavez), but others who were listed at SWAC may have been among the last ones working on the premises. In this directory four silversmiths are listed as residing at 422 W. San Francisco, which was the home of Max Maes.

The birthplaces/homes for Navajo silversmiths are as precise as could be determined from available records. In some instances, due to the practices of the Santa Fe Indian School, the locations listed may be postal addresses.

Those researching weaving should note that by the late 1930s, weavers identified in directories of Santa Fe far outnumber silversmiths.

Jose Abeyta. 1928: SWAC.

Charles Begay. 1932: no occupation (725 Agua Fria); 1934: Thunderbird Shop.

Juan Benada (Cochiti Pueblo, born 1915). 1936: SWAC (307 Hancock). Benada was a student at Santa Fe Indian School, and his name was occasionally misspelled Banada by school authorities in official records.

Antonio Jose Chavez (Navajo; Cañoncito, New Mexico; born 1917). 1934: SWAC (residing at Santa Fe Indian School, where he was enrolled).

Lawrence Chavez. 1940: Old Indian Shop (122 Quintana); 1942: SWAC (623 W. San Francisco). At least two individuals shared this name, both of whom were students at Santa Fe Indian School: Lorenzo Chaves (Acoma, born 1916) and Lorenzo Chavez (Navajo, born 1922). The latter dropped out of Santa Fe Indian School in 1932 and presumably returned to the reservation, so the silversmith noted here was more likely the former.

Vidal Chavez (Cochiti Pueblo, born 1913). 1938: (spouse Teresita) SWAC (124 Duran); 1940: (spouse Teresita) no affiliation (121 Elena); 1942: (spouse Teresa) no affiliation (121 Elena). Although Chavez was listed in directories with no affiliation, he is known to have been working for SWAC on their piecework system, as explained in the text. Chavez worked as a silversmith at Dressman's, on the plaza in Santa Fe, until 2006, when he retired at age 92. See also in text.

Mark Chee (Navajo; Lukachukai, Arizona). 1934: SWAC (623 W. San Francisco); 1936: SWAC (residing with Arturo Ortega, east side of Daniel, three doors north of Dolores); 1938: SWAC (rear 152 Duran). In 1935 Burton Frasher photographed Chee at work at SWAC (figure 105). See also under Albuquerque and in text.

William Cornfield (Navajo; Ganado, Arizona; born ca. 1914). 1934: SWAC (Rosario Blvd). Cornfield is listed as "Billie" or "Billy" in records of the Santa Fe Indian School, where he was a student of Ambrose Roanhorse during the third year that he taught silversmithing there.

Mark Duran. 1930: (spelled Marcos) SWAC (426 Galisteo); 1932: SWAC; 1934: SWAC (120 Duran).

David Garcia (Pueblo, born 1916). 1940: SWAC; 1942: SWAC (422 W. San Francisco). Garcia was a student at Santa Fe Indian School; he is identified in accessible records only as Southern Pueblo, born in 1916. The only David Garcia born in 1916 who can be identified in census rolls was from San Juan, which is not one of the southern pueblos.

Domingo Garcia. 1934: stonecutter, SWAC (124 Duran).

Jose B. Garcia (San Juan Pueblo, born ca. 1917). 1942: SWAC (422 W. San Francisco).

Albert Hardy (Navajo; Ganado, Arizona; born ca. 1912). 1934: SWAC (residing at Santa Fe Indian School, where he was enrolled); 1936: SWAC (152 Duran); 1938: (spouse Dottie) no affiliation (rear 152 Duran). Hardy was a student of Ambrose Roanhorse during the first two years that he taught silversmithing at Santa Fe Indian School. In 1935 Burton Frasher photographed Hardy at work at SWAC (figure 100). See also in text.

Herbert Herald (Navajo; Crownpoint, New Mexico; born ca. 1910–1914). 1934: (spelled Harold) SWAC (residing at Santa Fe Indian School, where he was enrolled). Herald was a student of Ambrose Roanhorse during the first two years that he taught silversmithing at Santa Fe Indian School. See also in text.

Domingo Herrera (Cochiti Pueblo, born 1918). 1940: SWAC.

Elfego Herrera (Cochiti Pueblo, born 1915; brother of Perfecto Herrera). In 1935 Burton Frasher photographed Herrera at work at SWAC (figure 102).

Justino Herrera (Cochiti Pueblo, born 1919). 1942: SWAC (616 College).

Perfecto Herrera (Cochiti Pueblo, born 1909; brother of Elfego Herrera). 1930: SWAC (residing at St. Catherine Indian School); 1934: (spouse Maria) SWAC (627 W. San Francisco); 1936: SWAC (139 Candelario); 1938: (listed with middle initial H.) SWAC; 1940: (spouse Mary) SWAC (122 Quintana); 1942: (spouse Mary) no affiliation (523 W. San Francisco). The fact that Herrera resided at St. Catherine Indian School implies he was enrolled there. In 1935 Burton Frasher photographed Herrera at work at SWAC (figure 101). See also in text.

Steven Herrera. 1942: SWAC (422 W. San Francisco).

William Johnson (possibly non-Indian). 1940: turquoise cutter, SWAC (apartment 4, 435 Guadalupe).

Wilfred Jones (Navajo; Farmington, New Mexico; born ca. 1915). 1940: teacher [silversmithing instructor] Santa Fe Indian School (residence same). In his fieldnotes of 1940 John Adair noted that Buford Thomas of SWAC told him that Jones had worked at SWAC, but he did not indicate when. Jones also taught silversmithing at Shiprock Indian Boarding School. See also in text.

Joseph L. Kieyoomie (Navajo; Salina Springs, Arizona; born 1917). 1936: SWAC (152 Duran). "Joe Lee" was a student at Santa Fe Indian School, where his last name was often misspelled in school records as either Kayonie or Kieyoonie.

Clive E. King (possibly non-Indian). 1942: (spouse Clefaine) stonecutter, SWAC (145 E. Alameda).

Fidel Klass. 1942: SWAC. According to U. S. World War II Army Enlistment Records, 1938–1946, Fidel Klass, a Native American of unspecified tribal affiliation who described himself as a jeweler, enlisted at Fort Bliss, Texas, on March 16, 1942.

Thomas Knoki (Navajo; Fort Defiance, Arizona; born 1910). 1934: SWAC (residing at Santa Fe Indian School, where he was enrolled).

Jos Lee. 1938: SWAC (rear 152 Duran); 1940: SWAC.

Alvin C. Lewis. 1942: Candelario's (220 W. Water [Candelario's Auto Court]). This is probably Alvin Lewis of Laguna, born ca. 1910.

Ambrose Lincoln (Navajo). 1942: silversmith, Santa Fe Indian School (residence same). In his fieldnotes of 1940 John Adair identified Ambrose Lincoln as Navajo, then working at Zuni for both C. G. Wallace and Charles Kelsey.

David Lino (Acoma or Zuni Pueblo, married into Tesuque Pueblo; born ca. 1910). 1928: (spouse Virginia) SWAC. Indian census rolls identify Lino as either Acoma or Zuni. He married Virginia Romero of Tesuque (also born ca. 1910) and resided at Tesuque. See also under Albuquerque.

Herbert Lino. 1928: SWAC.

Louis Lomayesva (Hopi [Oraibi], born ca. 1915; name later changed to Lomay). 1936: (listed as Lomayesva) Thunderbird Shop (115 Grant); 1938: (listed as Lomay) Thunderbird Shop; 1940: (spouse Sophie) Thunderbird Shop (rear 408 Rosario); 1942: (spouse Sophie) Thunderbird Shop. Lomay became a noted silversmith.

Eugene O. Loomis (non-Indian). 1942: (spouse Ann [clerk, SWAC]) stonecutter, SWAC (326 W. San Francisco).

Thomas Martinez. 1942: SWAC (516 W. San Francisco).

Marcus McElmurry (non-Indian). 1936: (spouse Emogene) turquoise cutter, SWAC (320 W. Manhattan).

Thomas Montoya. 1932: SWAC (124 Duran).

Al Naranjo (Santa Clara Pueblo, born 1915; brother of Ernest, Manuel, and Paul Naranjo; brother-in-law of David Taliman). 1934: SWAC. In his fieldnotes of 1938 John Adair stated that Naranjo's father, Nestor, told him that Al was working as a silversmith in a shop in Los Angeles. In interviews of various dates, neither Al's son, Edwin, nor his brother, Manuel, had any knowledge of Al working as a silversmith, either in Santa Fe or elsewhere, though they were aware that Al resided in Los Angeles in the late 1930s. See also in text.

Ernest Naranjo, Jr. 1942: SWAC (239 W. DeVargas). This is probably Ernest Naranjo of Santa Clara Pueblo, born 1922; brother of Al, Manuel, and Paul

Naranjo; and brother-in-law of David Taliman. However Ernest was a son of Nestor, and therefore was not Ernest Jr.

Paul Naranjo (Santa Clara Pueblo, born 1912; brother of Al, Ernest, and Manuel Naranjo; brother-in-law of David Taliman). 1934: SWAC. From at least 1947 to 1958, Naranjo worked as a silversmith for the H. H. Tammen Company in Denver. From about 1970 to 1974, Naranjo worked as an independent silversmith in Colorado Springs under the name Paul Rainbird. See also under Albuquerque and in text.

Jose Ortiz. 1934: SWAC (627 W. San Francisco). This is probably Joseph Ortiz, who in Santa Fe Indian School records is identified only as Southern Pueblo, born 1914.

Louis Pajarito (Santo Domingo Pueblo, born ca. 1893–1896). In his fieldnotes of 1940 John Adair stated that Pajarito told him that he once worked for SWAC. In federal documents, Pajarito's date of birth ranges from 1881 to 1901, but 1893 and 1896 are cited most often; his first name was sometimes recorded as Luis. See also in text.

Aloysius Pecos (Cochiti Pueblo, born 1915). 1936: (spelled Pecas) SWAC (307 Hancock). Pecos attended Santa Fe Indian School. In 1935 Burton Frasher photographed him at work at SWAC (figure 103).

Antonio Perez (Nambe Pueblo, born 1909; brother of Bernabe and Claudio Perez). 1930: (listed as Candio) SWAC (resides with Salvador Perez); 1938: SWAC (147 Duran); 1942: SWAC (517 Houghton). For further information, see listing for Claudio Perez.

Bernabe Perez (Nambe Pueblo, born ca. 1916; brother of Antonio and Claudio Perez). 1938: (spelled Bernie) SWAC (147 Duran); 1942: (spouse Margaret) SWAC (648 W. San Francisco). For further information, see listing for Claudio Perez.

Claudio Perez (Nambe Pueblo, born ca. 1911; brother of Antonio and Bernabe Perez). 1928: student (residing with Salvador Perez); 1930: no occupation (residence same); 1932: (spouse Estefana) SWAC (121[street name lacking]); 1934: (spouse Estafanita) SWAC (south side of Dolores one door east of Daniel); 1936: SWAC (147 Duran); 1938: (spouse Estefana) SWAC (147 Duran); 1942: (spouse Estefana) SWAC (147 Duran). Salvador Perez (Cochiti Pueblo, born 1888), father of Antonio, Bernabe, and Claudio Perez, was the shoemaker at the Santa Fe Indian School. He married Leonora Rivera of Nambe Pueblo, and according to Indian census rolls the family was residing at Nambe in 1930. Salvador eventually was recognized as a member of Nambe Pueblo. The Santa Fe directory implies that the family resided in Santa Fe in 1930, but no street address is given, and they were not living at the Santa Fe Indian School. In 1935 Burton Frasher photographed Claudio Perez at work at SWAC (figure 99).

Vicente Perez (Cochiti Pueblo, born 1911). 1930: SWAC (215 Rosario). Vicente Jose Perez is identified in some records as Jose Vicente Perez, and it appears that he may have changed the order of his name as an adult.

Jerry Quintana. 1934: SWAC; 1936: (spouse Margarite) SWAC (residing with Arturo Ortega [the same address as Mark Chee]).

Joe H. Quintana (Cochiti Pueblo, born 1915). In his fieldnotes of 1940 John Adair noted that Quintana worked for SWAC on their piecework system. Following the war, Quintana had an important career working for shops in Albuquerque; he was innovative and prolific. See also in text.

Silviano Quintana (Cochiti Pueblo, born 1913). 1938: (spelled Severiano; spouse Mensia) SWAC (152 Duran). In 1935 Burton Frasher photographed Quintana at work at SWAC (figure 104).

Ambrose Roans (Navajo; Navajo Station, Arizona; born ca. 1906; brother of Samuel Roans; name later changed to Roanhorse). 1930: SWAC (Hillside Ave.); 1932: silversmith, Santa Fe Indian School (residence same); 1934: laborer, Santa Fe Indian School (residence same); 1936: silversmith, Santa

Fe Indian School (residence same); 1938: (spouse Garnet) silversmith, Santa Fe Indian School (residence same). See also in text.

Samuel Roans (Navajo; Navajo Station, Arizona; born ca. 1916; brother of Ambrose Roans; name later changed to Roanhorse). 1940: SWAC. Roans was a student of his brother, Ambrose, during the fifth year that he taught silversmithing at the Santa Fe Indian School. See also in text.

Camilo Romero. 1936: jewelry apprentice, Thunder Bird Shop [sic] (520 Lolita); 1942: (spouse Stella) no affiliation (520 Lolita [same address as Jose Romero]).

Jose Romero. 1942: Thunderbird Shop (520 Lolita [same address as Camilo Romero]).

Salvadore Romero (Cochiti Pueblo, born ca. 1917). 1938: (spelled Salvador) SWAC.

Alfredo Roybal (possibly non-Indian). 1938: (spouse Lola) "silverman," La Fonda Hotel (536 Alto). Given the location of this occupation, a "silver-man" could have been either a silversmith or somebody in charge of the hotel's or its restaurant's silverware. The term does not occur in any other directory listing of the 1930s.

Homer Samuel (Navajo, born ca. 1913). 1930: SWAC (Hillside). Samuel became an enrolled member of Tesuque Pueblo, where he married Emiliana Romero and raised a family. See also under Albuquerque.

Dooley Shorty (Navajo; Cornfields, Arizona; born 1911). In his fieldnotes of 1940 John Adair noted that Buford Thomas of SWAC told him that Shorty had worked at SWAC, but he did not indicate when. See also in text.

Jos Shorty. 1942: SWAC (239 W. DeVargas).

Joseph Siow (Laguna Pueblo, born 1920). 1942: (listed as Jos) SWAC (rear 422 W. San Francisco).

Bally Suina. 1936: SWAC (132 Duran).

Cree Suina (Cochiti Pueblo, born ca. 1914; brother of Jose Rey Suina). 1942: (spouse Eusebia) no affiliation (135 Duran). Suina's given name was Crescencio, but he was always known as Cree.

Hicuan Suina. 1938: SWAC (rear 515 Rosario [same address as Jose Rey Suina]). This name was recorded incorrectly, and the listing was probably for Cree Suina.

Jose Rey Suina (Cochiti Pueblo, born ca. 1911; brother of Cree Suina). 1928: (listed as Jose Suina) SWAC; 1930: (listed as Jose Suina) SWAC (215 Rosario); 1934: (listed as Joseph) SWAC (627 San Francisco); 1938: (listed as Jos; spouse Mary) no affiliation (rear 515 Rosario [same address as Hicuan Suina]); 1942: (listed as Jos, spouse Mary) SWAC (rear 517 Rosario).

Reyes Suina. 1928: SWAC; 1930: SWAC (609 Agua Fria); 1938: SWAC (921 Dunlap); 1942: SWAC (921 Dunlap). This may be Reyes D. Suina of Cochiti, born 1897.

David Taliman (Navajo; Oak Springs, Arizona; brother-in-law of Al, Ernest, Manuel, and Paul Naranjo). 1930: (spouse Anne) SWAC (residing with Francisco Trujillo [127 Hillside Avenue]); 1932: no occupation; 1934: no affiliation (west side of Daniel four doors north of Dolores). In his fieldnotes of 1938 John Adair stated that Nestor Naranjo told him that David Taliman was then working as a smith for the Spanish and Indian Trading Company. Taliman learned silversmithing on the Navajo reservation, and following the war he had a successful, independent career as a smith. His wife, Anacita, was the sister of Al, Ernest, Manuel, and Paul Naranjo. See also under Albuquerque and in text.

Francisco Teyano (Santo Domingo Pueblo). In his fieldnotes of 1940 John Adair stated that Teyano, whom he visited at Santo Domingo, told him that he had worked for SWAC in about 1937. Adair also noted that Teyano had studied silversmithing for five years at Santa Fe Indian School under Ambrose Roanhorse. See also in text.

Ross Trujillo (possibly non-Indian, born ca. 1885). 1930: (spouse Vronia) SWAC (215 Rosario). Trujillo is listed in the 1930 federal census of Santa Fe, where he is identified as native New Mexican, but not as Native American. His spouse's name was listed as Veronica.

Thomas Weahkee (Zuni Pueblo, born ca. 1917). 1934: (spelled Weakkee) SWAC. Weahkee attended Santa Fe Indian School, where his name is recorded as "Tom" in most records. See also under Albuquerque.

Raymond Woods (possibly non-Indian). 1934: stonecutter, SWAC (627 San Francisco).

Chester Yellowhair (Navajo; Sand Springs, Arizona; born 1912). 1934: SWAC (residing at Santa Fe Indian School, where he was enrolled). In his fieldnotes of 1940, John Adair noted that Yellowhair was from Tuba City, but other documents indicate he was from Sand Springs. Yellowhair was a student of Ambrose Roanhorse in the second year that he taught silversmithing at Santa Fe Indian School. He became a recognized master of the technique of sandcasting, but he also served as a judge. See also under Albuquerque and in text.

# References Cited

Adair, John
1944    *The Navajo and Pueblo Silversmiths.* Norman: University of Oklahoma Press.

Allred, Kelly W.
1993    The Trail of E. O. Wooton. *New Mexico Resources* 9. College of Agriculture and Home Economics, New Mexico State University. Las Cruces.

Anderson, Duane
2002    *When Rain Gods Reigned: From Curios to Art at Tesuque Pueblo.* Santa Fe: Museum of New Mexico Press.

Ballenger & Richards
1890–1907    *Ballenger & Richards'* [later *Ballenger & Richards*] ... *Denver City Directory ... for 1890* [*1891, 1892,* etc.]. Denver: Ballenger and Richards.

Bandelier, Adolph F.
1966    *The Southwestern Journals of Adolph F. Bandelier, 1880–1882.* Charles H. Lange and Carroll L. Riley, eds. Albuquerque: University of New Mexico Press; Santa Fe: School of American Research and Museum of New Mexico Press.

1969    *A History of the Southwest. A Study of the Civilization and Conversion of the Indians in Southwestern United States and Northwestern Mexico from the Earliest Times to 1700. Edited by Ernest J. Burrus, S. J. Volume I: A Catalogue of the Bandelier Collection in the Vatican Library.* Rome, Italy, and St. Louis, MO: Jesuit Historical Institute.

1970    *The Southwestern Journals of Adolph F. Bandelier, 1883–1884.* Charles H. Lange, Carroll L. Riley, and Elizabeth M. Lange, eds. Albuquerque: University of New Mexico Press.

Baskin & Co.

1880    *History of the City of Denver, Arapahoe County, and Colorado*, Chicago: O. L. Baskin & Co., Historical Publishers.

Batkin, Jonathan

1987    *Pottery of the Pueblos of New Mexico, 1700–1940.* Colorado Springs: The Taylor Museum of the Colorado Springs Fine Arts Center.

1998    Some Early Curio Dealers of New Mexico. *American Indian Art Magazine* 23(3): 68–81.

1999    Tourism is Overrated: Pueblo Pottery and the Early Curio Trade, 1880–1910. Pp. 282–297, 367–369 in *Unpacking Culture: Art and Commodity in Colonial and Postcolonial Worlds.* Ruth B. Phillips and Christopher B. Steiner, eds. Berkeley: University of California Press.

2004    Mail-Order Catalogs as Artifacts of the Early Native American Curio Trade. *American Indian Art Magazine* 29(2): 40–49, 76.

Batkin, Jonathan, editor

1999    *Clay People: Pueblo Indian Figurative Traditions.* Santa Fe: Wheelwright Museum of the American Indian.

Batkin, Jonathan, and Patricia Fogelman Lange

1999    Human Figurines of Cochiti and Tesuque Pueblos, 1870–1920: Inspirations, Markets, and Consumers. Pp. 40–63 in *Clay People: Pueblo Indian Figurative Traditions.* Jonathan Batkin, ed. Santa Fe: Wheelwright Museum of the American Indian.

Beach-Akin Curio Co.

[1902]    *Illustrated Catalogue. Mexican Hand Carved Leather. Beach-Akin Curio Co. El Paso, Texas, U. S. A.* El Paso.

Benson, Maxine

1986    *Martha Maxwell, Rocky Mountain Naturalist.* Lincoln: University of Nebraska Press.

Bernalillo Mercantile Co.
n.d.      *Navajo (Pronounced Nava-ho) Rugs. A Hand Woven Product of a Primitive People.*
Domingo, NM.

Blake, J. A.
1875–1879      *Colorado Business Directory and Annual Register, for 1875 [1876, 1877, etc.].*
Denver: J. A. Blake.

Boswell, George B.
1874      *Office of the Rocky, Mountain Mineral Agency, Laramie City, W. T. March, 20th 1874.*
Laramie, WY.

Butterick Publishing Company
1896      *The Art of Drawn-Work. Metropolitan Art Series* 2(1), March 1896. London
and New York: The Butterick Publishing Co.

Campbell, W. D.
1898      *Catalogue of Western Souvenirs. Indian Mexican and California Curios. W. D. Campbell's Curio Store.* Los Angeles.

Candelario, J. S.
1903      *To My Friends and Customers . . . Santa Fe, N. M., June 20, 1903.* Santa Fe.

1904      *The Old Curio Store. J. S. Candelario, Prop'r. . . . Santa Fe, New Mexico.* Santa Fe.

1905      *If the Corners Do not Contain What you Desire, Select From this List and Write me.
The Old . . . Curio Store.* Santa Fe.

ca. 1911      *Candelario, The Curio Man, Santa Fe, N. M.* Santa Fe.

Carlisle Indian School
ca. 1910      *Indian Crafts Dept. United States Indian School, Carlisle, Pa. Partial List of Regular Stock. Distributors of Baskets, Beadwork, Navajo Blankets, Silverware, Moccasins . . . In fact, Everything made by the Indian.* Carlisle, PA.

Chapman, Kenneth M.
1938      *The Pottery of Santo Domingo Pueblo: A Detailed Study of Its Decoration. Memoirs
of the Laboratory of Anthropology* 1. Santa Fe.

Citizen Publishing Company
1907　*The Albuquerque City Directory 1907. Published by the Citizen Publishing Company. . . .* Albuquerque: Press of the Evening Citizen.

Corbett, Hoye & Co.
1873　*Corbett, Hoye & Co's Directory of the City of Denver for 1873.* Volume One. Denver: Printed by the Denver Tribune Association.

1874　*Corbett, Hoye & Co's Second Annual City Directory for 1874 . . . City of Denver.* [Denver]: Corbett, Hoye & Co.

1875　*Corbett, Hoye & Co's III Annual City Directory . . . City of Denver, for 1875.* Denver: Corbett, Hoye & Co.

1877　*Corbett, Hoye & Co's . . . City Directory of the . . . City of Denver.* Kansas City: Printed by St. Joseph Steam Printing Company.

1878　*Corbett, Hoye & Co's . . . City Directory of the . . . City of Denver.* n.p.

1879　*Corbett, Hoye & Co's . . . City Directory of the . . . City of Denver.* Denver: News Printing Company, Printers and Binders.

1880　*Corbett, Hoye & Co's . . . City Directory of the . . . City of Denver.* Denver: Rocky Mountain News Printing Co., Printers and Binders.

Corbett & Ballenger
1881　*Corbett & Ballenger's . . . Denver City Directory . . . for 1881.* Denver: Rocky Mountain News Printing Co., Printers and Binders.

1882–1887　*Corbett & Ballenger's . . . Denver City Directory . . . for 1882* [*1883, 1884,* etc.]. Denver: Corbett & Ballenger, Publishers.

Cotton, C. N.
n.d.　*The use of Navajo Blankets as a home decoration. C. N. Cotton Co. Indian traders Supplies and Navajo Blankets Gallup, New Mexico.* Gallup, NM.

Dartt, Mary
1879　*On the Plains, and Among the Peaks; or, How Mrs. Maxwell Made Her Natural History Collection.* Philadelphia: Claxton, Remsen & Haffelfinger.

Davis, W. W. H.

1938    *El Gringo, or New Mexico & Her People.* Santa Fe: Rydal Press. (Originally published in 1857)

Dike, Sheldon H.

1958    The Territorial Post Offices of New Mexico. Albuquerque: Published by the author.

Dollfus-Mieg & Compagnie

*n.d.*    *Drawn Thread Work.* D. M. C. Library, edited by Th. De Dillmont. Mulhouse: Printed by the Societé Anonyme Dollfus-Mieg & Cie.

Doña Ana County Historical Society

1983    The Francis E. Lester House, Mesilla. *Doña Ana County Historical Society. Seventeenth Annual Banquet.* Best Western of Las Cruces, October 20, 1983. Las Cruces, NM.

Douglas, Frederic H.

1941    Santo Domingo Pottery of the "Aguilar" Type. Clearing House for Southwestern Museums, Newsletter 37: 133–134.

Doyle, Gene F.

1968    Candelario's Fabulous Curios. *The Denver Westerners Monthly Roundup,* 24(9): 3–13, 20.

Dozier, Thomas S.

1904    *About Indian Pottery.* Española, NM.

1906    *Statement to the Trade for 1907. Thomas S. Dozier, Collector of Curios. Cor. Burro Alley and San Francisco Sts. Santa Fe, New Mexico. Successor to Gold's Old Curiosity Shop, Established 1859.* Santa Fe.

Dunne, "Bee Bee"

1948    Santa Fe's First Museum. *New Mexico* 26 (August): 11, 37, 39, 41.

El Paso Directory Co.

1900    *Buck's Directory of the City of El Paso, Tex. For 1900–1901.* El Paso: El Paso Directory Co.

1902    *Buck's Directory of El Paso, Tex. For 1902.* El Paso: El Paso Directory Co.

El Paso and Juarez Directory Co.
1892    *Classified Business Directory, of the Cites of El Paso, Texas and Ciudad Juarez, Mex. for the Years 1892 and 1893. . . . Published by the El Paso and Juarez Directory Co.* El Paso: Printed by Reinhardt and Company.

Elder, Jane Lenz, and David J. Weber, editors
1996    *Trading in Santa Fe: John M. Kingsbury's Correspondence with James Josiah Webb, 1853–1861.* Dallas: Southern Methodist University Press.

Evan and Worley
1896    *Evan and Worley's Directory of the City of El Paso, Texas, 1896–'97.* Dallas: Press of John F. Worley.

Falkenstien-Doyle, Cheri
2006    The First Phase: Early Navajo Textiles and Silver. *Ornament Magazine* 29(5): 36–39.

Farrar, Charles Alden John
1879    *Camp Life in the Wilderness.* Boston: A. Williams and Company.

Foster, Kate McCrea
1889    *Fifty Designs for Mexican Drawn Work, with Directions for Working.* Boston: The Priscilla Publishing Co.

Gallup Mercantile Co.
n.d.    *Navajo (Pronounced Nava-ho) Rugs. A Hand Woven Product of a Primitive People.* Gallup, NM.

Gans, Julius/Southwest Arts & Crafts
ca. 1934    *Southwest Arts & Crafts, Julius Gans, Santa Fe, New Mexico.* Catalog number 16. Santa Fe.

ca. 1939    *Southwest Arts & Crafts, Julius Gans, Santa Fe, New Mexico.* Catalog number 19. Santa Fe,

Gazetteer Publishing and Printing Co.
1918    *New Mexico State Business Directory . . . 1918.* Denver: The Gazetteer Publishing & Printing Co.

1929–1941    *The Gazetteer Co. Inc. Denver Directory 1929* [*1930, 1931,* etc.]. Denver: The Gazetteer Publishing and Printing Co.

Gold, Jake
ca. 1887    *Gold's Free Museum.* Santa Fe.

1889    *Catalogue of Gold's Free Museum and Old Curiosity Shop.* Santa Fe.

1892    *Catalogue of Gold's Free Museum and Old Curiosity Shop.* Santa Fe.

Gottschall, Amos H.
1894    *Travels from Ocean to Ocean, from the Lakes to the Gulf; Being the Narrative of a Twelve Years' Ramble and What Was Seen and Experienced....* Fourth edition. Harrisburg, PA: Amos H. Gottschall

1924    *Descriptive, Priced Catalogue of the Utensils, Implements, Weapons, Garments, Ornaments and General Handicraft of the North American Indians.... Prepared by Amos H. Gottschall.* Harrisburg, PA: Amos H. Gottschall.

Gould & Co.
1886    *C. A. Gould & Co's General Directory of the City of El Paso. For 1886–1887.... Compiled by C. A. Gould & Co., El Paso, Texas.* Dallas: A. D. Aldridge & Co., Steam Printers.

Graves, Laura
1998    *Thomas Varker Keam, Indian Trader.* Foreword by David M. Brugge. Norman: University of Oklahoma Press.

Hill, W. W.
1982    *An Ethnography of Santa Clara Pueblo, New Mexico.* Charles H. Lange, ed.. Albuquerque: University of New Mexico Press.

Howard, Kathleen L.
1986    "A Most Remarkable Success": Herman Schweizer and the Fred Harvey Indian Department. Pp. 87–101 in *The Great Southwest of the Fred Harvey Company and the Santa Fe Railway.* Marta Weigle and Barbara A. Babcock, eds. Phoenix: The Heard Museum.

Howard, Kathleen L., and Diana F. Pardue
1996    *Inventing the Southwest: The Fred Harvey Company and Native American Art.* Flagstaff: Northland Publishing, in cooperation with the Heard Museum.

Hubbell, J. L.

1902    *Catalogue and Price List. Navajo Blankets & Indian Curios. J. L. Hubbell, Indian Trader. Ganado, Apache County, Arizona. Branch Store: Keam's Cañon, Arizona.* Ganado, AZ.

Hudspeth Directory Company

1918–1940    *Hudspeth Directory Company's Albuquerque City Directory 1918* [*1919, 1920,* etc.]. El Paso: Hudspeth Directory Company.

1928–1942    *Santa Fe City Directory 1928–1929* [*1930–1931...1936–1937, 1938, 1940, 1942*]. El Paso: Hudspeth Directory Company.

Ives & Co.

1885–1893    *Colorado State Business Directory . . . 1885* [*1886, 1887,* etc.]. Denver: James R. Ives & Co., Publishers.

Kabotie, Fred

1977    *Fred Kabotie: Hopi Indian Artist. An Autobiography Told with Bill Belknap.* Flagstaff: The Museum of Northern Arizona with Northland Press.

Kline, Cindra

2001    *Navajo Spoons: Indian Artistry and the Souvenir Trade, 1880s–1940s.* Santa Fe: Museum of New Mexico Press.

Kohlberg, Ernst

1973    Letters of Ernst Kohlberg 1875–1877. Translated by Walter L. Kohlberg. Introduction by Eugene O. Porter. *Southwestern Studies, Monograph* 38. El Paso: Texas Western Press, University of Texas at El Paso.

Kropp, Phoebe

1986    "There is a little sermon in that": Constructing the Native Southwest at the San Diego Panama-California Exposition of 1915. Pp. 36–46 in *The Great Southwest of the Fred Harvey Company and the Santa Fe Railway.* Marta Weigle and Barbara A. Babcock, eds. Phoenix: The Heard Museum.

Lea, Tom

1952    *The Wonderful Country.* Boston: Little, Brown and Company.

Lester, Francis E.

1902      A Southern New Mexico Flower Garden. *New Mexico College of Agriculture and Mechanic Arts, Agricultural Experiment Station, Mesilla Park, N. M. Bulletin 40,* November 1901. Mesilla Park, NM.

1903      *Mexican Drawn Work and Indian Rugs. Francis E. Lester Importer and Manufacturer, Mesilla Park, N.M.* Mesilla Park, NM.

1904a      *Mexican Drawn Work and Indian Rugs. Francis E. Lester Importer and Manufacturer, Mesilla Park, N.M.* Mesilla Park, NM.

1904b      *The Francis E. Lester Company Inc. Mesilla Park N.M. Indian Rugs Woven to Order. Fine Navajo Blankets. Pottery — Baskets. Mexican Drawnwork. Mexican Fire Opals.* Mesilla Park, NM.

1905a      *Annual Spring Sale of High Grade Mexican and Indian Goods, Mexican Drawnwork....* Mesilla Park, NM.

1905b      *A Special Holiday Offering...1905.* Mesilla Park, NM.

1906a      *A Special Summer Offering of Mexican Hand-Woven Hats....* Mesilla Park, NM.

1906b      *Annual Holiday Offering. Christmas 1906. The Francis E. Lester Company....* Mesilla Park, NM.

1907a      *The Indian Blanket. Being Vol. 1 No. 1 of Lester's Handicraft Talk.* Mesilla Park, NM.

1907b      *The Mexican Sombrero. Being Volume 1, Number 2 of Lester's Handicraft Talk. The Francis E. Lester Company. Largest Retailers of* Genuine *Indian and Mexican Handicraft in the World. Mesilla Park, New Mexico.* Mesilla Park, NM.

1907c      *Indian & Mexican Handicraft. The Francis E. Lester Company, Inc.* Mesilla Park, NM.

1908      *Mexican Sombreros and Panama Hats. The Francis E. Lester Company. Largest Retailers of Native Handicraft in the World. Mesilla Park, New Mexico.* Mesilla Park, NM.

ca. 1911      *Summer Sale Catalog of Mexican and Panama Hats Direct from Importer to Wearer. The Francis E. Lester Co. Mesilla Park, New Mexico.* Mesilla Park, NM.

1942    *My Friend the Rose. By Francis E. Lester, with an Introduction by J. Horace McFarland, L. H. D. With sixteen illustrations reproduced from paintings by Mary Lawrance, first printed 1799.* Harrisburg, PA: Mount Pleasant Press, J. Horace McFarland Company.

Lucero, Helen, and Suzanne Baizerman
1999    *Chimayó Weaving: The Transformation of a Tradition.* Albuquerque: University of New Mexico Press.

Maisel's Indian Trading Post
ca. 1928–1930    Maisel's Indian Trading Post, Albuquerque New Mexico, 117 So. First St., Indian Made Silver and Turquoise Jewelry, No. 7. Albuquerque.

ca. 1930–1932    Maisel's Indian Trading Post, Albuquerque New Mexico, 117 South First Street [some copies also with 324 W. Central Avenue], Indian Made Silver and Turquoise Jewelry, No. 8. Albuquerque.

Matthews, Washington
1883    Navajo Silversmiths. Pp. 167–178 in *Second Annual Report of the Bureau of Ethnology to the Secretary of the Smithsonian Institution, 1880–'81.* Washington.

McKenney & Co.
1882    *McKenney's Business Directory of the Principal Towns of Central and Southern California, Arizona, New Mexico, Southern Colorado and Kansas. . . .* Oakland and San Francisco: Pacific Press, Publishers. L. M. McKenney & Co. Managers.

Meline, James F.
1867    *Two Thousand Miles on Horseback. Santa Fe and Back. A Summer Tour through Kansas, Nebraska, Colorado, and New Mexico, in the Year 1866.* New York: Hurd and Houghton.

Moore, J. B.
1906    *Illustrated Catalogue of Navajo Hand-Made Silverwork. Manufactured and sold by J. B. Moore, Indian Trader and Collector, Crystal, New Mexico. Compiled by J. B. Moore and done into print by The Indian Print Shop, Chilocco, Oklahoma, in the year '06.* Crystal, NM.

Murray, Andrew Evans
1947    A History of Presbyterianism in Colorado. Ph. D. dissertation, Princeton Theological Seminary.

Nathanson, Philip D.

2007    *Gold's Old Curiosity Shop, Santa Fe.* [Los Angeles]: Philip D. Nathanson.

Nequatewa, Edmund

1936    *Truth of a Hopi, and Other Clan Stories of Shung-Opovi.* Flagstaff: Northern Arizona Society of Science and Art.

Nolan, Frederick

1992    *The Lincoln County War: A Documentary History.* Norman and London: University of Oklahoma Press.

Oxford Universal Dictionary

1955    *The Oxford Universal Dictionary of Historical Principles.* Oxford: At the Clarendon Press.

Pardue, Diana

2005    Native American Silversmiths in the Southwest. *American Indian Art Magazine* 30(3): 62–69.

Parish, William J.

1961    *The Charles Ilfeld Company: A Study of the Rise and Decline of Mercantile Capitalism in New Mexico.* Cambridge: Harvard University Press.

Peterson, C. S.

1912    *Representative New Mexicans: The National Newspaper Reference Book of the New State containing Photographs and Biographies of over Four Hundred Men Residents of New Mexico.* Denver: C. S. Peterson

Porter, Eugene O.

1973    Introduction. Pp. 3–8 in Letters of Ernst Kohlberg 1875–1877. Translated by Walter L. Kohlberg. *Southwestern Studies, Monograph* 38. El Paso: Texas Western Press, University of Texas at El Paso.

Powell, H. M. T.

1931    *The Santa Fe Trail to California, 1849–1852. The Journal and Drawings of H. M. T. Powell.* San Francisco: The Book Club of California.

Rackliff & Wainey

1885    *El Paso, Texas and Paso del Norte, Mexico, Business Directory for 1885. Published by Rackliff & Wainey.* Albuquerque: Daily Journal Steam Printing House.

Riggs, Chauncey Wales

1897    *Exhibitions at Wanamaker's April and May 1897: Antique Tapestries and Textiles. The Riggs Collection of Navajo Indian Rugs and Curios, Ancient and Modern. . . .* New York: John Wanamaker.

1899    *"Rough Rider" Robes of the Wild West. By a Rough Rider.* New York.

Riggs, Chauncey Wales, Althea Riggs, and Frank Markwood

ca. 1897    *Camp Life in the Wilderness. n.p.*

Ritch, Alan

n.d.    *Roses of Yesterday and Today: A History in Catalogs.* http://library.ucsc.edu/exhibits/rosehistory.html

Sanborn Map Company

1883    *Map of Santa Fe, New Mexico, October 1883.* New York: Sanborn Map and Publishing Company.

1886    *Map of Santa Fe, New Mexico, June 1886.* New York: Sanborn Map and Publishing Company.

1927    *Las Cruces Dona Ana County New Mexico May 1927.* New York: Sanborn Map Company.

Schaefer, Jack

1974    Introduction. Pp. i–xi in *Cowboy and Indian Trader* by Joseph Schmedding. Albuquerque: University of New Mexico Press. (Originally published in 1951)

Schmedding, Joseph

1974    *Cowboy and Indian Trader.* Albuquerque: University of New Mexico Press. (Originally published in 1951)

Schrader, Robert Fay

1983    *The Indian Arts & Crafts Board: An Aspect of New Deal Policy.* Albuquerque: University of New Mexico Press.

Seligman's

ca. 1949    Genuine Hand-Made Indian Jewelry From the Southwest.... Seligman's, 2309 W. Central Avenue, Albuquerque, New Mexico. Albuquerque.

Stern, Mort

1989a    *Looking for a People's Champion: A Search for the Real Harry Tammen.* Denver: [Privately published].

1989b    Harry Tammen and his Great Divide: Early Magazine Journalism in Colorado. *Essays and Monographs in Colorado History* 10: 1–49.

Stevenson, James

1883    Illustrated Catalogue of the Collections Obtained from the Indians of New Mexico and Arizona in 1879. Pp. 307–422 in *Second Annual Report of the Bureau of Ethnology to the Secretary of the Smithsonian Institution, 1880–'81.* Washington.

Tammen, H. H. (and succeeding company names)

1882a    *Western Echoes: Devoted to Mineralogy, Natural History, Botany, &c, &c. Published by H. H. Tammen & Co., Denver, Colorado.* Denver.

1882b    *Western Echoes: Devoted to Mineralogy, Natural History, Botany, &c, &c. Published by H. H. Tammen & Co., Denver, Colorado.* Denver.

ca. 1887    *Relics from the Rockies. H. H. Tammen, Denver, Colorado.* Denver.

1901a    *The H. H. Tammen Curio Co. Denver, Colo. Established 1881.* Denver

1901b    *Supplement. The H. H. Tammen Curio Co. . . .* Denver.

1903a    *The H. H. Tammen Curio Co. Denver, Colo. Established 1881.* Denver.

1903b    [Supplement] *The H. H. Tammen Curio Co. Denver, Colo. Established 1881.* Denver.

1904    *The H. H. Tammen Curio Co. Denver, Colo. Established 1881.* Denver.

1905    *Supplement. H. H. Tammen Curio Co. Denver Colorado. Established 1881.* Denver.

1908    *The H. H. Tammen Company Established 1881 Denver Colo., U.S.A. General Catalogue.* Denver.

1917    *The H. H. Tammen Co. Wholesale Only. Established 1881. Denver Colo. Manufacturers — Jobbers — Importers. Leather Goods, Ivory, Brass and Metal Novelties, Toys, Dolls, Novelty Jewelry, Navajo Silverware . . . Novelties of All Kinds.* Denver.

Walz, W. G.
1888    *Illustrated Catalogue of Mexican Art Goods and Curiosities. Also, Indian Goods, for Sale by the Mexican Art and Curiosity Store, W. G. Walz, Proprietor, El Paso, Texas, U. S. A.* Philadelphia: Press of Edward Stern & Co.

1906    *Illustrated Catalogue and Retail Price List of Mexican and Indian Souvenirs and Curiosities, Mexican Drawnwork . . . W. G. Walz Company, El Paso, Texas.* . . . El Paso: El Paso Printing Co., Printers and Binders.

Weigle, Marta, and Kyle Fiore
1982    *Santa Fe & Taos: The Writer's Era.* Santa Fe: Ancient City Press.

Wooton, E. O., and Paul C. Stanley
1915    Flora of New Mexico. *Contributions from the United States National Herbarium* 19. Washington.

Worley & Co.
1898    *Worley's Directory of the City of El Paso, Tex. 1898–1899. . . . Compiled and Printed by John F. Worley & Co., publishers of the Dallas, Waco and El Paso City Directories.* Dallas: Press of John F. Worley.

1899    *Worley's Directory of the City of El Paso, Tex. 1900. n.p.*

1903    *John F. Worley & Co.'s El Paso Directory for 1903.* Dallas: Press of John F. Worley.

1904    *John F. Worley & Co.'s El Paso Directory for 1904.* Dallas: Press of John F. Worley.

Wright, Margaret
1972    *Hopi Silver: The History and Hallmarks of Hopi Silversmithing.* Flagstaff: Northland Press.

# INDEX

*This publication and the accompanying exhibition*
*were made possible by the generous support of the following:*

National Endowment for the Humanities
Thaw Charitable Trust
Martha Ann Healy
The City of Santa Fe Arts Commission and the 1% Lodgers' Tax
Leo and Donna Krulitz
Stockman Family Foundation
Elizabeth Jenifer Merrin Publication Fund
Lucia Woods Lindley
Leonie F. Batkin
The Mittler Family
New Mexico Arts, a division of the Department of Cultural Affairs, and the
National Endowment for the Arts

AlphaGraphics, Santa Fe
American Indian Art Magazine, Scottsdale
Century Bank, Santa Fe
Charter Bank, Santa Fe
Historic Toadlena Trading Post, Toadlena, NM
Hotel Santa Fe
Jan Musial's Navajo Arts, Flagstaff
Kania-Ferrin Gallery, Santa Fe
King Galleries, Scottsdale
Las Campanas, Santa Fe
Robert Bauver American Indian Art, New Salem, MA
Santa Fe Country Furniture
Silver Plume Trading Company, Albuquerque
Turkey Mountain Traders, Scottsdale

# PHOTO CREDITS

Published by the Wheelwright Museum of the American Indian
704 Camino Lejo
Santa Fe, NM  87505
www.wheelwright.org

Published in conjunction with the exhibition, *From the Railroad to Route 66: The Native American Curio Trade in New Mexico*, May 17, 2008–April 19, 2009.

Editors: Jonathan Batkin and Cheri Falkenstien-Doyle
Design and Production: David Skolkin / Skolkin + Chickey
Typesetting: Angela Taormina
Printed and bound in Singapore by Tien Wah Press

ISBN: 978-096227776-4 (hardcover)
ISBN: 978-096227777-1 (softcover)